IndigePop

Genre Fiction and Film Companions

Series Editor: Simon Bacon

IN DI GE POP

A Companion

Edited by Svetlana Seibel and Kati Dlaske

PETER LANG

Oxford - Berlin - Bruxelles - Chennai - Lausanne - New York

Bibliographic information published by the Deutsche Nationalbibliothek. The German National Library lists this publication in the German National Bibliography; detailed bibliographic data is available on the Internet at http://dnb.d-nb.de.

A catalogue record for this book is available from the British Library.

Library of Congress Cataloging-in-Publication Data

Names: Seibel, Svetlana, 1982- editor. | Dlaske, Kati, 1981- editor.
Title: IndigePop : a companion / editors Svetlana Seibel, Kati Dlaske.
Description: Oxford ; New York : Peter Lang Publishing, 2024. | Series:
 Genre fiction and film companions, 2631-8725 ; volume no. 16 | Includes
 bibliographical references and index.
Identifiers: LCCN 2024031309 (print) | LCCN 2024031310 (ebook) |
 ISBN 9781803743080 (paperback) | ISBN 9781803743097 (ebook) |
 ISBN 9781803743103 (epub)
Subjects: LCSH: Indigenous popular culture. | Indigenous peoples in popular
 culture.
Classification: LCC NX180.S6 I53 2024 (print) | LCC NX180.S6 (ebook) |
 DDC 306.4/7089--dc23/eng/20240904
LC record available at https://lccn.loc.gov/2024031309
LC ebook record available at https://lccn.loc.gov/2024031310

Funding acknowledgement: A Tribe Called Geek and IRTG Diversity.

Cover caption: Sonny Assu, Legacy (2015). Acrylic on panel. 36" x 96".
Photo: Dayna Danger. Image courtesy of the Artist and the Equinox Gallery © Sonny Assu.
Cover design by Peter Lang Group AG

ISSN 2631-8725
ISBN 978-1-80374-308-0 (print)
ISBN 978-1-80374-309-7 (ePDF)
ISBN 978-1-80374-310-3 (ePUB)
DOI 10.3726/b21220

This publication has been peer reviewed.

For Christian
For Jonas
For Sofie

Contents

Acknowledgements

The process of creating this book has been a team effort of so many people. First and foremost, our sincerest thanks go to all contributors, who invested time, effort, brilliance and infinite patience into making it what it is. We would also like to express out deep gratitude to Simon Bacon, the editor of the Genre Fiction and Film Companions series at Peter Lang, for welcoming us into his series and giving our book a home; and to our wonderful editor Laurel Plapp at Peter Lang for her open-minded and ever supportive guidance as we made our way through the challenging process of putting together a book. Our deepest gratitude also goes to Dr Lee Francis 4, the CEO of A Tribe Called Geek Media and the Executive Director of Native Realities, for his support of this publication from the very earliest moments of its inception, not only by generously allowing us to attend and conduct research at the Indigenous Comic Con 2 (and, later, 3), but also by his steady encouragement in the years that followed. We owe a debt of deep gratitude to A Tribe Called Geek for supporting this publication financially; our thanks go also to the IRTG 'Diversity: Mediating Difference in Transcultural Spaces' for financial support of this project. We wish to thank the anonymous peer reviewers who dedicated time and effort to helping us improve this publication and provided thoughtful and supportive comments. Last, but far from least, we would like to thank our families, who supported us as innumerable hours were spent in working on and realizing our vision for this book.

Svetlana Seibel

Approaching IndigePop:
Some Thoughts to Start

Get your Indigenerd on!

– Programme booklet of the IndigiCon 3, 2018

This book began with a journey. On a cloudy November day in 2017, we, the editors of this volume, have met in the waiting area of the Copenhagen airport – Kati coming from Helsinki, me coming from Frankfurt am Main – to board our joint flight to Albuquerque, NM. With the generous permission of its executive director and the CEO of Native Realities, Dr Lee Francis 4 (Pueblo of Laguna), we were bound to attend the second Indigenous Comic Con – IndigiCon, as it came to be called – which was taking place at Isleta Resort and Casino on the Pueblo of Isleta land near Albuquerque (Figure 1). Merely in its second year, the Indigenous Comic Con has by then become arguably the most significant event on the Indigenous pop culture calendar.[1] The atmosphere of excitement suffused the venue from the eve of the event on and did not diminish until its end. At the time of this writing, IndigiPopX 2024 – this year's instalment of the Indigenous Pop Culture Expo – has just

[1] The Indigenous Comic Con initiative has grown considerably since its inauguration in Albuquerque in 2016. In July 2019, an Indigenous pop culture convention Indigenous POP X, organized by Kristina Maldonado Bad Hand (Sicangu Lakota/Cherokee) and Rafael Maldonado Bad Hand, took place in Denver, Colorado. In November 2019, another Indigenous Comic Con was held in Melbourne, Australia, organized by Cienan Muir (Yorta Yorta/Ngarrindjeri). Both these conventions were inspired by the example of the Indigenous Comic Con in Albuquerque. In March 2023 and April 2024, the convention was held under the title IndigiPopX, or IPX, at the First Americans Museum in Oklahoma City.

wrapped up. The Expo represents an expansion of the Indigenous Comic Con and an effort to formally embrace and explore Indigenous creativity in all popular media. The core of its mission and vision, however, remains true to its beginnings as Indigenous Comic Con eight years ago.

Whomever we talked to in the course of the convention's three days, we met with kindness and generosity, and a good bit of humour. Among this warm welcome that had been accorded to us, we did raise an eyebrow or two, with people humorously reacting to our questions and explanations along the lines of 'Really? You are academics, and you are studying *this*?' Invariably, we all laughed at that. Because we all understood the importance of *this*. This book is very much informed by our experiences at the Indigenous Comic Con, the embodied perceptions they generated and the relationships they forged.[2]

It is easy to see why the IndigiCon, and now the IndigiPopX, carry such a strong significance. It is a space that is dedicated squarely to celebrating 'Indigenerdity'[3] – Indigenous geekdom, fandom and nerdy creativity – without reservations. It is a space where Indigenous geek culture, Indigenous fandom and entrepreneurship are at the centre of attention. As Lee Francis tells Taté Walker (Miniconjou Lakota) in an interview for Walker's article on the first Indigenous Comic Con (2016) in *Native Peoples* magazine:

> It's important for us to be able to have an event like this, our own space, where we have sci-fi and fantasy that's about our future, and we're writing ourselves into the future and

2 I returned to Albuquerque the following year to attend the IndigiCon 3 (2018), where I also served as a volunteer and offered a workshop on Indigenous vampire fiction.

3 The term 'Indigenerdity' is associated not only with the Indigenous Comic Con but is also central to the vision of the media platform *A Tribe Called Geek*, founded by Johnnie Jae (Otoe-Missouria/Choctaw). The platform's original slogan is 'Indigenerdity for the Geeks at the Powwow.' The flyer of the platform distributed at the IndigiCon 2 characterizes it as 'a community of intelligent, imaginative, innovative and creative Indigenerds acknowledging and advancing the visibility of our contributions to pop culture and STEM. From indigenous superheroes to Harry Potter and more, our podcasts, website and social media are a celebration of Indigenous Representation and Geekery.' See also <https://atribecalledgeek.com/about-atcg/>. *A Tribe Called Geek* collective was a co-sponsor of Indigenous Comic Con's inaugural year.

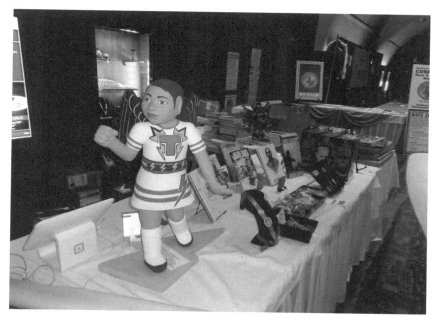

Figure 1. Native Realities booth in the making on the eve of the Indigenous Comic Con 2. Photo: Svetlana Seibel. Reproduced with permission.

into mainstream pop culture[.] [...] It shows the world we exist intellectually, creatively, culturally and in stimulating, dynamic and exciting ways. (qtd. in Walker 2016: 19)

Given the history of appropriation and cultural colonization through mis-representations of Indigenous people(s) and cultures in the context of popular culture, the importance of a space like this for both decolonization and resurgence cannot be overstated, as Francis reiterates:

In this nerd pop-culture era we live in, especially for Native folks, we're marginalized in those spaces. Specifically, we're historicized, seen as artifacts or relics, or we don't even exist[.] [...] But it's also something internally for us. It's a place for us. A place where we can nerd out. A place we don't usually get to exist within. This event is built as a safe space for Indigenous people and the content we create. (qtd. in Walker 2016: 19)

The Indigenous Comic Con can be viewed as a microcosm that reflects the entirety of Indigenous popular culture, and many of the dynamics Francis

notes in his remarks on the story, purpose and motivation behind the Con's inception are visible as the defining characteristics of IndigePop at large – a cultural field that encompasses all expressions of Indigenous creativity at the intersection with popular culture.[4]

As is the case with popular culture in general, Indigenous popular culture is difficult to define with any degree of exhaustiveness – because of its dynamic and ever-evolving nature, it refuses to be conceptually pinned down, and any definition seems outdated the moment it is committed to paper. Far from being a cause for despair, however, this elusive quality constitutes one of the main strengths that define popular culture, Indigenous and otherwise: pop culture goes where its participants take it. Any attempt at definition therefore presupposes a degree of incompleteness and conceptual volatility that at the same time flows back into this very same definition. Simon Frith sees this elusiveness as in itself constitutive of popular culture, pointing out that 'the essence of popular culture is its conceptual slipperiness, its fluidity, and lack of clear definition. Any critical analysis of popular culture must, therefore, be concerned to open up the concept rather than to close it down' (Frith 2010: 555). The open-endedness of popular culture is such a prominent feature that John Storey ventures to interpret popular culture as 'in effect an *empty* conceptual category, one which can be filled in a wide variety of often conflicting ways, depending on the context of use' (Storey 2006: 1, emphasis in original).

While this conceptual nebulousness makes popular culture a challenging, at times downright frustrating object of study, the possibilities for practitioners, artists and fans are virtually limitless. Storey's idea of popular culture as an open receptacle for varieties of content is of great significance for conceptualizing Indigenous popular culture in particular, insofar as Indigenous practitioners of the popular modify and (re)invent the content of popular productions by introducing culturally sensitive (counter)content rooted in Indigenous

4 I have come across varying spellings of terms that are blends of the word 'Indigenous' and pop cultural terms such as 'Con', 'nerd' or 'pop.' Indigenerd/Indiginerd, IndigiCon, IndigiPop/IndigePop are all possible variations. Despite differences in spelling, there appear to be no discernible differences in meaning. For the sake of consistency, we the editors have decided to adopt the spelling Indigenerd and IndigePop throughout this volume, except when referring to events/organizations that use a different spelling in their self-identification or when quoting material where a different spelling is used.

perspectives and lifeworlds. As noted above, participants and practitioners are the driving force and the defining agents of popular culture, so much so that, for Stacy Takacs, the central conceptual nexus of popular culture lies in involvement and interaction – between producers and consumers as well as between members of the audience among themselves: popular culture is about 'the expression of people's interests, choices, and activities' (Takacs 2015: 6). Consequently, one of the main features of popular culture becomes the fact that within its bounds

> people are active agents in the production of cultural meanings and pleasures and [...] they use the raw materials provided by the cultural industries to enact their agency. The 'popular' of popular culture, in this case, refers to 'people' (members of the populace) and the work they do to transform the cultural resources available in society into meaningful expressions of localized desire. (Takacs 2015: 6)

The idea of popular culture as an expression of 'localized desire' – a rooted desire, we could also say – is key for Indigenous popular culture as well. As Francis's remarks in relation to the Indigenous Comic Con indicate, participation is a vital issue where Indigenous popular culture is concerned – and, to stress this again, the issue of participation in popular culture always involves both producers and consumers. In other words, a question introduces itself: who is part of the 'people' in popular culture and who is not? Is everyone who participates doing so on equal terms and under equitable conditions? Until quite recently, in – for lack of a better term – mainstream popular culture, both on the level of production and on the level of representation or text, Indigenous creators and audiences have been largely excluded from participation. What is more, mainstream popular culture was, and often still is, ignorant or actively hostile in its representations of Indigenous people, creating a culture of representational toxicity that both discursively mirrors and politically promotes coloniality – what Lee Francis in this volume terms 'Pop Culture Colonization'. Indigenous popular culture corrects this asymmetry of representational sovereignty in the field of the popular while simultaneously localizing its desire, to once again use Takacs's terminology, in diverse Indigenous cultural contexts and realities, from nation-specific to urban to transindigenous and beyond. It challenges stereotyping expectations pointedly described by Dakota Sioux scholar Philip

J. Deloria in his book *Indians in Unexpected Places*, expectations that present Indigenous people as 'distance[d] from both popular and aesthetic culture' and '[unable] to engage a modern capitalist market economy', at the same time as it provides a space and a platform for Indigenous creativity and entrepreneurship in the context of the popular (Deloria 2004: 230). Indigenous pop culture is able to do all that not only by specifically targeting Indigenous audiences but also, crucially, by supporting Indigenous creators who produce content in the framework of popular culture.

Building on these deliberations, for the purposes of this book Indigenous popular culture may be defined as a field of cultural production which encompasses Indigenous-authored cultural texts and creative expressions that make use of tropes, icons, genres, media, industries and practices of globalized popular culture and are simultaneously situated in Indigenous cultural contexts, ancestral as well as contemporary (categories that, naturally, frequently overlap). This definition, while certainly imperfect, allows us to delineate and approach Indigenous popular culture as a specific cultural field, and, in the words of Frederick Luis Aldama, 'to think deeply about everyday, living, breathing cultural phenomena that richly texture vital intersectional identities and experiences' (Aldama 2019: xii). In many respects this definition connects to the definition proposed by Mintzi Auanda Martínez-Rivera, who understands Indigenous popular culture 'as cultural practices that are imagined as such both in and by indigenous communities, that are not used for rituals, and that have a ludic component' (Martínez-Rivera 2019: 96). However, in this book we seek to take a more comprehensive approach, conceptualizing the Indigenous popular as a diverse but unified cultural field that, in addition to the ludic, is governed by a number of defining characteristics which we also see emerging in and from the contributions to this volume – a conceptual understanding that is emphasized in the term 'IndigePop'. In the following, I will explore this understanding through a triangulation of three areas at work in IndigePop: community and communitism, politics, and resurgence and celebration. As we consider these characteristics, it is crucial to note that these aspects and areas are not sharply separated from each other. On the contrary, they routinely intersect with and connect to one another, which makes drawing sharp demarcation lines difficult and perhaps counterproductive. Therefore, as I look at these characteristics separately, it

is done merely for the purposes of clarity and does not imply any ontological or experiential separation.

Community-Building and Communitism

Similar to other avenues of Indigenous artistic expression, Indigenous popular culture is a phenomenon that is both community-oriented and community-building. This communal function encompasses different kinds of communities in all their multiple variations. These communities can be Indigenous nation-specific or transindigenous or global, but also communities that are built around an emotional and creative affiliation to a medium, a form or a content – that is, 'communities of affinity' (Takacs 2015: 182) that centre on the practice and experience of Indigenerdity (see Duffett 2013: 244). As one example, the organizational structure of the Albuquerque Indigenous Comic Con between 2016 and 2018 reflected this communal focus in all its facets, from the way it supported local Indigenous communities through such strategies as the choice of venue, date and vendors, to youth outreach initiatives, to the intimate, familial atmosphere that defined the event. Many of the participants of the Indigenous Comic Con 2 have stressed the latter aspect as one that is particularly appealing. In an interview with us during the event, Z. M. Thomas, a Dakota Mdewakanton Sioux comic book writer and publisher, noted: 'Usually, when I go to a comic con, it's always business, business, business, but when I come here, I feel like it's almost a homecoming.'[5]

In a way, community-generative function is inbuilt in popular culture as such – its creative output tends to facilitate fandom, and fans tend to understand themselves in terms of communities. Mark Duffett writes:

> Fandom can begin in private, though 'private' is not quite the requisite term: friends and family make recommendations, and potential fans always engage with media products and performances that they know are *collectively valued*. [...] Public social groupings act to foster, facilitate and maintain fandom. Many fans characterize their entry into

5 Unpublished interview conducted by the editors, Indigenous Comic Con 2, 4 November 2017.

fandom as a move from social and cultural *isolation* – whether as rogue readers, women in patriarchy or gay men in heteronormative culture – into more active communality with kindred spirits [...]. (Duffett 2013: 244, emphasis in original)

Stacy Takacs calls such pop culturally focalized fandoms 'communities of affinity' which 'provide mutual aid and support to their members, give them an outlet for their passions and their creativity, and help them expand their horizons by putting them in touch with like-minded but experientially different individuals' (Takacs 2015: 182). Both these scholars emphasize that, at their best, pop culturally motivated communities can provide emotional support and facilitate relational bonds that promote a sense of belonging, also in the face of different forms of discrimination and exclusion.[6]

This last aspect is even more central to Indigenous popular culture, given the community-oriented outlook of Indigenous societies and the historical and contemporary realities that surround Indigenous communities in settler-colonial states. The communal vision of Indigenous popular culture is arguably more nuanced than is the case for 'mainstream' popular culture – it is not only communal, it is communitist. The idea of Indigenous communitism, coined by Cherokee scholar Jace Weaver and articulated most fully in his book *That the People Might Live: Native American Literatures and Native American Community*, emphasizes the link between creative endeavours and the general wellbeing of Indigenous communities. As Weaver explains, the term 'communitism' 'is formed by a combination of the words "community" and "activism". Literature is communitist to the extent that it has a proactive commitment to the Native community, including what I term the "wider community" of the Creation itself' (Weaver 1997a: xiii).

Like literature, Indigenous popular culture fulfils a communitist mandate. Beyond communities of affinity, IndigePop revolves around the social wellbeing of Indigenous communities of different kinds, and often Indigenous youth in particular. This becomes clear not only from the community work

6 It should be noted, however, that fandoms are not immune to policing their borders. At their worst, communities created on the basis of shared fandoms can be exclusionary, discriminating and even abusive. Occurrences such as GamerGate and the harassment of the media critic and blogger Anita Sarkeesian are readily available highly publicized examples of that. This aspect of fan culture is explored especially in Red Haircrow's and Judith Leggatt and Monica Flegel's contributions in this volume.

within the framework of the Indigenous Comic Con and IndigiPopX, for example, but also from the work of such media creators as Johnnie Jae (Otoe-Missouria/Choctaw), the founder of the media platform *A Tribe Called Geek* that focuses on Indigenous Geek Culture and STEM and that also runs a suicide prevention initiative #Indigenerds4Hope.[7] This commitment to positive change and sustainable Indigenous advancement relates the communal aspect of IndigePop to its political aspect.

The centrality of community for popular culture in general, and especially for Indigenous popular culture, is a recurring theme in many contributions to this volume. In his personal reflections on his lived experience of popular culture, Richard van Camp (Tlicho) powerfully notes: 'We were connected. From the end of Highway 5 in Northern Canada to everywhere HBO or The Movie Channel could reach, we were sharing something – feeling something – together' (72). In his analysis of the artwork presented at the exhibition *The Force Is With Our People*, Anthony Thibodeau explores the community-building work of Indigenous popular culture through the lens of the *Star Wars* phenomenon. And the contribution by Monica Flegel and Judith Leggatt is devoted to the podcast *Métis in Space* and its objective of decolonizing fandom and fan criticism, an objective that translates into decolonizing pop cultural communities.

Politics

When asked in an interview with Birgit Däwes and Robert Nunn whether his plays have a political side to them, Anishinaabe author and playwright Drew Hayden Taylor answered: 'I would say yes they do, because being born Native in Canada is a political statement in itself. So anything to do with an oppressed people and telling their story is bound to have some level of politics' (Taylor 2008: 193). This assessment certainly rings true, and its scope is limited neither to the geographical space of Canada nor to the creative context of theatrical performance arts. As several of the contributions to this

7 *A Tribe Called Geek* media platform can be accessed here: <https://atribecalledgeek.com/>. The platform is currently run by Lee Francis 4.

collection attest, Indigenous popular culture maintains constant dialogue with political issues and discourses affecting Indigenous communities and individuals, as well as with Indigenous political practice. Apart from being entertainment, IndigePop brings with it a level of political engagement. This is hardly surprising, given both Taylor's argument cited above and the general outlook of popular culture vis-à-vis politics.

The political potential of popular culture is well-documented in popular culture theory. Liesbet van Zoonen, in her book *Entertaining the Citizen: When Politics and Popular Culture Converge*, demonstrates that popular entertainment is and must be part of politics, just as politics is and must be part of entertainment (van Zoonen 2005: 3). This is particularly true where politics of representation are concerned. In many ways contemporary popular culture is a representational battleground where stereotypes, (mis)representations and policies can be exposed and challenged; as such, it fluctuates under the constant push and pull of hegemonic, resistant and countercultural forces. Popular culture, thus, 'may be used to contest the agenda-setting power of the socially dominant' (Takacs 2015: 90). As John Fiske famously theorized, popular culture is a field whose political potential is defined by what he calls 'semiotic power, that is, the power to make meanings' (Fiske 2000:10):

> So semiotic resistance that not only refuses the dominant meanings but constructs oppositional ones [...] is as vital a base for the redistribution of power as is evasion. The ability to think differently, to construct one's own meanings of self and of social relations, is the necessary ground without which no political action can hope to succeed. (Fiske 2000: 10)

Cherokee scholar Daniel Heath Justice puts it succinctly, writing: 'We can't possibly live otherwise until we first *imagine* otherwise' (Justice 2018: 156, emphasis in original). Indigenous popular culture is a productive and dynamic platform precisely for imagining otherwise.

It follows that popular culture provides an effective arena where politics can be engaged: one text at a time, one image at a time, popular culture challenges dominant ideologies on the level of everyday lived experience. But the kinds of 'guerilla raids' (Fiske 2000: 12) against the status quo which can be undertaken through popular culture, according to Fiske, go beyond semiotics and are potentially effective in terms of a material change in social relations:

> [T]he resistances of popular culture are not just evasive or semiotic: they do have a social dimension at the micro level. And at this micro level they may well act as a constant erosive force upon the macro, weakening the system from within so that it is more amenable to change at the structural level. (Fiske 2000: 11)

In this way, popular culture may be seen as participating not only in politics of representation but also in representational politics.

Popular culture, therefore, is not only an arena of interactive creativity but also a potential framework of political negotiation: although popular culture is not always *necessarily* subversive, *potentially* it is. Indeed, when I think about popular culture, I am reminded of the ancient Greek 'concept figure' the *pharmakon*, which can mean both 'medicine' and 'poison' (Herlinghaus 2018: 2) – the relationship between Indigenous people and popular culture demonstrates that popular culture, too, can have the same double meaning, the same seemingly paradoxical potentiality: it can frequently show up as poison, but under right conditions can just as readily become medicine. The negative side of popular culture manifests itself when it becomes a space ruled by misrepresentations; when fans and fandoms adopt hostile, exclusionary, discriminatory attitudes towards those they deem outsiders; when homogenous, exclusively Eurocentric ideals of heroism are promoted through pop cultural narratives and products, as Red Haircrow's essay elucidates. But notwithstanding these problematic tendencies, the multifaceted interventions of IndigePop, through its focus on building supportive communities and lifting up Indigenous creativity and Indigenerdity, work to transform popular culture into medicine, as contributions to this volume show. Kānaka Maoli scholar Colby Y. Miyose analyses the role popular songs play in the Mauna Kea resistance movement in Hawai'i, also pointing to its connections to Hawaiian Sovereignty Movement. With her print image 'We Are Manua Kea', Tongva and Scottish artist Weshoyot Alvitre provides a powerful example of transindigenous support for the We Are Mauna Kea movement in a visual medium circulated through popular channels. In his turn, James J. Donahue looks closely at the role of Indigenous graphic novels in addressing and redressing traumatic legacies of Canadian residential schools. Juliane Egerer considers Sámi cartooning as a decolonizing political practice, while Kati Dlaske's contribution focuses on the politics of Sámi lifestyle blogs and what they can tell us about the channels of political participation open to young Sámi women. The medicinal quality of IndigePop showcases the politically subversive potentiality

of popular culture at the same time as it makes its own use of it. Indigenous interventions turn popular culture into what in Indigenous episteme is known as good medicine – 'the universe's medicine', as Richard Van Camp puts it (72).

Resurgence and Celebration

This aspect of Indigenous popular culture connects notions of resurgence and celebration. Elaine Coburn summarizes the idea of Indigenous resurgence as 'joyful affirmations of individual and collective Indigenous self-determination' (Coburn 2015: 25). IndigePop asserts such self-determination within the context of popular culture both through expressions of lived experiences of Indigenerdity and through the development of sovereign 'storyworks', to use Jo-ann Archibald's (Stó:lo) term (Archibald 2021:17). These engagements put forth Indigenous visions of popular narratives, franchises, content, media and industries, and function not only as creative but also as critical practice.

While thus staking its claim on contemporary popular culture, the Indigenous popular in no way turns its back on ancestral philosophies, knowledges, practices and 'story-based traditions' (Archibald 2021: 17). In fact, the opposite is true: the Indigenous popular functions as one of the important arenas of interaction between ancestral wisdom, inherited storyworlds and contemporary realities. In her exploration of Indigenous 'storywork methodologies', Archibald asserts that in this context the old and the new are no binary opposites (if indeed they ever are), but dynamic entities in constant exchange – 'because ways of making meaning with the stories may reflect traditional epistemological, ontological, or philosophical ways' (Archibald 2021: 17). Neither is popular culture in general a phenomenon that dwells in perpetual newness – it, too, maintains constant and complex flows of meaning, influence and relation between the past, the present and the future. Indigenous methodologies, such as the one articulated by Archibald, call attention to that fact.

Accordingly, as a field, Indigenous popular culture is characterized by contemporaneity that tends towards continuity and affirms the vital role of community. Cree/Métis scholar Emma LaRocque asserts:

[as Indigenous people] we not only have dynamic cultural heritages but we also have a birthright to this contemporary world. And these two aspects, cultural heritage and contemporaneity is a matter of imbrication, not a matter of absolute ontological or fathomless chasm. We all have blended heritages, Europeans no less so, but it has obviously been to the advantage of colonizers to emphasize our differences, those real and those imagined or constructed. (LaRocque 2015: 15)

By writing Indigenous people and their diverse cultural, epistemological and intellectual traditions into the space of popular culture, Indigenous creators 'joyfully affirm' contemporary Indigenous presence on the land and in societies, and thus participate in resurgent action. In addition, Indigenous popular culture serves as one of the reservoirs of revitalization and transmission of Indigenous knowledges, languages, philosophies, sciences, intellectual traditions and cultural wisdom. Cree scholar Neal McLeod writes: 'To tell a story is to link, in the moments of telling, the past to the present, and the present to the past' (McLeod 2016: 170). Thus, 'Stories act as the vehicles of cultural transmission by linking one generation to the next' (McLeod 2016: 182). Indigenous popular culture is a field driven by stories in dialogue, and so it constitutes one of the spaces where such transmission can and does take place. In this space, Indigenous epistemological systems and pop cultural fandoms and franchises intersect in productive ways, creating a polyphonic storied space of resurgent Indigenerdity. Drew Hayden Taylor's *The Night Wanderer: A Native Gothic Novel*, for example, makes use of the vampire fiction genre to diegetically facilitate and explore the transmission of Anishinaabe knowledge and historical information unaffected by Eurocentric colonial historiography. In this novel, the vampire longevity – one of the genre's defining tropes – is the narrative device that simultaneously serves as a vehicle for intergenerational transmission and as a means of catching the young protagonist's (and, by extension, the young audiences') attention because, to her (and, by extension, to them), 'a Native vampire' is 'cool' – and his story, informed by an embodied knowledge of Anishinaabe history pre and post contact, is 'better than any book they had made her study at school' (Taylor 2012: 206).

Indigenous futurisms, too, centre Indigenous knowledges by focusing on Indigenous science, and so promote what Anishinaabe scholar Grace Dillon calls 'Indigenous scientific literacies' (Dillon 2012: 7). Dillon asserts that by utilizing, refining and subverting the conventions of science fiction (sf) genre, Indigenous futurisms create a space for both transmission and imaginative flourishing of Indigenous science:

> Writers of Indigenous futurisms sometimes intentionally experiment with, some-
> times intentionally dislodge, sometimes merely accompany, but invariably *change* the
> perimeters of sf. Liberated from the constraints of genre expectations, or what 'serious'
> Native authors are *supposed* to write, they have room to play with setting, character, and
> dialogue; to stretch boundaries; and, perhaps most significantly, to reenlist the science
> of indigeneity in a discourse that invites discerning readers to realize that Indigenous
> science is not just complementary to a perceived western enlightenment but is indeed
> integral to a refined twenty-first-century sensibility. (Dillon 2012: 3, emphasis in original)

With their sustained focus on Indigenous scientific and cosmological frame-
works and approaches, Indigenous futurisms, therefore, move towards and
with resurgence by different means.

In her book *Dancing on Our Turtle's Back: Stories of Nishnaabeg Re-
creation, Resurgence and a New Emergence*, Leanne Betasamosake Simpson
(Michi Saagiig Nishnaabeg) recounts a Nishnaabeg community procession
'down the main street of Nogojiwanong' (Peterborough, Ontario) in June
2009 as a lived example of resurgence (Simpson 2011: 11):

> Settler-Canadians poked their heads out of office buildings and stared at us from the
> sidelines. 'Indians. What did they want now? What did they want this time?' But that
> day, we didn't have any *want*. We were not seeking recognition or asking for rights. We
> were not trying to fit into Canada. We were celebrating our nation on our lands in the
> spirit of joy, exuberance and individual expression. (Simpson 2011: 11)

Just as Coburn's definition of resurgence, Simpson's example shows the cen-
trality of joyful togetherness and celebration to the idea of resurgence, and
in that, resurgence and Indigenous popular culture intersect once more.
This celebratory aspect of joyful togetherness is particularly visible in the
Indigenous Comic Con. Explaining the significance of the event in an inter-
view with us, Lee Frances notes:

> Indigenous existence is in a political space. [...] This is about affirming our identities in
> a way that doesn't conform to what mass media has tracked for us for 400 years. This is
> allowing us to come from a space where we get to be nerds, where we get to be celebra-
> tory, where we get to show our creative sides in a way that nothing else represents like
> that. And so it's significantly important to put that out in the world as an act of political
> resistance, as an act of political defiance, but [also] as an act of celebration. Which I find
> to be more compelling, because I think within our political spheres, mostly it's the re-
> sistance acts, but how do we also celebrate and embrace what we're doing, how do we
> invite people to come see this? And so, we have Native people here [at the IndigiCon],

that's great, but I love watching non-Native folks come in and they're just like 'What is this?! I've never seen this before! It's not a powwow? What are you guys doing?' You know? But having those cultural elements – we had drumming going on in the hall the other day, we had drumming going on in here, we got all of these aspects of our culture that come in. So it's really important for that.[8]

These energies of celebrating Indigenous life and creativity that define both IndigiCon/IndigiPopX and IndigePop at large enact a powerful defiance of all attempts at erasure, but they are not focused on them. These celebratory energies are turned inwards, towards Indigenous communities instead of the settler-colonial state, and are defined by a flow of positive emotion, demonstrating the potential of Indigenous popular culture to generate, affirm and celebrate expressions of both Indigenous sovereignty and everyday lived experience in the world.

The celebratory aspect of Indigenous popular culture is amply evident in the artistic work and personal reflections of Indigenous artists included in this volume. Richard van Camp's essay celebrates popular culture as a source of inspiration that sparks much Indigenous creativity, and to demonstrate this, his contribution includes a built-in story featuring a very particular little green alien. The selected excerpts of interviews with participants of the Indigenous Comic Con 2 printed here, too, variously reflect on the inspirational and celebratory potential of popular culture and the cultural space of geekdom for Indigenous creativity in all its multiple iterations, from visual arts to comic books to t-shirt printing to cosplay and beyond.

Towards Indigenous Nerd Theory

In addition to everything mentioned above, Indigenous popular culture affirms the fact that Eurowestern producers, audiences and cultural institutions do not own popular culture, and neither is it a purely contemporaneous

8 Unpublished interview conducted by the editors at the Indigenous Comic Con 2, 4 November 2017. These comments are slightly edited for brevity and clarity, with no changes to the content.

invention that has no connection to narratives and media of the past. Jo-ann Archibald Q'um Q'um Xiiem, Jenny Bol Jun Lee-Morgan (Waikato-Tainui) and Jason De Santolo (Garrwa) postulate a link between historical and contemporary Indigenous media, observing that 'Indigenous storywork'

> connects story, film, and musical framework, allowing lyrical wisdoms to emerge as liberational bush reggae rhythms. Storywork is of the moment – it is about freedom of existence through story. It is mindfulness in action; reverence spans all markers of tradition, acknowledging that the cave and rock markings of our ancestors are reframed in youth-driven communication ecologies, where mass consumption models constantly unfold into spaces of media matrix, or as Pua Case expressed it, within the sacred FB [...]. (Archibald et al. 2021: 12–13)

In his essay 'Personal Totems', reprinted in this volume, interdisciplinary artist Sonny Assu (Ligwiłda'xw of the Kwakwaka'wakw Nations) affirms a connection between the Raven stories of Indigenous nations of the Coast Salish territory and his practice as an Indigenous artist of the popular:

> Raven, in my work, transforms into these objects/icons of pop culture to stay in the loop. [...] My work is the embodiment of Raven's transformation, his ability to adapt. [...] It's all about survival: Raven as iPod, Raven as a can of Coke, and so on. But these objects of pop culture lack Raven's finesse and charm, which is why I put them in the context of 'Personal Totems': to explore our fascination with these objects and how we use them to dictate our personal pop lineage. (50–51)

With their theoretical work, Indigenous intellectuals and artists such as Sonny Assu and Lee Francis are actively engaged in negotiating an Indigenous critical theory of Indigenerdity – Indigenous Nerd Theory, as it were. Sonny Assu's concept of 'personal totems' theorizes the relationship between Indigenous consumers and popular merchandise, brands, franchises and narratives which, he contends, can be arranged into a particular totemic model of relationality that lays claim to these narratives and icons from an Indigenous viewpoint, as 'personal totems': 'We are so inundated by items and imagery of pop culture, we also have the right to use it as a way to dictate our own lineage. Yes, we are the Pepsi Generation', Assu writes (39). At the same time, his art (like his essay) is distinguished by humour, sarcasm and a deep sense of irony with which he approaches popular culture, its industries and its intersections with colonial past and present. In a common IndigePop

fashion, his artistic engagement with pop culture is simultaneously dialogical, generative, revisionist and resistant.

Sonny Assu's 'Personal Totems' was written between 2007 and 2008 and first published in 2010 in the collection *Troubling Tricksters: Revisioning Critical Conversations*, edited by Deanna Reder (Cree-Métis) and Linda M. Morra. This essay was an important influence on my own thinking about Indigenous popular culture, so much so that I asked the author for, and was granted, permission to use the essay's title in the title of my dissertation – a gesture that acknowledges the debt I owe to Sonny Assu's work. It will come as no surprise, therefore, that as soon as the idea for the book before you was conceived, 'Personal Totems' came to my mind. When I approached Sonny Assu with a request to reprint it he immediately agreed, but he also proposed to write a preface-like retrospective to the original text in order to contextualize the essay in the development of his own thinking and creative practice since. Thus 'Reflections on "Personal Totems"' was born. In this collection, it precedes the essay itself, so that the readers may dive into 'Personal Totems' with the author's retrospective analysis guiding them – after all, the original essay is now over 15 years old and may be considered a modern classic of Indigenous pop theorizing. For this publication, the essay itself has been updated with images in colour, not only the ones originally included but also a few additional ones representing Assu's more recent artwork.

Assu's notion of 'personal totems' can be connected to Richard Van Camp's idea of 'pop life', which he explores in his contribution in this volume. Van Camp's 'Pop Life: How Pop Culture Saved My Indigenous Bacon All These Blessed Years' defies formal categorization by being an autobiographical reflection essay that also contains a short story. As readers, we slip from one into the other and back again, moving between pop cultural references and 'Raven Talk' with ease, prompted to consider our own pop life – what it means to us, how it drives us, what it draws out of us. While thinking through the trajectory of his relationship with popular culture, Van Camp simultaneously traces the contours of his own pop life, creates a catalogue of his 'personal totems' and puts it all into creative practice in the form of a story, 'The Ol' One Two', embedded in the essay. With this integrative approach, Van Camp's contribution demonstrates how Indigenous Nerd Theory has the potential to challenge and undermine artificial separation between critical practice and theory-building

on the one hand, and artistic and creative practice on the other, which to a considerable extent persists in Eurowestern academic discourse – although increasingly challenged from within by approaches and methodologies such as 'Practice as Research' that pose fundamental questions 'of what constitutes knowledge in research' (Nelson 2013: 3); or, in literary studies, a recognition that, not infrequently, 'texts [...] are, in themselves, part of a process of critique' (Heilmann and Llewellyn 2007: 2).

Accordingly, the conceptual work that Indigenous Nerd Theory (and, indeed, this volume) performs draws in no small part on knowledge production facilitated through artistic processes and within cultural locations and institutions of Indigenous popular culture. Both editors of this volume are convinced that this knowledge is vital for the understanding of the Indigenous popular. To the extent that Indigenous Nerd Theory is informed by lived experience of Indigenerdity, it can be read as a form of *felt* theory' in Tanana Athabascan scholar Dian Million's sense – a theory that is grounded in and 'achieved by felt action, actions informed by experience and analysis' (Million 2008: 268). Molly McGlennen (Anishinaabe) asserts that 'creative expression creates the critical models', after asking: '[C]an a Native women's theory help redefine the nature of theory itself?' – which she answers in the affirmative (McGlennen 2009: 117, 116). Knowledge produced at the intersection of research and practice, in Robin Nelson's words, serves to 'challenge the schism in the Western intellectual tradition between theory and practice' (Nelson 2013: 5) at the same time as it draws attention to more holistic and integrative processes of inquiry encoded, for example, in Indigenous methodologies and concepts, particularly those emerging from Indigenous feminist theoretical work, such as Million's 'felt theory' (2008: 268) or McGlennen's 'Native women's theory' and the notion of 'lived feminisms' (2009: 116, 105).

The concepts of 'personal totems' and 'pop life' outlined above both echo Diné scholar Lloyd L. Lee, who makes a similar argument as he speaks of his personal 'Diné matrix' (Lee 2014: 4):

> This individual matrix consists of the Diné creation narratives, Diné cultural activities, American stories, American television, American popular culture, and everything else in the world that I read, listen to, and watch. All of this exposure to the world helps define my perspective and approach to living. (Lee 2014: 4–5)

The repeated emphasis on the personal and the experiential that shines through in all these theories and models of engagement with Indigenous popular culture stresses its status as a cultural field that is above all relational and lived, and that is constituted by a multiplicity of networks of relationality. The autobiographical dimension carries much weight here, echoing Deanna Reder's assertion that 'Indigenous authors use their life stories to question both the concept of epistemological objectivity and the tenets of white supremacy' (Reder 2022: 9). Similarly, Dian Million singles out 'first person narratives' as a hallmark of 'felt theory' (Million 2008: 268).

Indigenous Nerd Theory is a term that directly derives from Lee Francis' concept of 'Critical Nerd Theory', or 'NerdCrit', which he introduces in his essay in this book. Francis' Critical Nerd Theory is a lived theory that is closely connected to everyday practice of Indigenerdity where it is constantly renewed and reinvented. It is also connected to Critical Race Theory, a link that foregrounds NerdCrit's political dimension and decolonial outlook, as well as to Jack Mezirow's transformational learning theory. NerdCrit, for Francis, is a critical theoretical framework 'that helps to understand how pop culture, nerd culture, and marginalized communities make meaning from influential sources' (60). With an educator's eye, Frances traces the links and intersections between 'Nerd Identity' formation, transformational learning, and personal, cultural and communal empowerment and belonging. Francis' Critical Nerd Theory establishes the overarching analytical frame within which Indigenous Nerd Theory can unfold, within which concepts such as 'personal totems' and 'pop life' can develop their meaning, and which is able to integrate all components of Lloyd L. Lee's 'matrix'.[9] Theories of Indigenerdity that are advanced by contributions in this book join other theories that are focused on specific locations of IndigePop, such as Steven Loft's (Kanien'keha:ka/Jewish) theory of 'media cosmology' – a media theory grounded in Indigenous epistemologies that 'embraces an Indigenous view of media and its attendant processes that incorporates language, culture, technology, land, spirituality, and histories encompassed in the teachings of the four directions' (Loft 2014: xvi). Through their creative practice and, indeed, creative living, Indigenous artists of the

9 The concept of a 'matrix' that Lee adopts originates in the work of Jicarilla Apache/ Hispanic philosopher Viola F. Cordova. See Cordova (2007).

popular continuously develop Indigenous Nerd Theory further, affirming IndigePop as an Indigenous poetics of the popular.

About This Book

This book brings together Indigenous and non-Indigenous scholars as well as Indigenous artists, intellectuals and educators who engage with popular culture in their academic, public and activist work and/or their artistic practice. The book thus highlights the multiplicity of sources from which knowledge in this field is derived. As it includes contributions that engage Indigenous popular culture through diverse approaches and from different standpoints, the perceived epistemic boundary between theory-building, analytical activity, personal reflection and artistic engagement dissolves. With multi-directional entanglements between theory, criticism, art and personal living evident in it, the composition of this book aims to emphasize relational links between epistemological positionings in the context of the Indigenous popular. All contributions to this volume foreground and bear witness to the multifaceted diversity, polyvocality and creative power of Indigenous popular culture, regardless of what form their engagement takes. As outlined above, and as Gordon D. Henry (Anishinaabe) observes for Indigenous literatures, in this process story can quickly become theory, and vice versa: 'In fact stories may lead to, may have already led us to, theories and then back again to stories' (Henry 2009: 18). 'We believe the proof of a thing or idea is in the doing', writes Stó:lo writer and scholar Lee Maracle (1992: 62). 'There is a story in every line of theory, not in our capacity to theorize. [...] We humanize theory by fusing humanity's need for common direction – theory – with story' (Maracle 1992: 63); 'No thought is understood outside of humanity's interaction' (Maracle 1992: 64).

This book is divided into five parts, each of which foregrounds a particular aspect of or mode of engagement with Indigenous pop culture. Part I, titled 'Conceptualizing IndigePop', focuses on the conceptual work that takes place at the intersection of artistic and interpretative practice. Sonny Assu's 'Personal Totems', already discussed extensively in this introduction, proposes

and explains the eponymous concept, accompanied by examples from his own artistic practice and personal reflection. It is preceded by 'Reflections on "Personal Totems"' which offers some retrospective thoughts by the author, briefly reassessing the process of writing the essay and revisiting it from the vantage point of fifteen years past. The section closes with Lee Frances's chapter 'Critical Nerd Theory: A Brief Introduction', in which he introduces the term presented in the title and reflects on some of the central aspects that are at stake in Indigenous nerd-centric theorizing. Offering his conceptual thoughts, Francis draws on his experience as a community educator and education scholar, as well as an Indigenous artist, entrepreneur and a passionate Indigenerd.

Part II is comprised of essays that engage in autobiographical practice as they address various aspects of popular culture and IndigePop. Titled 'Autobiographical Practice as a Critical Lens in IndigePop', this section illustrates the significance of 'Autobiography as Indigenous Intellectual Tradition', as Deanna Reder puts it in the title of her book, by showing it in action. In that sense, there is a notable overlap between the first and second book sections evident in the importance of autobiographical reflection and personal narration for all contributions in them. The second section begins with Richard Van Camp's essay 'Pop Life: How Pop Culture Saved My Indigenous Bacon All These Blessed Years', in which he assesses the role various aspects and products of popular culture have played in his life as an Indigenous person, author and creator. He stresses the generative potential of popular culture as a source of inspiration and creativity, and, moreover, as a connective tissue between individuals and communities. In the spirit of show-don't-tell, the tone of the essay is humorous and geeky – supremely IndigePop; and it also includes a story.

Van Camp's essay is followed by Red Haircrow's autobiographical essay 'Surviving Skywalker'. In it, Haircrow presents a different, more sombre perspective on the influence of popular culture on Indigenous life, narrating through personal experience negative psychological consequences that pop cultural icons marketed as role models, such as Luke Skywalker or Indiana Jones, can have, and how they relate to social and structural injustices experienced by Indigenous individuals and communities in the United States and elsewhere.

The following two sections reflect the scope of creative activity that unfolds in the context of Indigenous popular culture. Contributions in Part III, 'Visual and Graphic Art Forms in IndigePop', demonstrate the vital role of visuality for Indigenous pop culture and the various ways in which it develops its own visual language in conversation with pop cultural archives. Anthony J. Thibodeau's '*The Force Is With Our People*: Contemporary Indigenous Artists Reimagine the *Star Wars* Universe' offers insights into and reflections on the exhibition he curated at the Museum of Northern Arizona in Flagstaff. The exhibition, which opened in October 2019 and won the 2020 Viola Award Excellence in Visual Arts, showcased the wide and vibrant spectrum of engagement with the *Star Wars* universe in contemporary Indigenous art and encompassed the work of Indigenous artists from the region known as the Greater American Southwest. Noting the particular prominence of *Star Wars* in Indigenous popular art, Thibodeau explores the various meanings that emerge in this work through the lens of fandom studies and Henry Jenkins's work on popular culture. In his article, Thibodeau offers a unique perspective as the curator of the exhibit who conducted many interviews and conversations with the artists represented in it, and an ardent *Star Wars* fan with extensive knowledge of the franchise.

James J. Donahue's chapter 'Graphic Representations of Residential Schools: Using Popular Narrative to Teach Unpopular History' focuses on Indigenous comic books the plots of which explore the troubled history of residential schools in North America and their traumatic intergenerational consequences. Donahue's emphasis is specifically on the visual component of these tales and how it co-creates and deepens the meanings they communicate. In addition, he offers reflections on the didactic potential of the comics medium, not only in the context of formal education but also the society in general, to create awareness of history that until recently remained unarticulated.

In her chapter 'Reframing, Rewriting, Redrawing the Past: The Creation of Decolonizing Narratives in Sámi History Cartooning', Juliane Egerer also ponders the intersection of a visuo-textual medium and history. In doing so, Egerer is concerned with political/historical cartoons and the way Sámi artists in Scandinavia utilize this genre to challenge historical narratives that centre colonial paradigms and versions of history.

Part III closes with the artwork by Tongva, Spanish and Scottish artist Weshoyot Alvitre titled 'We Are Mauna Kea'. The original print was created as an expression of solidarity with the We Are Mauna Kea movement of Hawai'i and printed on various image carriers, including a t-shirt release in collaboration with The NTVS Clothing which donated the sales proceeds to The Aloha 'Āina Support Fund. This artwork and its story demonstrate how close the link between Indigenous popular culture and Indigenous political activism often is, and how fruitful a site of transindigenous support and alliance-building IndigePop can be.

Part IV, 'Popular Genres and Media in IndigePop', opens with an article by Kānaka Maoli scholar Colby Y. Miyose, in which he explores the use of popular songs in the We Are Mauna Kea movement, a social movement protesting the construction of an observatory on a site that it sacred to Hawai'i's Indigenous peoples. Adopting a thematic and textual approach, Miyose analyses two particularly prominent songs – *Rise Up* by Ryan Hiraoka, featuring Keala Kawaauhau, and *#WeAreMaunaKea* by Sons of Yeshua. In doing so, he attends to the processes and dynamics of resignification which these songs represent and foster in the face of idealized and commodified versions of 'Hawaii' produced and distributed by means of popular culture and popular music.

Cécile Heim's chapter ' "It's Not Me": Displacing Alienness in Stephen Graham Jones's *All the Beautiful Sinners* and *Not for Nothing*' demonstrates Jones's masterful use of popular genres, specifically the hard-boiled detective story, in order to create a characterization and a reading experience that 'displaces alienness' onto settler society as a form of resistance to discursive othering of Indigenous characters and artists in literature and popular culture, and in larger discourse. By engaging in genre criticism, Heim elucidates the manifold strategies through which Jones bends the crime fiction from within and turns it in on itself, thus opening a creative space that fosters Indigenous perspectives and political critiques.

Kati Dlaske's chapter 'Mediating Indigenous Voices: Sámi Lifestyle Blogs and the Politics of Popular Culture' closes this section. This article is dedicated to Sámi women's lifestyle blogs in Finland, offering a close analysis of representative examples. In her approach, Dlaske adopts a dual lens that focuses simultaneously on the participatory possibilities opened by lifestyle blogs as another outlet for Indigenous political struggles, and on societal exclusionary

structures that preclude young Sámi women from participating in political discussion through other, more tightly guarded, media outlets. The insights that emerge from the analysis of this particular medium are transferrable to other popular and social media, many of which manifest similar dynamics.

Part V, 'Creatorship, Fandom and Critical Practice in IndigePop', once again turns toward intersections of creative and critical practice. Here, Monica Flegel and Judith Leggatt's article explores opportunities opened by employing pop cultural criticism as decolonial practice, as exemplified by *Métis in Space/ Otipêyimisiw-Iskwêwak Kihci-Kîsikohk*, a podcast by Molly Swain (Métis) and Chelsea Vowel (Métis). The authors approach the program as a manifestation of Indigenous futurisms, a form of creative discourse and critical methodology that foregrounds Indigenous cosmologies and futurity. Flegel and Leggatt illuminate ways in which the podcast runners adopt this framework as a critical lens that questions both academic and fan-based pop cultural criticism in relation to representations of Indigenous peoples and characters in popular culture, while using the program as a vehicle of pop cultural representation in its own right.

The book closes with a chapter entitled 'Voices of the Indigenous Comic Con 2', in which the editors of this volume offer a selection of excerpts from the interviews with Indigenous artists and vendors we conducted at the second Indigenous Comic Con in Albuquerque in 2017. In the interview excerpts presented therein, Indigenous practitioners of the popular share their thinking on Indigenous popular culture in their own words, offering their unique perspectives on the meaning of Indigenous popular culture, its politics and their experiences and creative practices within it.

Kati and I are both non-Indigenous academics based in Europe – Kati in Finland, and I in Germany. This is the location from which we approached putting together this book and engaged with its range of contributions, and this positionality indubitably influenced 'the meaning that [we] have made from abundant and powerful knowledge shared with [us]' (Kovach 2012: 7). As Plains Cree and Saulteaux scholar Margaret Kovach reminds us, 'We know what we know from where we stand. We need to be honest about that' (Kovach 2012: 7). Similarly, in this introduction, rather than speaking authoritatively on the book's subject I offer my thoughts, grounded in my particular positionality and experience, as impulses for further thinking and as one possible entry

point for an engagement with this volume's range of insightful and beautiful contributions. My purpose – and indeed our purpose in this book – is far from speaking the final word; quite the contrary, we hope that this volume will contribute to many ongoing and future discussions.

Needless to say, this collection is also far from exhaustive, both in terms of its geopolitical range and the cultural areas under consideration, nor did it ever attempt to be. No one book can encompass all the richness of Indigenous popular culture and its manifestations across the globe. Rather than striving for completeness, therefore, our hope is to offer a contribution to critical conversations around Indigenous popular culture, add useful conceptual and critical vocabulary to these discussions, and perhaps help consolidate Indigenous Popular Culture Studies as a systematic field of inquiry. There is much room for future work in many areas, particularly in addressing diverse intersectionalities that are at play in various manifestations of Indigenous popular culture. Approaching IndigePop naturally remains a continuous conversation – a journey. We cannot wait to see where it will take us.

Part I

Conceptualizing IndigePop

Sonny Assu

Reflections on 'Personal Totems'

Our Town, an East Vancouver coffee shop, was my neighbourhood coffee spot. It was located at the corner of Kingsway and Broadway, close to my apartment and studio, and I considered it my office. Yeah, I was, and am, one of those annoying creatives, camping out at a coffee-shop table for hours on end. Sipping coffee after coffee, nose-chuckling at my own jokes. I met lots of great people there, and I liked it because I felt connected to the creative community of Mount Pleasant.

I wrote 'Personal Totems' there, and it's been interesting to reread it because it's full of nostalgia for me. I no longer live in Vancouver, and that era was transformative for me, personally and creatively. In a complete longing for life pre-mid-to-early-late-40s, I can remember where I was sitting when I wrote some of those paragraphs. I can recall the weather (wet and grey), the atmosphere (coffee-shoppy) and interactions with staff (flirty) and fellow patrons (pleasant) alike. I'd often sit at a prime window spot, allowing me to take daydream breaks to think or just observe the hustle and bustle of Vancouver's East Broadway.

From the vantage point of my current thinking, some aspects of the essay aged better than others. As I reread it, I'm confronted by some of the ableist language I used and the misappropriation of neurodivergent terminology. That section where I talk about 'crazy people' and then bring in my love life … Ugh, so cringe in hindsight. I can assure you, I have gone through a lot of personal growth and understanding of socio-political situations in the last fifteen plus years. 'Personal Totems' was really my first kick at the can as a writer, and even though there are parts that make me cringe, I hold it close because in it I can see my growth as a creative person. I wrote it in 2007 or 2008, nearly two decades ago, and in reading it over, I can see the immature qualities of my writing. If I were to write it today, it would probably be a whole lot different.

Yes, we are our own worst critics, but it is beneficial to look back at our older works and see how we've grown.

I've found my voice as a writer now. I mean, I don't consider myself to be a writer, but I do enjoy writing as part of my practice. Fifteen years ago, I was still looking for my voice and in that, I recognize that I was trying to emulate two authors I was reading at the time, Douglas Coupland and Chuck Klosterman. Klosterman, in particular, as I had just finished reading *Sex, Drugs and Cocoa Puffs*, and I thought his use of footnotes to be unique. In the traditional sense, they weren't footnotes, but more like sidebars within the essays to further the narrative in an engaging way. I wanted to have that as part of my essay as well, but the publisher didn't want to break away from the academic format for the book and my footnotes became endnotes. This republication fixes that.

In looking back at this writing, I can see the thesis of Personal Totems still holding true: Frankly, it's even stronger today. Aspects of technology and consumer culture have become more intertwined and more ubiquitous. Back when I wrote this, I carried a Razr flip phone, my MacBook (if I was working), an iPod for my music and a Sony digital camera along with me constantly. I saw all those as items of my personal totemism that connected me to other people. Now, my iPhone alone does all the work of those four objects, and it comes down to the iOS or Android clans. And we can't talk about the rise of the smart phone/pocket computer, without talking about the rise of social media and how it has affected our lives in totemic ways. Consider all the totemic influencers from Instagram, (what was formerly known as) Twitter, TikTok, and YouTube. These people, on their platforms, have the power to corral their clans in ways that were unimaginable to me fifteen years ago. And personally, I feel my connection to pop culture has only grown in the last ten years. So much so that I don't prescribe my 'otherness' to a Euro-standard of whiteness: I am Ligwiłda'xw and I am pop culture.

Anyway, I was thrilled when Dr Svetlana Seibel asked if she could republish this work in *IndigePop: A Companion*. 'Personal Totems'[1] was her first

[1] As we both reminisced about it now, Dr Seibel reminded me that she asked me if she could use Personal Totems as part of the title of her dissertation, when we first met in Montreal. Her thesis was eventually submitted under the title *'Personal Totems': The Poetics of the Popular in Contemporary Indigenous Popular Culture in North America*.

foray into my practice, and as nostalgia hits me now, I remember meeting her in person for the first time when I was living in Montreal. We met, of course, over a coffee.

The images accompanying the essay have been updated, and I've added two new works from my recent Speculator Boom series (Figures 6 and 7), which show the continued evolution of my use of pop culture and its related ephemera in my work.

Sonny Assu

Personal Totems

I was born a poor, Black child

– Steve Martin, 1977

The absurdity of that comic statement, from Steve Martin's stand-up routine, is realized by the fact that he wasn't actually born a poor, Black child. Obvious, I know. Then again, you may not know who Steve Martin is; however, his racial identity did become a central plot point behind his 1979 movie, *The Jerk*. In the movie, Martin was raised by a poor, Black family in the southern United States. Sheltered from the world outside him and from the fact that he isn't Black, he decides to leave the nest, so to speak, to experience the world around him, and to live in a world in which he belonged – a white world.

The fundamentals within the story (I won't deconstruct them further) can be seen in a number of different stories throughout the ages, most notably as a pop culture reference – Superman. A Kryptonian boy crash-lands on earth and is raised by human parents. From the get-go, Superman (Clark Kent) is strong and aware of his powers at an early age. Steve Martin's character in *The Jerk* isn't aware he isn't Black, a fact he doesn't realize until his adoptive mother finally has had enough of his lack of rhythm and lets him in on the obvious secret.

In a way, I think *The Jerk* relates to my own childhood. For a brief stint, I actually thought I was blue. Blue, you ask? Yes, blue. Grover from *Sesame Street* was, back then, my best TV friend. And, as a child raised on TV programming, I was presented with a model that my 4-year-old brain couldn't really grasp.

That which is presented to you on TV isn't always the truth – obviously. Not that thinking I was blue for a while was a morally changing experience for a 4-year-old, but it does mirror another interesting part of my history.

Growing up at the pinnacle of television pop culture, I was blissfully unaware of the rich cultural heritage to which I belonged. Born in May of 1975, I was the product of my mother's summer love when she was quite young. Luckily, I was born into a family and a culture that valued keeping adoption within the family, so I was raised by my grandparents. By the time I began to realize I wasn't blue, I began to form memories of relationships. And the strongest I had and still have is of my sister, who, in fact, came memorably to my aid one fall afternoon.

I had come home from school to discover, in an era of rarely locked doors, that the side door was locked. Puzzled, I walked around to the back to check out the sliding door, which was also locked. Being the crafty kid that I was, I noticed that the kitchen window was open, so I slid my (then) small frame through. I was either bewildered as to why my Mom and Dad weren't home or I was hungry, so I picked up the telephone and dialled the only number I could think of – that of my sister.

I can't recall the details of the conversation, but I'm sure it had something to do with both my inability to open up a can of Chef Boyardee and her questioning me about why my parents weren't home. When you're seven, falling into a predictable routine is commonplace: get up, go to school, come home. Also: Mom wakes you up; Mom makes you breakfast. Then: you rip your pants on the fence; you go through the day not caring that the said pants are ripped; you hop the same fence again; you come home. Finally: Mom gives you a snack, then dinner; you sleep. Repeat the next day. So I was also a bit worried as to why neither my Mom nor my Dad were home. Shortly after our telephone call, Dani, my sister, came to see me.

Our subsequent conversation is one that I clearly remember. It's one of those memories that someone is likely unable to forget. After learning that I was left alone, Dani had come over with her boyfriend and his incredibly cool car (I credit him and *The Dukes of Hazzard* for my love of 1960s–1980s muscle cars. But I digress). I remember that I must have been sitting on the floor, possibly playing with some toys, when she came up behind me. She told me that she was there to get me and that I was going to come live with her and

Jerry because Mom and Dad were having some issues. There was a pause, as I could imagine I must have been upset and acting like any 7-year-old would: a bit overcome with emotion, wanting it all to be normal again.

Cue: the sappy 1980s *Days of Our Lives* music.

'I am your Mom', she finally said.

As I play it all out in my head, I imagine myself utilizing the greatest of all actors' tricks, perhaps something the Haida Raven himself perfected long before he coaxed the first man from the clamshell. I'm conjuring up how the scene must have gone down – and I credit it to one part overactive imagination and one part obligatory soap opera watching for an entire spring break. So, after the scene is played out in my head in the vein of cheesy daytime soaps, I figured, as a 7-year-old, that it was commonplace for the people with whom I lived to be my parental units. Woman, man, kid = family. It wasn't until I was about twelve that I finally clued into the fact that our strong resemblance was more than just a brother/sister similarity. I don't recall what it was that finally helped me clue into my slightly skewed lineage. I just remember being twelve and finally figuring it out. Maybe it took my brain those five years to put all the pieces together, but when I look back on my life I notice some displacement. The year when I was eight was a huge transition for me. It was the start of the school year, and I went from the familiar to the unfamiliar – from a suburban elementary school to an inner-city school. I guess one could look back and figure I might have had it a bit rough. But the only thing that I see as negative in those years was the fact that I must have liked grade three so much, I wanted to do it again.

Yes, being uprooted and made to repeat a grade could be seen as negative – but I went along with it. I never rebelled in my teenage years and I never used it as a crutch to gain sympathy. I was just being me: a happy 1980s kid going through the motions of the week and waiting for my Saturday morning cartoons.

I dissect my life for the sake of my art and, within that dissection, I discover a lot about myself and about how pop-consumerism works. I have learned that my generation was bred to consume: Saturday morning cartoons were thirty-minute advertisements for various toys that we just couldn't live without. The

1980s set up the framework for contemporary consumerism. You can ask me if my uprooting and the discovery of my biological mother were traumatic all you want – some might even get off on dissecting the inner workings of how it affects me as an artist and as a person. But ask me what was *really* traumatic to me at that point in my life and I'll tell you it wasn't the discovery that the person I thought was my sister was actually my mother. No – it was the fact that I never got to have a Megatron Transformers action figure. Fuck, what I would not have done for that shiny transforming gun. This was the holy grail of Transformers – what kid from the 1980s wouldn't want to whip out one of those Mo-Foes in a dusty Vancouver alley gunfight?[1]

If a thirty-minute episode of the Transformers isn't a thirty-minute toy advertisement, I don't know what is. Kids have a powerful inclination towards adapting. And I see these childhood memories of my life as a story about adapting to fit in with what I was about to become. It was a big year of change for me: living seven years of my life in one house, and finding out that the people whom I thought were my parents actually were my grandparents and that the person whom I thought was my sister was, in fact, my mother. It makes for a very special episode of *Jerry Springer*. But, as with every good episode of *Jerry*, there comes a twist.

A year later and I celebrated my eighth birthday in my new life. Tensions between my grandparents only allowed for one to attend the party. But, within that year, we had moved to the lower level of the duplex we lived in and soon my grandfather, who at the time was living in a hotel, moved into

1 Playing guns. I remember that back in the day, toy guns used to look like real guns. So much, in fact, that I freaked out some dude ripping through the alley one day. The neighbourhood I grew up in was along the lines of what was to be later known as the SkyTrain – built to bring the 'burbs out for Expo 86. There was an open construction pit down the block from my house, when construction sites were not being fenced off. I spent hours in those pits with my friends, sliding down the dirt hills in boxes we took from the back of the drugstore. Anyway, one day I was playing in the open pit by myself. The construction crew placed a nice, big pile of dirt by the alley. Perfect for a pop-gun sniper. I took aim at the speeding truck from my perch and fired the pop. No projectiles came out, but the dude in the truck slammed on his brakes and backed up to give me an earful about the safe use of a gun – which is odd, because I can't think of any 8-year-old having a real gun. But that is just how real-looking the toy guns used to be. When toys were toys ...

our old suite upstairs. I then became known as Ronnie's shadow, a seeming aside to the story I'm telling but relevant to my lineage nonetheless. With the minor hiccup of where I was living and with whom I was living finally tucked neatly away in the recesses of my mind, I began to settle into the normal existence of being an 8-year-old child. I was living in the city and growing up in an age that can only be described as the beginning of contemporary pop culture.

That year for my birthday I received a strange new gift from my mom, a.k.a. my grandmother – a Walkman! It might as well have been a Volvo, the thing was half the size of my torso and heavy as hell. I tried to hide the shame of the large brick that I lugged around to school back in the good old days. I did feel safe that it wasn't about to get stolen anytime soon. After all, the school bully, who was only slightly bigger than I was, would probably get about five feet away before discovering he would be unable to make a clean getaway with an additional eighty-pound kid strapped onto the seemingly only twenty-pound Walkman. Now there is no way I looked even accidentally cool with a small country hanging from my neck, and there was no way in hell I was even going to attempt a moonwalk with this thing throwing off my balance. Top off the image with ridiculously large orange foam earphones and I stood out more than the almost abnormally tall tubby kid in the class picture who was held back a year. Mind you, it didn't help that *I* was the almost abnormally tall tubby kid in the class picture that was held back a year. I would lug this brick around with a shoulder strap astride me, listening to my first tape, Michael Jackson's *Thriller.* 1982 was a good year for me, not just because of the Walkman (the early versions of the thing should have been dubbed 'back-problemsman'), but also because, while consumerism was being marketed to me via my favourite Saturday morning cartoons, I discovered something about myself that would later shape my chosen path in life as an artist.

'I always was the cowboy'

I had come running home from school one day, super-excited over what I had just learned about Indians. Of course, this was the time before

political correctness, and before we referred to this group of people as the First Nations[2] (or First People). So, I burst in through the front door, out of breath and excited. I blew past my dog, Skipper, in my excitement, and flung off my shoes as I normally did: with such enthusiasm that I tried to hit the ceiling with them. I ran towards the kitchen and slid in, Tom Cruise *Risky Business* – style (before he went crazy). I was unaware that I had just blasted by Dani as she tried to nap on the couch. I'm sure my door-slamming, shoes-hitting-the-ceiling, Skipper-barking-like-crazy antics put an end to her after-noon siesta.

I enthusiastically told her about the people we had learned about that day – told her the art that was shown to me was similar to that which her boyfriend, Jerry, did. I repeated my lesson with great detail, told her about the art and culture and about how these people once lived on the coast where we spent our summers in commercial fishing: 'Today, we learned about the Kwakiutl people.'[3]

She propped herself up on the couch and looked at me with a half-smile: 'That is who you are, Sonny.' Being 8, I really didn't understand the ramifications of what it was like to be part of a minority. After all, I was just some little white kid from the 'burbs, although living in the city, a kid playing 'Cowboys and Indians' in the alley, blissfully unaware that I was actually a double agent.

We all have stories that make up who we are. I try and delude myself in thinking that this 'double agent' status is just the normal run of things. But when I explain my lineage to people, I might as well just tell them I arrived on earth one day from a planet that exploded, or that I grew up a poor Black child in the deep South. But those events in my early life led to the inspiration to-wards the artwork I make today. I see it as an important step in deconstructing who we are as purveyors of pop culture. Do I think I am unique? I'd be lying if I said, 'No.' But the fact of the matter is that my generation and the gen-erations after me have felt the effects of consumer culture since we began to walk. And this is why I believe that, as the pop culture generation, we have

2 I've just been informed that we are now to call ourselves Aboriginal. But wait a week – there will be another definition of who we are supposed to be.

3 Now referred to as the Kwakwaka'wakw.

the right to use these icons as our own personal totems: we are so inundated by items and imagery of pop culture, we also have the right to use it as a way to dictate our own lineage. Yes, we are the Pepsi Generation.

The Family Biz; or, 'Sonny's a whiny B****'

I guess one could hold onto the romantic notion of what it is like to be an artist. I could spew out typical crud like, 'Oh, I've been an artist all my life', which is pretty much bullshit if you ask me. It's almost like saying I got involved in the arts because I showed my early talent in kindergarten by eating paste. It's one of those clichés we artists like to implore. It gives our chosen profession a bit of a romantic sheen. I've recently seen a documentary in which the subject was a 5-year-old abstract painter. But, really, what 5-year-old isn't an abstract painter? The parents were proud that their child was starting to rake in thousands of dollars per painting, but they were scared to death that their child was a prodigy, which, for these parents, was tantamount to being a 'freak'.

I could argue that I've been an artist all my life because I would rather have been doodling in the margins than actually getting 'hooked on phonics'. However, calling yourself an artist isn't about selling your first work or landing some big project. Art, for the most part, is a personal thing. And calling yourself an artist isn't something you do just willy-nilly. It takes time to build yourself up and to be aware of what it is exactly to be an artist – which is something that is needed to be discovered on a personal level. At first, calling myself an artist was a hard thing to do. Even in art school, I'd blurt out every so often that I was an artist and I felt like I had to explain myself – like I had just told the whole room I was radioactive. But it wasn't the completion of art school that made me want to call myself an artist. It was the realization that I was doing something I loved. This wasn't my hobby: this was my path in life. It was when I figured out that I had a voice in what I was creating that I felt I could shed the inhibitions revolving around my label. And, ultimately, it was when I was able to make people question the fabric of 'what is Indian art or what is art' that I considered myself a creative thinker.

I come from a long line of fishermen[4] that included my grandfather –
a.k.a. 'dad' – and his son Ted, which through the rather *Jerry Springer* version
of my life, was known to me as 'my brother' – a.k.a. 'Uncle.' Okay, so the line
isn't that long, but take into consideration that colonization in BC happened
under 200 years ago and also that I come from a culture whose main food
source is salmon. So, yeah, I come from a long line of fishermen. My grand-
father was the youngest captain in the commercial fleet during that time; add
to the fact that he was an Indian man, and that's truly something to consider,
especially given that, back in the early 1940s, the First People were badly op-
pressed. But he beat the odds and proved himself to be a valuable asset to the
fleet. So I spent every summer between the ages of 5 and 17 on a commercial
seine boat. I grew up on the W#4 and my grandfather wanted to groom me
to take over the reins one day, much like how he groomed Ted. For the most
part, I spent the early years in the galley doodling, lying in my bunk reading
comics, or sitting on the top deck from which I could look down and watch
the crew work. This is where I probably picked up my knack for colourful
language. When I got a little older, I'd venture down onto the deck to help
put the fish in the hatch. Around the time I hit my teenage years, my grand-
father would start to remind me what he had in store. He wanted me to be
a captain: one day I'd work side by side with him, eventually taking over the
big chair, even if it was more like an uncomfortable stool.

The summer before my grandfather passed away, I started to venture onto
the deck a little more. At that point in my life, I was more immersed in art
and theatre than I was in becoming a fisherman. Maybe it was the hard work;
maybe it was the slimy working conditions. Something in me knew I wasn't
going to be able to fulfil my grandfather's dreams of becoming the next seine
boat sensation. One afternoon, in particular, I got up rather late. I wasn't an
integral part of the crew, so my sleeping past four in the morning was okay.

4 To be politically correct, it is 'fisher.' But 'fisher' sounds like some ridiculous looking
 long-billed water bird who sits on rocks all day looking for the next opportune moment
 for food. I will entertain 'fish-fighters' or 'fish entrapment officers', if you like. Don't get
 me wrong: I'm not belittling the women who work in the industry. My grandmother
 worked on commercial fishing boats all her life and her sister was one of the first female
 captains in the fleet. Even they called themselves 'fishermen'. It's the whole Indian/
 Aboriginal thing on another level.

Anyway, I was mostly just along for the ride, so I tried not to get in the way. But, after the guilt of laziness set in, I'd usually pop on the deck to help out a little. Nothing big – coil some ropes, put fish in the hatch or pump out the bilge. What I really wanted to do was run the drum or the winch. I was allowed to run the winch once, but nearly 'fucked some shit up', as I remember it being put to me. This one afternoon, I made my way out onto the deck at pretty much the end point of the set. I wandered to the stern to help remove salmon from the webbing. My grandfather had manned the drum and had put it in idle for me to remove a sockeye caught by the gills in the webbing – usually a simple task, but I stood there, trying as hard as I could to get that sockeye loose. Pulling on the tail, as it wiggled in a last fight for breath, I grabbed the web and tried to snap the salmon loose, but nothing was budging. I was frustrated, so I began to deploy some of that previously discussed colourful language. I swore like the devil himself took hold of me. It wasn't my proudest moment; to save you the gory details, as no one likes to be on PETA's naughty list, the sockeye was flung from the net, *sans* head.

My grandfather stopped the drum altogether to allow the crew on the middeck to do some work. I wiped scales from my face and kicked the sockeye head over board. Some say that the head of a salmon is a delicacy, but I just couldn't take those cold, lidless blue eyes staring up at me from the deck. Dad walked over to me and said, 'You're going to law school.'

I laughed that comment off pretty quick. I wasn't the best student during my high school days, as I much preferred to draw or to be on stage. I believe I was destined to be in some sort of creative field, and, if it weren't for the lack of love for hard work, the lure of good fishing money would have surely sucked me in. But I knew my life wasn't meant for something as labour-intensive as fishing, let alone law. But I think at that point he knew I was on my own path. My frustrations with a simple fish sealed the deal for him. Regardless of my path, he just wanted the best for me. Even with his flaws, he was able to inspire other generations to step up to the plate and forge a new path – or one that happened to be the same as his. He knew I was meant for something else and he had a message for me – find my own path. No matter what I did, he knew I'd be forging my own way. Save for a few tantrums.

My grandfather helped shape me into the person I am today – a little more so than in the traditional ways you could imagine. He helped shape my

obsession with pop-consumerism and helped shape my mindset with personal totems: what we own dictates our lineage. When my grandmother and he split, for reasons that were their own, for which I know now had nothing to do with me, they started a mini-battle for who might be the coolest – a.k.a., 'Who can spoil Sonny the most?' It seems silly, really, and, at that point in my life, I never really saw it as a battle – I just saw it as a way to get new shit I didn't really need. It was their split that helped fuel my obsession with becoming a collector of pop culture. It also gave me the stigma of what some would call a spoiled brat. But that's another story. Their guerrilla warfare of who could give me the most crap was at the pinnacle of 1980s consumerism. I never really saw their over-giving to me as a way to buy my love. It was just cool to get new toys every couple of weeks. So why the hell didn't I get that Megatron Transformer I so desired? I was the envy of my friends and I became the centre of attention to the kids who just wanted to play with my new toys. I became a casualty of consumerism in their battle – which led not only to the dissection of my childhood through my art and my dissection of pop culture but also to my consideration of how it affects us as a whole and as a First culture that is the complete opposite to the hoarding culture that has become our society.

Challenging Tradition

When I first began my post-secondary exploration of art, I did so without reference to the culture that I learned of at the age of 8. That was more of a last step in finding out where I fit within the world and what I was going to do with my life. I knew who I was and where I came from, but I never really explored the options that were open to me. I never grew up in the culture, so I was never exposed to the same cultural experience as my many cousins were. I was blissfully unaware of my lineage, and when I decided to forge my own path, I went in blind, clinging to something I just loved to do.

As a kid, I read comic books; now I'm a collector. Comics were my escape and provided me with more entertainment than a television ever could. It was that love for superheroes that propelled me to create my own. Anyone in my family could look back fondly on my childhood and teen years and say they

never saw me without a pencil in my hand. It was that love of drawing that propelled me into pursuing a post-secondary education. My high school years were filled with artistic expression. I was heavily involved in theatre and, at the time, when I decided to go to school, I was faced with a choice: pursue theatre or pursue art. Sometimes the choice is made for you; as my future luck would have it, the choice for me was art.

The path that was laid out for me was the path of an artist. Jumping ahead a few years, I transferred into one of Canada's most prestigious art institutions. It was at the Emily Carr Institute in Vancouver where I really started to delve into who I was. And, in doing so, I had to look into my past to discover what fundamentally made up 'Sonny'. I was bored in the studio late one night, quite possibly coming down off a high from a quick Hacky Sack session, and more than likely licking the salt off my fingers from the bag of chips I inhaled while giggling through the empty halls of the school. It was on that late fall evening that I discovered a new direction for my work. I wanted to come up with something that was uniquely my own and that was more representative of both who I was and how I fit within my culture.

My base mandate for most, if not all of my work, is to forge something new out of the old. At the time, I was toying with using new media to tell old stories. I was successful in my technique, but what failed me was the message. I was more content with trying to fight the stereotypes of what was 'Indian art' than actually trying to come up with something uniquely my own. My work, iconically West Coast, was based more in theory than image. At the time, what I was creating was no different in my eyes than what was already created. Whether it was work being created by a master carver of the past, the most sought after contemporary master carver, or some dude sitting on the corner of Robson and Howe carving up $5 plaques for the tourists, it was all the same – it promoted a stereotype of what that Indian art should be, a stereotype that not only dictated what Indian art should be, but what a 'real Indian' is. For me, the challenge was, and has been since then, to overcome the wall of stereotype, to extend the boundaries of First Nations art, to push contemporary art and ideals in a new direction.

My Indian-ness is not made up of the stereotypical notions that some hold onto. I don't live in a tipi and, even though my great-grandfather was a chief, that doesn't make my grandmother a 'real Indian princess'. My hair

isn't long, my skin is not red and my Indian-ness is not dictated by my status card. What dictates my Indian-ness is my knowledge of the past, the fact that I know who I am and where I come from. It's with these notions that I can challenge the stereotype of the perceived Indian identity. I decided, that late fall evening, that it was best to drop what I was doing and try to come up with something truly new – rooted in the culture, but completely different from anything that anyone else had done. I thought about how I got involved with art in the first place: Super Heroes. I thought that maybe if I just got back into drawing the way I used to, it would free me up and provide me with a new direction. I was fuelled by sugar and weed, so I set out to look back to the past to find a bit of inspiration.

A main focus of my work over the past few years has been trying to figure out how pop culture affects us through a direct exploration of how it affects me. Moreover, I'm trying to figure out how it affects the First People of Canada. It's no secret that the First Peoples have had a bit of a rough go: it's a tad demoralizing to have your culture and home ripped away from you. Not that I understand this from first-hand experience: how could I know when I look like your seemingly average white guy? But that is one of the things I enjoy doing, although it is a bit hard to take. I don't have first-hand experience of what it is like to lose your culture; I am the by-product of that loss. My lineage wasn't exactly hidden from me, but neither was it explained to me until I discovered it. Some could call me a 'born-again Indian', but that just tempts me to grow my hair out: trust me, my days of long hair are best left to bad high school photos.

Before This Turns into an 'Angry Indian Rant'

But I must digress: Who is a First Nations person? Who is an Indian? Why am I using the word 'Indian'? Are the factors that determine culture or race made up of skin colour? Or is it cultural upbringing that makes you who you are and who you become? I ask these questions because these questions are constantly asked of me. I mention them because

of who I am and how I was raised. I mention them because the 'angry Indian' is not me, although I did break into those rants from time to time. I've heard the 'angry Indian' rant too many times to care and, like most people who tend to be at the receiving end of the said rant, tend to glaze over. I soon realized the truth of the old adage, 'You'll catch more flies with honey.'

For me, humour is honey. I found that the best way to draw people into the political side of my work was to sugar-coat it, much like the sugary cereals of pop culture and much like any functioning government would. I lure people in with a bit of humour to make the politics easier to swallow. It's all about education and, for the most part, it's received well. I use subliminal advertisements, although my message isn't as bad as an ad for KFC (*go and get a bucket of chicken*!). To me, the angry Indian rant is dead. Why do I need to be angry? Me – white boy incognito from the 'burbs? How could I have had it rough at all? In the history lesson about Sonny's life in this essay, some might see that my life was a little upside down for a few years. Some might even think I'd be a prime candidate for being a bit off-kilter. But I'm resilient: I constantly look to my past to find answers. When I first started off as an artist, I constantly looked to the past for guidance. And what I found angered me. I found the atrocities that afflicted my people and became socially angry for the first time. And I used to deploy the 'angry Indian rant'. On occasion, I still do, but it's usually with my friends, and, in that case, I'm just preaching to the choir.

I began to explore the rich cultural heritage to which I belonged. I was influenced by Bill Reid and his mission to have his work and First Nations art hung alongside other masterful works in an art museum, instead of an anthropology museum. Bill's work was a stepping stone for me. His work helped define my direction as an artist. And I began to explore the issues that came along with being a First Nations person. I knew that there were events in Canadian history that were a blight, but I wasn't fully aware of those issues until I started to learn of them while at the Emily Carr Institute. In my early work, I tried to build a concept of what I'm doing, which is furthering the exploration and the understanding of my culture.

Sugar-Coated Lies and Sugar-Coated Cereal Share Similarities

First Nations culture in Canada is defined by the stereotypical notion of what or who a real 'Indian' is. I follow in the belief of many that, with the eyes of the world coming to us, specifically in Vancouver in 2010, Canada has chosen to reiterate this stereotype and to deliver this view to its audience. Vancouver is located in the territory of the Coast Salish. And their aesthetic is something uniquely representative of West Coast iconography. So what did the organizers of the 2010 Olympics choose as the logo? One would assume a totem pole, or some sort of totemic image – a welcome figure or perhaps the image of the Raven. Nope: Inukshuk. Something clearly representational of the Inuit people, thousands of miles away. Welcome to Vancouver, home of the cultural stereotype. Vancouver is using this 'ideal' stereotype from the North. I can't wait to see all the tourists coming into Vancouver, geared up for parka weather, when they should be gearing up for a raincoast climate. But hey, it's not my call to promote to the world what it's actually like here on the 'wet coast'. The world is seeing us as fur-clad, ice-dwelling, seals-as-pets people, which is fine by me because it gives me something to complain about and fuels a new direction for my work: consumerism.

We belong to a culture of consumerism; we choose objects of mass production to represent our identities. With brands such as Coke, iPod, Nike and McDonald's, it's no wonder that the overall trademark loyalty is seemingly growing by leaps and bounds. With every new generation that comes into its own self-awareness, corporate association is bringing the world together in a weird clash of globalization and anti-conformity.

Over the past twenty years (at least in the realm of contemporary pop culture), branding has become a way of life for many. I'll even admit that I am part of that conformity.

And for those immersed in the pop culture aesthetic, choosing a particular brand to represent yourself is a way to communicate to the world where your affiliations lie. It states, 'I'm different, but I'm still just like you.' In essence, it's choosing conformity to speak for individuality.

My current body of work, the Breakfast series (Figure 2), Personal Totem series (Figure 3) and Urban Totem series, examines how we allow everyday

Figure 2. Sonny Assu, Breakfast Series, 2006. Digital Print, Foam-core,
12" × 7" × 3" each. Photographer credit: Chris Meier. Image courtesy
of the Artist and the Equinox Gallery.

consumer items and icons of pop culture to define our lineage – how branding, brand loyalty and technology relate to the idea of totemic representation. I too am a product of pop culture. I grew up in the age of mass media advertising, subliminal advertisements and the stories/mythos of Saturday morning cartoons. I am able to combine my pop roots with my learned traditional Ligwiłdaxw heritage. Learning of my dual identity at the age of 8, I began to explore and understand that identity by the age of 21. In the past eleven years, I've been able to juxtapose two seemingly un-combinable cultures and then to speak about how we choose icons and objects to define ourselves. By creating the personal and urban totemic representation imagery, laden with a sense of ironic wry humour and informed by social, economical and environmental issues, I speak to the idealistic notion of conformity by *not conforming* to the notion of the 'Indian identity'.

'We are Canadian'

What is the problem with Canada? We have this pristine preconception of us: we're awesome. *We are Canadian*. But as I sit here and write this essay, I'm

confronted by something that usually happens to me on a daily basis. I'm a crazy magnet. Not only has my love life been plagued by women who were clearly off their rocker, but I'm approached on an almost daily basis by people whom most would consider crazy. But, in a city as affluent as Vancouver, you would assume that we have measures in place to help out the people who need help. We don't; we're just like any major Western city. We have problems we'd much rather ignore.

As I sit here in this café, surrounded by people sipping on their lattes, writing papers, chatting, including that one dude sitting in the corner with a guitar plucking the same strings in ADD fashion, I'm confronted by a Native man. I'm tucked neatly behind a pane of glass, staring out at the street, and giving my eyes a break from the screen. I look out of the window when this person obstructs my peripheral vision for too long; I slowly raise my head. He is a little dishevelled, not completely down and out, but someone I probably would not want to run into in a dark alley. I look over and do what most do when they notice a 'crazy' person in public – I ignore him. But, as I look up, he starts to talk to me through the plate glass window. What he was saying, I'll never know. As I said, I see people like this on a daily basis rambling at me, telling me tales of how they lost their shopping bag and so forth. My problem, apparently, is compassion.

When I look up at this man in the process of writing this essay about myself and my work, I begin to question why we as a society have shunned this man. And it only proves my point: we much prefer to bury the problems our ancestors have created. The settlers of what is now called Canada chose to decimate a race; they made First People the dregs of society. We – 'Canadians' – are not a pristine example of humanity. We like to pretend we are – and people see us as such – but we show them what we want them to see. We break out our First People as totems of this land. We use them to promote a harmonious society. But here I am, sitting in a small café in the urban jungle, being yelled at through the window by a man who clearly needs attention. This man is the epitome of what is wrong with our society – we ignore those who need help, whose very situation we've directly or indirectly created, but instead we spend resources on a two-week parade that will only exacerbate these problems in the long run.

'Death Blanket' and 'To the Indians ...'

Two of my works, 'Death Blanket' and 'To the Indians ...', are my comments about the ugly stain on the pristine white carpet that is known as Canadian history – and, as with any other stain, the couch has been moved around to hide it from view. Not everyone knows of this stain, and most are content with keeping it that way. Admit it or not, there was a genocide that occurred here in Canada, that dramatically reduced the size of the Indigenous population. I call it the world's forgotten genocide. Something tells me it's probably not the first, but it is the largest in our Western history. It far outnumbers those who died in the Holocaust, but no one is willing to acknowledge the fact that it happened. Most would rather see it merely as sour grapes rather than an actual crime against humanity.

First People had no immunity to the industrial diseases brought over from Europe: measles, influenza, whooping cough, and, most notoriously, smallpox. These diseases had already wiped out a large number of people within the early years of first contact. Those who didn't die right away were shipped off to reserves, and eventually residential schools, to be stripped of their humanity and, paradoxically, to be assimilated into 'civilized' society. Treaties and agreements were beginning to be ignored in the hopes that, with assimilation and attempted genocide, the land would eventually belong to the government and the Hudson's Bay Company. Eventually, the decimation of the people led to the adoption of the Indian Act (1876), which rendered every Native in Canada a ward of the state: infantile white guilt at its finest, really. Realizing that we've caused a problem, now we must try and rectify the problem. How? By adopting an Act that forced the people to become dependent on a handout by the government. Removing oneself from the confines of the Act meant one lost a connection to one's resources; assimilation was the only other alternative. It was the hope of the Act that the people would assimilate, give up and walk away from any claim they could have held to their own culture and resources.

Some hold to the misconception that the Act dictates that I get a house, that I get free education and that I get free health care. It does not. If I want a house, I have to move to an area that won't provide me with the resources that I need to sustain myself, and, if I did, the house wouldn't be free. My

education is not free. And I, just like everyone else in Canada, take part in the joke known as 'Universal Health Care'. The Act only had one goal, to assimilate the First People fully, to remove the 'Indian' from the Indian. I think the writer of *Star Trek: The Next Generation* must have been doing some research into world history before coming up with the idea for the Borg, which is associated with the phrase 'Resistance is futile'. In the words of Lt. Cmdr. Worf, 'Assimilate this!'[5]

How Does the Trickster Relate to These Politically Heavy Pieces?: Trickster, Oh Trickster, When Did You Go?

I've never been one for being overly heavy-handed or prone to the 'angry Indian rant'. But, from time to time, it can and will be conjured up. When I talk about these pieces, I usually prefer to place these rants between humorous pieces. Exploring the notion of the trickster is a subtext in my work. I make reference to Raven in the vast part of my works; however, sometimes it's not blatantly obvious that what you are looking at is indeed Raven. But Raven is a transformer, and I see him 'keeping up with the Joneses', so to speak. Raven, in my work, transforms into these objects/icons of pop culture to stay in the loop. After all, he is the creature that brought light to the world by knocking up the Chief's daughter after turning himself into a pine needle. A win–win situation, if you come to think of it: he gave us light and got the virtue of the daughter at the same time. Very *James Bond*.

My work is the embodiment of Raven's transformation, his ability to adapt. I feel like saying, 'I embody the trickster', but I have this weird feeling that if I do that, this essay might turn into some sort of manifesto that I write from a cave with a typewriter that has a sticky 'T' key.

5 The movie *Star Trek: First Contact* has some interesting comparisons with the discovery of the new world and colonization of North America. Not to go into too much of a nerd-gasm over probably one of the best *Star Trek* movies – this particular quotation was from a climactic scene in which there is a battle to regain control over the starship Enterprise, almost lost to the evil Borg. Lt. Cmdr. Worf readies his trusty phaser rifle and blasts the Borg out of the sky.

It's all about survival: Raven as iPod, Raven as a can of Coke and so on. But these objects of pop culture lack Raven's finesse and charm, which is why I put them in the context of 'Personal Totems': to explore our fascination with these objects and how we use them to dictate our personal pop lineage. We are a culture obsessed with items. Some say it's the design aesthetics or the functionality that makes us crave these things. But really, it's just stuff we don't really need, which detaches us from the world around us. We ignore others by drowning them out with the latest album ripped to some sort of media device. But, even though some of these objects remove us from society, we are still able to relate to each other because we all have the same sort of crap. Whether it's a Blackberry (aptly nicknamed 'Crackberry'), iPod, laptop, digital camera, or any other object of pop-consumerism, we can relate to these items like figures on a totem pole. You might not have

Figure 3. Sonny Assu, Personal Totems #1 and #2, 2008. Acrylic on Deer hide. 20" and 16" diameter. Photographer credit: Chris Meier. Image courtesy of the Artist and the Equinox Gallery.

Personal Totems

Figure 4. Sonny Assu, iDrum for the Chief, 2009. Acrylic on Cow hide.
22" diameter. Photographer credit: Chris Meier. Image courtesy
of the Artist and the Equinox Gallery.

anything in common with the Goth-chic on the bus you see each morning
on the way to your job, but, regardless of the blood-curdling screaming
coming out of her iconic white ear buds, you may relate to her based on
the fact that you have those same buds rammed in your ears. Even if you're
listening to Barry Manilow, you have something in common: you share the
same personal totem.

The Cola Wars

The Cola Wars of the 1980s brought consumerism to the forefront – which
carbonated sugar water you chose to drink told the tale of whose side you

were on. I'm sure that, ten years from now, if anyone from my generation mentions 'Cola War' to someone in their twenties, that same 20-year-old will ask who won, what was the casualty rate and did it have something to do with the Cold War? Were there nuclear weapons? Were there casualties? One could answer in this way: yes, the nuclear fallout could be thwarted by a pair of Levi's jeans and there was death – to individuality. Bringing pop culture and the Cola War to Cold War Russia could be considered the first step in creating a democracy. Giving a voice to the people via consumerism: democracy through pop culture.

When the 2010 Olympic bid was awarded to Vancouver, the majority of the public sighed with relief and joy. Bringing the world to Vancouver would surely help, not hinder. If you ask anyone on the Downtown East Side if the Olympics have benefited them in a positive way, I'm pretty sure you'll get a resounding 'no!' I was pretty disappointed in the bid being awarded to Vancouver. After all, we have (much like any major urban centre) problems that the money could be better spent on, instead of a two-week parade: hospital beds, housing for the homeless and the treaty process in BC. But, as any good governmental mandate, all those things are being 'addressed' in the coming of the Olymp-apocalypse. For example, the athletes' housing will be turned into a combination of low-income/social housing and luxury condominiums. But I beg the question: Who would want to spend from nearly $0.5 million to over $2 million for a condo to live in the same building as someone on social housing? I bet you one ridiculous Olympic mascot that the social housing aspect gets axed and the luxury condo owner can live in peace knowing that he won't have the bane of society living three floors below.

Okay – so how the hell does this all relate to the trickster? Ah. Art – you have so many levels. In the history of the Olympics, this is the first time that leaders of a host city, in this case, the Vancouver Organizing Committee for the 2010 Olympic and Paralympic Winter Games (VANOC), have tried to include the local indigenous communities in order to avoid conflict. After all, with the treaty process in full swing, the four nations that reside in the Vancouver/Whistler area could have a dramatic impact on the Games and, through protest, leave an ugly stain on the pristine reputation of the Games. Now, it seems that there has always been some element of protest to the contemporary Olympics. Mostly because, as I stated before, the money could be

better spent on aspects of our society that need fixing. But the Games promote themselves as a fix, and bring in revenue and infrastructure. All of which is a band-aid, really. Canada promotes itself as a caring, understanding culture – one that embraces multiculturalism and welcomes all with open arms. And the government will implore the First People to put a friendly, sometimes stereotypical face to Canada. Canada is the friend to the Indian when it wants something, but, for the most part, this country tries to hide the shame that is its past. The strategy, to bring the Four Host Nations to the table and allow them a voice, automatically curbs some of the potential controversy.

The trickster makes a subtle subtextual appearance in 'Enjoy Coast Salish Territory' (Figure 5). I created this piece to speak to the notion that the Games, and the world, will be visiting Coast Salish Territory – a reminder that the land and the original people need to be respected. Heavy politics aside, the piece also has more of a personal connection to it as well. I think back to the day when I learned who I was – the temporal pinnacle of pop culture, when the war between Coke and Pepsi was a dominating force in all modes of pop communication. 'Hands across America' was pop advertising at its finest. It proved that there were people with the inspiration to think outside the box, as it was also a valiant attempt at 'one love':

> I'd like to buy the world a home and furnish it with love
> Grow apple trees and honeybees and snow-white turtledoves
> I'd like to teach the world to sing in perfect harmony
> I'd like to buy the world a Coke and keep it company.
> It's the real thing. Coke is what the world wants today.[6]

I'm what is classed as an 'Urban Indian';[7] I'm pretty serious about respecting this land that I inhabit. This piece not only brings political awareness to this area, but it is a tribute to the fact that I reside in Coast Salish territory and that I pay respect to the Four Nations that make up this area. I thank and honour them in my contemporary-traditional way in the creation of this piece.

6 Coke's iconic 'I'd Like to Buy the World a Coke' ad from 1971. Affectionately called the 'Hilltop Ad'.

7 'Urban Indian' is a term used to describe Indigenous people living off their home reserve in a major urban area.

I love how the piece is invisible in the right context and how it speaks to the notion of how we are aware, yet unaware, of how pop advertising affects us. One of the best comments I've heard on the piece was, 'I walked into the gallery and immediately said, "What the fuck is a Coke sign doing in here?" Then I went up to it. Brilliant!'

The Anatomy of the Trickster

On the West Coast, the trickster stories (in the form of the Raven) usually have a moral which the audience can pick up. The outcome for the trickster could be considered negative, but its interactions provide valuable insight or a valuable lesson in morality for the audience. A simple 'trickster story' of my life as an artist would go something like this: one day, Raven was presented with a choice, either pursue a path that he loves or work in a shoe store smelling feet all day. The choice for Raven was quite clear – pursue that which he loves and become the Creator. A year later, he was pursuing that which he loved, but he had to go back to smelling feet to be able to afford to do so.

Raven has adapted to fit in within our society, and he bombards us with what we think we need. Where is the moral in the contemporary retellings of the trickster? Will it be an awakening one day that what we need is driving us to destroy our environment? I really don't know; Raven likes to let the audience decode his message. Until we get it, he still continues to get away with whatever he wants. I'm still in the lucid dream-state in which Raven is telling me to paint iPods. iPods – this little white box that I convinced myself I needed is making its way into everything I paint. Why? Because it is part of who I am. My technology relates me to you: it is my personal totem.[8]

8 A final thought for the 2023 reflection.
I mention political correctness a couple times in the essay. A perfectly acceptable term then and now. However, as language and terminology evolve or in this case, de-evolve, I recognize the term 'political correctness' to be flippant. When I hear someone use the term, as either an argument for or against the topic, I try and not get drawn into the argument whether it's PC or not. For me, it's about respect and treating others with dignity and connecting to our shared humanity.

Figure 5. Sonny Assu, Coke Salish, 2006. Duratrans and Light box. 24" × 35". Photographer credit: Chris Meier. Image courtesy of the Artist and the Equinox Gallery.

Figure 6. Sonny Assu, 'Oh, yeah, the area's gettin 'real built up, for sure. Local indians are making a killing', 2021. Acrylic paint, acrylic ink, acrylic medium, Marvel comic book pages on panel. 51" × 33". Photographer credit: Byron Dauncey. Image courtesy of the Artist and the Equinox Gallery.

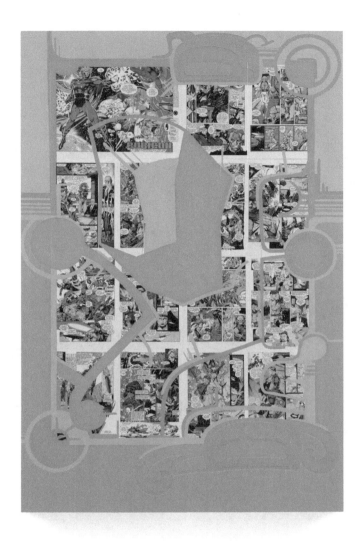

Figure 7. Sonny Assu, Mia-Moo, 2021. Acrylic paint, acrylic ink, acrylic medium, Marvel comic book pages on panel. 51" × 33". Photographer credit: Byron Dauncey. Image courtesy of the Artist and the Equinox Gallery.

Critical Nerd Theory: A Brief Introduction

As an Indigenerd, I am often asked about my origin story and when I started reading/loving comics. Inevitably, the conversation will turn to representations and how I feel about this comic or that comic that feature Native or Indigenous people. I find this question especially interesting because it allows me to reflect on my Pueblo Indigenous identity and how it has changed over the years. I grew up as a suburban Native kid. Always a nerd, forever a nerd. But I was keenly aware of my heritage, my culture and my community as I spent the summers with my grandmother at Laguna Pueblo.

I remember that whenever a Native person would come on screen or in comics, I would be delighted to see them as there were so few representations at all. Billy Sole in *Predator*, Forge in the *X-Men*. They provided inspiration and a reflection of my own heritage in popular media. But as I grew older and began to understand issues of representation and how they affect personal and political dynamics, I began to see how these representations followed a pattern of misrepresentation that capitalized on erasure at the hands of Pop Culture Colonization.

Enter Critical Race Theory. Although it has been much maligned in recent months, at its core, CRT helps to explain systems of oppression and how BIPOC communities can frame and understand their lived experience. It is through that understanding that there can be an opportunity to change both the self and the systems to be more equitable and accountable. Many find the whole idea of CRT disturbing because it forces large segments of the population to recognize their own culpability in allowing systems of oppression to continue marginalizing People of Colour.

Over the years, there have been numerous variations and interpretations of CRT. LatinoCrit, TribalCrit and so on. It was from these expansions of CRT that I began to employ a new term in the field of popular culture: Critical Nerd Theory (NerdCrit).

Whereas CRT seeks to explain, NerdCrit seeks to resolve. In essence, it seeks to make sense of pop culture representations and how they affect personal identity and critical development. In some ways NerdCrit could be considered under the banner of critical media studies, that is, an analysis of media representations throughout the ages. But NerdCrit assumes a framework that looks for understanding and growth of individuals and communities who have too often been marginalized by mainstream media and popular culture. NerdCrit is still a work in progress and this essay is more of an introduction to the concept rather than a full-blown theoretical analysis and framework. Yet, it is a beginning that helps to understand how pop culture, nerd culture and marginalized communities make meaning from influential sources.

Before continuing it is important to develop definitional terms, especially in defining what is a Nerd? As a colleague stated at a comic convention several years ago, a nerd is someone who loves something deeply, unequivocally and unironically. A person can be a sports nerd, a politics nerd, a science nerd and so on. For the purposes of NerdCrit, the focus is on popular culture and subcultures of comics, science fiction, fantasy and games. These subcultures have entered the mainstream with the rise of global mega-media and have moved the 'nerd' from a place of ridicule to a place of power.

The formation of a Nerd Identity often starts in adolescence when the personal identity begins its fundamental formations through moments of pop culture engagement that allow for personal agency and awareness. These are moments where the imagination connects with the interpersonal. Seeing *Star Trek* or *Dr Who* for the first time becomes revelatory, especially when the experience is something that the individual adolescent can take ownership of. The connections to these areas of pop culture generate strong and immediate attachments. Sometimes, these attachments are formed through external influences such as connections with friends and family who are also engaged with the media or experience, that is, 'you should totally watch this, or play this!' Whatever the moment of attachment, these are influential and personal moments that have a direct impact on identity formation. NerdCrit

recognizes these moments of identity development as critical to personal trajectories. But the more important aspect is framed within transformational learning. Because it is one thing to form an identity, but when that identity is challenged internally, how does one make sense of the cognitive dissonance and identity disruption that may take place?

Transformational learning theory, developed in the works of Jack Mezirow, posits that learners can adjust their thinking based on new information. Mezirow 'theorize[d] that adults don't apply their old understanding to new situations, instead they find they need to look at new perspectives in order to get a new understanding of things as they change' ('What Is The Transformative Learning Theory' 2020: n.p.). Mezirow's theories stipulate that learners connect deeply to their past experiences and that learning that emerges from making meaning through critical reflection and critical review could lead to a transformation of their understanding. This transformation is most often a process that comes from accepting the new information and integrating it into the current individual identity.

Herein lies the central point of NerdCrit: how do marginalized communities and identities navigate the space of transformational learning without a radical rejection and schism of identity when confronted with a lack of or misrepresentation?

For example: my father and I were huge *Star Trek: TNG* fans when I was growing up. In the later seasons, there was an episode that featured a long-lost, intergalactic group of Native people. At the time, the episode was amazing for me but looking back I recognize how hundreds of years of Native American tropes influenced its narrative. I also found other *Star Trek* episodes that featured Native American stereotypes and misrepresentations. To complicate matters, I discovered that the animated series had a Native American writer on staff (who won an Emmy for his work). At that moment, I had a choice: to reject my love of *Star Trek* or reorient my individual schema to accommodate both the positive and negative representations and the overall value of the show itself for my life and identity formation.

Of course, this was not an immediate decision but rather a continued process of orientation and reorientation of my own personal attitudes and values, which is the core of NerdCrit. We see this process playing out among many individuals in marginalized communities, from Speedy Gonzalez to The

Critical Nerd Theory

Boondocks to Apu on *The Simpsons*, and this process is necessary in allowing for dynamic individual and community change. In this, NerdCrit doesn't seek to say what is good or bad about the representation, but rather how the individual makes sense and meaning for their own frameworks and identity in an age of change and overwhelming media consumption. NerdCrit allows us to reflect on and accept our own identity without the need for shame or condemnation. It is an investigation into the process of learning, understanding and human growth within communities historically disenfranchised by and through popular culture and popular media.

Ultimately, NerdCrit is an understanding of time and self, of how pop culture attitudes, both societal and personal, change, and how we make sense of those changes in a way that allows for socio-emotional growth, cognitive resilience and deeper interpersonal understandings.

Part II

Autobiographical Practice as Critical Lens in IndigePop

Richard Van Camp

Pop Life: How Pop Culture Saved My Indigenous Bacon All These Blessed Years

I think we're all living the Pop Culture Life. Pop Culture has done more for my inner bliss and happiness than any organized religion. It's carried me and continues to cradle me through heartache and heartbreak and grief. It's given me everyday joy ever since I heard the song 'Video Killed the Radio Star' in 1979, and I hope Pop Culture gives your day joy when you need it most.

In *Moccasin Square Gardens*, my new collection of short stories, I had so much fun writing the story 'Grandpa/Ehtse' and this is usually one of the three stories from the collection (the other two being 'Man Babies' and 'Aliens') that I get the most questions about. In 'Grandpa/Ehtse', we have a narrator who shows the movie *ET* to his grandfather who is Dene and a shaman and only speaks Tlicho. Both men weep at the end of the movie, and the grandfather is so moved by this experience, he wonders what ever happened to the 'little mushroom man who helped the boy in the movie'.

That's my playground: when I can braid Pop Culture with life in the north because that's how I grew up: I had the best of the north and I had the best of the land and community. We had culture camps and back to the land retreats for youth growing up. We had Ski-Doos and we were trusted to respect the land and ourselves when we were out and about doing donuts in powdered snow racing home before 4:30 because that's when *Degrassi Junior High* began on CBC. As long as our chores were done, we were given free rein on what we watched and what a great life I had in the 1980s: playing DnD, collecting

comics and GI Joes and Star Wars toys. Man, I had it made. I like to think we all did. I never needed booze or drugs to get high. Give me a pair of hockey stick nunchucks and some Platinum Blonde and watch out!

> Can we do a quiet poll?
>
> Okay, by a show of hands, how many of you wanted to be Patrick Swayze's character in *Road House* and be a bouncer and have a backup BMW in the parking lot and travel with your own medical records and marry a doctor so you could get your stitches for free after watching *Road House* the first 100 times?
>
> It can't only be me.
>
> Okay how many of you debated for days if you wanted to be a Soc or a Greaser after watching *The Outsiders*?
>
> How many of you hoped your first sexual experience was as great and as fun and as loud as the locker room scene in *Porky's*?
>
> How many of you can sing any song anywhere any time to the *Grease 2* Soundtrack?
>
> How many of you have secretly wondered if David Lynch has any idea of what he's creating or if he's just left it to his editors to bewilder the world?
>
> This can't only be me. (I don't want it to be only me).

Pop Culture RULES and I get the tinglies every single time I see another author share what Pop Culture has done for them. The last twenty-four years of Indigenous literature since I jumped in the pool have been about reclaiming with so much celebrating of our resilience despite every attempt to extinguish us.

I have been asked over the years what is Indigenous Literature? And what makes Indigenous Literature so unique from other world literatures?

I think I have an answer: A long time ago, I was a Writer Trainee for the CBC series *North of 60*. I was on Set in Bragg Creek, AB, for a month with cast and crew and I stayed on with the series for a few seasons as a Cultural and Script consultant. It was fun. But what was frustrating for me as a Writer Trainee and as a script and cultural consultant was this: we would shoot the script but we'd have to whittle it down so it was 52 minutes in total for CBC. This way CBC would show the intro, the credits and have time for the commercials.

What I found was the humour, the nuances, the teasing, the jokes, the wisdom, the looks between the actors, the pregnant pauses before speaking, the silence of not saying anything at all if you didn't know what to say – or if there was nothing to say – was all usually cut. That was it. That was the first to go in the whittling an episode down to 52 minutes to meet the mould of what a broadcaster and the industry demanded. So much of that northern and cultural magic was lost.

So what we had was a very good CBC script but it had lost so much of the Northern and Dene charm, the strength of the people and the magic of hamlet or small town north of the sixtieth parallel.

Indigenous literature to me is all of that that was cut from the main script: the laughter, the nuances, the jokes, the teasing, the wisdom, the silences, the 'Holees', the 'Take it easy's' the 'as if's', the 'Wah's' – the Raven Talk – as I like to call it.

Never heard of Raven Talk? Let me demonstrate.

Let's Call This 'The Ol' One Two'

(Let's change the names to protect the mongez, which is pronounced 'mon jez' which means 'losers'.)

You know, as I get on in years, my sense of recall is getting clearer most of the time.

Here's one:

A long time ago in Fort Smith, NWT, our home town, my brother Roger called me. He was Tree Forting with Shawn Rapids. This must have been 1985. Roger was 13. I was 14.

I was having, you know, a casual day, watching my brothers, Johnny and Jamie, who are eleven years younger than me. My brother Roger called the house.

'Hey', Roge said on the phone. 'Shawn and I discovered an alien.'

'What!' I said. My energy exploded right then and there. 'How?'

'Awww, it was just crawling around in his yard.'

They were across town by Home Hardware.

'As frickin' if', I said. 'Is it hurt? Don't go near it.'

'Aww, Shawn's holding him right now.'

'What?' I yelled. 'If birds carry nits, aliens carry radiation! Just run home, you, right damn now!'

'No way', Roge said. 'He's kind of cute but he has a spike.'

'A spike? *Oh come on.* Run home, you.'

'Uhh, I think we're just going to hang here and play with him.'

'An alien? You're going to play with an alien? Get the hell home or I'll down you.'

'Nahhh', he said. 'Oh. He's moving again.'

I was scared for him. 'Frickin' run home, you! Hurry!'

How I wish I could teleport my brother home to safety. I had throwing stars Brendan Wayas brought me back from Mexico and I made my own nunchucks out of hockey sticks and a bicycle chain. Garth Bone had given me his butterfly knife after fibbing and feeling so bad about it. He told me he was a Cree Grass Dancer and that he'd train me as his helper IF I did everything he asked of me for six months (copy down notes in class, pass cootie catcher love letters on The Keemooch, open doors for him, buy him coffee and bottomless fries at the Pelican, etc. etc.). It turned out he was not, in fact, a Cree Grass Dancer. He was Cree but the Regalia we found upstairs in his closet wasn't actually Garth's: it was his cousin's and they were too broke to put the Regalia on the bus to PA where his cousin lived. Cheap.

'Nope', Roger said. 'He's our alien. We're keeping him.'

'Well what does he look like? Big ant eyes, er what?'

'No, he's tiny.'

'Tiny? As if. Like, how small?'

'Like he's in Shawn's hand, Bro. It'll be okay.'

It'll be okay? I just watched that documentary on Nostrafrickendamus on HBO. How was anything ever going to be okay?

'What colour is he?' I asked.

'Green.'

'Wah! Green?'

'Yup. He has a spike, too.'

'Well that's how they give you radiation. Frickin' run, you!'

'No way. I don't have to be home 'til 8. You can't make me.'

'Put Shawn on.'

My brother handed Shawn the phone.

'Hey', Shawn said.

'Shawn Rapids, you send my brother home right now. Quit playing with Aliens. It's not for kids.'

'Settle down', he said. 'It's amazing. I am holding an extra-terrestrial right now.'

'Shawn, I swear to God, I will kick you in your bonch the next time I see you if you don't send Roge home right damn now.'

'I'll charge you', he said.

'Charge me?'

'Then I'll call Social Services on you.'

'Fuck, yer dumb. Send him home, Monge!'

'Namoyah. He and our alien stay until Home Time. You're not the boss of us.'

'I am the frickin' boss', I yelled into the phone. 'I'm his older brother and I'll Jimmy "SuperFly" Snuka you the next time I see you.'

'Yeah right', he said.

'Send my brother home, and you better keep an eye out at school. I'll frickin' pile drive you.'

He started laughing. 'Never mind about it. I'm going to hang up now. The alien is tickling me.'

'Put my brother on.'

'Say you're sorry', he said.

'What?'

'Say you're sorry', he calmly explained, 'and then I'll hand the phone over to your brother.'

I crossed my fingers. This is exactly what happened the last time he and I locked horns. He ran to his dumb yard and kept pointing to an invisible line going, 'Property line. You can't come in. Richy Ricardo smells my gonchies.' He started singing. 'Richy Ricardo smells my---'

Pow!

I cheap shotted him so hard I like to think that his whole family forgot how to drive.

That was the ultimate Fort Smith threat and boy did I deliver. I drove him and he went down like a sack of potatoes. I felt bad after but he was so damn cheeky. This would be the same thing. I'd give him the ol' one-two the next time I saw him.

'I'm sorry, Shawn. Please let me speak to my brother.'

'No', he said. 'You're going to still cheap shot me.'

'Roge!' I yelled into the phone. 'If you can hear me, run home. Shawn, I swear to God ...'

'What?' he lowered his voice and said this slowly. 'What you gonna say that's gonna make me bust a move, huh?'

Bust a move? What was this – Rocky 9? 'Oh I'll talk about it, Shawn. Your whole family is weird, ya know? Let's talk about your uncle and when he gets hammered up and takes his shirt off at the bar and lets people throw pencils at his big rubber nipples for five bucks.'

'Shut up!' he yelled. 'I'll kick YOU in YOUR bonch!'

'Yeah right', I said. 'Your whole family is cheap shooters, you rubber nippled dinknose!'

'Why don't you have another asthma attack like back when you were in grade 3 and they had to call an ambulance and the whole school came out and your lips turned blue?'

'Fuck you, face melt!' I said. 'You know I was a preemie.'

'Don't get worked up then', he giggled. 'Monge preemie.'

Oh I was worked up.

'Here's Roge', he said. 'I'm tired of you.'

I felt a whistle in my right lung. My blood was boiling. My crazy vein was throbbing!

'Holy', Roger said. 'How come you're just yelling, you?'

'Because I want you home and I want you home now. Don't mess with aliens. Kick Shawn in the nuts for me, okay? I'll give you my allowance.'

'No way', he said. 'We're going to have Jiffy Pop. Oh. Look. The alien is back on the lawn.'

'And?' I asked.

'Aw, it's so cute. I think it just wants to sleep.'

'Okay then. Come home, you.'

'Why? You got Jiffy Pop?'

'Uh huh', I lied. 'Lots.'

'Okay', he said. 'Shawn can double me but don't fight him. He probably has radiation. He touched the alien way more than me.'

'Okay', I said making a fist. 'I won't down him.'

Yeah right: I'd do a running jump in my Chuck Norris extenda-crotch jeans that I ordered, and I'd Jimmy 'Superfly' him off to the top stairs on our porch when he tried standing.

Wait.

He'd have radiation.

I better give him a few days and, just when he thought we were true party buds, I'd give him the ol' one-two in the breadbasket.

Wah. Bringing up my asthma attack cuz of a high pollen count. Now that was dirty and low down.

Well, after a lot of begging and pleading, we figured out it wasn't actually an alien. It was one of those green worms with the spike at the back.

After all that, it was one of those.

Roge and Shawn did keep it as a pet and I think it lasted a few days before it became a moth or a butterfly or something, but people wonder why I went silver in my 30s.

Raven Talk celebrates the northern magic of it all and the panic and worry and fear and the laughing and the jokes and the teasing and my big horse teeth shining as I wipe tears of joy and belly laughs away.

:o)

I love you, my sweet brothers, Fort Smith and that little baby alien (kind of) and I am still in awe of everything, but who knew Jiffy Pop was giving people the Popcorn Lung, hey?

That's what I love to write and read the most: what I know, what I grew up with, what I see every single time I'm home or am visiting in an Indigenous community. That's the magic I've been chasing ever since I started writing and publishing twenty-eight books these past twenty-eight years.

It hit me while working on this essay that I think I need to add that because I was never taught to be fluent in Tlicho growing up in Fort Smith, NWT, there was a confusion and uncertainty and even a resentment about my situation – and yet: with Pop Culture, I found my own way band by band, song by song, magazine by magazine, comic by comic, DnD campaign skirmish

Pop Life

after skirmish. Pop Culture became my culture and my self-esteem soared deep inside because I loved who I was when I was playing, reading, and discovering, and, when I met other members of the comics community, the movie lovers, the DnD players, I found my community.

But let's talk about Pop Culture and how it's made my life magic. It's been the ace up my sleeve ever since the 1970s when our babysitters, the Clark Sisters, used to scream their heads off when the Bay City Rollers used to sing 'Saturday Night' on CBC TV. Or the first time I saw pictures of KISS and needed to know more. Who? Why? Wha?

I remember the first time I felt the pull of Pop Culture. I can remember the exact meal. We had just moved to Calgary when I was in grade two (1984?) where we attended school and I'd heard the song 'Video Killed the Radio Star' by The Buggles, and I remember we were out for supper. We were kids. Our family was young in so many ways, and I could not wait to get back home and find that song again on the radio. I'd wait days for it if I had to. Don't get me wrong: the pizza we were enjoying was great, but what was that song? Where did it come from? Why had I never heard it on CBC North? This kind of music was new to me and it felt amazing to me: it wasn't KISS; it wasn't Country, but it was my first glimpse at a larger world where we weren't being told what to listen to by radio rotation or waiting around for our fave song to come back on. It was my very own alchemy waiting for me to explore and I didn't have to defend it to anyone. It was all mine and it was waiting to be played over and over and over on TV and on college radio. It was like there was this magic waiting in a field just for me. It was my own kind of magic. My own kind of grace. From there it was Platinum Blonde, Gino Vanelli, A HA, Skinny Puppy, ABC, The Ministry, Iron Maiden, Accept, Lee Aaron, Duran Duran, Depeche Mode, Kate Bush, ACCEPT, The Cure, Sons of Freedom, Cocteau Twins, The Smiths, Sisters of Mercy, The Mission. I'd found my way.

Pop Culture was and will always be the universe's medicine for me. What's more is I knew that when I was watching *Fast Times at Ridgemont High* or *Grease 2* or *Hellraiser* that other teens just like me everywhere else in the world were watching it too. We were connected. From the end of Highway 5 in Northern Canada to everywhere HBO or The Movie Channel could reach, we were sharing something – feeling something – together. Look at Drake's lyrics in HYFR: 'Uh, all my exes live in Texas like George Strait.' Even Drake

was listening to George Strait, which, incidentally, my buddy Garth gave me. It was the first CD I ever owned and I still have it. We crank this album all the time at the house.

And the comics: from Mike Grell's *The Warlord* or IDW's *Cobra: The Last Laugh* to *The Sandman* to *Heavy Metal Magazine* or *Savage Tales* or *The Savage Sword of Conan* to *Car-Toons* or *Mad Magazine*: there's a sweet sorcery going on here with the perfect marriage of writing, art and craft. Have you read Image Comics' *Wytches* #1? Have you read Aftershock Comics' *Hot Lunch Special* #1? Have you read any of Ted May's *Injury* comics? Have you read *Zero*? What about *Oink: Heaven's Butcher*? As a comic book and graphic novel writer, I want to be that great. We were shortlisted for an Eisner Award years ago for my graphic novel *A Blanket of Butterflies* (Highwater Press) about a samurai suit of armour that mysteriously arrived in our hometown (true story) and I invented a stranger, Shinobu, who comes to repatriate it for his family and for his honour. When I was writing the graphic novel, I had an agenda: I wanted to honour the prophecy of Ayah, a Dene prophet from Deline, who foresaw the detonation of Hiroshima and Nagasaki several years after he passed. I also wanted to place our Dene laws in a comic so students, parents and educators could see the laws we were given by our ancestors. I also wanted to celebrate our Elders who do so much for so many, and I wanted to honour Ehtse ('Grandma' in Tlicho) as a peacemaker using the protocol to stop escalating warfare between men. I can't wait for you to see what we're working on right now with our Wheetago War graphic novel series with Renegade Arts Entertainment. Holy cow – I can't wait!

Looking back on my life, I've had so many years of fun playing, listening to, experiencing and enjoying the tentacled reach of most things Pop Culture that I was able to benefit from: from the video games: *Dungeons of Daggorath* on the TRS-80 to *Half Life* to *Unreal* on my PC to the four games I have on my phone right now: *Megapolis, Game of Thrones: Conquest, Rogue Assault, DomiNations*.

And the toys: everything Star Wars, Micro Machines, Sectaurs, Mighty Maxx, 3A Toys, Crossbows and Catapults, He Man, GI Joe.

And movies and TV series: *Night Tracks*, Videos on MuchMusic, *Good Rockin' Tonight* with Stu Jeffries, *Degrassi Junior High*, *Ninjas* and WWF Wrestling and *Predator, Terminator, Aliens, T2, Porky's* to *Fast Times at*

Ridgemont High to *KRULL* to *Beastmaster*, *Ozark*, *Entourage*, *Hogan Knows Best*.

To the Horror: *It Follows*, *IT*, *Begotten*, *Hereditary*, *It's Alive*, *Exists*, *The Ring*, *28 Days Later*, *Cloverfield*, *The Descent*.

To the revenge flicks: *The Fourth Horseman*, *Mandy*, *Wind River*, *Harry Brown*.

To the redemption stories: *Red Sun* with Charles Bronson and Toshiro Mifune.

To the Video Games: *Unreal*, *No One Lives Forever*, *Rise of Legends*, *The Battle of Middle Earth*, *Star Wars Galactic Battlegrounds*, *Shadow Warrior*, etc. etc.

The movies I need on my laptop to watch over and over are *Funny People*, *Terminator 2*, *Miami Vice*, *Heat*, *Any Given Sunday*, *Sicario 1* and *2*, *Wall Street: Money Never Sleeps*, *Hostiles*, and the series that I love are *Love*, *Easy*, *Friends from College* and *Ozark* on Netflix. Have you seen *Mandy* yet? There is no bottom to that movie. It just goes on and on with magnificence and meaning. I'm obsessed.

All of this magnificent Pop Culture influenced us in Fort Smith in the 1970s and 1980s: 'We Are the World', Michael Jackson's moonwalk, racing to the drugstore to purchase cassettes and records. Prince, General Public, Fine Young Cannibals, Cindy Lauper, Hulk Hogan finally power-slamming Bundy and Andre the Giant. Even my mom had a crush on Ricky Steamboat in WWF Wrestling. There's a reason we were allowed to watch all the WWF *she* wanted (!) – as long as Mom was in the room 'to supervise'.

There's a reason Ernest Cline's novel *Ready Player One* spoke to the forty somethings. That was our childhood and teen years in a book. We were holding our emotions, our quiet victories at defeating a Boss or finding a hidden room in a game of *Dungeons and Dragons* (which I played with fascination and focus), our Pop Culture Life gave us a window into different universes, different worlds, different lives. Our imaginations soared: whether it was reading, listening, watching or plotting our next campaign. I'm reading the sequel, *Ready Player Two*, as I write this and it is a joy to be back in the world Ernest Cline has invited us back into.

Maybe that's why my writing along with Eden Robinson's and Dawn Dumont's and so many other Indigenous authors connects with an International

audience: because we use Pop Culture as the bridge between traditional story-
telling with contemporary Indigenous life stories with readers from other
backgrounds who were just as terrified or in awe of the movies, books, music
and toys we grew up with.

As I look back on my twenty-eight-year history as an author, I see Pop
Culture Ninjalix in so many of my stories ('The Contract', *A Blanket of
Butterflies, BEAST,* 'The Fleshing') and I see board games like *Crossbows and
Catapults* in 'Children of the Sundance'. I see my magical childhood in so many
of my stories and in so many of the titles of my short stories: 'Snow White
Nothing for Miles' by the Sisters of Mercy; my novel, *The Lesser Blessed,* was
titled from a line from a Fields of the Nephilim song.

So many

So many

So many.

It just hit me that perhaps the reason I write in lyric form in *The Lesser
Blessed* and in several of my short stories ('the uranium leaking from port
radium and rayrock mines is killing us' and 'The Night Charles Bukowski
Died' from *Angel Wing Splash Pattern*) is because of the hundreds of lyric
sheets that I studied from the records and sleeve notes on cassettes and CDs.
All my devotion to studying the words and committing them to memory is
now paying off.

So, Cousin, I hope that this essay has brought up good memories for you.
I think that the fellowship of Pop Culture is a universal one and it brings all
together, kind of like when you're at a concert and 26,000 strangers are all
singing along with the band, all singing as one. The rush of it all found me
when I needed a welcome into something bigger than me, filling me with a
sense of belonging, and it's grown with me and inspired me to add my own
voice to it to honour it. Whether it's the debate about whether *Star Wars* or
Star Trek is better or who was the best Batman or Joker in the movie franchise,
well, it's an ongoing dialogue and I'm grateful for all of it.

I couldn't do what I do now with my life without the guidance and inspir-
ation and magic of every Creator I ever adored: From the alternative music TV
shows 'The New Music' to 'The Wedge' to DJ Acid Wash's podcast 'Phased Out'
to Vice Magazine and to everything zany and wild that I find on YouTube today.

Man, we had it made in the 1980s as teens in Canada's far north.

From Crystal Castles' interpretation of Platinum Blonde's 'Not in Love'. From Faith and the Muse's cover of Kate Bush's 'Running Up That Hill' and Placebo's, I see so many artists spring boarding off the shoulders of giants. I am certainly one of them and that's why I thank every artist that swoons me on my journey at crafting a story at the end of my books.

If there wasn't a Pearl Jam, I never would have written *Little You*. If there was no My Bloody Valentine's 'Loveless', I wouldn't have written *The Lesser Blessed* the way that I did in soulblur. If there was no System of a Down's 'Spiders', I couldn't have written 'Wolf Medicine: A Ceremony of You'. In fact, I don't think I could have written a single word that I've published had it not been for my Pop Culture Life, and I'd sure like to hear about what Pop Culture has given you one day when we visit soon.

And I am grateful.

I am grateful.

I am grateful.

Mahsi cho.

Red Haircrow

Succeeding Skywalker

I remember the 1977 premiere of *Star Wars* as clear as glass although I was only 5 years old at the time. Summer had just begun, and the day promised to be hot, but no one seemed to care as we stood in a line wrapped around the four-plex pale stone building, an island in a grey concrete sea. I had seen the poster for the film in the local market, and it had fascinated me although my mother and sister declared it 'strange', especially the black-helmed knightly figure. We had no idea what the story was about, but the stylized images suggested a fantasy sci-fi adventure with young people. Very different from other films in the genre in the 1970s and early 1980s, where bearded Connerys and serious-faced near or past middle-agers were usually the main players.

Once the theatre doors opened, my older sister and I streamed in along with the others, stopping to get popcorn and drinks, making it an especially unforgettable outing in and of itself. The tickets plus snacks were a real splurge for my low-income family. I had barely settled in my seat, eyes raised upwards with a hundred others when the opening blast of the *Star Wars* fanfare made me jump so badly, I spilled half my popcorn but I didn't care. As the upward-scrolling text introduced us to a tale of epic resistance against a seemingly all-powerful totalitarian empire in a galaxy far, far away, a dream and ideal took root in me.

For the next two hours, I was transfixed, awed and overwhelmed, not understanding everything, of course, but enough of longing, loss and anger, great enough to make you rebel. I admired the sporadic pluckiness of Luke Skywalker as he listed from gloomy teenager to courageous pilot and companion, and with those blue eyes, the golden hair? I was smitten and immediately sought to find and admire the same in real life. Having learned to read at

4 years of age, I also sought to find 'him' in books, of which Western society amply supplied: the dashing white hero, who must be male, often blond if good and nearly virtuous (i.e. Luke Skywalker) or, if darker haired, romantically and/or sarcastically inclined (i.e. Han Solo). I started creating my own fantasies and universes peopled with my imaginary friends and creations reflecting society's heroes and saints, villains and stooges, both on and off screen.

In grade school, I searched for such a 'Luke Skywalker' to befriend, and later as a romantic partner, too, but my affection was inevitably unspoken or unrequited. My adoration was also strong because almost everyone looked up to them and they always seemed positive and happy. Such guys rarely received the treatment, the negative comments, the bullying, the disregard and derision, both from peers and school staff alike, that people of colour did. The treatment I'd seen my parents and members of our community endure: infantilization and/or discrimination in public, in academia, at doctors' offices, at work. The racial and ethnic slurs, the stereotyping, the unwanted sexual advances and demands, all of which you were supposed to yield to or expect retribution and violence, all on top of the extreme injustice at the hands of law enforcement and civic bureaus, of governments. Again, such things were in every facet of life and living, from which you might sometimes have respite when with your peoples, within your communities.

In the society where I grew up in the deep south of the United States, like the rest of the country in covert or overt ways, if you were not Anglo, Caucasian, of European ancestry or white, whatever you want to call it, you were perpetually the stereotype or worse. You were expected to be comedy relief or labelled the angry one, the jive talker, the thug, the slut, the charity case, the brain. Anything but the hero. Just your presence in a room, a group, a position, a club or a restaurant could be considered a threat or problem in any given situation. It could certainly be used to change the dynamic, just like in film or TV series, beyond the token Black, Asian sidekick or the famous 'Tonto', if there are too many of 'us' (meaning more than two POC) the production could quickly be labelled an 'ethnic' or Black film, quickly panned and hyper-criticized by reviewers and major demographic audiences. In reverse, however, such films as *Star Wars* and the majority of others, despite being overwhelmingly or solely cast with white actors, are deemed and considered of universal appeal.

Such attitudes and practices were and are present in every class, at every level of socio-economic status, and even present in primarily or only 'non-white' communities because of the persistent patriarchal white-centricity in fiction and in real life. The hierarchy of worthiness, which I as a person of both Black and Native American heritage was on the lowest tier of, where most everyone else, be they 'white, yellow, black or red', seemed invested in never letting you forget they were above you on the manufactured racial pyramid. As a literal BIPOC, person of Black and Indigenous heritage, I often was subjected to derision and abuse from each, the white, the black and the red. Certainly not a part of the former, but never considered good or pure enough by many of my Black or Native extended family and communities.

We were all conditioned to believe the white man was the smartest, most worthy, the natural leader we should all look to for salvation, as the quarter-back of the team or the person who not only tells everyone else what to do but even further, is conditioned to expect obedience. Some associate or label this with the 'white man's burden', which in many ways harms them as well, placing enormous pressure to succeed, using any means, vice or tactic to meet that elusive pinnacle of heteronormative masculinity.

Communities and individuals of colour experience a variety of side effects from such Eurocentrism and patriarchal beliefs, as such ones strive to further retain their violently, genocidally gained dominant position in Western society. Many 'white' sons, brothers and peers are traumatized or destroyed by those same cycles of violence, repression and extremism, and some people of colour recreate and use the self-same on their own. Some of the products are 'white proximity' or seeking to gain favour or immunity through nearness to a white person or people, and 'self-hate', specifically of the racial variety, in which one dislikes perceived racial or ethnic characteristics about oneself, resulting in over-criticalness of or disassociation from that group, or even aggressions towards the group. As mentioned before, a particularly insidious belief with so many layers of harm and that can generationally reseed itself is 'Eurocentrism':

> Eurocentrism often leads to negative attitudes and beliefs about groups of people and can confirm mainstream stereotypes about non-European group members. In essence, a Eurocentric belief system assumes that European American culture (i.e., Western culture) is the norm and should be viewed as the standard against which other cultures are judged. ('Eurocentrism': n.p.)

More on the Early Years

Growing up in a home where not only extreme Christianity was violently enforced but Eurocentrism was also deeply entrenched, I didn't know at the time, but my cognitive dissonance was growing and would reach debilitating proportions even before I left high school. The trauma gained from seeking conditioned approval from and adoration of heroic 'whites' progressed (or digressed) from the innocent appeal of Luke Skywalker to the older damaged charm of Han Solo, played by actor Harrison Ford, who by the mid-1980s had also taken on the iconic role of Indiana Jones, my new fixation. When I was a kid, I pretended I was secretly a Jedi who used 'the Force', but Dr Jones was more accessible and visibly provable, so I wanted to have everything like him, the hat, the coat and shirt (sadly no gun or whip), and even aspired to be an archaeologist for a time. As we were as financially challenged as ever, my mother sewed me an Indiana Jones outfit, which I treasured, and even many years later, my son also fancied and wore to threads.

As a child and young person, I was an avid reader of science fiction and fantasy, where Edgar Rice Burroughs, Frank Herbert, Isaac Asimov and others kept the same stereotypes and archetypes in imaginary jungles or the distant future – however fantastical or expansive the stories or created histories, 'white' people were always the prominents and dominants. I spent my afterschool times, summer holidays and weekends at the library if at all possible, and before I was in double digits of age, had nearly read through everything accessible at my local branches.

While other teens might skip school to hang out with friends and party or 'steal' their parents' car, as early as age 13, I used it to drive to larger cities and libraries to learn more. I quickly saw the pattern of lies and misdirection we were fed, and which still was taught in schools, about Native Americans, about colonization, about the transatlantic slave trade. So many things. History and social studies teachers throughout middle and high school perhaps hated me, as I challenged the misinformation about slavery, Natives, or 'manifest destiny' and the courageous spirit of American settlers. While I could produce the highest mark in whatever era's test if I wished, more often I found myself

sitting at the vice principal's office having been kicked out of class, having been labelled disruptive.

When other children were playing in the yard or rolling their eyes at another 'walk down Memory Lane' by their elders I was the child who sat and listened to the old people, about life of the past and the real stories behind the mendacity and Eurocentrism of school textbooks, often quite different than the original accounts by figures in history like George Washington, Thomas Jefferson, Abraham Lincoln or Christopher Columbus. Each of these men accurately recorded their racism, genocides, abuse/misuse and rape of African, Native and Indigenous peoples.

In the same vein, as the *Star Wars* franchise and *Indiana Jones* series continued through the 1980s, the entertainment industry became preoccupied with 'political correctness', which served society in the self-same way nineteenth-century forward revisionism of American History and Western Civilization did. 'Political correctness' involved adding more people of colour to films and TV series, almost always still as tokens or comedy relief characters on the screen, who were used to redirect away from the fact that few things had changed behind the scenes. POC were few and far between, and rarely if ever in directorial, casting or managing positions.

American and Western society was supposedly now equal opportunity, post-racial and postcolonial, with anyone who claimed differently labelled as refusing to let go of past trauma and unwilling to 'get over it'. Most people of colour knew this to be untrue because our lives and experiences clearly told a different story, just like the textbooks and news stories. We see the long-time consequences of such 'political correctness' around us today in the form of a lack of empathy, understanding and the new rise of normalized, mainstreamed racism, fascism, sexism, genderism, religious extremism and so forth. Some have surmised this was the underlying aim of 'political correctness', decision-making social behaviours and labels created and largely used by the demographic benefiting most from its usage, indeed, the white male group of a middle to upper social-economic status.

It was ironic and self-delusional that despite having educated myself on accurate history and racism, my offers of friendship to white peers continued and were still rejected or betrayed. I set myself up for humiliation, mockery and failure, with the few romantic overtures I made meeting with

soul-crushing responses. I grew more cynical, more critical in examining myself and focused on what I disliked or even hated about me. My erroneous but conditioned conclusion was that something was wrong with me. I was too brown or too Black, too Indigenously or ethnically strange, and non-binary. I was also too short, too thick of body, of nose, of lips, each were additional strikes against me, and no matter how many long hours I worked out or played in sport, those things wouldn't change. A large facet in Western society's Eurocentric crown are beauty standards, pinnacles and point powers deemed the epitome of true masculinity or feminine attractions and traits. All are strictly based on European features, particularly those of tallness, of narrowness, of thinness, of paleness, which many of them do not possess either.

As I reached my late teen years, my societally supported dissatisfaction with myself grew along with the dual realization many of the characters and stories I loved excluded, stereotyped or caricatured anyone who looked like me. Such stories might include the histories, cultures and traditions of people like me, even stories about my peoples, histories and cultures, yet excluded writers, producers, directors and artists like me. I realized and accepted that for all his good qualities, and as attractive and vigorous as Dr Indiana Jones was, he was still a colonizer and cultural thief. That Luke Skywalker had actually been rather whiny and privileged despite his self-professed abused and denied state. I believed no one like them would ever like or love someone like me, something I still secretly craved, hoping proximity and acceptance by someone like them would reduce the daily racism, dehumanization and dismissiveness I experienced.

For all my earlier self-directed learning, local knowledge and positive experiences gained from my multicultural community and connections, I came to believe and realize that either no one cared to correct all the lies, and such was a pointless endeavour, or though they recognized the oppression, it seemed too embedded and overwhelming to fight. I felt and was made to feel worthless, small and something to be used, abused and discarded, not just as an individual but as a representative of historically and strategically marginalized and minoritized peoples. Especially so if I did not yield and remove as many traces of those peoples and cultures as I could from myself and accepted their version of everything. I was only treated passably nice or

generally accepted if I were an obedient, subservient person of colour, the stereotype, caricature and a tool they found 'safer' and useable. Being a rebel had served me nothing of the accolades, love and loyalty with which Luke Skywalker was rewarded.

My Professional Life

As a way to more closely align with and be admired by 'the white man', to gain a position of power where I had control of others in ways I felt I'd previously had little over myself or anyone, the profession I chose to pursue as a young person was in law enforcement. Embedded in the training process, in the hiring and vetting processes, are supremacist and elitist thinking and mentalities that encourage bias, and that can quickly pervert the intentions and will of any but the most sincerely missioned, who choose the profession wanting to help others and retain their integrity and humanity. It can especially adulterate and change anyone with unrecognized and/or untreated trauma, producing a propensity for bullying and violence as first solutions. The basic unnaturalness of the profession is that it seems to attract many with low self-esteem or inferiority complexes, attitudes and behaviours routinely observed in topically labelled CIS males, whatever their ethnic or racial background, who boost their egos through the legitimized authority and immunity with which they are conferred.

I distanced myself from my cultural roots even further, quickly noting the puzzlement when I spoke about family and heritage to my new colleagues and college classmates, remembering the embarrassment I had sometimes felt observing my ethnic peers and communities' behaviours when compared to 'white' sensibilities and conservatism. I had come to look at the BIPOC or POC world through the harsh 'white' lens of criticism. I especially became critical of my older sister who was an extrovert who continued to explore our African and Native roots and was known as a frequent mocker of police, the status quo and the establishment.

I was on my way to becoming the type of law enforcement officer of colour that James Baldwin warned the world about:

'If you just *must* call a policeman' – for we hardly ever did – 'for God's sake, try to make sure it's a *White* one.' A Black policeman could completely demolish you. He knew far more about you than a White policeman could and you were without defenses before this Black brother in uniform whose entire reason for breathing seemed to be his hope to offer proof that, though he was Black, he was not Black like you. (Baldwin 1986: 66)

Yet even as I tried to talk like them, walk like them, dress like them and be like them, daily training and interactions showed me I was first or only my skin colour. One night while riding with a training officer, this was shown explicitly, and still chills me thirty years later, especially in light of the sharp rise of police brutality and killings in the USA, and the militarization of police forces, especially against POC and anyone in poverty.

We had arrived at a multiple arrest scene in a housing project, where several handcuffed mostly Black suspects sat on a curb surrounded by officers in various positions. We stepped out of the car and joined an ongoing conversation with one group, but my attention soon diverted to the detainees. Although well-groomed and dressed in professional attire to which was affixed a 'trainee' badge, and clearly known to and having engaged in friendly banter with other officers, suddenly the Luke Skywalker looking cop standing watch over the detainees drew his gun on me and advanced aggressively yelling, 'Didn't I tell you to stay on the curb? Get back on the curb! Get back on the curb!' When his error was pointed out, he didn't even apologize. He just shrugged and walked away. Just the colour of my skin was provocative and all he saw and perceived as a threat. Without hesitation, from 'zero to 60', he drew his weapon and might have shot me dead. I was deeply shaken not only by his actions but also the casual laughter of the other officers who thought it funny.

In the course of my training, I have seen officers deliberately provoke POC in order to respond with full force, fail to render aid to POC in need or committing the abuses and assaults themselves, without a second thought, if the person were non-white. There was additional gleeful disregard and disdain if they were part of another marginalized group such as GLBTIQ2S persons. Early on you are observed and tested for your ability to keep your mouth closed about the racism, sexism, misogyny and homo- and transphobia rampant in police departments across the USA. There were a few good ones who did try to stop or reduce such practices, but the majority did not want change. They wanted more control and power over everyone, more guns, less

oversight and less reviews of conduct. My Luke Skywalkers, my Han Solos and my Dr Joneses. Yet I still persisted in trying to modify myself to suit their ideals, and alienating my family and multicultural community, who no longer wanted to be around me nor I around them. Their realness, their love, their honesty and their fearlessness in the face of the fearsome shamed me. My attitude worsened and I found myself violating the rights and boundaries of others even as new suicidal ideations and the patterns of alcoholism shared by many officers for a spectrum of reasons became part of my life ... until I learned my son was to be born.

I had grown up loving the times with my Native and BIPOC grandmothers, my uncles and all their teachings and stories. I had grown up proud of the variety, beauty and richness of our non-European cultures, loves and traditions, the sometimes over loud but genuine laughter, the generosity of spirit and respect for all others, the earth, the water, the sky, the universe. I had grown up learning knowledge gathering, the truth of things, and had challenged anything or anyone I thought was harming others. In my pursuit of American, of European, of 'white' acceptance and approval, I had forfeited those things. I had abandoned my peoples, cultures and value systems that treasured humility, integrity, spirituality, peace and diversity, things that had sustained and inspired me early on in life, and encouraged and comforted me with its wisdom, depth and breadth. I had been glamoured by the superficial, by impossible dreams and myths perpetuating systems and structures that not only harm but are designed to harm and eradicate certain groups, peoples and ways of life. I had nearly lost my life, my Self and my healthy relationships, to things I did not wish my child immersed and indoctrinated in.

Succeeding the Skywalkers and Solos

Twenty-five years later, I still avidly love the science fiction and fantasy genres and have happily shared them with my son. I still remember my love of Luke Skywalker, Han Solo and Indiana Jones fondly, but also with bittersweet knowledge of what these characters and symbols perpetuate in Western society and in the USA especially. What is more about such roles,

such characters, whether one believes them heroes of their adventures, finds them admirable or likeable in some ways, they are products of the minds that create them and the beliefs they hold, of the histories and acts they seek to glorify or embolize, and those they seek to erase or romanticize. Those latter, almost always are the acts of genocide, theft and brutality perpetuated on those different from themselves, even if of the same ethnicity or heritage.

If a character is 'good', they should also be demonstratively heteronormative. If they are bad, they are homosexual or asexual, power-focused. Whether weak or strong, flawed or infallible, each can glorify systems of erasure, misrepresentation as they are the projected beliefs of their creators, the reality that negates the complaints against calling out appropriation and/or misrepresentation, the 'But it's just fiction or fantasy!' Systems that even some BIPOC people like myself once defended and sought to use for individualistic glory and power. Emotionally maturing, I learned to understand and accept characters and stories conceptually can be problematic and flawed, deserving of criticism by society and future generations, yet can metamorphize and change.

In my personal essay, 'When I Think of America', I shared one of the major omissions resulting in historical amnesia and ignorance about European history: the erasure of the extermination of original and Indigenous cultures and belief systems in Europe using the power of the foreign religion of Christianity (Haircrow 2020: n.p.). If it is not absent, it is romanticized into rapturous recitations of how, for example, the holidays of Christmas and Easter were created, when in fact, they are the result of the torture, death and destruction of healthy societies, cultures and peoples, the obliteration of different realities, belief systems and ways of life. Millions of people, resisters, chose or fought to the death against the foreign 'god', its binary imperatives and violent intolerance. Many Europeans today, wherever they are now in the world, have forgotten they once were Indigenous, too, and instead locked themselves into egocentric, Eurocentric, patriarchal repressive and oppressive systems and structures that also continue to harm them. For acceptance, for power, for wealth, they homogenized themselves, weaponizing whiteness and conformity, while the adaptability, humility, empathy, curiosity, the necessary innovative brilliance inherent in Indigeneity, became scorned as primitive, savagery, lack of sophistication, civilization, intelligence and logic.

Indigeneity, the reality of being Indigenous peoples and their response to this through Indigenous pop culture is the antithesis, the opposite of the 'white male' fabricated history in our societies, whether in film or in real life. The creativity of Indigenous people, whether in literature, art, film, fashion or other mediums, increasingly reaches non-Natives, often mocking or 'making light' of the Euro-generated narratives of Native savagery, primitivity and darkness. They continue to provide clarity and truth, much needed in the face of the mendacity that has been fed the world about Indigenous peoples, cultures, histories and traditions, a relief from normalized patterns of abuse, stereotypes and oppression. It is a freedom from things with which the hierarchies, patriarchies and valueless systems have burdened and harmed all of us in some way.

Indigenous use of history, past and present, and the imagining of various futures, display a refreshing ingenuity mainstream pop culture has largely lacked or which has appropriated and 'borrowed' heavily from other peoples all while misrepresenting interactions and engagements. Eurocentrism is the standard in all productions, even if we are seeing more people of colour on screen, the casting agents, the directors, the studios especially continue with the same demographic, which is why so many 'non-white' characters continue to be caricatures.

While without a doubt this treatment is done to other marginalized or minoritized groups, it is historically, palpably and nauseatingly done to both Native characters and stories far more often. While the film or series may seem and be fictional by description, as previously mentioned, characters and stories are generated from the writers and directors' beliefs and opinions based on real life, and influence and manipulate societies and popular beliefs, whether intentional or not. Indigenous pop culture by nature challenges those beliefs and stereotypes, not only of themselves, but others. Are you really the hero you claim to be? Are you really the greatest country? Since we are absent from your supposedly universal stories or stereotyped and misrepresented, how does this speak to your view of us, our place in society now and in the future, our relevance, of anyone else's relevance or worth except your own? While honestly responding to those questions, we must also not rely on their answers clearly evidenced around us: on screen and behind the camera, on the awards committees and in the writing rooms.

The *Star Wars* universe has been one of the most, if not the most, influential series of stories and characters in modern history, gaining unprecedented fandom around the world, crossing cultures, borders and countries with its still ongoing sagas and spinoffs of 'good vs. evil' and noble vs. the ignoble. Luke Skywalker has been rated one of the most popular film characters of all time, as has Dr Indiana Jones, the intrepid archaeologist saving precious artefacts from even their rightful Indigenous owners or peoples so that they can be placed in western museums boosting European profit and prestige.

We all need to succeed from the Dr Joneses, the Solos and the Skywalkers, not because of the characters themselves or even what they represent as the projections from their creators' minds, but because of what they omit, trivialize or erase. When playing the hero, they weaken the empathetic bonds to and between those who 'don't look the part' and remain the perpetual stereotype and minion. Indigenous pop culture and its creators provide critically different and necessary angles, perspectives and realities on humankind's history as a whole, on ourselves as individuals, on our identities, our fears and dreams, our unique features which should make the rest of Western society pause and reflect on the enormity of effects of misrepresentation and stereotypes, and take decided steps to create positive change that benefits all of us, not just one demographic. Not just one type of hero.

Part III

Visual and Graphic Art Forms in IndigePop

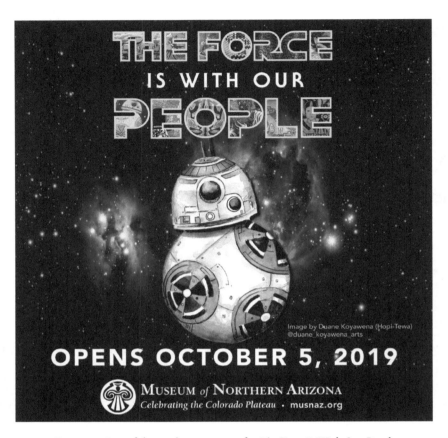

Figure 8. One of the marketing images for *The Force Is With Our People* exhibition at the Museum of Northern Arizona. Art by Duane Koyawena (Hopi-Tewa). Reproduced with permission.

Anthony J. Thibodeau

The Force Is With Our People: Contemporary Indigenous Artists Reimagine the *Star Wars* Universe

Introduction

It is no wonder that the stunning visuals of George Lucas' *Star Wars* have been fuelling the imaginations of fans since the first film was released in the late 1970s. Combined with the rich narrative that has been built through the films, TV series, novels, comics, video games and toys (what is typically referred to as the *Star Wars* Expanded Universe, or SWEU), it was inevitable that fans would seek to interpret the *Star Wars* mythology in creative and divergent ways. Professional artists were involved early in the production of *Star Wars*, and the work of artists such as Ralph McQuarrie is now viewed as almost as iconic as the films themselves. However, besides artists like McQuarrie, many others from a wide spectrum of the art world, including comic book artists, graphic artists and fine artists, have been commissioned to reimagine and reinterpret *Star Wars* characters and imagery for numerous projects, such as the *Star Wars Art: Visions* volume, an official Lucasfilm project. Years of official *Star Wars* comics, first by Dark Horse Comics, and currently by Marvel Comics, as well as several series of trading cards by Topps, have provided an almost limitless outlet for artistic reinterpretation of the *Star Wars* universe, all licensed and approved by Lucasfilm (and since 2012, Disney).

However, artistic reinterpretation has by no means been limited to official outlets when it comes to *Star Wars*. As is the case with many beloved pop

culture properties, a vibrant and creative community of fans, or fandom, has grown around the franchise, providing new ways for fans to engage with *Star Wars*. This engagement varies by degrees, from hardcore fans who dress as *Star Wars* characters (or cosplay, short for costume role play) at science fiction and comic conventions, to nostalgic parents who just want to turn their kids on to their favourite series of films. Within this community, there are imaginative artists who yearn to see their favourite characters in different situations from those provided in the official *Star Wars* canon, whether it be through fan fiction (or fan fic), fan-created films or through other forms of artistic expression, such as drawing and painting. In fact, this type of fan cultural production has been at least partially responsible for maintaining the *Star Wars* mythology and fan interest during the intervals between official *Star Wars* releases, especially between the first trilogy and the prequels in the late 1990s and early 2000s (Jenkins and Hassler-Forest 2017: 20). These fans are the focus of this paper, though I will be looking at a very specific subset of fans/artists who are currently reimagining *Star Wars* in exciting and provocative ways.

In November of 2016 I attended the very first Indigenous Comic Con in Albuquerque, New Mexico, and subsequently returned as an attendee in 2017 and 2018. The event grew quickly, and in 2019 the organizers planned an international convention in Australia, as well as an expanded week-long event, rebranded as IndigiPopX (or IPX). Since that first con in 2016, while a variety of popular culture fandoms have been represented, *Star Wars* fans and cosplayers played an especially prominent role. In addition, what might be considered *Star Wars* fan art has also been one of the most popular and consistently available works at participating artists' booths. The strong affinity that some Indigenous artists and fans in general display for *Star Wars* may be a result, at least in part, of a project undertaken in 2010 by the Navajo Nation Museum, in partnership with Lucasfilm, to dub and release a version of the first *Star Wars* film, *Episode IV: A New Hope*, translated into the Navajo (or Diné) language. This project has been well received by Indigenous people, especially those involved in language revitalization projects on the Navajo Nation. While some artists' work can be traced to before the translated film was released on DVD in 2013, the film has served to reinforce the connection between *Star Wars* and Indigenous audiences. At each of the Indigenous Comic Cons I attended, a screening of the Navajo version of *A New Hope* was

one of the most popular events. In fact, at the 2018 Indigenous Comic Con in Albuquerque, one of the featured events was a five-year reunion of about ten of the voice actors from the translation project, with a Q&A session and meet-and-greet with fans.

While I believe Indigenous artists' *Star Wars* work represents something beyond the tradition of fan fiction, film and art, it still has much in common with these practices, with some distinctive differences that I will explore in this chapter. This work ranges from large paintings on canvas to digital prints, beadwork, stickers, t-shirts and customized toys. The individuals who produce this work range from professional artists who have experience in the fine art market, to comic book artists and street artists who create their work on t-shirts and other graphic media, and primarily distribute their work at small art markets, regional fairs and, of course, through a robust social media presence on the internet. The sheer volume of this work inspired me to look to contemporary artists outside of the Indigenous Comic Con, and I continually found work by other Indigenous artists who have been influenced by the *Star Wars* cultural phenomenon.

The search for more Indigenous artists influenced by *Star Wars* led to the development of an exhibition at the Museum of Northern Arizona (MNA), *The Force Is With Our People*, which opened in October 2019 and closed in October 2020 (Figure 8). This exhibit featured artwork from over twenty contemporary Indigenous artists from across the American Southwest. While the Museum of Northern Arizona is located on the Colorado Plateau, very close to the Navajo Nation and lands of the Hopi Tribe, as well as seven other tribes on the Plateau, the scope of this exhibit and project was the Greater American Southwest and included artists from as far as northern New Mexico and southern Arizona. My role in this project was curator and researcher for the content in the exhibit as well as a companion volume targeted to a general audience (Thibodeau 2020). I am a non-Indigenous researcher, so any insight I have into these artists' practice is through interviews I conducted with the artists, and my experience researching and interpreting fandoms and other cultural phenomena. Additionally, however, I am a long-time *Star Wars* fan, so I am viewing these artists' work and practice through that lens as well.

While the focus of the exhibit and companion volume was to explore the possible parallels between elements of the *Star Wars* mythology and Indigenous

oral traditions, my intent in this chapter is to examine these artists' practice in the context of fandom studies and cultural studies, drawing especially from work by cultural scholar Henry Jenkins. By incorporating images, characters, symbols and other elements of the *Star Wars* narrative and mythology into their own artistic works, these artists are participating in a shared culture of *Star Wars* fandom. Also, by creating a parallel *Star Wars* universe that communicates something beyond simply expanding the official *Star Wars* canon, they are essentially reimagining *Star Wars* as an Indigenous story. However, the shared goal between the exhibit, the companion volume and this paper is to investigate the influence that *Star Wars* has had on contemporary Indigenous artists and explore the question of why this enduring piece of popular culture seems to resonate so strongly with Indigenous communities, specifically those in the American Southwest.

Theoretical Framework

The general theoretical framework of this chapter is a cultural analysis, applying concepts such as participatory culture, textual poaching and transmedia storytelling. While complete textual analysis of specific artwork is outside the scope of this chapter, I will analyse some elements from select artwork to illustrate specificities of a given artist's interpretation of *Star Wars* imagery. I refer to the 'text' of *Star Wars* as one would refer to the text of a book, but what I am implying is the entire *Star Wars* narrative archive, including but not limited to the saga of nine films that have been released so far. In his seminal book *Textual Poachers*, Henry Jenkins references Italian scholar Umberto Eco on the transformation of a movie into a 'cult object', who asserts that it is necessary to 'break, dislocate, unhinge it so that one can remember only parts of it' (Jenkins 1992: 50). This disintegration, or breaking apart of a text, creates a situation where the individual elements become more important than the whole work, and it is precisely because these elements have been broken apart from their original context that they can be recycled and used in another context in sometimes surprising ways. This is a powerful transformative process, and without the disintegration of

the *Star Wars* text, none of the works by the artists discussed here would be possible. This is the essence of Jenkins' concept of textual poaching, although he borrows the 'poaching' idea (somewhat ironically) from Michel de Certeau, which Jenkins describes as 'an impertinent raid on the literary preserve that takes away only those things that are useful or pleasurable to the reader'(Jenkins 1992: 24). While de Certeau was primarily concerned with literature and the written word, Jenkins has adapted this concept to the larger media environment, including film and TV. At first glance, the idea of 'poaching' something from another creator may seem unscrupulous, but this practice gives agency and power to the consumer, leveling the playing field between audience and cultural producer.

While the disintegration of the *Star Wars* text into a collection of strong characters and bold imagery is critical to these artists' creative process, for the work featured in this exhibit at least, the concept of participatory culture, also coined and applied by Jenkins and first introduced in his book *Convergence Culture* in 2006, is especially applicable. Jenkins distinguishes this practice from the term *participatory media*, which refers primarily to media platforms (especially social media) which allow the user to interact with other users, on a personal or group scale, but is essentially still a tool limited by the host platform (such as Facebook or Instagram) (Jenkins, Ito and boyd 2016: 11–12). As Jenkins notes, however, these tools may be very useful to online communities (such as fandoms) for 'maintaining social contact or sharing cultural productions' (Jenkins, Ito and boyd 2016: 11–12). Participatory culture is the process of creating these communities, whether online or offline, as well as the results of this contact and sharing. It is important to keep in mind that this term does not imply the existence of some forms of culture that are not participatory (Jenkins, Ito and boyd 2016: 13). In fact, all culture is inherently participatory, so the term can certainly be applied in a wide range of contexts. However, the way Jenkins and other cultural scholars use it, participation refers to 'properties of culture, where groups collectively and individually make decisions that have an impact on their shared experiences' (Jenkins, Ito and boyd 2016: 12). I am making the case in this chapter that, intentionally or not, the artists in the exhibition are participating in creating a collective expression through the use of *Star Wars* imagery in their work and sharing it through similar platforms and outlets to form a community.

A useful concept that is related to participatory culture is the process of transmedia storytelling, described by Jenkins as 'the art of world making' (Jenkins 2006: 21). *Star Wars* is the most successful example of transmedia storytelling in comparison to almost any other form of popular culture, and this began almost as soon as the first film was released in 1977. Shortly after, *Star Wars* toys began appearing on store shelves, and the merchandise tie-in industry that today we have come to take for granted was really born. After the toys (and more toys) came waves of novels, comics, video games and TV series, including the obscure *Star Wars Holiday Special* in 1978, which is currently only available in grainy versions on YouTube, despite George Lucas and some of the participating actors likely wishing it would simply go away. For some fans it is still a bitter pill to swallow that this kitschy TV variety show is actually canonical, since it is the first appearance of Boba Fett (in a short, animated piece), prior to the release of *The Empire Strikes Back* in 1980. Though on the surface this continuous onslaught of merchandising seems like simple crass commercialism, which it arguably is, it also serves to expand the dimensions of the *Star Wars* universe and the layers by which fans can engage with the franchise. By extending the *Star Wars* narrative over a wide variety of media platforms and products, this 'world making' results in a rich, diverse environment, literally an entire galaxy full of possibilities and cultural morsels for fans to latch onto and use for their own artistic expression. While many fans may be interested and influenced primarily by the film series itself (the original trilogy especially, depending on the age of the fan), most fans are at least aware of this expanded universe. Jenkins explains that the process of transmedia storytelling allows fans to 'read *Star Wars* as a world', and building this world necessitates extension, expansion and, finally, extraction (Jenkins and Hassler-Forest 2017: 19), which I view as the ability of fans to leave the *Star Wars* world but take elements of it with them. While extraction would seem to conflict with the ability of fans to fully immerse themselves in the world of *Star Wars* (or any other fictional world), Jenkins argues that extraction builds mastery over the text, so that when fans return to that world, they have a greater sense of immersion (Jenkins and Hassler-Forest 2017: 19).

The relative lack of representation in popular media of strong, accurate Indigenous characters and stories has served to make fantastic narratives such as *Star Wars* more relevant to Indigenous people than other forms

of popular media, which are still driven primarily by white, upper middle class social norms. This makes even more sense when we consider the burgeoning 'Indigenous futurisms' movement, a concept first introduced and championed by Anishinaabe scholar Grace L. Dillon. This movement pushes back firmly on the typical way that Indigenous cultures have been presented by scholars and museums for centuries as historic curiosities that only exist in the past and are only authentic or traditional when they remain in that specific colonial view of the past. Science fiction opens limitless possibilities for Indigenous voices and stories to be heard, and Indigenous creators have embraced this genre for their own original work, as well as adapting existing fictional worlds and expanding those to include Indigenous characters and environments. Some of these interpretations take on a dystopian vision of the future, while others use this opportunity to imagine an Indigenous-centred world (or worlds) where settler colonization has either been reversed or eliminated altogether. Dillon describes one type of Indigenous futurisms as the 'Native slipstream' (Dillon 2012: 3), where alternative realities, universes and time travel are not only possible but also may collide with surprising results, where fictional worlds can coexist with a reimagined future where Indigenous cultures have not been permanently scarred by colonization. Dillon describes the appeal of slipstream as allowing authors to 'recover the Native space of the past, to bring it to the attention of contemporary readers, and to build better futures' (Dillon 2012: 4).

The Artists and Their Work

Due to space constraints in this chapter, not every work or artist included in *The Force Is With Our People* can be described here, but I have chosen a few select works to give the reader an idea of the work selected for display. After each artist's name, I have noted their tribal/cultural affiliation, as it has been given to me by the artist. Please note the term 'Diné' rather than 'Navajo' is the preferred cultural designation for some of these artists, though I use the term 'Navajo' in other areas of this paper when referencing specific proper names (such as the Navajo Nation Museum).

Ryan Singer (Diné) is an artist based out of Albuquerque, New Mexico, who primarily works in acrylic paints and canvas. He has created dozens of pieces incorporating *Star Wars* characters and Singer clearly uses the similarities between the landscapes of the Navajo Nation and those featured in the *Star Wars* universe, especially the desert environment of the planet Tattooine, home to Luke Skywalker. Singer's vision creates seamless scenes where two cultures converge, which is particularly evident in his 2011 piece, 'Tuba City Spaceport' (Figure 9). Tuba City is a real-life community of about ten thousand people in Coconino County, Arizona, situated between the western edge of the Navajo Nation reservation and the eastern border of the Hopi reservation, the entirety of which sits within the boundaries of the Navajo Nation. Like many towns on the edges of the Navajo Nation, Tuba City has a history of trading posts, and the image featured in Singer's piece refers to a specific establishment, the Tuba City Trading Post, which Singer has reproduced perfectly in the building's design and signage. Singer often inserts real landmarks into his

Figure 9. Ryan Singer (Diné), Tuba City Spaceport, 2011, acrylic on canvas, 30" × 40". Photograph courtesy of Museum of Northern Arizona. Reproduced with permission.

work, and this makes them especially relevant to anyone who has spent time in these places. Trading posts are a place of both economic and cultural exchange, with both positive and negative effects on Indigenous people, and are often seen as a product of colonization, when Indigenous people were pushed onto reservations and came to rely on trading posts to survive. With a backdrop signifying the architecture of Tattooine, most of the scene in 'Tuba City Spaceport' implies peaceful interaction between the Indigenous people, Jawas and a Tusken Raider, but the inclusion of two blaster-wielding Stormtroopers at the back of the building hints at an Imperial presence.

Mavasta Honyouti (Hopi) is an artist from the village of Hotevilla, on Third Mesa in northeastern Arizona. He comes from a family of Hopi wood carvers, and much of his award-winning work follows traditional forms, including katsina dolls and other carved figures. However, some of his pieces draw from popular culture, including characters from DC Comics, but especially from the *Star Wars* universe. In his piece 'Phas'mana' (Figure 10), a small

Figure 10. Mavasta Honyouti (Hopi), Phas'mana, 2017, carved wood plaque, 4" × 4". Photograph courtesy of Museum of Northern Arizona. Reproduced with permission.

carved and painted wooden plaque, Honyouti replicates the iconic image of an Imperial Stormtrooper's helmet, with the addition of a necklace below the chin representing a portion of a 'squash blossom' necklace. Interestingly, Honyouti's tribal affiliation is Hopi, while the squash blossom necklace is most commonly produced by Diné silversmiths. While some may read this as culturally incongruent, the close proximity of these two groups and their long history of social and cultural exchange makes this apparent discordance unsurprising. Honyouti is one of the few artists represented in this exhibit who works in a more traditional medium, while much of the other work in the exhibit is done with relatively contemporary techniques such as digital graphic arts. This links Honyouti's *Star Wars* pieces directly to a long tradition of wood carving using content specifically related to Hopi culture, and he typically presents both types of work for sale side-by-side, without making any cultural distinctions to imply a difference in authenticity between his traditional pieces and those that are pop culture-inspired.

Since its inception in 2016, one of the main components of the Indigenous Comic Con has of course been comic book artists and publishers. I met comic book artist Dale Deforest (Diné) at that first con and have followed his work ever since. Among his many other projects he published a comic called *Hero Twins*, based on Diné oral traditions and the story of the twin warriors, critical figures in Diné creation stories. There are some obvious parallels between these twins and Luke and Leia from *Star Wars*, and these comparisons are further explored in the exhibit. Moreover, Deforest has also done a series of one-shot prints, included in the exhibit, which envision different *Star Wars* characters as prominent Diné figures, such as the piece 'R2D2 C3PO Codetalkers' (Figure 11) which, as the title suggests, reimagines the familiar droids R2-D2 and C-3PO as 'code talkers', Native American soldiers who helped transmit encoded messages for the Allied forces during World War II. Code talkers are still celebrated by Indigenous people at various events, and there is a great deal of pride in Indigenous communities for the service and sacrifice these soldiers gave for their county. The code talker has also become somewhat of a symbol for Indigenous language survival and revitalization, so this image may hold special relevance for Indigenous people involved in those efforts. Some of these one-shot prints by Deforest also veer into the realm of political or social commentary, such as his 'Darth Shelly' piece, a caricature of former Navajo Nation President Ben Shelly (2011–2015), whose political career was

Figure 11. Dale Deforest (Diné), R2D2 C3PO Codetalkers, 2015, digital print. Reproduced with permission.

marred by several corruption allegations. This image portrays Shelly as Darth Vader with his helmet removed, with the raw, deformed grimace of Anakin Skywalker when his face is revealed in *Return of the Jedi*.

Working in a traditional medium in a similar way to Mavasta Honyouti, Cynthia Begay (Hopi/Diné) is a silversmith from the Hopi village of Sipaulovi on Second Mesa, and now based out of Los Angeles. Begay also goes by the moniker 'Hopi Girl Silver' and her body of work is comprised mainly of silver jewellery, incorporating symbols and patterns specific to Hopi culture. Unlike some of the artists in this exhibit who have produced a range of *Star*

Wars-related work, the 'Empire Rattle' and 'Hunter' pieces (Figure 12) are her only pieces that draw from popular culture imagery. In the 'Hunter', the iconic helmet of Mandalorian bounty hunter Boba Fett is nestled in between two stepped designs signifying a common element on Navajo rugs. In 'Empire Rattle', Begay borrows elements from a traditional design found on Hopi rattles, the spoked turkey feathers, to recreate the iconic symbol for the Empire in *Star Wars*. Significantly, silversmithing in Hopi and Diné communities is typically a male artistic endeavour, so Begay's work is something of a gender role reversal, possibly a reflection of how flexible these types of barriers can be, especially when artists are working with non-traditional subjects. However, these gender barriers are still very real, and Begay has met some resistance to her working in a male-dominated medium, but she explains: 'I have been very supported by the art community overall, so I find their support the best way to overcome these challenges. They reassure me that our art is meant to

Figure 12. Cynthia Begay (Hopi/Diné), Empire Rattle silver pendant and Hunter silver ring. Photograph courtesy of Museum of Northern Arizona. Reproduced with permission.

evolve, and who I am is my story to share. So being urban and a woman adds to my story as a silversmith' (Begay email message to author 6 August 2020).

Rod Velarde (Jicarilla Apache) lives and works in the community of Dulce, on the Jicarilla Apache Reservation in northern New Mexico, just south of the Colorado border. Though he also creates intricate drawings on paper, frequently featuring well-known characters in popular culture, Velarde's customized *Star Wars* toys are a striking example of 'Indigenizing' an otherwise non-Indigenous object of mass production. Velarde enhances these objects with patterns and designs from his own cultural background and imagination, and transforms them into true works of art. One of his most popular creations is a scale model of BB-8 (Figure 13) that he has customized with his original

Figure 13. Rod Velarde (Jicarilla Apache), BB-8, 2019, acrylic on etched plastic. Photograph courtesy of Museum of Northern Arizona. Reproduced with permission.

geometric designs, inspired by his Apache heritage and Pueblo cultures of the Upper Rio Grande Valley.

While many artists featured in the MNA exhibit have extensive experience circulating their art in the contemporary fine art market, and some are represented by professional galleries, others situate their work in the world of graphic arts, as is the case for Enoch Endwarrior (Diné/Oneida) and his company, Reclaim Designs, based out of Bernalillo, New Mexico. Endwarrior's work is available on T-shirts, stickers, water bottles and coffee mugs. Though it is a challenge to present this type of artwork in a typical museum exhibit, I feel it is important to present this type of work next to other media that historically has been valued higher for its artistic merit, such as painting and printmaking. Endwarrior's images rely heavily on the existing themes of resistance in *Star Wars* and borrow their iconography to make statements about resistance to colonization and imperialism, issues that Indigenous communities still grapple with in contemporary society. The first design, 'The Force Has Always Been With Our People' (Figure 14), was the original inspiration for the title of the exhibit, *The Force Is With Our People* (used and adapted with Endwarrior's permission). This design transforms the symbol of the Jedi Order from *Star Wars* into a symbol of Indigenous strength and resilience. The message itself in Endwarrior's image implies the strong spiritual connection Indigenous people have long cultivated with the universe and the natural world and suggests that the idea of 'the Force' in *Star Wars* aligns closely with core concepts across Indigenous philosophies. Endwarrior has added specific symbols from Indigenous cultures to the Jedi symbol, including numerous crosses (which represent stars), a ceremonial pipe, a looped stick with webbing suggesting a traditional Indigenous lacrosse stick and eagle feathers, which hold spiritual value across Indigenous cultures in North America.

The design of 'Oka Standoff' (Figure 15) is a reference to a conflict between residents of the town of Oka, Quebec and members of the Mohawk community of Kanesatake in 1991 over the planned expansion of a golf course on Mohawk traditional lands. Endwarrior's image reproduces an iconic photo from that conflict, replacing the Canadian soldier in the original photo with a Stormtrooper. This image, however, also has relevance to more recent events, echoing many of the images of confrontations between water protector activists and police during the Standing Rock protests over the Dakota Access oil pipeline in North Dakota in 2016 and 2017.

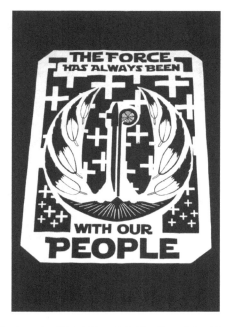

Figure 14. Enoch Endwarrior (Diné/Oneida), The Force Has Always Been With Our People, 2015, T-shirt design. Photograph by author. Reproduced with permission.

One artistic form that has an especially prominent role at pop culture conventions, including the Indigenous Comic Con, is the art of cosplay. Dressing as one's favourite character from comics, film or video games is an extremely powerful practice and can take a fan's engagement with their fandom of choice to another level. Dezbah Rose (Yuchi/Chippewa/ Diné) is a cosplayer, model and artist based out of Oklahoma, and though she has cosplayed other characters from different films, comics and game franchises at all the Indigenous Comic Cons, it is her role as 'Diné Rey' (Figure 16) that continues to stand out for her portrayal of this relatively new character in the *Star Wars* canon. The Rey character, as well as other strong female characters such as Jyn Erso (*Rogue One*) and Rose Tico (*The Last Jedi*), have been instrumental in breathing new life into the *Star Wars* mythology. Rey is a character that resonates strongly with girls and young women and steers the narrative away from what was once primarily a story about a young white

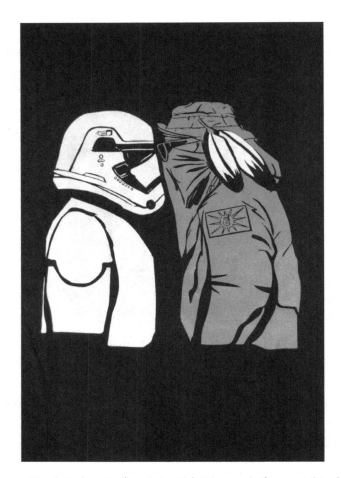

Figure 15. Enoch Endwarrior (Diné/Oneida), Oka Standoff, 2015, T-shirt design.
Photograph by author. Reproduced with permission.

man's journey to adulthood. As she is presented in the new films, Rey is a
character that represents a shift in the *Star Wars* mythology, and Dezbah
Rose cosplaying Rey as an Indigenous woman is especially significant, trans-
forming what is already a symbolically powerful female figure and essentially
creating a new character that can resonate deeply with a group who are mar-
ginalized in dominant culture.

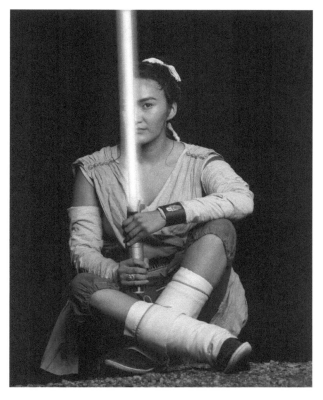

Figure 16. Cosplay by Dezbah Rose (Yuchi/Chippewa/Diné), Diné Rey, 2017, digital print.
Photograph by Terrance Clifford. Reproduced with permission.

One of the most iconic pieces in the exhibit that became a great draw for visitors was 'HOPI R2' (Figure 17), created by engineer Joe Mastroianni and Hopi-Tewa artist Duane Koyawena. Koyawena has several other pieces in the exhibit, including a painted skateboard deck and a pair of skate shoes, and he contributed some creative design elements to the gallery itself. The HOPI R2 project began when local engineer Joe Mastroianni got the idea to build a functional R2 unit from scratch, to help market the exhibit. After hours of online research and making contacts with other R2 builders and ordering custom parts for the unit one piece at a time, nine months later

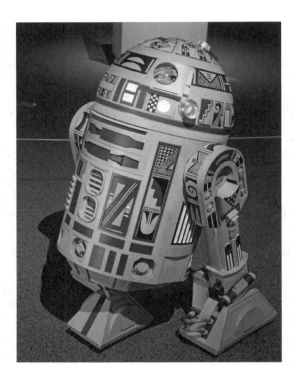

Figure 17. Joe Mastroianni and Duane Koyawena (Hopi-Tewa), HOPI R2, 2019, acrylic on
metal and electronics. Photograph courtesy of Museum of Northern Arizona. Reproduced
with permission.

Mastroianni had HOPI R2 nearly complete. However, it was his decision to
invite Koyawena to paint the unit that led to its inclusion in the exhibit as a
work of art, and not simply as a (albeit extremely high-tech) marketing tool.
The interior of 'HOPI R2' includes nine computers, and the droid can move
by remote control, turn its head and reproduce the familiar sounds of R2-D2
from the films with the help of a smartphone app. It is a true achievement of
science and art, and Koyawena's contribution brings the piece to life. Once he
saw the domed head of the unit, Koyawena immediately envisioned it with
Hopi pottery designs, which he then extended over the whole unit. 'HOPI
R2' is especially popular with Hopi youth, who recognize some of the pottery
designs, but of course are drawn to the piece through their love of *Star Wars*.

Connecting with youth is a high priority for Koyawena in all his work, and he is committed to using his art to inspire younger generations to live a good life, or *loma qatsi* in the Hopi language.

In addition to the artists mentioned above, there were seventeen other artists represented in the exhibit at MNA. These artists included: Susan Folwell (Santa Clara Pueblo Tewa), Jason Garcia /Okuu Pín (Santa Clara Pueblo Tewa), Randy Kemp (Choctaw/Muscogee-Creek/Euchee), Jonathan Nelson (Diné), Farlan and Alesia Quetawki (Zuni), Darby Raymond-Overstreet (Diné), Shandiin Yessilth (Diné), Shaun Beyale (Diné), Jared Tso (Diné), Kim Lohnes (Diné), Landis Bahe (Diné), Mike Toya (Jemez Pueblo), Raymond Trujillo (Laguna Pueblo), Randall J. Wilson (Diné), Virgil Wood (Diné) and Geri Hongeva (Diné). These artists displayed a wide range of styles and mediums, and while they all contributed different types of work to the exhibit, they all followed an approach similar to the artists discussed above in their reinterpretations of the *Star Wars* universe from an Indigenous perspective.

All of these artists have found a way to engage more deeply with *Star Wars* fandom, but in a culturally specific mode of participation. The symbols and images used by Singer and Begay, for instance, and the inside humour and references to notable figures and events by Deforest and Endwarrior, are not instantly apparent to the average viewer, but are ways of communicating a sense of belonging to a group. This practice is not only an expression of individual work but also of a collective vision using familiar imagery and a common set of symbols. The practice of creating this particular type of work is a form of participatory culture, and since 'participation implies some notion of affiliation, collective identity' (Jenkins, Ito and boyd 2016: 14), through such participation these artists have effectively created their own community based on this practice. The benefits of participatory culture are the opening of avenues and democratizing the means of cultural production and circulation, giving people agency and power using otherwise tightly controlled corporate imagery. While Mizuko Ito notes its sub-cultural origins (Jenkins, Ito and boyd 2016: 20), participatory culture does not have to be defined as a subculture in the same terms first identified by Dick Hebdige in his seminal work *Subculture: The Meaning of Style* in 1979 to be valuable, since it is the 'act of creation and contribution to a shared purpose that is most important' (Jenkins, Ito and boyd 2016: 20). Hebdige relies heavily on style as a defining factor for subculture,

but this group of artists form a community based less on style and more on the use of common imagery from *Star Wars* and the shared purpose of blending these elements with their own work and respective Indigenous cultural archives to create an alternate *Star Wars* universe and narrative.

These artists are part of a loose artistic community, and in fact many know each other personally, through events such as the Indigenous Comic Con and various art markets and fairs across the Southwest. However, from what I have observed, the relationship between these artists extends beyond simple familiarity and I believe their work actively influences each other and reinforces the appeal and significance of *Star Wars*. In fact, one of the most common comments I received after the exhibit opened in October 2019, especially from contributing artists who attended the opening reception for the exhibit, was how struck they were to see so many pieces together in the same room. Though they were mostly aware of each other's work in general, seeing it all curated and assembled really made it feel like a cohesive body of work, as opposed to a disparate collection of similarly themed works of art.

As a venue for exchange that has helped create this community and place it within a larger community of Indigenous pop culture producers and consumers, Indigenous Comic Con has certainly played a role in promoting this kind of cultural production. At the con in 2018 in Albuquerque, the interest in and influence of the Navajo Nation's dubbing project of *A New Hope* was elevated, potentially reaching a new audience through the reunion of the original voice actors, providing a celebratory event for Indigenous *Star Wars* fans to engage with this specific mode of participation. The shared *Star Wars* mythology originally created by George Lucas and the ability to tap into this mythology and extract key elements has allowed these artists to connect with Indigenous and non-Indigenous audiences in a unique way. Besides the Indigenous Comic Con and the art markets, it should be emphasized that most of these artists rely heavily on the internet and social media (especially Instagram and Facebook), to share new work immediately, in some cases before the work is even finished, creating anticipation for new releases and allowing fans detailed insights into their process. Ryan Singer uses this technique to build excitement for new work, posting images of pieces that are unfinished, or sometimes even just as he has started them.

While this practice can certainly be viewed as participatory culture, it has inherent barriers built into it. Access to this community of artists is relatively open, but there are still some boundaries, as there are for any community, and in this case, it is the cultural identities of these individuals as Indigenous artists that serve as a defining factor, even more so than being a *Star Wars* fan. These boundaries are not actively policed, but inclusion in this community is self-selective. In other words, it would likely be seen as inappropriate by members of the community (the artists themselves and their fans), for a non-Indigenous artist to produce the same type of work. This 'participation gap' (Jenkins, Ito and boyd 2016: 23) is not necessarily intentional in this community, but nonetheless serves to limit open participation (beyond consumption) to any interested parties by maintaining structural barriers. In some ways, the exhibit itself may have reinforced the geographic limitations of how this community is defined in this paper, since these limits reflect necessary curatorial choices based on the scope of the museum hosting the exhibit.

Though these artists' work is clearly connected to other types of *Star Wars* fan cultural production, such as fan fiction and fan film, it should not be viewed as just another subcategory of fan art, since this body of work differs in significant ways from other modes of participatory culture in terms of production and especially circulation. While most fan cultural production is primarily shared with other fans, going back to an era before this was easy to do on the internet, the art in this exhibit was often made for sale, either through the artists' online outlets, or at art markets, and of course, the Indigenous Comic Con. Since the first 'Indigicon' was launched in 2016, I have personally noticed that it has grown exponentially each subsequent year, through expansion to other cities and venues, and extension of the original con to a week-long Indigenous expo, evidence that its popularity and influence continues to reach a larger audience.

As the original curator of *The Force Is With Our People* at the Museum of Northern Arizona, it has been exciting to witness the impact of the exhibit since it closed, and the surge in popularity of *Star Wars*-related Indigenous art and Indigenous pop culture in general. Our exhibit garnered a great deal of media attention, which was gratifying, but I especially appreciated all the positive feedback we received from Indigenous artists in the exhibit, as well as members of the public who were able to visit Flagstaff

Star Wars in Indigenous Art

to see the exhibit for themselves. Of course, the Covid-19 pandemic that began in 2020 was certainly a blow to cultural institutions like museums, as it quickly changed everyone's lives in so many ways. When we opened the exhibit in October 2019, we obviously had no idea how things were about to play out, but we extended the exhibit to close in October 2020 rather than May 2020 as originally planned. By July 2020 our museum had reopened to the public with limited hours, so we were grateful that more people were able to experience the exhibit before it closed. We were also pleased that we were able to publish a companion volume to the exhibit in Spring 2020, a dedicated issue of MNA's journal, *Plateau*, which served as an exhibition catalog and included some expanded essays from what was included in the exhibit text.

The pandemic also impacted many group gatherings like pop culture conventions. The Indigenous Pop Expo (which was later rebranded to IndigiPopX or IPX) was launched in July 2019 in Denver, then in Melbourne, Australia in November 2019. It was scheduled to be in Albuquerque again in November 2019, as a week-long expo and comic con on the weekend, but that was rescheduled for March 2020. Unfortunately, that was cancelled due to the global pandemic, and the event in all forms went dormant until IndigiPop X returned in March 2023 in Oklahoma City. By all accounts, it was a very successful event, and Indigenous pop culture appears to have returned in full force, showing no signs of diminishing during the pandemic, which impacted so many Indigenous communities in devastating ways. In fact, Indigenous creators seemed resolved to demonstrate their resiliency by embracing this event and other forums that highlight Indigenous pop culture. In 2020 and 2021 Marvel Comics released several one-shot comics in their *Marvel's Voices* series, showcasing Indigenous comics writers and artists. Among the many outstanding Indigenous creators in these comics was Shaun Beyale (Diné), one of the artists in *The Force Is With Our People*. Dr Lee Francis (Pueblo of Laguna), the founder of Indigenous Comic Con and IndigiPopX, who also contributed essays to our exhibit, had a hand in the development of the Indigenous volumes of the *Marvel's Voices* series. Since *The Force Is With Our People* opened in 2019, there have been numerous other museum exhibits focused on Indigenous futurism and pop culture, including one at the Weltmuseum Wien in Vienna (which borrowed several pieces for the exhibit from MNA that were in *The Force Is With Our*

People), and another to open in September 2024 at the Autry Museum of the American West in Los Angeles.

Finally, though we had hoped to travel *The Force Is With Our People* to other venues, that proved impossible during the pandemic, but I am thrilled that a second version of the exhibit, titled *The Return of the Force*, opened at the Center for Southwest Studies at Fort Lewis College in Durango, Colorado in September 2023. While many artists from the original exhibit are included in this new version, I am excited that so many new artists welcomed the opportunity to contribute their own *Star Wars*-themed work. Unlike the original exhibit, which sought to explore the influence of *Star Wars* on contemporary Indigenous artists, without the exhibit itself becoming an influence (since none of the work was solicited in the original exhibit), *The Return of the Force* can openly acknowledge the influence of the original exhibit. I am especially excited that *The Return of the Force* is curated by Hopi-Tewa artist Duane Koyawena, who played an integral role in the development of *The Force Is With Our People*, and he brings his own unique vision to the next phase of this project.

Conclusion

In Will Brooker's extensive analysis in 2002 of *Star Wars* fandom, he observes, with supporting evidence from his interviews, that fan film is 'simply a branch of fan fiction and has a very similar relationship to the primary text; a creative departure that stays within a recognizable framework, an experiment that sticks to accepted rules, a filling in of the gaps within the official narrative' (Brooker 2002: 173). While it could be argued that these artists' work and practice are indeed a form of fan fiction, taking creative liberties with the original text to produce fictional characters and scenes that tell a new story, their work only stays within a 'recognizable framework' in the most minimal of ways, using essential images and symbols that make it instantly recognizable to even the most superficial fan that this work is drawing from the *Star Wars* narrative. However, these artists are not simply adding to the official canon of *Star Wars*, filling in gaps Lucas and the *Star Wars* Expanded Universe have left open. Rather, these artists combine *Star Wars* characters

and themes with symbols and imagery from Indigenous cultures, essentially creating an alternate universe where *Star Wars* is reimagined as an Indigenous story, and cultural mashups of *Star Wars* characters and Indigenous people appear entirely congruent.

Jenkins has repeatedly asserted that fandoms do not simply appear out of nowhere, and 'fandom is born of fascination and some frustration' (Jenkins, Ito and boyd 2016: 14; Jenkins and Hassler-Forest 2017: 31). Though the fascination with *Star Wars* for these artists, and the general interest in *Star Wars* among Indigenous fans, can be partially explained by the same overall appeal that the franchise has with all other fans, there are clearly elements of the *Star Wars* mythology that resonate in special ways for Indigenous people. This has been the focus of the exhibit and this project in general, and it is clear from the interviews I gathered that the themes in *Star Wars* of resistance to imperialism and the concept of balance between the light and dark sides of the Force have some parallels in contemporary Indigenous cultures and oral traditions. The frustration Jenkins refers to in this case is a result of Indigenous people still not seeing themselves sufficiently represented in popular culture, so playing with these images is a form of regaining power, creating Indigenous characters and situations, and asking the question: What if *Star Wars* was an Indigenous story? Grace L. Dillon's concept of the 'Native slipstream', described earlier in this chapter, can help explain the value of asking such questions, especially when Dillon frames Indigenous futurisms as a form of decolonization (Dillon 2012: 10–11). The important work of decolonization can be done in many different contexts at both larger and smaller, more personal scales. These artists' work and practice is a form of decolonization, as a form of cultural resistance to the experience of ongoing settler colonialism, using imagery from one of the most ubiquitous mass culture products to comment both on the current state of Indigenous experiences, and the potential for a more optimistic future. As Jenkins has noted, cultural production by fans is not necessarily resistant to the media narratives themselves, but serves to expand those media narratives (Jenkins and Hassler-Forest 2017: 31). The fans/artists in this exhibit, however, utilize the symbols and themes of resistance in *Star Wars*, playing with these with a great deal of humour and satire, to resist against large power structures within contemporary colonial society, in contexts such as land and

water rights, Indigenous language survival or simply reclaiming space where Indigenous voices can be heard.

The creative practices of the artists represented in *The Force Is With Our People* exhibition embrace the idea of collective ownership of stories and characters, which is significant as Indigenous communities in general struggle to maintain control of their own intellectual property as it is appropriated in dominant culture. These artists are also reading the *Star Wars* text in a different way than other fans, since they are interpreting the images of *Star Wars* not simply from within a frame of reference that is accepted and understood by any group of *Star Wars* fans, but through the lens of their own personal experiences as Indigenous people. While transmedia storytelling is indeed the 'art of world making' (Jenkins 2006: 21), all groups of fans or artists will not make that world in the same way; rather, through a common thread of interpretation, these artists are creating a parallel world, using a wide range of art media, to actively rework Lucas' mythology. This can be observed as part of a 'larger trend of young activists using popular culture as a shared vocabulary for social and political change' (Jenkins and Hassler-Forest 2017: 26). The shared vocabulary of *Star Wars*, which includes images and symbols, is clearly tapped into by the artists in this exhibit, and they put this vocabulary to good use in creating powerful new images and narratives that often have social and political relevance.

As the *Star Wars* saga enters a new era, with a new cast of characters, figures such as Dezbah Rose's 'Diné Rey' tap into a process of reimagining that had already started when these artists put their own stamp on *Star Wars*, since the acquisition of the property by Disney (Jenkins and Hassler-Forest 2017: 26). Despite many fans' concerns and complaints about Disney and the new films, the gender and ethnic diversity introduced by characters such as Rey and Finn have shifted the focus of *Star Wars* from a story stuck in white male normativity to one that translates better to a changing demographic in the United States, and a global market that can now better envision itself in these stories.

James J. Donahue

Graphic Representations of Residential Schools: Using Popular Narrative to Teach Unpopular History

If we accept Craig Womack's assertion (and I certainly do) that '[a]s rich as oral tradition is, [Native Americans] also have a vast, and vastly understudied, written tradition' (Womack 1999: 2), the situation is even more pronounced in the study of Indigenous-authored comics and graphic novels than it is for literary fiction. With few exceptions,[1] academic studies of comics and graphic novels overlook contributions by Native American/ First Nations creators.[2] And this is despite the large number of Indigenous artists working in various capacities (as writers, illustrators and editors), in various formats (online as well as in print, in book-length projects as well as short anthology pieces) and at various vectors of market penetration (self-published work as well as publication by both academic and popular presses). As comics scholar Frederick Luis Aldama has noted, 'Cultural phenomena by and about Indigenous identities, histories, and experiences circulate far and wide', and we are currently witnessing 'the rise of important Indigenous-grown spaces for connecting with Indigenous

1 One obvious example to the contrary is Frederick Luis Aldama, whose body of work on comics has centred largely on the work produced by Latinx and Indigenous creators throughout North and Central America. His 2020 edited collection *Graphic Indigeneity: Comics in the Americas and Australasia* is a fantastic response to this grievous oversight.

2 For the remainder of this chapter, I will use the word *Indigenous* to refer to artists from the US and Canada who identify as either Native American or First Nations.

audiences' (Aldama 2020a: xv, xvii).[3] Despite these growing phenomena, scholarship on Indigenous comics is comparatively scarce. In this regard, the absence of Indigenous artists and their art from academic studies is largely in keeping with various other means of erasing Indigenous peoples from the various landscapes – geographic, political, aesthetic – they have been actively participating in throughout the many years of active colonizing efforts in North America.

The graphic presentation of these efforts – of the various machinations of settler colonialism – has been a much-covered subject for many Indigenous comics artists. And one of the most popular subjects among Indigenous graphic artists – especially those whose work tackles overtly political issues – is the visual representation of reservation boarding schools. This is not to say that Indigenous writers have not been addressing the painful memories and legacy of residential schools in their poetry, fiction and especially memoirs. Far from it. However, presenting these stories in graphic narrative format opens up new possibilities with respect to the presentation of the narrative and, more importantly, will undoubtedly find an important new audience for these important stories. Appealing to a broad array of audiences – younger readers as well as older, casual readers as well as scholars – comics and graphic novels have long remained a cornerstone of popular culture and, increasingly, have been used by educators and scholars alike in their teaching and research. As such, graphic representations of the horrors of reservation boarding schools such as those I discuss below are poised to have a significant impact on the population at large, and hopefully will work to affect positive change. For while it is true that most such schools have closed their doors, the full impact of these schools on the individuals and their communities is incalculable.

Of course, many readers of graphic novels will know of the wide popular and critical appeal of Art Spiegelman's graphic novel *MAUS* (serialized 1980–1991; published as a two-volume graphic novel in 1991), which was the first graphic novel to win a Pulitzer Prize and remains a popular choice for educators in history as well as literature. Recounting Vladek Spiegelman's life

3 Aldama also specifically mentions the 'yearly Indigenous Comic Con in Albuquerque' (xvii), as well as numerous internet spaces that Indigenous comics creators have taken advantage of.

before, during and after the Holocaust – as well as his son Art's coming to terms with the legacy of the Holocaust for those who did not experience it directly – *MAUS* is for many readers, including Hillary Chute, a paradigmatic text for discussing the use of comics form for narratives of disaster.[4] In fact, for Chute, comics are an ideal form for this kind of work, stating quite succinctly in *Why Comics?* that 'Disaster is foundational to comics' (Chute 2017: 34). And for Chute, this is a balanced equation, for just as disaster has long been central to comics narratives – from traditional superhero stories to documentary histories – so too are comics an ideal form for the presentation of disasters, especially those, as she focuses on in *Disaster Drawn*, that 'express history – particularly war-generated histories that one might characterize as traumatic' (Chute 2016: 2). If we then also consider Margaret Noori's reminder that 'Not only are comics rich with potential in their own right, they are historically one of the original formats of native [*sic*] narrative' (Noori 2010: 59), then it should come as no surprise that Indigenous artists have long used comics as an outlet for politically charged narrative, despite their absence in the scholarly literature.

While there are a great many traumatic events and legacies that Indigenous comics artists can and do grapple with in their work, one of the most popular is the history and legacy of residential schools. Working in various genres – from personal memoir to national history to fictional superhero stories – these artists all present various moments of a painful North American institution that has not yet been fully recognized by official histories, nor been fully accepted by the general population. The artists whose work I discuss below, then, are working to correct this grievous oversight and opt to do so through the popular narrative form of comics, working in a medium that Chute characterizes as 'an instrument for commenting on and re-visioning experience and history' (Chute 2016: 259). For that is exactly what many Indigenous authors – and not just those working in comics – aim to do with their art: draw attention to experiences that have long been denied and present histories that have long been ignored, ideally educating their readers beyond what is provided by the history books.

4 For a more in-depth discussion, see also Chute (2016) and Chute (2017). While much of Chute's discussion focuses on nonfiction narratives, I will be treating fictional as well as nonfiction narratives in this article.

Though perhaps I should amend the previous paragraph: if that history is discussed at all. To give but one piece of anecdotal evidence, many of the students in my Native American Literature classes at SUNY Potsdam – which is located in traditional Haudenosaunee territory and educates students from Akwesasne Mohawk Reservation – are unaware of the scope of this problem; many of my students are shocked to learn how widespread these schools were, how long they operated, or that a great many living survivors of these schools are still among us. And perhaps this is one of the problems inherent in teaching this history. It is likely safe to assume that most North Americans are at least passingly aware of the colonization of Indigenous populations (however sanitized the efforts of settler colonialism may be in the approved curricula), though it is just as safe to assume that most North Americans locate these abuses squarely in the past, as part of a colonial machinery that has been replaced by a modern, liberal democracy. That is to say, the 'history' of boarding schools is a *living* history located in the past but not exclusively so, with continued traumatic implications for the survivors and their communities at large.

As Andrew Woolford notes in his sarcastically titled history *This Benevolent Experiment: Indigenous Boarding Schools, Genocide, and Redress in Canada and the United States*, the 'forced assimilation and other forms of violence through residential schools in both the United States and Canada' has its roots in 'missionary societies' dating back to the 'seventeenth and eighteenth centuries' (Woolford 2015: 2). Given this long history – as well as the number of schools established and their policies – Woolford uses Raymond Evans and Bill Thorpe's term 'Indigenocide' to 'refer to the particular experiences of Indigenous peoples under colonialism' (Woolford 2015: 27).[5] Of course, one reason Woolford (and others) use such pointed language is that '[i]t can be very difficult to convince Westerners to look on education, even in its most assimilationist form, as a potential course of harm much less genocide' (Woolford 2015: 49). This is likely also one reason why even recent studies of the history of such schools can characterize this history as one of 'the good intentions articulated in official documents and instructions [that] were frequently ignored or given a low priority by those grappling with practical

5 See also Woolford (2015) and Evans and Thorpe (2001).

problems in the presence of and in relationship with native [*sic*] peoples' (Glenn 2011: 19). Or that allows the same author to romantically suggest that

> [i]n an ideal world, perhaps, Indian youth would be so educated that, at adolescence, they could make a reasoned choice about whether to continue to speak their ancestral language and to follow their ancestral customs [...] or turn their back on all of those and plunge wholeheartedly into the majority society and culture. (Glenn 2011: 7)

Such statements seem to ignore the force of law – not to mention physical violence – that enforced the separation of families, as well as the difficulty faced by many children when they returned to their homes and communities.[6] As David Wallace Adams reminds us, '[t]he pressure exerted on returned students could be intense. In some communities, ridicule and ostracization, traditional methods of control in native [*sic*] society, were unmercifully employed to force returnees back into the tribal fold' (Adams 1995: 278).[7]

What these histories of reservation boarding schools remind us of is that, despite the rhetoric of salvation that has been employed to describe these institutions, they were little more than prisons for those who were forced to attend them. So that such a point does not get lost, Woolford explicitly reminds his readers not 'to forget that boarding schools, in both the United States and Canada, were incredibly violent places. Indeed, most prominent among memories of the schools, especially for survivors in Canada, are those acts of physical, cultural, and sexual violence with which the schools are indelibly associated' (Woolford 2015: 184). As such, it should come as no surprise that one common thread in the various comics and graphic novels I will address below is the presentation of violence. That said, these works are not

6 The United States seems intent on reliving a horrific version of this history, given the enforced separation of children from their parents along the border with Mexico. As of this writing, it has been estimated that more than 1,000 children were separated from their parents, with nearly 500 still waiting to be released from captivity and returned to their families. Some of the narratives that will be discussed below undoubtedly provide us a glimpse of the emotional and cultural trauma awaiting these children.

7 This may, admittedly, seem a controversial statement. Adams does not mean to suggest that all – or even most – students faced such pressures when returning home. Rather, for those who had been more successfully assimilated, returning home posed a variety of problems. We should not forget that, horrific as this system was, it was sadly not entirely unsuccessful in its aims.

simply continued representations of the same acts of violence, presented in the same ways. In fact, one reason for reading many such works is to appreciate the breadth of the kinds of abuses, as well as the various means the artists have of presenting them. And this, of course, is one of the primary reasons why such authors might work within this narrative tradition. Comics, for Chute, are narratives that allow for a 'multiplicity of juxtaposed frames on the page', which allows them to operate 'differently from other documentary images in print' (Chute 2016: 16). Kate Polak takes this one step further in her study of ethics in comics that present fictionalized historical narratives:[8]

> The formal qualities of graphic narratives – including the gutter, the staging of point of view, and the textual-imagistic hybridity – make them uniquely suited to questions relating to how we negotiate representations of extremity because their staging of the gaze and their staging of questions surrounding both how and what we remember prompts readers to consider their emotional and ethical relationships to the text. (Polak 2017: 2)

As such, the study of these narratives, to which I will now turn, is not merely a cataloguing of the various kinds of abuses, though such work would certainly have documentary value. This is also a study of the formal properties of these texts, and as such it addresses the various means by which Indigenous artists have chosen to share their stories with their readers. Such aesthetic diversity is not only a testament to the flexibility of the form or a reflection of the artists' skill; it is also a reminder of the various ways we can learn from these comics.[9]

To begin with a relatively straightforward narrative, I will first look at David Alexander Robertson (Cree) and Scott B. Henderson's 2011 graphic novel *Sugar Falls: A Residential School Story*. Published by the Helen Betty

8 Where Chute works explicitly with nonfiction narratives, Polak works explicitly with fiction. Obviously, there is much productive work that can be done working in the space they jointly create. While most of the works I discuss in this chapter are nonfiction, I did not wish to exclude the obviously fictional texts, particularly as they consciously incorporate the legacy of this very real history and do so with just as much political value as those working in nonfiction.
9 While I hope that fellow educators will consider using these texts in their own classes, my focus will not be on pedagogical theory or classroom practice.

Osborne Foundation,[10] this work is 'based on the true story of Betty Ross, Elder from Cross Lake First Nation', and 'was created in remembrance and respect for those who attended residential schools and those who were affected by their legacy' (Robertson and Henderson 2011: n.p.). This short, black-and-white narrative opens in a high school where students have been asked to seek out a personal account from a residential school survivor and write an essay telling their story. Originally unenthusiastic about the work – he sarcastically thinks to himself 'Great' and 'Seems like I just finished the essay on Helen Betty Osborne. Now this?' (Robertson and Henderson 2011: 1) – Daniel not only completes the assignment but also comes to value what he learned from Betty Ross, thanking her at the end and noting how 'honoured' he feels to be able to share her story (Robertson and Henderson 2011: 40), which makes up the bulk of the graphic novel. As such, Robertson and Henderson employ a frame narrative for the purpose of highlighting the book's possible use in the classroom or, at the very least, reminding the reader of the importance of what Daniel – who appears to stand in for the average non-Indigenous Canadian teenager – learns.

And what he learns, of course, is quite chilling. Along with Daniel, the reader learns that Ross was abandoned by her mother (herself a survivor of residential schools), taken from her adoptive parents by a priest who raped some of the girls under his care, physically beaten by nuns, and also helplessly watched as one of her classmates drowned while trying to escape. And to anyone familiar with stories from the survivors, accounts like this are far from uncommon. However, graphic novelizations of these stories allow readers to imagine – quite literally visualize – these stories from perspectives not their own. As Kate Polak notes of such traumatic stories more generally, 'we are often inspired by an admirable desire to "feel with" the victims, as well as to learn warning signs so as to heed the call of "Never again!"' (Polak 2017: 14). One powerful means of assisting the reader in such a 'feeling' is to represent the acts of violence visually, and from specific perspectives. Polak further notes, 'Focalization offers a powerful distinction between how a panel is *framed* (i.e.,

10 Named for Helen Betty Osborne, a 19-year-old Cree woman from Norway House (Manitoba) who was abducted and subsequently murdered in The Pas (Manitoba) on 13 November 1971. Robertson and Henderson later collaborated on a graphic novel telling her story titled *Betty: The Helen Betty Osborne Story* (2015).

what point of view it depicts) and how it is *positioned* (i.e., through which character's memory the scene is filtered or, alternatively, how the reader is connected to the characters in the scene)' (Polak 2017: 27). We can see through specific examples drawn from Robertson and Henderson's work that great care is taken in just such a framing of the artwork and positioning of the reader with respect to the narrative.

To start with the latter, the frame tale – Daniel's school assignment – provides a situation not unlike what many of the non-Indigenous readers might be familiar with; that is to say, their exposure to the history of residential schools will come through schooling, as opposed to the personal stories that would be shared in Indigenous communities. Further, Daniel's initial scepticism likely aptly mimics how many students would approach such an assignment, as chore rather than an opportunity. Additionally, Daniel's first move is to ask his Indigenous friend for help: 'You're First Nations. [...] Maybe you can help?' (Robertson and Henderson 2011: 2). To turn now to the focalization, we note that this frame narrative is presented as externally focalized, which means that we watch Daniel as an actor as opposed to seeing this from his perspective. Instead of positioning the reader as Daniel, we are positioned as an outsider watching this story unfold (not unlike how an audience member watches a movie). And some of the choices preclude the reader from identifying as a classmate, or someone else in the story itself. For instance, on the first page, we get a close-up of Daniel from a position atop his school desk; later we watch Daniel, his friend April and April's kokum Betty enter Betty's round room from across the room (Robertson and Henderson 2011: 1, 4). As such, the reader is positioned as an outsider to the events of the narrative, or as Polak characterizes such a positioning, 'the reader is a bystander witnessing the act' (Polak 2017: 19). The readers are invited to witness the actions but are precluded from experiencing the events as the characters do.

This changes when we get to Betty's story of her experiences. While it is the case that most of the panels are presented by means of the same external focalization – so that the reader can watch what happens to Betty (as she runs through the snow, hits a priest with an oar or is being kicked in the head by a nun [Robertson and Henderson 2011: 7, 15, 29]) – certain panels are focalized through her, presenting the action from her perspective. This allows the reader to see what Betty sees, encouraging the readers to empathize with her as we

witness these experiences through her eyes. For instance, when Betty is abandoned by her birth mother, the panel is shown from Betty's perspective: the view comes from below, looking up to her mother who tells her 'I have no daughter. I don't want one any longer' (Robertson and Henderson 2011: 6). This emotionally charged moment is presented from Betty's perspective, specifically to encourage the reader to develop a stronger emotional reaction. In addition to emphasizing how small Betty feels (or how large her mother is as a presence), the panel also puts much of the mother's face in shadow, producing a grim, menacing look that reflects both her own anger as well as Betty's fear. This same focalization is employed when Betty first sees the priest that takes her away from her adoptive family: the priest is seen from Betty's perspective, making him a large, imposing figure. (Further, as both the mother and the priest are standing in doorways in these panels – both characters are framed by doorways, thus visually tying them together – the reader may be encouraged to equate them, or at least the emotional damage they inflict on Betty.)

This focalization is selectively employed at various points throughout Betty's story and done so specifically at moments that highlight the abusive practices of the school. As such, Robertson and Henderson attempt to present Betty's story as truthfully as possible from her own telling, while working in a medium notorious for being stylized invention. This issue has been addressed by several comics scholars, perhaps most succinctly by Charles Hatfield when he asks, 'If autobiography promiscuously blends fact and fiction, memory and artifice, how can comics creators uphold [comics artist Harvey] Pekar's ethic of authenticity? How can they achieve the effect of "truthfulness"?' (Hatfield 2005: 114). Further, as Hillary Chute points out, 'Acts of eyewitnessing that find testimonial form in comics, or acts of bearing witness to the experience of others in comics, are rarely accorded the transparency that photographs are' (Chute 2016: 29). Thus, one problem faced by the comics author who wishes to present nonfiction accounts is the comics medium's artifice: this is not a document from the time of the event, but a story told after the fact and recorded by another, in a medium that substitutes stylized artistry for photographic evidence. For scholars like Chute, comics is 'a form of documentary, [...] a form of witnessing' (Chute 2016: 1). Or, in the words of scholar Brian Montes, *Sugar Falls* is an example of 'the visualization of historical memory through a form of multimodal learning through which social, political, and

cultural messages are made meaningful through literary and artistic form'
(Montes 2020: 206). That said, however, the average reader may be put off by
the inherently mediated nature of the comics form, reading it as more 'litera-
ture' than 'history' (even though those terms need not operate oppositionally).

And this is precisely why Robertson and Henderson change the focal-
ization of specific panels in such a way as to turn Betty from a character in
her own story into the vehicle through which the readers visualize the events.
These panels force the reader to see Betty's world through her eyes, showing
the reader these various abuses both as objective fact as well as subjective ex-
perience, in one visually compelling way that comics authors can overcome
'the unique challenges when it comes to engendering credibility with readers'
(Schell 2020: 257) that scholar John Logan Schnell identifies as a chief concern
for memoirists who work in the medium of comics. In this way, Robertson
and Henderson work to bridge the distance between the reader and the events
being narrated, while simultaneously highlighting this mediation through
stylized artistry. For instance, soon after her arrival, Betty had her hair cut
and was viciously scrubbed by a nun. In one particular panel, we see a close-
up of the nun's hand holding the scrubbing brush, with a text box sharing
Betty's thoughts: 'She scrubbed violently and didn't stop until my skin was
sore and red' (Robertson and Henderson 2011: 19). Where the other panels
show Betty experiencing these abuses, this one panel gives us Betty's view of
the nun's work. The artists highlight this switch in perspective later in the
narrative when, in one panel, we see Betty squinting her eye and pinching
her fingers while looking across the river. In the following panel, the reader
sees through Betty's eyes, and realizes that she is looking across the river at
a cabin, thinking to herself, 'Sometimes, we pretended we could even touch
the other side' (Robertson and Henderson 2011: 22). And perhaps most pain-
fully, the reader watches through Betty's eyes as her friend and classmate Flora
drowns while attempting to escape by swimming across the river (Robertson
and Henderson 2011: 32). As such, Robertson and Henderson are inviting the
readers to 'witness' these events as a means of developing the readers' empathy
with Betty. That only the most horrific scenes are so focalized highlights the
emotional purpose for this conscious shift in the narration.

Further, this use of focalization gives increased agency to Betty herself as
a storyteller. While the majority of the narrative is externally focalized – even

though the narrative throughout her story is presented in her voice – these moments remind the reader that Betty experienced these events first-hand; this is Betty's story, and not just Betty's story as told by others. The artists use the paratext to highlight this as well; on the inside of the back cover is a picture of Betty Ross, and the note that 'Sugar Falls is based on the true story of Betty Ross, Elder from Cross Lake First Nation. We wish to acknowledge, with the utmost gratitude, Betty's generosity in sharing her story' (Robertson and Henderson 2011: n.p.). These details add to what Hatfield calls the 'truthfulness' of the narrative by highlighting Betty as an individual as well as a member of a particular community.[11] And in doing so, Robertson and Henderson also attempt to counter the 'vanishment' that Emerence Baker laments regarding stories that erase the presence of Indigenous women.[12] Betty's presence in the book – as character, as narrator, as authorizing agent – becomes a form of 'giving witness' that Baker situates at the centre of Indigenous women's storytelling as a form of survivance (Baker 2005: 111). Further, the constant reminders that children like Betty were not alone in their schools – as well as the similar stories that come from Indigenous communities across North America – highlight the damage done to communities as well as individuals. And such a focus on community not only reflects the cultural violence these schools brought, but it also fits squarely into what Jace Weaver defines as the primary concern of Indigenous literature: community.

In his now classic essay 'Native American Authors and their Communities', Weaver asserts that 'the single thing that most defines Indian literatures relates to this sense of community and commitment to it' (Weaver 1997b: 52). Further, Weaver employs the neologism '*communitism*' to highlight Indigenous authors' activist function, a 'proactive commitment to Native community, including the wider community', for the benefit of 'communities that have too often been fractured and rendered dysfunctional by the effects of five hundred years of

11 In most of the works discussed here, the focus is on one particular child. However, we should remember that these schools were populated by numerous children from tribal nations across the continent. Those whose stories are told should serve as a reminder that the vast majority of such stories will be forever lost to us.

12 Robertson has also written about the Missing and Murdered Indigenous Women (MMIW) crisis in his 2016 graphic novel *Will I See?* See also Rifkind and Fontaine (2020).

colonialism' (Weaver 1997b: 52). Such a focus on the effects of the residential school system is the subject of Jason Eaglespeaker's (Kainai) powerful graphic novel *UNeducation Volume 1: A Residential School Graphic Novel*.[13] This book is divided into two parts: the first part is a collection of various documents (newspaper clippings, admission forms and photographs); the second is a series of short comics-style vignettes presenting some of the abuses inflicted upon children in residential schools. In this way, Eaglespeaker attempts to give voice to as large a portion of the community as he can; rather than telling a story from the perspective of one survivor whose story serves as one example of a larger number, Eaglespeaker uses his work to document and distribute a larger number of stories, attesting to the scope of the problem.

Writing about graphic novels that have incorporated primary sources, Rob Kristofferson and Simon Orpana have argued that 'graphic histories enable strategies for using primary sources that actually enhance and popularize the ways historians can effectively use evidence, particularly with an eye towards helping build the critical consciousness of an expanded base of readers' (Kristofferson and Orpana 2018: 189). Eaglespeaker sets out to build just such a consciousness before getting to the narrative portion of his book; he opens with several pages of documentary history, giving his readers a brief reckoning of the abuses inflicted by residential schools, as reported by the press and represented by those who oversaw the operations. For instance, the first piece of text following the Foreword and Preface is the following: 'I want to get rid of the Indian problem. Our object is to continue until there is not a single Indian in Canada that has not been absorbed' (Eaglespeaker 2014: n.p.). Attributed to Dr Duncan Campbell Scott, Deputy Superintendent General of Indian Affairs, this 1920 quotation lays out very clearly the goal of the residential school system and its use as a tool in the larger machinery of settler colonialism. Further, it is reprinted in large font, taking over more than half of the already oversized pages of Eaglespeaker's text, thus suggesting its importance to what follows. Eaglespeaker follows this text with his commentary (which appears sporadically throughout this section), noting that 'The lack of accountability would have devastating results' (Eaglespeaker 2014: n.p.), before

13 This book was published in two different editions, a 'PG' and an 'Uncut' version. As the latter is currently out of print, I will work with the former version in the following discussion.

then moving to several pages' worth of news clippings that report on just a few of the cases that have been reported on by the press. A brief survey of some of the headlines should give a general impression of the stories they tell: 'Former minister alleges officials killed students', 'Native kids "used for experiments"', 'School's electric chair haunts natives [*sic*]' (Eaglespeaker 2014: n.p.). Such stories serve as an introduction for the reader unfamiliar with the history of residential schools, as do the short statements that follow penned by many survivors of the school system.

The survivors who share their experiences – all of whom are named on the book's back cover – in many ways suggest how similar those experiences were; one, in fact, opens his brief account by noting that 'my experience isn't unusual' (Eaglespeaker 2014: n.p.). Testifying to the uniformity of many of these experiences – physical abuse, sexual abuse, emotional abuse and erasure of language and cultural traditions appear throughout these statements – their inclusion suggests the breadth of the problem, countering the persistent belief that each one is an 'isolated incident' (Eaglespeaker 2014: n.p.). Further, these statements all appear on the left page, while on the facing page are black-and-white photographs of Indigenous people from multiple generations, some of whom are wearing traditional tribal accoutrements. Eaglespeaker thus juxtaposes visuals of actual Indigenous people (the implication is that some of these people are survivors, whose statements appear on the facing page) with their testimony, emphasizing the brutal reality of these stories. Through various kinds of documents, Eaglespeaker is providing a short documentary history as a preface to the graphic narratives that follow, visually stylized to mimic the news articles that came before. In this way, the artistry of the pages encourages the reader to give the personal statements as much documentary weight as the news stories. Such emphasis is required given the persistent belief that these abuses were either isolated incidents or fabrications. Eaglespeaker quotes former Canadian Prime Minister Stephen Harper twice to demonstrate the persistent belief that residential schools were benevolent educational institutions. First, in the Preface, Harper is quoted as having noted that 'some former students have spoken positively about their experiences at residential schools'; later in the text, Eaglespeaker quotes Harper's now-infamous remark at the 2009 G20 Summit: 'We have no history of colonialism' (Eaglespeaker 2014: n.p.). Eaglespeaker's use of collage for these various kinds of documents

thus serves to counter the persistent dismissal of the stories shared by survivors and their communities.

After these two sections, Eaglespeaker then provides a number of short comics stories depicting some of these various abuses alluded to in the first half of the volume. And although he uses different means from those employed by Robertson and Henderson, Eaglespeaker similarly uses some of the visual artistry available to graphic novelists to emphasize the truth value of the narratives that follow, hoping to dismiss any reader's hesitancy to treat graphic narrative as fictional rather than nonfictional. Narratives – perhaps especially graphic narratives – provide a different kind of truth than one will find in history books and government reports; Eaglespeaker addresses this in his Preface: 'If you're looking for statistics and studies, you need to look beyond "UNeducation". What lies ahead are rough, rugged, raw and REAL stories. What lies ahead are uncensored experiences and uncut visceral emotions' (Eaglespeaker 2014: n.p.). And the graphic narratives are no less 'REAL' than the other documents provided.

These short, graphic vignettes – through their artistry as well as their subject matter – highlight the diversity of experiences, despite the many shared similarities. From the bright, almost cartoonish colouring of '... No History of Colonialism?' and 'The Law' to the almost grotesquely proportioned 'SPEAK ENGLISH ... or else ...', the different art styles suggest the variety of abuses suffered by students at these schools while simultaneously reflecting the emotional states of the storytellers. For instance, in 'SPEAK ENGLISH', the reader sees the image of a nun from the perspective of one of the students. Her frightening image as seen from below (recall the discussion of Betty's mother and the priest, above) is emphasized by the harsh, rugged, bold black letters 'SIT DOWN' written above her head. Further, her bony finger pointing to a desk breaks the frame of the panel, suggesting the nun's authority in this situation; she possesses the power to break the frame, to shatter the confines of the narration, as it were. All of these details give her a larger-than-life presence on the page that reflects the fear the children feel in her presence. This sense of fear is represented differently in 'The Law'. All but two of the panels are in bright, vibrant colours; the two exceptions are those that feature the nun who is attempting to take the children from their home. These panels are in black and white, suggesting the sadness they feel in opposition to the

happiness felt in the brightly coloured panels where the family is enjoying a meal or a drive together. Further, in the second of these panels, the nun's face is cast in a shadow that makes her appear as a skeleton; she is thus represented as a Grim Reaper figure, who is taking the children not just to a school but to their certain death. And at this point, the reader should remember that, while many children did survive to tell their stories, a great many did not.

Both *Sugar Falls: A Residential School Story* and *UNeducation Volume 1: A Residential School Graphic Novel* provide graphic novel-length treatments of the horrors of the residential school system, and as such give readers a glimpse of the scope and persistence of this historical tragedy. Other comics authors, however, include allusions to this history as part of a larger narrative. These small inclusions in books covering a variety of topics demonstrate some of the ways that these schools and their legacy have impacted the larger community. For while there is value in such book-length treatments that focus exclusively on this important aspect of settler colonialism, there is equal value in taking a larger view of Indigenous life and culture and exploring how residential schooling fits into that larger picture. So with the remainder of this essay, I would like to briefly highlight a few works that include residential schools in a larger narrative of Indigenous life and history.

In another work of nonfiction that serves to educate its readers about the history and continued legacy of settler colonialism, Gord Hill's (Kwakwaka'wakw) *The 500 Years of Resistance Comic Book* is a series of short vignettes focused on specific historical moments that demonstrate the continued need for active resistance against the various efforts at genocide (physical, cultural, legal, etc.). Hill clearly hopes that this will be used as a pedagogical resource when he writes in his Preface that

> this format ['graphic art'] is useful for reaching children, youth, and adults who have a hard time reading books or lengthy articles. We use many diverse methods of communication – including newsletters, books, videos, music, posters, stickers, paintings, banners, and T-shirts – because no single one will be successful by itself. (Hill 2010: 6)

Noting many forms of communication embraced by protesters as well as common forms of media for popular consumption, Hill situates comics as both a popular and a potentially politically effective means of communicating to a broad audience. The short pieces (the longest of which is ten

pages) certainly would work to inform readers disinclined to long, academic treatises, and could also be useful as a starting point for further study to those interested in learning more. However, what is important for my point here is that Hill includes a short section titled 'Assimilation' that situates residential schools within the larger context of the violence of North American colonization.

Opening with sections titled 'Invasion!' and 'Resistance!', Hill frames his narrative history in terms of the physical violence perpetrated by settler colonists, graphically depicting such scenes as hanging Indigenous men over a fire, cutting off the hands of Indigenous women, forcing Indigenous peoples into slavery for mining, among other acts of violence (Hill 2010: 29–30). Additional sections focus on such historical moments as Inca and Mapuche insurgencies in the sixteenth through the eighteenth centuries up through more recent efforts such as the Oka crisis and the Ts'peten standoff in the 1990s. And situated roughly in the middle of this history is a short section titled 'Assimilation' focused on residential schooling. Showing Indigenous peoples being forced to build the schools they would attend, then sitting in classes with their hair cut short and wearing European-style clothing (Hill 2010: 61), Hill suggests that the kind of cultural violence inflicted by these schools is every bit as devastating as the physical violence against Indigenous people depicted elsewhere in the narrative and should be noted as one piece of the much larger story of European colonization and Indigenous resistance. Further, as Rob Kristofferson has noted of activist comics in a review essay that included Hill's more recent writing, such comics

> demonstrate ways in which the past can be used to inform and provide inspiration and strategic thinking for struggles in the present day. Importantly, they do this through comic art's unique ability to build a critical consciousness in its reader through the act of closure: the positioning of the reader as an active participant in the construction of the narrative by necessitating that they complete gaps and thereby co-create meaning. (Kristofferson 2020: 178)

In other words, activist comics creators are not just informing their readers about the past; they are participating in a literary call to arms inspiring their readership to continue the ongoing work of decolonization.

Indigenous graphic novelists have also used residential schooling as the major plot points in fictional stories, whether these stories are realistic or rooted in fantasy. One example is again provided by Robertson and Henderson, whose book-length *7 Generations: A Plains Cree Saga* provides the history of one family from the early nineteenth century through the present. Focusing on a young Cree man named Edwin who learns about his family's history after a failed suicide attempt, the narrative moves back and forth between the past and the present in order to situate Edwin's current circumstances (including the troubles he is dealing with) against the longer history of abuses against the Cree. For instance, Edwin's recovery from his suicide attempt is juxtaposed against scenes showing some of his ancestors dying from smallpox.

One of the most significant traumas Edwin is attempting to come to terms with is his absentee father who, we learn later in the narrative, was a survivor of the residential school system. James tells his son about his past in an effort to be part of his life again. And as we have seen in the works discussed above, a violent priest plays a central role: in a large panel, a steely eyed priest is shown striking a young James with such force that it knocks him down, with the word 'SMACK' printed in large letters along the angle of the outstretched hand (Robertson and Henderson 2012: 75). In other scenes, the reader watches as James is force-fed cod liver oil, forced to work long hours as a groundskeeper and watches as his younger brother Thomas is led away by the priest in order to be sexually molested (Robertson and Henderson 2012: 79, 80, 84–85). Most importantly, perhaps, for Edwin's understanding of his father is when James explains how he stopped the priest from beating Thomas one day. The priest is seen holding a folded belt above his head, ready to strike the young Thomas. This scene is almost exactly recreated a few pages later, only with James holding the belt, ready to strike a young Edwin (Robertson and Henderson 2012: 92, 96). The implication is clear: James had internalized the priest's disciplinary habits because the priest was the only male authority figure he had after being abducted from his family. And we learn that his absence from Edwin's life was an effort to learn how to be a proper parent, to ensure that he would not beat his children like he had been beaten. As such, James's experiences in the residential school system had a direct, negative impact on Edwin's life. The horrors of the residential school system were, in this case, quite literally repeated in the next generation.

We see a somewhat similar move in Theo Tso's (Paiute) superhero comic book series *Captain Paiute*. Following the adventures of Captain Paiute, this series joins a growing number of Indigenous superhero comics that depict Indigenous heroes using their powers to defend reservation communities. One key component of the superhero genre is the origin story, an explanation of how the hero came by their powers, as well as an explanation behind how the hero came to understand their mission. In the case of Captain Paiute, both aspects of his origin story centre on water. As Luther Pah, a professional hydrologist, he spends his days working to improve the water system of his reservation community. Following an accident in his youth, we learn that he was also selected by the Paiute water spirit Pah to serve as a warrior defending the community against those who would do them harm, granting Luther superhuman command over water (which he can use as blasts from his hands, or in the formation of an ice shield, etc.). And while much of this comic alludes to water (and other environmental) abuses suffered by Indigenous communities, Tso consciously includes a reference to residential schools as part of Captain Paiute's origin story. Pah's grandfather gives him (and, thus, the reader) a brief history of reservation life for the Paiute, including multiple panels depicting children being loaded onto carts to have their hair cut before being marched to school (Tso 2015: n.p.).[14] In the central panel of this page, we see a young Paiute boy crouched over in pain as water is violently dumped on him, under the caption 'They were stripped, scrubbed, doused …' (Tso 2015: n.p.). Here, Tso not only depicts one of the physical abuses suffered by the children – the attempt to literally wash away their darker skin[15] – but does so in a way that highlights Captain Paiute's mission. Here, water is used as a means of abusing Indigenous children, instead of using it as a source of life. Tso thus visually depicts the abuse of Indigenous children while vaguely alluding to the longer history of physical and environmental abuse that Indigenous peoples still fight against today.[16]

14 Hair cutting is depicted in nearly every comic/graphic novel discussed above and has long been seen as a sign of cultural assimilation through explicit body manipulation with the intended effect of demoralizing the children, who no longer look – even to themselves – like they did before their forced schooling.
15 Images such as this are also found in most of the works discussed above.
16 For a contemporary example, we need look no further than the protests against the Dakota Access Pipeline, an event also alluded to in the first full issue of *Captain Paiute*.

As we see in these two quick examples, Indigenous authors are also using their fictional work to educate readers about the history and legacy of residential schooling in North America, demonstrating that the experiences of those who survived the schooling – as well as those who live in its wake in succeeding generations – are fundamental for understanding the lives of Indigenous peoples today. That the authors have chosen to present their work in the popular narrative of graphic art in comics and graphic novels not only suggests their interest in reaching a broad audience, but also allows them to employ the visual art in such a way as to generate empathy, or otherwise present visual information intended to affect the audience emotionally. Telling these stories and situating them within a larger history of Indigenous responses to settler colonialism has clearly become one of the major foci within the recent rise of Native American and First Nations comics artists, and demonstrates a new direction in what Miami/Shawnee scholar Malea Powell (quoting N. Scott Momaday) has noted about Indigenous writing: '[I]n coming to terms with our relationship to the colonizing consequences of writing in our past, we will begin, indeed, to tell new stories of "who and what, and *that* we are" ' (Powell 2002: 428). May these books enjoy a large and generous audience, so that future generations can learn from the grievous mistakes of the past.

Juliane Egerer

Reframing, Rewriting, Redrawing the Past: The Creation of Decolonizing Narratives in Sámi History Cartooning

Introduction: Sámi Cartooning as a Form of Sámi Popular Culture

In both print and online media, Sámi cartoons as a popular art form make visible and reclaim Sámi culture. When it comes to Sámi people opposing colonial perspectives of the dominant cultures, however, one does not immediately think of humorous, cartoonish narratives and short, sketchy comics as a tool for changing mainstream society. What first comes to mind are internationally renowned Sámi musicians who use a blend of traditional joik, drum and ambient sounds of, for example, rock and pop music, 'reframing traditional musical knowledge in ways that speak to both ecological issues and global audiences' (Ramnarine 2017: 283). As Coppélie Cocq and Thomas A. DuBois have shown, since the protests against the damming of the Álttá River in the 1970s, the Sámi acquired strategies of how to use various forms of media to further Sámi image making and self-representation as well as advance Sámi social, cultural and political agendas in purposefully promoting processes of decolonization (Cocq and DuBois 2020: 49–81; for predecessors see also 34–48). In the hybrid media system of the Democratic Corporatist Model of Northern Europe in which media financed by the dominant settler societies with a wide reach play as much a role as Sámi-controlled media with a smaller reach, Sámi find ways to reassert their sovereignty as Indigenous peoples (Rasmussen, Sara and Krøvel 2022: 415–418, 426). Sámi artists and

cultural workers reach out across the globe, conveying messages of belonging, identity and the ecosystems we all share and live in (see Ramnarine 2017; Hilder 2017; Werner 2017). 'Downloadable tunes, music festivals, films, YouTube videos, Facebook posts, Instagram images, and Twitter tweets [now X] are just some of the diverse media through which Sámi activist spears can reach their targets: the hearts and minds of willing audiences' (Cocq and DuBois 2020: 6). Artivism – that is, art used decisively for activism to create changes in society – involves various artistic forms that generally do not have to be considered art, as Moa Sandström indicates: Sámi artivism focuses on 'Narratives about contemporary colonialism and decolonising, alternative visions conveyed through artistic expressions including music, visual arts, performative acts, and poetry' (Sandström 2020: 243; see also 9–11). As Tina K. Ramnarine points out, during the last few decades, a 'new history of Sámi as a colonized people developed' (Ramnarine 2017: 282), accompanied by Sámi gender studies, 'calls for decolonization, self-determination, and social transformation' (Ramnarine 2017: 288). However, 'this historical framing of the colonization of indigenous populations is entirely absent from an-other new historiography that is concerned with questions about colonial complicity and the role of the Nordic countries in European imperialism' (Ramnarine 2017: 288). Ramnarine calls attention to the fact that Sámi as a colonized people within the Nordic countries are absent in Keskinen's et al. anthology *Complying with Colonialism: Gender, Race, and Ethnicity in the Nordic Region* (Ramnarine 2017: 288; Keskinen, Tuori, Irni and Mulinari 2009). Sámi are also left out of Lill-Ann Körber's and Ebbe Volquardsen's key publication on contemporary Scandinavian postcolonial literature and culture entitled *The Postcolonial North Atlantic. Iceland, Greenland and the Faroe Islands* (Körber and Volquardsen: 2012). In the twenty-first century, this is an irritating observation. '[T]he Sámi were accepted as an indigenous people only in 1975 when Nils-Aslak Valkeapää performed a joik at the first meeting of the World Council of Indigenous People' (Ramnarine 2017: 282). Since then, Sámi have been upholding transnational cooperations with Indigenous peoples from all over the globe (Minde, Jentoft, Gaski and Midré 2008; Minde 2008). Before the rise of the Sámi movement in the 1960s and 1970s, Sámi received very little attention as an ethnicity significant in northern Scandinavia: 'As a people whose traditional land, Sápmi,

traverses northern regions of Norway, Sweden, Finland, and the Russian Kola Peninsula, the Sámi have largely been ignored in national historical narratives and discussions of Sámi culture, by fixating on "difference", have often displaced the Sámi from Nordic modernity, temporally and geographically' (Hilder 2017: 363). A romanticized and at the same time colonizing external view on Sámi and their (semi-)nomadic life as reindeer herders was prevalent in children's books such as *Barnen i Kautokeino* (Hagbrink 1986)[1] as well as in professional marketing of Sámi art such as, for example, the book illustrations and paintings by Sámi artist Nils Nilsson Skum (1872–1951), who collaborated with the Swedish ethnologist Ernst Manker in the first half of the twentieth century (Manker 1965). These views and the tacit passing over of the Sámi in connection with decolonization processes are no longer appropriate today.

While Sámi popular music – similar to other forms of Sámi art – 'has been linked with indigenous political assertions for greater sovereignty, minority language sustainability, new historical narratives, and environmental challenges in the transnational socio-cultural contexts of the Nordic world' (Ramnarine 2017: 277), nothing like this can be said about Sámi comics and cartoons. Compared to the art forms and media investigated by Sandström (2020) and Cocq and DuBois (2020), cartoons are a relatively new and still unresearched art form in Sámi popular culture to serve Sámi interests and to increase international Sámi visibility. In Norway, the political satire and self-ironic *Sápmi* comic strips by Karasjok-based illustrator Runar Balto alias Ronardo have regularly been published in the Sámi newspapers *Ságat* (in Norwegian) and *Ávvir* (in North Sámi) since the 1990s. In 2010 and 2017, Balto published two printed cartoon collections of his works from the 1990s and more recent drawings, respectively (Balto 2010, 2017, see Larsen 2011). In 2015, a gallery of up-to-date *Sápmi* cartoons was taken to the websites of The Norwegian Broadcasting Corporation NRK, the government-owned radio and television broadcasting company, after having been rated second best out of 1,538 Norwegian cartoon strips in Norway a few years earlier (Larsen 2012). In an interview, Runar Balto states that his Sámi cartoons ventilate people's emotions about press images as

1 For still problematic appropriations in children's and young adults' literature by Sámi and non-Sámi authors see Manderstedt, Palo and Kokkola (2021).

well as mirror stereotypes in Sámi communities (Larsen 2015). While Balto lives in Sápmi and has his cartoons edited in two languages, Norwegian and North Sámi, Maren Uthaug is a Denmark-based award-winning novelist,[2] a well-known blogger and illustrator of the Danish newspaper *Politiken*'s daily comic strip *Ting jeg gjorde* (Things I did).[3] In addition to that, her Danish creative work is paralleled by her Sámi and Norwegian cartoon books as she is also a Sámi cartoonist. Uthaug is the daughter of a Norwegian mother and the Sámi activist, social worker and ex-chairman of *Norske Samers Riksforbund NSR* (Sámi Association of the Kingdom of Norway), Tor Regnor Solbakk, who died in 2009 (Hætta 2010). She lived in the Norwegian part of Sápmi until she was about 7 years old but grew up in Denmark after her parents' divorce. She stayed in Denmark and now lives with her partner and their children in Copenhagen. Uthaug characterizes herself as 'Halv samisk. Halv norsk. Ret dansk' (Half Sámi. Half Norwegian. Quite Danish) (Uthaug 2009–ongoing; see also Platou, Viallatte and Cunningham 2014). Published by her Sámi uncle's *Forfatterens Forlag Čálliid Lágádus* (Author's Publisher), her cartoon books are available in North Sámi, South Sámi, Lule Sámi and Norwegian (Uthaug 2010a, 2010b, 2011a, 2011b, 2012a, 2012b, 2012c, 2012d, 2013b, 2013c, 2015a, 2015b, 2016b, 2017b). Therefore, Maren Uthaug's books easily reach out to a large part of the transnational and multilingual Sámi community in Sápmi.[4]

Given Maren Uthaug's international success in Sápmi, Norway and Denmark, the question arises whether Sámi cartoons attain an artivistic function and to a similar extent as Sámi 'Popular music can act as a powerful political voice [...] [and] [...] contribute to new historiographies' (Ramnarine 2017: 288). Especially with her fourth cartoon book *Det var en gang en same, En nesten sann fortelling om samenes historie (There Once Was a Sámi, A Nearly*

2 Uthaug's debut novel *Og sådan blev det* was first published in Danish (Uthaug 2013a), followed by translations into Norwegian and North Sami (Uthaug 2014, 2016a). See also Egerer (2020b). Meanwhile, she has published two more novels (Uthaug 2017a, 2019, 2022).

3 All translations from any of the languages used here into English are by the author of this contribution. It is Uthaug's blog (Uthaug 2009–ongoing) and the daily published newspaper cartoons (Uthaug 2013–ongoing) that keep her present first and foremost to a Danish audience.

4 For more information on Maren Uthaug's other cartoon books see Egerer (2020a).

True Story about Sámi History) from 2015 (Uthaug 2015a),[5] Maren Uthaug rewrites and redraws the history of the Sámi as a colonized people as well as the mainstream postcolonial history from which Sámi are absent. Relying on cartooning as a popular art form and using the printed medium of a Sámi-owned publishing house, she shows ways of healing colonial wounds while opening new, humorous, self-confident as well as ironically self-deprecating perspectives on Sámi history.

Challenging History with Two Intertwined Threads: History Storytelling

Descriptive knowledge, especially when created by a dominant culture, has constitutive and subjugating effects. However, rewriting something 'in order to improve it or change it because new information is available' ('Rewrite' 2013: n.p.)[6] opens up alternatives. In this sense, rewriting history involves selecting or presenting new information about past events in a way that does not serve the purposes of the dominant culture's historiography but rather the purposes of the underrepresented cultures by covering events and perspectives that are new to mainstream historiography. By analogy, redrawing is the process of drawing something again or anew, whereby re-drawing can also be used figuratively ('Redraw' 2023: n.p.). Maren Uthaug's cartoons offer resistance against widely known episodes of Nordic colonial Indigenous histories. The history cartooning *Det var en gang en same, En nesten sann fortelling om samenes historie* (*There Once Was a Sámi, A Nearly True Story about Sámi History*) challenges mainstream historiography and tries to renarrate the Sámi past[7] in an effort to bring about change. Thus, cartoons as known from popular culture resonate with artivism (cf. Sandström

5 Also translated into Sámi languages (Uthaug 2015b, 2016b, 2017b).
6 See *Cambridge Advanced Learner's Dictionary*: 'rewrite [...] to write something such as a book or speech again, in order to improve it or change it because new information is available.'
7 On this type of renarration in general see also Wilson (2008).

2020: 9–11, 243, 247). Focusing on milestones in Sámi history, Uthaug's cartooning spans millennia from prehistoric times to the twentieth century from an Indigenous perspective, with the last reported event being the foundation of *Sametinget* (*The Sámi Parliament*) in 1989.[8] Furthermore, Uthaug's history cartooning inspires detailed investigation as the following questions arise: First, what new information is available that suggests rewriting and redrawing history? Second, how are the past events rewritten and redrawn, that is, which strategies and techniques are used? And third, whose purposes will the rewriting and redrawing serve?

I take the paronomasia of the book's subtitle as a cue for how to set out on my research quest: On the one hand, there is a representation of well-known historical events, that is, the factual narrative of mainstream history. On the other hand, there is a fictional rewriting and redrawing of these events as stories. Uthaug obviously creates two layers of telling that blend into each other. Consequently, my approach will have to recognize these two intermingling aspects of narratives, too. However, before delving deeper into this matter, I'd like to make a few remarks on Maren Uthaug's drawing style, comparing it to Runar Balto's and Sámi traditional art.

A Sámi Feeling for Art and Painting: Contextualizing Uthaug's Style of Drawing with One of Balto's Cartoons

For investigating the role of Sámi cartoons in society along with the ideological messages contained as well as the psychological impact on individuals and groups cartoons can have, one needs to take a closer look at the drawing style. In one of his cartoons from the *Sápmi* comics, Runar Balto makes a statement about the Sámi fine art of painting. A Sámi artist, remotely resembling the internationally renowned Sámi painter and sculptor Iver Jåks (1932–2007), teaches one of the recurrent *Sápmi* cartoon characters, Hilmar, about the Sámi understanding and definition of art (Figure 18).

8 An undated cartoony glimpse into the Sami future on the very last page shows a Sámi woman and man in a spaceship (Uthaug 2015a).

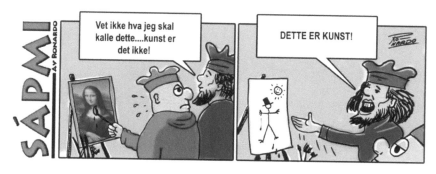

Figure 18. Balto 2017. 'Hilmar studerer kunst' (Hilmar studies art). (I don't know what to call this ... this is no art! THIS IS ART!). English translation mine. Reproduced with permission from Runar Balto.

Both characters are clearly culturally marked as they wear traditional Sámi clothes and hats. The student Hilmar produced a high-quality copy of one of the most famous paintings of the Eurowestern tradition, the Mona Lisa by Leonardo da Vinci. However, his master is not pleased with the result. Instead, he suggests that a very simple-looking drawing of a matchstick man be true art. The statement is emphasized with capital letters. At first glance, the contrast between what is collectively regarded as fine art and the master's peculiar idea of art is amusing.

An in-depth look at the cartoon, however, reveals more nuanced messages. Hilmar succeeds in copying recognized Eurowestern classical art. Seen from a Eurowestern perspective, his piece of work is not original, but worthless as Hilmar reveals himself just being one of Leonardo da Vinci's epigones. The Sámi master's remark makes clear that from a Sámi perspective as well this is not art and, therefore, is not adequate to meet the appreciation of a Sámi audience. So far, a Eurowestern and a Sámi perspective accord with each other, although for different reasons, as for a Sámi, emulating Eurowestern art is counterproductive and does not support the process of gaining cultural identity and sovereignty. Perspectives differ greatly, however, as the matchstick man which from a Eurowestern point of view might be a child's drawing seems to fulfil the requirements of Sámi art. For one, the master's statement can be read as an allusion to the fact that this seemingly simplistic and supposedly primitive drawing is original and very close

From left to right. Figures 19a–c. Manker 1950: 17, 51 and 53: human figures.
Figure 19a. Drum nr. 3 figure 15 (3:15).
Figure 19b. Drum nr. 26 figure 21 (26:21).
Figure 19c. Drum nr. 37 figure 14 (37:14).
Figure 19d. Balto 2017: Detail from Balto's cartoon. Reproduced with permission.

to the iconography found on the reindeer hides of Sámi shaman drums. For
the other, the respected Sámi artist in the cartoon defines 'correct' Sámi art
with complete authority, inflexibly following a matchstick model known
from traditional Sámi artistic expressions and restricting further Sámi art-
istic development by freezing Sámi art in the past. Despite the ambivalent
reading of this statement, there seems to be a striking similarity between
human-like figures on Sámi drums as collected by Ernst Manker and the
matchstick man in Balto's cartoon (Figures 19a–d).⁹

Rolf Christoffersson regards pictographs on Sámi shaman drums as 'den
enda autentiska samiska religionsurkunden' (the only authentic Sámi religious
document), although the drum paintings should not be mistaken for a de-
scription of Sámi beliefs as they also contain everyday items (Christoffersson
2010: 153; see also 162). Even though the cultural references of the drum paint-
ings are highly uncertain and understanding the sometimes non-naturalistic
symbolism will most likely continue to be a lot of guesswork due to lost oral
transmissions and Christianized written interpretations (Christoffersson
2010: 156–157, et passim), following Manker's reading of the three human figures
mentioned above throws an interesting light on Balto's matchstick man. While
Manker regards 3:15 (Figure 19a) as 'gewöhnlicher Mensch' (ordinary human
being), he interprets 26:21 (Figure 19b) as 'dominierende Menschenfigur', 'der
Geistliche [...] oder der Noid' (dominating human figure, the priest or noid
[i.e. the noaidi, the Sámi shaman]), and 37:14 (Figure 19c) as 'Menschenfigur',
'Geistlicher' (human figure, priest) (Manker 1950: 229, 297 and 336). Reframing

9 For more information on Sámi shaman drums see also Manker (1938).

Balto's cartoon through the drum paintings and Manker's interpretations, the *Sápmi* cartoon contains an even more decolonizing message: The matchstick man is not only an ordinary human being, a modern Sámi as expressed in highly valued contemporary Sámi art but also a dominating human being as the matchstick figure is specially marked with a headdress and a stick beneath one hand, attributes which seem to make the difference between ordinary and dominating human figures on drums.

Moreover, in Balto's cartoon, the master's exemplary painting also shows *beaivi*, the sun, who is regarded as a very powerful being by Sámi people. The sun is a recurring symbol, often placed near the centre of the oval-shaped Sámi drums (Figures 20a–c). Truly modern and new in Balto's cartoon is the smiling face of the sun. While a Eurowestern person might see a child's naïve, unelaborated drawing, to a beholder familiar with the Sámi drum paintings the allusion to *beaivi* is clear.

The shaman drums and their paintings still serve as strong Sámi cultural identifications, probably as much as the joik does. Christoffersson, however, questions Manker's interpretations of Sámi drum paintings, as Manker often describes them as simplified, naturalistic and/or stylized (Christoffersson 2010: 164 and 168). To encourage a more balanced view on Sámi drum paintings, Christoffersson asks some important questions that are implied in Balto's cartoon, too: 'Är det enkla enkelt? Är det förenklade förenklat? Vad betyder naturalism? Vad är stilisering?' (Is the simple really simple? Is the simplified really simplified? What does naturalism mean? What is stylization?) (Christoffersson 2010: 167). Christoffersson focuses on the various ways drum paintings can be interpreted. They can be seen as

From left to right. Figures 20a–b. Manker 1950: 59: various sun symbols.
Figure 20a. Drum 42 figure 1 (42:1).
Figure 20b. Drum 61 figure 18 (61:18).
Figure 20c. Balto 2017: Detail from Balto's cartoon. Reproduced with permission.

naturalistic, symbolic and/or abstract, depending on whether one emphasizes their denotative or their connotative meaning, or both. Additionally, the paintings can show the physical world as well as religious feelings about it (Christoffersson 2010: 223–224).

I suggest that reframed with the Sámi shaman drum paintings, Balto's cartoon is enriched and loaded with a far deeper meaning. Its provocative or even artivistic statement is that an adequate contemporary recognition of Sámi culture and an appropriate Sámi self-understanding are neither about merely emulating Eurowestern art nor about restricting any further development of Sámi art. Rather, contemporary Sámi artists should draw their inspiration from traditional Sámi art as, for example, the drum paintings by mingling traditional and modern ways of life. If the Sámi master in the cartoon is indeed referring to Iver Jåks, it would be an allusion to one of those artists who serve as an outstanding example of combining traditional Sami origins and modernity. As Christoffersson points out, Sámi drum paintings are not only religious symbols and documents but also individuals' expressions of their worldviews and experiences, that is, art in the proper meaning of the word (Christoffersson 2010: 187–189). Therefore, I read Balto's cartoon in a twofold way: On the one hand, it references an ordinary and funny everyday situation Sámi might find themselves in when studying fine art, maybe joking about the Sámi people's legendary exclusive interest in regional and local Sámi matters. On the other hand, it presents a rather deep and ambivalent view on decolonization and the hard process of creating a modern Sámi identity.

As we will see, Uthaug's entire drawing style is condensed to very simple matchstick figures. Her figures are reminiscent of the drawings on traditional Sámi shaman drums as well as resemble the matchstick man in Balto's cartoon. Reading Balto's cartoon as an implicit appeal to the Sámi to uphold their own artistic traditions and, while meeting their needs, creatively transfer them into their own modernity, Uthaug's history cartooning can be seen as just such a contemporary Sámi art form dealing with matters that are challenging for the Sámi. In this way, her drawing style might be a symbol of Sámi self-understanding as well as a source of identity and thus have a function similar to the one of the Sámi shaman drum.

The Sámi's Place in Historiography and as Historiographers

'Tidligere har fremmede skrevet om samene. Nå skriver samene selv Samelands og samenes historie' (In former times, foreigners wrote about the Sámi. Now Sámi themselves write the history of Sápmi and the Sámi people) (Uthaug 2015a, back cover).[10] Implicitly pointing out a deficit in mainstream historiography, this programmatic statement on the back cover of *Det var en gang en same, En nesten sann fortelling om samenes historie* (*There Once Was a Sámi, A Nearly True Story about Sámi History*) announces a new historiographic discourse. Uthaug suspends a slavish adherence to the necessity of arranging events and processes in terms of cause and effect. Instead, she emphasizes narrativity by humorously undercutting the distinction between history and story. However, historical correctness is not dissolved into mere fictionality. Throughout the book, there are easily recognizable links to recorded events.

Rewriting and Redrawing an Episode from *Heimskringla*

In a widely known episode from Snorri Sturluson's medieval historiographic Kings' Sagas compilation *Heimskringla*,[11] King Haraldr hárfagri visits his giant Finn or Sámi neighbour Svási and meets his daughter Snæfríðr.

> Þar stóð upp Snæfríðr, dóttir Svása, kvinna fríðust, ok byrlaði konungi ker fullt mjaðar, en hann tók allt saman ok hǫnd hennar, ok þegar var sem eldshiti kvæmi í hǫrund hans ok vildi þegar hafa hana á þeiri nótt. [...] [E]n konungr festi Snæfríði ok fekk ok unni svá með œrslum, at ríki sitt ok allt þat, er honum byrjaði, þá fyrir lét hann. (Snorri Sturluson and Bjarni Aðalbjarnarson 1941, 126)

> (Then Svási's daughter Snæfríðr rose, a very beautiful woman, and she poured the king a drinking vessel full of mead, and he took it altogether, also her hand, and then it was

10 There are no page numbers in the entire cartoon book.
11 *Heimskringla*: Old Norse for Latin *orbis terrarum*, i.e., globe, world.

like love and desire coming into his body and he wanted to have intercourse with her this night. [...] And the king made her his wife and got her and he was love-blind so that he neglected his kingdom and everything that befitted him.)

While the passage in *Haraldar saga hárfagra* (*The Saga of King Harald Hairfair*) implies that this mystical woman bewitched King Haraldr with mead and a love-spell causing a strong sexual desire, Uthaug provides an additional perspective (Figure 21).

The cartoon is not entirely fictional or diametrically opposed to the saga. However, in addition to a completely addicted king, Uthaug depicts a strong Sámi woman who voices her opinion about a dressed-up Norwegian aristocrat and his courting by bringing his cultural background into derision. King Haraldr is ridiculed as someone smelling of the well-known traditional Norwegian whey cheese. His kneeling position emphasizes a radical changeover of perspective, the Sámi woman clearly being the superior one.

Figure 21. Uthaug 2015a. (Back in those times, there was a very beautiful Sámi Lady named Snefrid. The Norwegian king Harald Hairfair hurried to marry her. I love you! You smell of whey cheese.). English translation mine. Reproduced with permission from Maren Uthaug.

Enrichment of Story with History and the Mise-en-scène of History

Following history chronologically, Uthaug begins in the distant past, distant and unprovoking to all alike, thereby bridging the gap between contemporary Sámi and non-Sámi readers. As the historical reliability of *Konungasögur* (Kings' Sagas) is questionable and Snorri's *Heimskringla*, of course, does not meet the requirements of present-day scholarly elaborated historiography, no one minds that the medieval king is satirized, so the audience has no reason for objection and easily gives Uthaug permission to humorously enrich history with story. Neither Sámi nor non-Sámi readers need to feel offended but are guided to share their humour. Eva Gruber states about North American First Nations' literature that 'humour in relations between Native people and non-Natives tends to play a didactic and to some extent diplomatic role' (Gruber 2008: 225). In much the same way, Uthaug implements didactic humour to educate non-Sámi readers by pointing out alternative viewpoints. At the same time, humour fulfils a diplomatic function due to the cartoon's setting in a temporal distance and within a literary work typically recognized as medieval historiography. This opens up readers' minds to new information.

Moreover, to achieve the enrichment of history with the story, Uthaug uses performative strategies. The term 'performative' implies a double meaning. On the one hand, there is the artistic process of staging information. On the other hand, there is the constitution of new ideas in the reader's mind. The underlying idea of Uthaug's art seems to be in line with the ambiguity and the ubiquitous use of the term 'performative' (see Wirth 2002: 9–10). Uwe Wirth points out John L. Austin's essential differentiation between the constative description of current states which are either true or false, and performative utterances which change current states of the social world in the act of uttering. Hence performative utterances do not describe facts but create facts (Wirth 2002: 10–11; see Austin 1962: 1–14). This does not license the creation of incorrect information but rather opens up for a new vantage point from which existing facts can be seen. In changing the perception of Sámi history

by adding fictitious elements, Uthaug creates new information and allows sociocultural facts to come to light.

Performative History Writing According to Kalle Pihlainen

Performative history writing is even more precisely defined by Finnish philosopher and historian Kalle Pihlainen, who criticizes that

> choices concerning historical narratives have depended on an either-or logic according to which truthfulness to the past prevents the historian from engaging in creative presentation since [...] this would involve her in a process of 'fictionalizing the facts'. The option of utilizing the referential dimension of historical narratives in presentations is one that is easily overlooked once the opposition of fiction to fact is adopted. The renewal of the representational form employed by historians has thus been seen as primarily a referential *or* a literary issue. (Pihlainen 2007: 4, original emphasis)[12]

As Uthaug suspends this binary logic, a closer look at Pihlainen will help to understand the unique creation of a cartoony Sámi history. According to Pihlainen, the function of historical narrative, that is, storied history, is both representative as it refers to past events, as well as performative as it is also oriented towards the 'Here and Now' and, therefore, incomplete. To Pihlainen, representation means referring to and narrating the past, while now-orientation implies no end, no closure of narration, but an ongoing and foregoing closure in the act of perceiving a piece of history writing (Philainen 2007: 6).[13] Therefore, Pihlainen proposes two functions of history writing: a reference function and a presence function. Both seem applicable to describe Uthaug's strategies. Moreover, Uthaug's art of history cartooning as a form of popular culture seems to embody a power of change and in this respect is related to the key function of artivism mentioned above.

12 The quote 'fictionalizing the facts' in this quote is from White (1978: 53).
13 For the incompleteness of history see also Pihlainen (2002) and Pihlainen (2016).

Performative History Cartooning

Some of Uthaug's cartoons refer to King Christian the Fourth of Denmark's decision from 1609 to write a letter of instruction to his deputies in Northern Norway regarding 'the Sámi problem' which consisted of a conflict of interest in fishing, herding and hunting rights between the Sámi people and Norwegian settlers. King Christian's original letter gives orders that 'de som blir funnet skyldig i å bruke trolldom, gjennom dom og straff, uten all nåde avlives' (those who are found guilty in the use of magic, will without mercy be killed with sentence and punishment) (Lilienskiold, Hagen and Sparboe 1998: 62; see also Hagen 2015, 2016). The cartoon below addresses this historical episode in a revisionist way: In emphasizing the King's greed and his attempt at bringing more people to the North who do not adhere to superstition, Uthaug provides the cartoon with an ethically motivated presence function in performing and presenting past events (Figure 22).

Men Christian den fjerde satt i Danmark og var lei av å være fattig.
Han tenkte på alle rikdommene i Sápmi, men hadde et problem.

Der er jo ikke nok folk der
oppe til å utnytte det. Og
ingen tør jo flytte opp dit
på grunn av de helvetes
samiske trolldomskunstene.

Figure 22. Uthaug 2015a. (But Christian the Fourth sat in Denmark and didn't want to be poor anymore. He thought of all the treasures in Sápmi, but he had a problem. There aren't enough people to exploit it. And nobody takes the risk of moving up there because of this diabolic Sámi magic.). English translation mine. Reproduced with permission from Maren Uthaug.

Få måneder etter at skrivet kom fram, ble tre samer brent.

Super logikk å brenne
folk i nord, fordi han
gjerne vil ha flere folk
i nord ...

Figure 23. Uthaug 2015a. (A few months after the letter arrived, three Sámi were burnt.
Super logic to burn people in the North because he would like to have more people in the
North ...). English translation mine. Reproduced with permission from Maren Uthaug.

Further intensifying the presence function, Uthaug points out the irration-
ality of the king's unreasonable decision of populating a region by depopu-
lating it (Figure 23).

By giving the burning Sámi a chance to speak, Uthaug indicates that Sámi
logical thinking even in immediate and life-threatening danger is by far wiser
and more foresightful than the King's decision-making without an urgent
need in his ironic state of presumed poverty. What is more, Uthaug rewrites
the custom of the annual Danish Sankt Hans-fire as a commemoration cere-
mony of the burning of innocent Sámi shamans (Figure 24). Thereby, the Sámi
women are stylized as culture heroines, the stories of their deaths gaining im-
portance for the annually celebrated Danish feast.

The cartoon provocatively implies that Danes have to be grateful for this
immense cultural enrichment of their Danish culture, clearly depicted as other-
wise poor. The biting humour of this cartoon matches Gruber's view on the use
of humour in First Nations' Literature: '[T]here are instances where humour
appears to be used in rather *confrontational* ways in order to vent some of the
anger and frustration that result from the injustices of colonization' (Gruber

Figure 24. Uthaug 2015a. (In about 400 years, they annually built huge bonfires in Denmark on 23 June, you know. They burn a doll resembling us and look at it while they are singing, drinking and having a great time. How funny! Super cozy!). English translation mine. Reproduced with permission from Maren Uthaug.

2008: 225, original emphasis). With the help of confrontational humour, Uthaug appeals to non-Sámi readers to change their perspective. Regarding the inner logic of this narrative episode, one might ask how the burning Sámi women can know what is going to happen in 400 years. Uthaug issues the provocative statement that the disregarded 'heathen' art of Sámi shamanism, which obviously includes foreseeing the future, eventually helps the Sámi people not only to survive but even to victoriously redefine the most terrible historical events suffered by them.

According to the historical source material, between 1601 and 1692 sixteen Sámi men, six Sámi women, nine Norwegian men and 106 Norwegian women were burnt because of King Christian's witchcraft act (Lilienskiold, Hagen and Sparboe 1998: 36, 41 and 42). Again, Uthaug references the fact that the vast majority were Norwegian women. She comments on this fact in a lapidary statement, provocatively giving present Norwegian readers the opportunity of actually stylizing themselves as being quantitatively far worse off than the Sámi: '85% av dem som ble brent var kvinner. Men overraskende få av dem var samer. Kanskje fordi den samiske noaidien som regel var en mann' (85 per cent of the burnt were women. But surprisingly few were Sámi. Maybe because the Sámi shaman usually was a man) (Uthaug 2015a). Thereby,

Uthaug offers today's readers a chance to put themselves in the position of the marginalized and oppressed. At the same time, she stages the overall ethical background of the witchcraft act as highly questionable, regardless of who the victims might be.[14] However, Uthaug seems to take advantage of recording gaps, as available source material is incomplete and no one knows how many deaths had not been recorded (Lilienskiold, Hagen and Sparboe 1998: 42). For the validity and significance of this kind of performative acts, it is important that the people who fulfil them are authorized to do so (Wirth 2002: 11). Uthaug qualifies because of her Sámi-Norwegian-Danish identity along with the unique triple perspective that comes with it.

Righting the Wrongs, Mediational Humour and Ways of Identification

Considering the fact that Uthaug's cartoons are situated within an ongoing decolonizing process, Pihlainen's following suggestion gains weight, too:

> Historical writing and interpretation continue to be important in the formation of con-
> ceptions of identities and community. This is especially so for any cultural politics [...]
> intending to offer new ways of conceptualising group identifications. To the extent that
> historical representation is involved in 'righting the wrongs of the past' it faces the same
> difficulties as all other attempts at transforming the present. [...] Producing historical
> understanding for its audience, historical representation should [...] be taken as a cul-
> tural practice that must willingly embrace its present-momentness. (Pihlainen 2007: 6)

With regard to offering new group identifications, Uthaug employs 'presentified' historical representations of key events inscribed into Sámi cultural memory as, for example, the experience of Norwegian boarding schools within the context of Sámi education and literacy. Assimilationist Norwegian boarding schools had destructive effects on Sámi language and culture (Figure 25). Sámi attending the boarding schools were exposed to

14 The statement also criticizes traditional, conservative gender roles that are problematic
 within modern Sámi communities.

Figure 25. Uthaug, 2015a. (For Norwegians, this [i.e. having a Sámi newspaper] wasn't sophisticated enough. They built boarding schools so all Sámi children could undergo a 'de-Sámification' process. Norwegian was the only language allowed at the boarding schools. Hello. Hello. Hello. [And so forth]). English translation mine. Reproduced with permission from Maren Uthaug.

multiple forms of institutional discrimination like physical, emotional and sexual violence, alienation and separation from home and family. The policy and aim of the boarding schools were to adapt the Sámi children to the dominant language and majority culture, while at the same time encouraging them to abandon their cultural identity and language. As a consequence, many Sámi who attended boarding schools experienced a mental health problem known as intergenerational trauma (Hansen 2022: 329–332).

In another cartoon, Uthaug also points out that Sámi were seen as less educated and underdeveloped despite the fact that they were organized and had installed their own newspaper *The News Teller* already in 1904 (Figure 26). At the same time, Uthaug indicates that the journalistic standard of the newspaper must seem strange to cultural outsiders, as the front page's headline says, 'The neighbour's reindeer cow has calved.'

However, the dull standards, the cultural homogenization and the meaningless repetitiveness of assimilated *sameness* instead of culturally proud *Sámi-ness* as well as the Norwegian language skills taught at the boarding schools seem to be quite as low from a Sámi perspective (Figure 25).

Vi lagde også den samiske avisen Ságai muitalægje i 1904.

Figure 26. Uthaug 2015a. (We also published the Sámi newspaper The News Teller in 1904.
'The neighbour's reindeer cow has calved'). English translation mine. Reproduced with per-
mission from Maren Uthaug.

Norwegian things do not matter to Sámi, in the same way that the fate of
some particular reindeer does not matter to Norwegians. With the help
of the underlying narrative of low standard education vice versa seen from
a Sámi and non-Sámi perspective, Uthaug enriches historical representa-
tion with storied presentation. Again, the story is involved in 'righting the
wrongs of the past'. In addition to that, Uthaug's performative method helps
to transform the present. These cartoons further mutual understanding by
implying mediational humour which Gruber analogically points out in First
Nations' literature from Canada:

> [H]umour sneaks up on readers unnoticed. It may, therefore, subvert Western epis-
> temologies and historiographic representation from within and align the readers'
> empathy and solidarity with Native viewpoints [...] allowing precarious topics to be
> addressed in a mediational and playful way that retains a basis for communication.
> (Gruber 2008: 235)

Complexity Increase by Adding Narrative Layers

Within the duality of story-history, Uthaug installs two speech positions: On the one hand, she uses a first-person narrator. In employing a collective royal 'we, the Sámi people', she offers the reader an interpersonal communication and uses a narrative means resembling the communication between performer and audience (see Pihlainen 2007: 8). On the other hand, she introduces two additional narrators, strange, anthropomorphized, time-travelling figures (Figure 27). In contrast to the first-person narrator, they further the complexity of narrative levels to alienate the reader. Provoking a change of perspective, they act as catalysts for the mainstream perception of Sámi history. All narrators have both telling and commenting functions on historical events and feelings caused by these. The above-mentioned burning of Sámi people (Figure 24) is also framed by two cartoons showing the time-travelling figures (Figures 27 and 28). The adult comforts the young one by assuring that it is only about enduring a finite number of deaths by burning (Figure 27). By announcing the seemingly exciting prospect that a comparatively cozy racist hate will replace murder, the parent cheers up the little one (Figure 28).

Så så, ikke gråt, det gjenstår bare å brenne 86 kvinner og 5 menn.

Figure 27. Uthaug 2015a. (There, there, don't cry, there are only eighty-six women and five men left to be burnt.) English translation mine. Reproduced with permission from Maren Uthaug.

The alienating function is clearly noticeable as the nature of these two creatures is entirely vague. Equipped with the fantastic ability to travel through time and talking about the Sámi as well as non-Sámi in the third person, 'dem' ('them') and 'man' ('one'), they are outside every historical discourse and at the same time compassionately affected by the events. Neither human nor animal, they fulfil an objectifying function. In addition, they challenge an underlying

Så, så, alt blir bra. I fremtiden hygger man seg
bare med å hate dem, man brenner dem ikke.

Figure 28. Uthaug 2015a. (Now, now, everything will be fine. In the future, one will be
comfortable with just hating them, one will not burn them.) English translation mine.
Reproduced with permission from Maren Uthaug.

mainstream perception as well as stereotypes of history writing, inviting the
reader with sarcastic comments to rethink their concepts. In contrast, the
first-person narrator invites the reader into an engaged dialogue and furthers
identification with a Sámi point of view. One of the strange figures also accom-
panies the exhibition of Sámi: Referring to the popular world exhibitions of
exotic creatures and new inventions in the late nineteenth and early twentieth
centuries, Uthaug introduces the reader to the Sámi as an exhibit (Figure 29).

 While the first-person narrator's statement 'we were exhibited in circuses
as well as zoos' in Figure 30 offers an opportunity of identification and – with
a shake of one's head – shocking empathy for the discriminated Sámi exhibits,

Figure 29. Uthaug 2015a. (In the big cities in Europe and America, a new exhibition trend
arose. Come look at Sámi. Wow! Wild! Incredible that people like these exist.). English
translation mine. Reproduced with permission from Maren Uthaug.

one of the time-travelling figures appears again and functions as an exhibit itself, representing and exhibiting the weirdness of the twentieth century (Figure 30). The figure is an indicator of the timeline and as such unmasks the mindset of the turn of the century as racist.

Cathrine Baglo points out that 'levende utstillinger' ('living exhibitions') of Sámi were limited to a certain period of time for which they must be considered typical: They took place and developed in Europe and America from 1822 to 1934 (with one case documented as late as 1950) as part of realistic staging of 'other' cultures and 'exotic' people, accompanied by Eurowestern ideologies of colonialism, racism and social Darwinism (Baglo 2017: 10–31, 151–156). From the 1870s, the Hamburg animal trader and zoo director Carl Hagenbeck, among others, played an important role in the exhibition and marketing of Sámi people and their reindeer, as well as the staging of other 'foreign' non-Western people and animals (Baglo 2017: 14, 45–47, 58–63, 67–73; Dreesbach 2005: 44–56 et passim). However, Uthaug emphasizes that the Sámi obviously were the smarter ones because they pretended to be not able to master any cultural techniques as well as simulated not being capable of any reasonable 'civilized' action. They concealed their knowledge, their literacy as well as their wisdom to meet the wishes of the exhibitors, showing

Vi ble utstilt i både sirkus og dyreparker.

Figure 30. Uthaug 2015a. (We were exhibited in circuses as well as zoos. Hello. Hee-haw. Flamingo. Sámi. Donkey. Elephant. Twentieth century.) English translation mine. Reproduced with permission from Maren Uthaug.

the 'primitivism' the so-called civilized people wanted to see. Actually, Sámi culture was and is as rich as any other culture, with Sámi people also being literate (Figure 31). The historical fact of Sámi earning money by serving as living exhibits is also known from the Skansen Museum in Stockholm, Sweden. Seen in the historical context of the early twentieth century, the phenomenon was one of Sámi leader and activist Elsa Laula Renberg's examples pointing out the discrepancy between a high interest in stereotyped Sámi culture and the overall politics of de-Sámification, both arising from non-Sámi people (Johansen 2015: 29–33). In the same historical context, *Lapparnas centralförbund* (Sámi Central Association), the first Sámi organization, was ironically founded at the Skansen Museum in 1904. However, regarding reference and presence function of performative history writing, Pihlainen points out that the artistically achieved 'uncertainty relates to reader's inability to appropriate the past in a satisfactory manner as well as to confusion concerning the limits of the presentation [...] with regard to what is "real" and what is not' (Pihlainen 2007: 10). These cartoons leave the reader with uncertainty. Were the Sámi really humiliated exhibits? Or were they smart businesspeople, taking advantage of a good fee for just being around in an exhibition square, cleverly playing

Figure 31. Uthaug 2015a. (People in the world were fascinated by the wild and primitive. A, B, C, D. Shush! RRROOOAR). English translation mine. Reproduced with permission from Maren Uthaug.

'the savage'? As Baglo has shown, the facets of working as living exhibits and the individual and historical contexts for the Sámi participants were very complex and ambivalent: Sámi were not only victims of injustice but also took advantage of opportunities to improve their economic situation and present Sámi culture (Baglo 2017: 224–265).

Conclusion and Coda: Broadening the Outlook

It becomes apparent that cartooning and especially history cartooning as a part of Sámi popular culture addresses the matter of Sámi identity and contributes to the ongoing process of decolonization. Due to its above-mentioned presence function, history cartooning is a form of reframing past events with humour and, thereby, renarrating them. Reframing and renarration open up new readings of events that seemed to be well known. This puts readers at unease. At the same time, rewritten and redrawn historical events offer a chance for the victims of history and colonialism to look at themselves and their history differently. It is a chance to change the prescribed, ideological historical knowledge created by dominant cultures in the service of settler colonialism.

In conclusion, I now return to the three introductory questions posed early in this chapter. In the first question, I asked what new information were available that suggests rewriting and redrawing history. In systems theory-informed counselling and constructionist therapy, reframing and renarrating past events are among the central means of dealing with any kind of experience. Psychotherapists Michael White and David Epston point out that 'a great deal of lived experience inevitably falls outside the dominant stories about the lives and relationships of persons'. However, 'those aspects [...] that fall outside of the dominant story provide a rich and fertile source for the generation, or regeneration, of alternative stories' (White and Epston 1990: 15). These seemingly irrelevant experiences offer new information that was hidden because of a dominating mainstream discourse. Every little hint that is not part of the mainstream history can function as a seed of a new history that provides an alternative perspective. Awareness of these small pieces of information suggests using

them to rewrite and redraw the dominant history. In spite of constructivism and systems theory's concepts of fluid constructed realities getting somewhere near Indigenous worldviews, they still see knowledge as individual in nature (Wilson 2008: 37–38). Indigenous Relational Accountability is more than these concepts, as Opaskwayak Cree academic Shawn Wilson states: 'Rather than viewing ourselves as being *in* relationship with other people or things, we *are* the relationships that we hold and are part of' (Wilson 2008: 80, original emphasis).[15] To come to life, therefore, the new information needs to be shared with both Indigenous and non-Indigenous people.

My second introductory question aimed at the strategies and techniques of how past events are rewritten and redrawn. Complementary to Pihlainen's claim of the importance of historical writing in offering new ways of conceptualizing group identifications, White and Epston state: 'With every performance, persons are reauthoring their lives' (White and Epston 1990: 13). By externalizing a problem, that is, putting it outside of yourself and communicating it, individuals and groups get a chance to renarrate their histories. In this way, well-founded knowledge that had previously been suppressed and rendered invisible by the mainstream knowledge of dominant cultures is made public. Uthaug uses the performative staging of historical events, installs two inner-textual speech positions, which further the complexity of narrative levels, as well as employs cartoony humour that triggers uncertainty in readers. All these strategies foster reflection on history construction. What is more, they further dialogue and might lead to lively discussions between Indigenous and non-Indigenous people and, thereby, promote dialogue, reciprocity and decolonization. As Elina Helander pointed out, 'interplay between the Western and non-western paradigms' rather than 'blindly imitating the prevailing Western paradigms' (Helander and Kailo 1998: 184) is necessary to initiate profound change also within academic disciplines – which history is one of. If the Sámi concept of ofelaš (pathfinder, guide) is seen as a dimension of the Sámi noaidi (shaman), as Helander suggests, then artists, 'writers and other cultural workers' like Uthaug could be considered 'as some kind of shamans,

15 For a literary analysis and exemplification of compatibility and intersections between Shawn Wilson's Indigenous Relational Accountability and Western epistemologies like Jan Assman's cultural memory as well as philosophies by Judith Butler, Michel Foucault and postcolonial theory by Homi Bhabha see Egerer (2020b).

"pathfinders", especially if they see as their task to maintain and develop Sami culture' (Helander and Kailo 1998: 165).

This leads to my third introductory question. Of course, the rewriting and redrawing of Sámi history will suit the Sámi population in Northern European nation-states and Russia. However, as a long-term effect, Indigenous as well as non-Indigenous people will benefit from righting the wrongs of the past. In 2017, the discussion about Sámi history gained momentum in Norway as the Storting, that is, the Norwegian Parliament, accepted a petition lodged by Members of Parliament Kirsti Bergstø and Torgeir Knag Fylkesnes on a *Norwegian Truth Commission* explicitly based on the example and model of the Canadian *Truth and Reconciliation Commission* (Stortinget 2016–2017; Bergstø and Fylkesnes 2016–2017). After that, *Sannhets- og forsoningskommisjonen – kommisjonen for å granske fornorskingspolitikk og urett overfor samer, kvener og norskfinner (The Truth and Reconciliation Commission – The Commission to Investigate the Norwegianization Policy and Injustice against the Sámi, Kvens and Norwegian Finns)* officially started their work and – after a delay due to the Covid-19 pandemic – delivered their report on 1 June 2023 (Stortinget 2017–2018; Stortinget 2021; Sannhets- og forsoningskommisjonen 2023). Given this contemporary context, Uthaug's cartoony Sámi history can be understood as a topical cultural practice that serves an overall purpose of giving an account of Sámi identity as well as Sámi and non-Sámi relationships. As Pihlainen puts it, 'presentist applications of historical knowledge' can accompany 'practical results of re-descriptions of [...] the roles and positioning of oppositional and minority groups' (Pihllainen 2007: 6).

Popular culture engages with politics; it is simultaneously conditioned by history as well as a means of influencing peoples' perspectives on history and, by doing so, changing peoples' perceptions of historical events. Sámi popular culture meets Sámi artivism when it employs an art form to achieve liberating and decolonizing changes in society. The complex reciprocity of history and history cartooning paves a new way of communicating. Sámi cartoons provide a site where Norwegian history (or even Nordic histories) can be rewritten, redrawn and reworked for both individuals and communities. What is more, in drawing, distributing and reading these cartoons, they also inspire a new and alternative Norwegian (or even Nordic) future. If we consider Sámi popular culture as a whole, compared to the global outreach of the

Sámi History Cartooning

Figure 32. Balto 2017c. Runar Balto's cartoonist quotation of Edvard Munch's 'Skrik'
('Scream'). Reproduced with permission from Runar Balto.

initially mentioned Sámi popular music, Sámi cartoons are strongly bound
to local events and politics in Sápmi. Although Uthaug's cartoons exist in a
Norwegian version and are translated into the Sámi languages, the language
barrier for understanding the jokes is high and pictures are not as accessible
as music for successfully bridging the gap of understanding. Rare captionless
cartoons, of course, have the prerequisite for global accessibility as, for ex-
ample, Runar Balto's quotation of Edvard Munch's (1863–1944) very famous
expressionist painting 'Skrik' ('Scream') from 1893 (Munch 1893) (Figure 32).
 Nasjonalmuseet (The National Gallery, Oslo) refers to one of Edvard
Munch's texts in which the expressionist painter points at the depiction of
existential angst:

> Jeg gik bortover veien med to venner – så gik [...] solen ned [.] Himmelen ble pludseli
> blodi rø [...] [.] Jeg standset, lænet mig til gjæret træt til døden – over den blåsorte fjor og
> by lå blod i ildtunger [.] Mine venner gik videre og jeg sto igjen skjælvende af angest – og
> jeg følte det gik et stort uenneligt skrik gennem naturen[.] (Munch 1982: n.p.)

> (I went along the way with two friends – then [...] the sun set [.] The sky suddenly
> became blood-red [...] [.] I stopped, leaned over the railing, tired to death – over the
> blue-black fjord and the town blood was laying in tongues of fire [.] My friends went on
> and I stood trembling of angst – and I felt a great, endless scream going through nature
> [.]) (Munch 1892: n.p.)[16]

16 The critical-philological transcription provided by the digital eMunch archive has not
 been reproduced here (Munch 1892).

Again, as with Leonardo da Vinci's Mona Lisa, it is not about copying a famous Eurowestern painting. This time, the cartoonist himself 'appropriates' the Eurowestern painting and transfers its meaning to a Sámi context. Balto depicts the existential angst of a Sámi – marked as such by traditional clothing – in a kind of 'visual joik', feeling as well as representing the enormous scream in nature. There is no longer an individual dealing with his or her existential angst. There are no longer friends in the background, but people and industries exploiting Earth's resources in various ways. This, Balto's cartoon implies, is the real existential angst that affects all contemporaries, Indigenous as well as non-Indigenous, although it is often Indigenous people who time and again draw attention to the problem of exploitation, environmental justice and the crucial interdependence and reciprocity of humans and nature – as Balto does with this cartoon.

As I pointed out, in Indigenous popular culture as a whole as well as in Sámi popular culture, Sámi cartooning is only a small branch with a local and regional outreach rather than a global impact. However, if any, a common trait of Sámi cartoons is a kind of paradoxical, serious humour, always aiming at strengthening Sámi identity, Sámi sovereignty, the Sámi way of being and creating narratives that decolonize.

'We Are Mauna Kea'

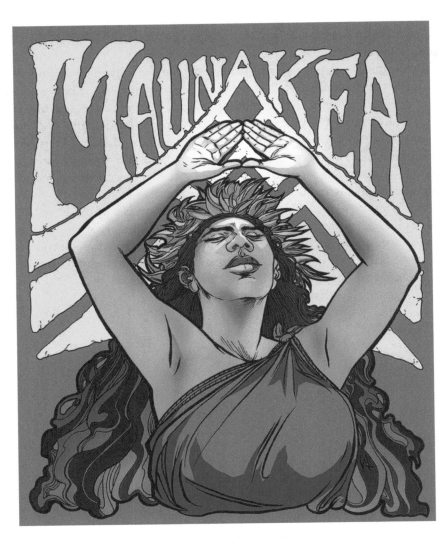

Artwork by Weshoyot Alvitre

This artwork by Tongva, Spanish and Scottish artist Weshoyot Alvitre was created in solidarity with the We Are Mauna Kea Movement. The proceeds of the artist's collaboration with The NTVS Clothing, which released a clothing line printed with the image, went towards The Aloha ʻĀina Support Fund. Reproduced with permission of the artist.

Part IV

Popular Genres and Media in IndigePop

Colby Y. Miyose

'A'ole TMT: The Use of Songs in the We Are Mauna Kea Movement

Dedicated to the memory of Donald Keala Kawaauhau Jr.

While spending my winter break in the trenches of research, on a whim of nostalgia, I turned my Pandora to the 'Classic Christmas' station and lo and behold, 'Mele Kalikimaka' ('Hawaiian Christmas Song')[1] was the first song played. I felt a sense of irony being a Native Hawaiian listening to a song that claims to be Hawaiian, all-the-while being sung by Bing Crosby – smiling, thinking that before Western contact, Christmas was not in the Hawaiian vocabulary or a part of Hawaiian culture. This song is 'hawaiian' rather than Hawaiian. It is viewed as a romanticized version of the Hawaiian Islands as opposed to a voicing of Native Hawaiian culture. As Jonathan Schroeder and Janet Borgerson argue, marketing and tourism constantly create and recreate what is considered to be 'Hawaii' discourse by selling the concept of aloha (Schroeder and Borgerson 2012: 21).[2] As Indigenous studies scholar Sarah Antinora asserts, when this type of marketing is utilized, 'predominantly white American tourists are targeted as consumers while Native Hawaiians are largely consumed' (Antinora 2017: 34). As Stephanie Nohelani Teves asserts, this is precisely how aloha got attached to the definition of Hawaiianness

1 Although it is technically a Hawaiian derived word, it was inspired and borrowed by the English 'Merry Christmas.' The Hawaiian translation of the word attempts to pronounce it as close as possible to the English pronunciation, but since the Hawaiian language does not have the letters 'r' or 's' the closest pronunciation is *Mele Kalikimaka*.

2 Keeping with the recent movement to resist making the native tongue appear foreign in writing produced in and about a native land and people, the author has decided not to italicize Hawaiian words in the text.

and Hawaiian culture, because under capitalism Kānaka Maoli are required to perform it as their worth (Teves 2018: 17). Native Hawaiian scholar and activist Haunani-Kay Trask equates the orientalization of Hawai'i and Kānka Maoli to prostitution, as she asserts that media and tourism have represented Hawaiian culture and Natives as prostitutes. She contends that 'the prostitute is a woman who sells her sexual capacities [...] the pimp is the conduit of exchange, managing the commodity that is the prostitute while acting as the guard at the entry and exit gates, making sure that the prostitutes behave' (Trask 1993: 140). Further, Native Hawaiians are fundamentally absent from any positions of power in the production of Hawaiian culture. Instead, 'the orientalization of Hawaiiana (Hawaiian culture) silences or marginalizes contemporary Native Hawaiians, and the Hawaiian Sovereignty Movement in particular, while simultaneously freezing them in a romanticized past' (Antinora 2017: 35).

While the historical appropriation and commodification of aloha have been justifiably criticized in past research, this chapter looks instead at the conditions that require Kānaka Maoli to perform aloha and how aloha can be reclaimed as a practice of their own world-making that exceeds the limits of settler colonialism. This practice is what Stephanie Nohelani Teves terms 'defiant indigeneity' (Teves 2018: 22). As Judith Butler, referencing Foucault, asserts, critique should expose the illegitimacy of hegemonic fundamental political moral order (Butler 2015: 1). To counter the Eurocentric marketing of Hawai'i,[3] the goal of this paper is to provide a textual analysis of two songs pertaining to the We Are Mauna Kea movement, a social movement that protests against building a telescope on top of Mauna O'Wākea (Mauna Kea). Lindsay Prior contends that texts and communication can be used as a source of empowerment: 'Discourse empowers certain agents to create representations, and thereby to authoritatively pronounce on the shape and form of the world' (Prior 1997: 66). 'Rise Up', by Ryan Hiraoka, featuring Keala Kawaauhau (2015), and '#WeAreMaunaKea', by Sons of Yeshua (2015), are written by Hawaiians, and speak against building on the sacred grounds of the mountain. Though

3 Although it is considered to be grammatically correct to spell it either Hawaii or
 Hawai'i, in its native language the *okina,* or glottal stop, between the two i's changes the
 pronunciation of the word. Recent efforts are being made to legally change the spelling
 to Hawai'i, so the author will use this spelling to honour the traditional way it is spelled.

multiple songs have been written surrounding this social issue, these two songs have been the most frequently played on local radio stations in Hawai'i and were the most accessible in terms of attaining lyrics and the songs themselves. Given that there are two texts a thematic approach will be utilized for analysis. Here, the content of the text is the focus. Before diving into evaluating these texts, an overview of popular Hawaiian music and its influencers will be provided, along with a brief summary of the We Are Mauna Kea movement.[4]

Hawaiian Music in Hawai'i

Outside of the Islands, the idea of 'Hawaiian music' is stereotyped as images of lei[5] wearing musicians sporting colourful floral print attire, serenading visitors to the soothing tropical vibes by the poolside. Exotic women adorned in grass skirts, as means of visual aesthetics to match the hypnotizing sounds, accompany them. Elizabeth Buck, a scholar in the cultural production of Hawaiian products, contends that the first mass production of 'Hawaiian' music recognized these stereotypes as an attractive lure for the visitor industry, all the while exoticizing Hawaiian artists as the object of the visitor's gaze and amusement:

> Tourism had constructed enduring images of Hawaiians as happy-go-lucky beach boys, friendly bus drivers, smiling lei sellers, funny entertainers, or beautiful women performing an exotic and somewhat erotic form of dance – all were part of the heavily marketed image of Hawai'i. (Buck 1993: 174)

This version of Hawaiian culture defined Hawaiians' roles in Hawai'i and strongly excluded them from attaining any other role. A cultural product that has been exported since the 1920s, these images are still a predominate

4 The We Are Mauna Kea movement is also known as the Protect Mauna Kea movement and the Aloha Mauna Kea movement. These titles will be used synonymously throughout.

5 A lei is a garland or wreath that is typically worn around the neck. Most leis are made from leaves or flowers but can also be made of numerous other materials such as fabric.

depiction of what tourists expect when they arrive to Hawai'i (Stillman 1998: 93). Though still prevalent today, this is just one type of Hawaiian music that is locally produced and consumed, and amongst local residents this category of music is the least popular.

Before Western contact, music on Hawai'i consisted of mele oli (chanting) and mele hula (chanting with traditional dancing) (Akindes 2001: 85). Since the arrival of the first travellers to the Islands, Hawaiian music has been a hybridized sound. This mixed music sees influences from a diverse range of genres such as folk, country, jazz, blues and pop. Many of the instruments used in creating Hawaiian music have been introduced by travellers and immigrants. For example, the ukulele was developed from the Portuguese four-stringed braguinha. Mexican cowboys introduced the guitar and motivated the creation of the slack-key style of guitar playing that is well connected to Hawaiian music (Akindes 2001: 87).

There are three main genres of modern Hawaiian songs. Hula ku'i only consists of Hawaiian language lyrics and is intended to be performed in conjuncture with hula (Stillman 1998: 95). Mele Hawai'i utilizes Hawaiian language that follows an alternating verse-chorus format and is inspired by the styling of Christian hymns. Lastly, Hapa-haole songs are English language songs that have lyrics about Hawai'i or some aspect of Hawaiian culture (Stillman 1998: 102). Usually utilizing a mixture of English, Hawaiian and Pidgin,[6] this type follows the thirty-two-bar song format that most American popular music employs. Most contemporary forms of Hawaiian music, though Hawaiian in its own sense, are influenced by other forms of popular music, most predominately reggae and hip-hop. Both, 'Rise Up' and '#WeAreMaunaKea' are hapa-haole variations that are influenced by, and employ, reggae and hip-hop.

Reggae has been a part of the popular music scene in Hawai'i since the 1970s. In the 1970s and 1980s, Andrew Weintraub contends, most who listened to reggae derived from three groups: Jamaicans who were temporarily stationed in Hawai'i for military service, local Hawaiian youths and university students (Weintraub 1998: 78). It was not until Bob Marley's live performance in 1980

6 Pidgin is an English-based creole language spoken in Hawai'i. Though English and Hawaiian are the official languages of the state, a majority of residents speak Pidgin in everyday conversation.

at the Waikiki Shell that reggae's popularity expanded to a wider audience. In the early 1990s, the inception of Jawaiian[7] music, a synthesis of Jamaican reggae and Hawaiian music, became a staple on local radio stations. The term was coined by local artist Bruddah Waltah, on the cassette jacket of his 1990 release, *Hawaiian Reggae*, where he defines Jawaiian as follows:

> Jawaiian (je wi' en', -way'yan), adj, 1: of pertaining to Jamaican-Hawaiian music indigenous to the Hawaiian youth of today. 2: music that makes you feel good.

Bruddah Waltah uses the term 'indigenous' to promote the idea that Jawaiian music has roots in Hawaiian culture. It has been so successful that it is currently the most popular musical style in contemporary Hawai'i (Weintraub 1998: 79).

Weintraub offers three reasons why Hawaiian Reggae is seen to be so widespread, especially amongst Hawaiian youths:

1. The popularity of reggae throughout the world, as an international style.
2. A desire for local Hawaiian musicians to share a musical style with Jamaicans because of the perceived similarities between the Hawaiian and the Jamaican people as historically oppressed populations.
3. The perceived similarities between contemporary Hawaiian and Jamaican 'island' lifestyles, attitudes and climate. (Weintraub 1998: 79)

Jawaiian music has roots in Hawaiian culture and is a means in creating community amongst Hawaiians and locals alike. It advocates for a local group identity as a way of asserting an insider-outsider dichotomy, outsider pertaining to the Mainland tourist or haole.[8] Artists like Ho'aikane and Butch Helemano call themselves Jawaiian musicians, and explicitly identify with the struggles of colonized Black people in the Caribbean (Imada 2006: 92). Jawaiian music constructs a larger collective political identity. It borrows

7 Jawaiian music can also be referred to as Hawaiian Reggae or Island Hawaiian music. These terms will be used interchangeably throughout, but will denote Jamaican Hawaiian music.

8 The term 'haole' originally translated as being a foreigner, but since the late 1880s came to be loosely used to describe white Americans.

features of Rastafarian ideals but asserts the importance of Hawaiian land and Hawaiian culture. Political messages are explicitly and widely inserted into Jawaiian song lyrics. For example, the song 'Hawaiian Lands' concerns the politically critical issues of land ownership, sovereignty and sustaining Hawaiian culture, as some of the lyrics contend their suggested solution to these social issues such as loving one another, seeing each other as kin, and cultivating and keeping the lands within the hands of Hawaiians. In the bridge of the song Waltah recites the Hawaiian motto, which is also the Hawai'i State motto, 'Ua mau ke ea o ka 'āina i ka pono [The life of the land is perpetuated in righteousness]', in a proclamation for Hawaiians to take care of the land, but for others to respect that the land is not an object.

In the mid-1990s Jawaiian music started to incorporate rap, adding another layer of complex hybridity to contemporary Hawaiian music. Hip-hop's inception as a Black expressive culture within an oppressive political history resonates globally with other cultures and peoples. Links between the displacement of Hawaiians and African Americans showcase a general bond between the two groups, as historically oppressed peoples (Osumare 2001: 172). As Stephanie Nohelani Teves argues, Native Hawaiians, like other marginalized groups in the United States,

> experience the brunt of economic tyranny, with median incomes far below state and national averages, high unemployment, a lack of educational attainment, drug abuse and an increasing risk of homelessness. All of these compromise a general quality of life. Hawaiian hip hop provides a forum in which to talk about these realities. (Teves 2011: 80)

Hawaiian musicians, particularly with their use of Black style accompanied with Hawaiian language, represent the best of the Hawaiian experience. Their raps signify a connective marginality of historical oppression (Osumare 2001: 176). Hip-hop and culture expert Halifu Osumare asserts: 'Situating their artistic approach within a Hawaiian context, rather than an appropriated imitation of mainland style, the compilation of strongly political jams is an important step, content-wise, in the hip-hop movement in the Hawaiian Islands' (Osumare 2001: 178). Hawaiian contemporary music's African American hip-hop and Jamaican reggae influences, mixed with Hawaiian chanting and subversive rapping in English and Hawaiian languages,

produces a complex multi-layering of sounds that represents the equally complex multi-layering of cultural identities of Hawaiian artists.

Before contact with the West in 1778, an estimated one million Native Hawaiians lived in the Hawaiian archipelago. By 1892 this number had diminished to 40,000 (Dudley and Agard 1993: 87). In 1990, there were a mere 8,244 full-blooded Native Hawaiians left, 992,000 less people than before Western contact, a decrease of more than 99 per cent (Dudley and Agard 1993: 88). Declining numbers of the Native Hawaiian population threaten the legacy of Hawaiian identity, culture and livelihood. This dismal history, coupled with the persistence of Western colonization in the State of Hawai'i today, has led to the creation of the Hawaiian Sovereignty Movement, a collection of land struggles, peoples' initiatives and grassroots organizations in the mid-1970s that still remains true to its cause present-day.

Hawaiian social movements have been, at their core, about protecting and energizing 'Ōiwi (Hawaiian tradition/Native) ways of life: growing and eating traditional foods, speaking the native language, renewing relationships through ceremonies and chanting, making collective decisions and simply remaining on the land that their ancestors tended (Goodyear-Ka'opua, Hussey and Wright 2014: 38). The resurgence of an authentic local Hawaiian music scene that is currently flourishing in the community is connected to the resurgence of Hawaiian cultural practices in the Hawaiian renaissance, which began in the early 1970s. On 22 March 1977, Hawaiian activist and founder of the Hawaiian Music Foundation, George Kanahele, presented an exhilarating speech about the importance of the Hawaiian Renaissance in front of a packed Rotary Club of Honolulu (Lewis 1987: 170). He exclaimed:

> Some have called it a psychological renewal, a purging of feelings of alienation and inferiority. For others it is a reassertion of self-dignity and self-importance ... What is happening among Hawaiians today is probably the most significant chapter in their modern history since the overthrow of the monarchy and loss of nationhood in 1893. For, concomitant with this cultural rebirth, is a new political awareness which is gradually being transformed into an articulate, organized but unmonolithic, movement. (qtd. in Lewis 1987: 170–171)

This cultural blossoming is strongly tied to the new developments in Hawaiian music and continues to influence Hawaiian social movements, a prime example being the We Are Mauna Kea movement, initiated in 2015.

We Are Mauna Kea

Kānaka Maoli have always been astronomers and life-long learners. The stars are seen as a form of navigation by Native Hawaiians, and most progressive Hawaiians[9] agree that education to further expand Hawaiian culture and practices is needed to peacefully adapt culture into a rapidly increasing technological society. The dormant volcano/mountain Mauna Kea is a sacred land. It is known to be the belly button of the Sky Father Wākea, one of the parents of the Hawaiian Islands. To Hawaiians, everything is related and interconnected. They believe that the environment is animate and is a part of an interconnected web of related elements (gods, land, ocean, humans, sky, animals) (Brown 2016: 158).

Hawaiians consider the ʻāina to be an entity, which works in harmony with life. Thus, ʻāina does not strictly translate to just 'land' but can also be conceptualized as 'sustenance' or 'that which feeds' (Beamer 2014: 13). This concept or belief is recognized as aloha ʻāina (love of the land) or mālama ʻāina (caring for the land). Rita Knipe, a Hawaiʻi historian, expresses that Hawaiians respect the tradition of nature's deities and inherit this mana (spirit) (Knipe 1989: 31). Hawaiians are the human form or representatives of these deities which include: ʻWākea, Papahānaumoku, Hoʻohu Kulani, Hina, Kane, Kanaloa, Lono and Pele. The sky, the earth, the stars, the moon, water, the sea, natural phenomenon as rain and steam and native plants and animals' (Knipe 1989: 31). Aloha ʻāina comes to be spiritually recognized during the course of life and death. Knipe states, 'The land is religion. It is alive, respected, treasured, praised, and even worshipped. The land is one Hawaiian, sands of our birth, and resting place for our bones. The land lives as do the spirits of our ancestors who nurtured both physical and spiritual relationships with the land' (Knipe 1989: 33). Kanahele notes that when reviewing the relationship of Mother Earth and ʻāina, if the earth is considered

9 Progressive Hawaiians are those who welcome the idea of Braiding Knowledge, taking the best from Western and Indigenous epistemology, understanding that advanced technology can help to further preserve ancient Hawaiian customs.

to be a living entity, so must be 'āina (Kanahele 1992: 185). He also states, 'Hawaiians, therefore, did not regard land as a lifeless object to be used or discarded as one would treat any ordinary material thing. As part of the great earth, land is alive – it breathes, moves, reacts, behaves, adjusts, grows, sickens, dies' (Kanahele 1992: 187).

According to Hawaiian scholar Marie Brown, in 1968, the University of Hawai'i System had promised to act as a steward for the sacred mountain, the highest point in the state standing at 4,205 m (13,796 ft) above sea level, and gained the approval to build an observatory there (Brown 2016: 160). Throughout the 1970s and 1980s, six telescopes were built, causing a swell of opposition and resistance from Native Hawaiians, sympathetic Americans and environmentalists alike. By 2014, there were thirteen telescopes on Mauna Kea, and as each were being built, concerns increased by the Hawaiian people. The peak of this frustration came to fruition with the building of the fourteenth telescope in 2015 (Brown 2016: 161). This telescope, known as the Thirty Meter Telescope (TMT), would be the largest built yet, stretching about one and a half acres wide, and standing at eighteen stories tall (Quirk 2017: 74). The $1.4 billion project has received funding from numerous private and public organizations, including the University of California System, the California Institute of Technology, the University of Hawai'i System and the Association of Canadian Universities for Research in Astronomy. The United States, Japan, India, Canada and China have all contributed government finances as well (Quirk 2017: 82).

At its inception, on the day of its groundbreaking on 7 October 2014, protests by Hawaiians as well as environmental activists began, giving birth to the We Are Mauna Kea movement. On 2 April 2015, the struggle came to a head when hundreds of protestors, keeping to the tenet of the movement to act peacefully, blocked the road to prevent the TMT contractors from preparing the TMT site. More than 30 protestors were arrested that day (Brown 2016: 161). At the peak of this conflict in 2015, Google searches for 'Mauna Kea protest' and 'We Are Mauna Kea' had 146,000 and 1,610,000 results, respectively (Brown 2016: 162). Inspired by these events, and the movement itself, 'Rise Up' and '#WeAreMaunaKea' were frequently aired on Hawai'i Reggae/Island music stations such as KWXX on the Big Island, and Island 98.5 on Oahu.

Music as Protest

Social movements are created not only as a response to conditions of oppression, injustice and inequality but also because of changing definitions of such conditions. Music can play a major role in (re)defining such circumstances. As Barbara Finlay notes, 'If one examines just the lyrics of protest songs associated with social movements, one can find many examples of diagnoses of what is wrong with the present order of things, proposed solutions to these wrongs, and rationales for participation in the movement' (Finlay 1980: 1). Thus, ideology can easily be formed in songs. Another advantage of music in social movements is its ability to build group cohesion (Lewis 1987: 170).

In order to achieve their goals, protest groups need to be well aware of the environment outside of their group and be adaptable should the situation change. To convey messages to the institutions and audiences that are not within their collectivity, specific strategies need to be adopted. These strategies are known as external tactics. As social movement rhetoricians Charles Morris and Stephen Browne contend, one way to evaluate movement rhetoric is to examine how groups develop messages to an exterior audience. Specifically, the process through which protestors negotiate their relationship with exterior audiences and opponents should be highlighted (Morris and Browne 2013: 163). The group's conveyance of messages is altered in particular ways to adapt to spectators, the context and the rhetorical situation. Morris and Browne further argue that in order for a group to be successful they 'must be closely attuned to the shifting demands of the situations they confront. They must also strategically address both those they wish to persuade and those most likely to resist their efforts' (Morris and Browne 2013: 163). Social movement groups need to be able to attempt to gain supporters, as well as counter the notions that their antagonists pose.

The success of a protest does not solely depend on the discourse used for out-groups, but also on the allegiance of their members (Morris and Browne 2013: 287). Sustaining and strengthening commitment to the movement may prove to be more challenging than communicating with external audiences. As Morris and Browne contend, 'members sometimes tire under the strain of opposition, commitments waver, other pressures intervene, conflicts arise, or

apathy sets in' (Morris and Browne 2013: 287). The pressure to form a cohesive identity may be what determines the group's success. As Morris and Browne further assert, 'the very possibility of joining a movement presupposes a sense of identity that may not initially exist' (Morris and Browne 2013: 287). The central focus on internal and external rhetoric for a critic is to evaluate how identification, or a group identity, is formed and sustained in order to keep commitment to the movement, while at the same time displaying their dis-approval and opposition to their opponents.

Identification through Moral Values and Culture

Both 'Rise Up' and '#WeAreMaunaKea' attempt to create the Burkean idea of consubstantiality, or identification, with an internal community of Hawaiians. Discourse – in this particular case, music – may be a solution to this urgency. Among the most famous lines of Kenneth Burke's work is the statement: 'You persuade a man [*sic*] only insofar as you can talk his [*sic*] language by speech, gesture, tonality, order, image, attitude, idea, identifying your ways with his [*sic*]' (Burke 1969: 55). If people were not alienated from one another, there would be no need for the researcher to examine the often times limited lines of unity that each party shares. Rhetorician James Herrick on Burke asserts that 'identification is the antidote or necessary remedy for our separation from one another' (Herrick 2017: 225–226). Communication is needed to find common meaning and ways of acting as a cohesive group, thus promoting cooperation with one another. Common core values and beliefs can overcome multiple divisions to create a sense of unity, and both songs under consideration attempt to create identification with a Hawaiian community by using a shared history and common heritage.

Thus, Native Hawaiian cultural values and language are used throughout both songs to help create a community. In order for supporters to converge on a common ground with each other, they reject the philosophy of 'White so-ciety' while identifying with Native Hawaiian culture. John Hammerback and Richard Jensen's 'Ethnic Heritage as Rhetorical Legacy: The Plan of Delano', asserts that ethnic groups often speak, write, listen, read and see in a tradition

unique to their experience and culture (Hammerback and Jensen 1994: 67).
Both Hammerback and Jensen's essay and Randall Lake's 'Enacting Red
Power: The Consummatory Function in Native American Protest Rhetoric'
suggest that when critics impose the majority's culture on a minority's dis-
course, misleading results could occur (Hammerback and Jensen 1994: 68).
Instead, the scholar should evaluate the text by the standards of that particular
group's standpoint. As Hammerback and Jenson also note, 'some rhetorical
qualities appropriate for a genre may be in opposition to qualities called for by
the broader orientation' (Hammerback and Jensen 1994: 54). Thus, a rhetor's
style of discourse should be viewed broadly to include the various structures,
content and strategies, instead of viewing the object from a singular, popular,
perspective. This approach is taken up here when evaluating 'Rise Up' and
'#WeAreMaunaKea'.

Hawaiian protest music is an ideal vessel to create identification
for the Native community by portraying Hawaiians' shared history and
common moral/cultural values. As performance studies researcher Chris
McRae states, 'music marks and is marked by identities, cultures and bodies.
Music is deployed culturally in the service of meanings and understanding,
emotions and feelings' (McRae 2015:1). Both songs resonate with Native
Hawaiian culture by conveying that there is a sacred connection between
Hawaiians and the land. For example, 'Rise Up' describes how nature is
the blood of Hawaiians, and that Mauna Kea is Hawaiian's family, be it
parental or sibling. In '#WeAreMaunaKea', the song speaks of how TMT
is uprooting an ancestor and prioritizing materialism in technology over
sacred ties to land.

There is an inherent physical and metaphorical connection to the en-
vironment portrayed here, as the artists state that the land is their lifeblood,
their relative and that they are rooted in it. Similar to how one might honour
their parents or elders, the 'āina is sacred and must be cherished. Identification
is created not only between Native Hawaiians but also between them and
all things akua and 'aumakua, relaying that everything is related and con-
nected. This point of view may be lost if the songs were evaluated from a
solely Eurocentric perspective. Reminiscent of what social movement scholars
Johanna Siméant and Christophe Traïni term the process of moralization,
both songs promote the moral values and culture of the Hawaiian people,

and their desire to keep the relationship that they have with the land intact (Siméant and Traïni 2016: 172).

Not only do both songs attempt to create a sense of Hawaiian collective identity, they also point out that this identity is related to the land. Hence, what happens to the environment and its identity is a reflection of what happens to Hawaiians. In a sense it is a metaphor for the 'Hawaiian way of life', though in a more literal sense than what most would think in the loose relationship of metaphors. As Imani Perry suggests, 'metaphor and simile engage the imagination and expand or transform the universe [...]. With them, the author creates a space of possibility' (Perry 2004: 65). There is a metaphoric parallel being displayed in these lyrics. As more things Western are built and introduced, fewer things Hawaiian survive. This can be connected to early colonialism and Hawaiians' first contact with Europe and America, as the essence of what it means to be Hawaiian slowly diminishes, as do all physical things.

Being hapa-haole Hawaiian songs, some Hawaiian is used interspersed throughout. As quoted earlier, Burke states, 'You persuade a man [*sic*] only insofar as you can talk his [*sic*] *language* by speech, gesture, tonality, order, image, attitude, idea, identifying your ways with his [*sic*]' (Burke 1969: 55). In the beginning of 'Rise Up', rapper Keala presents a prelude: 'E nā Hawai'i mai a Ni'ihau a hiki i ka moku o Keawe, 'o kēia ka manawa a kākou e kū ha'aheo, e kū no ka Mauna a Wākea.' This message is meant for those who speak the language. Using some olelo (Hawaiian language) builds a sense of identification and possibilities with each other, in that the language is connected to the culture, and those who know the language are invested in preserving the customs and the land for future generations.

Identification through Opposition

Not only does acceptance of ideas, values or culture create unity, but the common rejection of other's ideas can also create identification (Brock 1998: 187). 'Hip hop music [and protest music] celebrates Me and We, as opposed to You [...] the other is the competing MC or DJ, the challenger in a fight, or white people' (Perry 2004: 89). Termed 'conflictualization',

the creation of division between two opposing forces is established through sharing an unjust historical legacy bestowed by opponents (Siméant and Traïni 2016: 115). The idea of who is 'the other' is flipped in this situation. Instead of being the exoticized other, these songs are used to depict their antagonists as the 'morally wrong other'. As can be seen throughout parts of each song, a division between Hawaiian beliefs and Western beliefs is depicted, with Hawaiian values being morally superior to the oppressive Eurocentric notions. This is presented in the verses of each respective song.

The first verse from 'Rise Up' boldly states that politicians rather gaze at stars than deal with the increasing social issues surrounding Native Hawaiians. Terms such as 'wicked' are used to describe the politicians who want to build TMT. The second verse reverses the harsh tone describing politicians, to a tone of responsibility and encouragement for the Hawaiian people. They are described as peaceful and responsible people who care for their community. In '#WeAreMaunaKea', similar language and tone can be heard. The song describes how Hawaiians are peaceful peacekeepers of the land and community, while the government is seen as this entity that looks past Hawaiians and the local community with their goal on the stars. Both melodies display that, though they understand that non-Indigenous people want to further science, these views do not take into account Hawaiians' perspective. As the song '#WeAreMaunaKea' cheekily states 'we come in peace', it voices the opinion that the Hawaiian is viewed as 'the other' – as 'aliens' whose perspectives are not being seen, but instead being perceived as savage-like, foreign and strange. The songs frequently present the conflict between 'us' versus 'them' as historical and cultural differences.

Haunani-Kay Trask contends, 'to most Americans, then, Hawai'i is theirs: to use, to take, and above all, to fantasize about long after the experience' (Trask 1993: 136). By using strong language such as 'wicked' and 'evil' to label the opposition, and by blaming their choice to spend finances on other things instead of spending it on local social issues, these texts create an 'us against them' mindset. It presents the idea that non-Indigenous people do not understand or care for Hawaiians, so Indigenous people must protest against them in order to get their point across: 'The exaltation of the inclusive "we" in song often appears to be inseparable from the denunciation of a "they" referring to those profiting from injustice (oppressors, tyrants, etc.)' (Siméant

and Traïni 2016: 117). One might make the argument that 'evil' and 'wicked' may pertain to science versus Hawaiian culture, but that would be false, a point writer and artist Ryan Hiraoka spoke to in an interview that was conducted for a local Hawai'i news station. Hiraoka states: 'Astronomy is not evil. Nor is science for that matter … What I'm referring to as "evil" in the song is the mind set [sic] of people who put money and politics before what is right. This has happened throughout history and is what I'm calling Hawaiian people to rise up against' (Morishita 2015).

Labelling Hawaiians' beliefs and tactics as being 'peaceful' and 'responsible' displays a moral imposition on their opponents. All the while, stating that Hawaiians are defenceless while they are being confronted showcases a 'rhetoric of oppression' (Daynes 2010: 190). As Sarah Daynes argues in relation to reggae music, for example, a 'rhetoric of oppression defines the terms which govern a worldview and is rooted in the daily reality of the lives of poor people [...]. It also structures the social critique made by [...] music' (Daynes 2010: 191–192). This type of music describes the complete control of the privileged over the political, social and economic structures. The rhetoric of oppression in music argues that 'poverty is a consequence of the corruption of an elite that maintains a society based on exploitation, which therefore could be changed' (Daynes 2010: 192). This is observed in the lyrical choices of both songs.

Identification through Consciousness Raising

Identification can be garnered through conveying similar values and opposition to said values. It can also be accomplished through consciousness raising, which both songs convey in supporting the We Are Mauna Kea movement's values. According to George H. Lewis, there can be distinguished four stages of consciousness raising in protest movements. First, a level of social discontent is associated with the social conditions that the marginalized groups are facing (Lewis 1987: 172). Next, these social conditions are put into place by policies enacted by a group in power and thus can be changed when social discontent moves to social unrest – a willingness to challenge the current

political and social constructions (Lewis 1987: 172). Third, social unrest brings about proposed solutions to injustice, and new ideology is created. Lastly, this new ideology must be legitimized by group cohesion and a call to action (Lewis 1987: 172–173).

Both 'Rise Up' and '#WeAreMaunaKea' display all four steps. They both address the significant oppression that Hawaiians have faced historically, which has accumulated and led to present injustices. The aforementioned lyrics have demonstrated that the Hawaiian way of life has been silenced for years, and the Hawaiian people have been displaced from their own homes, language, heritage and land. The songs also condemn the choices of a morally corrupt power elite, describing their actions as 'evil' and 'wicked'. These melodies do not just stop at creating consubstantiality but go beyond by calling Hawaiians to action, as can be seen in their choruses. The chorus of 'Rise Up' pleads for Hawaiians to unite against those who are 'wicked', who are trying to take away the Hawaiian culture. It mentions how there is strength in numbers, and in creating a united front. In the chorus of '#WeAreMaunaKea', yet another plea is being made, again using the terms 'rise up' to inspire Native Hawaiians to fight for the land. The emphasis on a call for Hawaiians to 'rise up' in both songs suggests that inaction is also action, in that doing nothing supports building the telescope. Thus, the only action possible, as presented in these songs, is to protest against what is being done.

Using music is a more effective medium to disperse political claims because it can be more engaging than other discursive formulations (Siméant and Traïni 2016: 111). Listeners are able to understand their relation to the struggle by realizing that they are either a part of the movement or not. Those that decide to be neutral are also a part of the struggle in that they decide to be mute. These songs create a sense of consciousness raising, encouraging Hawaiians and Hawaiians-at-heart to a call to action through petitioning and peaceful protesting. The overview of historical transgressions leading up to this current struggle provokes a feeling that is harrowing and enraging, one that urgently calls for immediate action and commitment to the movement. These texts are used to spark an awakening in those who are ignorant about the wrongs that the Hawaiian people have faced. For those who already know about these woes, the songs are used as a constant reminder to keep the morale of supporters invigorated. As Siméant and Traïni contend:

> To the extent that they require the synchronization of gestures and voices, as well as shared aesthetic and repertoire, musical and choral practices form a kind of collective action [...]. The act of singing together is a clear materialisation of the determination of group members to act together in a coordinated fashion. Mobilisations for protest thus appear to be often closely linked to a tradition of ritualised performance, which use songs that symbolize a group in movement to assert the existence of a group of individuals with characteristics, desires and destiny that are all shared. (Siméant and Traïni 2016: 114)

Music as a social movement rhetorical device has the unique ability to extend an invitation to listeners to join in the 'singing' of these songs, thus encouraging them to join the movement (Siméant and Traïni 2016: 126). John Street argues that within music there is a political calling for togetherness, '[music's] politics lie as much in its collective character as in its radical lyrics and apocalyptic visions. Even without the words, the sounds are those of a collective resistance, of people making – albeit briefly – a world of their own' (Street 2013: 220). 'Rise Up' is an exemplar of this. The title in itself is an invitation to audiences from the very beginning, to not only listen but to act. As a prelude to the song, a plea for action is issued by Keala calling for all Hawaiians, from each island and beyond, to stand up for Mauna Kea. This is a bold statement, declaring that success is only possible through collective action. In listening and singing together, individuals are participating in creating a shared unity and solidarity.

Conclusion: We Are Mauna Kea Forever

In April 2015, an album titled *Sing for Mauna Kea* was released, with the goals of fundraising, spreading awareness and increasing support for the movement. Nine songs, including '#WeAreMaunaKea' and 'Rise Up', were collected in this album. Being that the thematic approach is useful for observing patterns and similarities within multiple cases, expanding the field of analysis to the other seven songs would be interesting and may help to create a more precise idea of how identification formation might help to shape a Native Hawaiian community. Regarding texts as representations of individuals and communities, using a classificatory system can be useful for qualitative

research. As Prior contends, 'for each use of the template and each revision of the score produces a new schema, and with it a new image of the world' (Prior 1997: 324). By continuing to use a thematic approach on other similar songs, one might gain a more refined understanding of how these texts are used in identity formation and identification with the Native Hawaiian cause, or one might gain an altogether different insight on the topic.

In addition, associated with the We Are Mauna Kea movement is the social media aspect. An area of expansion to this project is examining posts on Twitter or Instagram of #wearemaunakea, #protectmaunakea and #alohamaunakea. Also, photos of supporters who take selfies with the motto We Are Mauna Kea written somewhere on their body has been a trend, making for a fascinating evaluation between types of activism, treading the line between action and slacktivism, and may also elaborate on the importance of involving the body, both literally and metaphorically, in protest movements. Parasocial interaction, celebrity and fandom also play a role, with numerous celebrities who have ties to Hawai'i showing their opposition to the building of the telescope. For example, celebrities such as actor Jason Momoa, surfer Kelly Slater and singer Nicole Scherzinger have taken to social media to express their support for this cause.

As Prior also states, textual analysis can act as a starting point for other qualitative analysis (Prior 1997: 322). Evaluating these two songs has helped me to consider how music and other forms of performance, such as protest, Hawaiian chanting or hula could be methods that help to convey Native identity within the Hawaiian Sovereignty Movement. As Stephanie Nohelani Teves suggests, it is through these performances and texts that Kānka Maoli cultivate indigeneity and defy the expectations of colonialism. She notes, 'the double-binding pressures of the performance in indigeneity and how these performances are contested in the political and cultural context of Hawaiian indigeneity. [...] Defiant indigeneity is an amorphous performance that challenges settler colonialism' (Teves 2018: xiv, 11). Ethnography, using participant observation, may prove to be an experience that produces a rich understanding of Hawaiian culture. Being myself a fan of Jawaiian music, this project has reflexively generated my thoughts regarding my own connection, roots and involvement to my Hawaiian heritage, and autoethnography and performance ethnography may prove to be a productive branch-off for future ventures.

Conducting this brief analysis was captivating and fun, but also challenging. The fact that I had to listen to each song and transcribe the lyrics took some time, but also speaks to the availability of these texts. Is it by choice that these songs are not easily accessible? Should they be, if they want to reach a wider audience? Because the access to these songs is limited, how many people outside of Hawai'i are even aware of this social issue? Questions on ontology also come to mind. Perry states:

> One thing that hip hop [and other music genres] criticism should do in addition to providing interesting and informative analyses of the art form, is to use the creativity and ideology contained within the music to enrich the ways we think about society and the ways we create contemporary theory. [...] Realism encourages a critique of the media and reflects the significant realties of social inequality. (Perry 2004: 101)

How can these songs counter hegemonic, orientalizing songs such as 'Mele Kalikimaka' or 'Hawaiian Wedding Song'? How do Native Hawaiians use songs to convey their ways of understanding the world? How can particular texts be used within sovereignty movements to express identity? I think this evaluation was a pivotal launching point in understanding these questions.

Due to initial protests, the TMT project was temporarily halted by Governor David Ige on 7 April 2015. Construction was set to begin again on 24 June 2015 but was again delayed and halted by protests, resulting in eleven arrests (Associated Press 2017: n.p.). On 2 December 2015, the Supreme Court of Hawai'i invalidated TMT's building permits, ruling that the process that they went through in attaining their permit did not follow proper protocol. A revised permit was approved on 28 September 2017 by the Hawai'i Board of Land and Natural Resources, and on 30 October 2018 the Supreme Court of Hawai'i ruled 4–1 that the revised permit was acceptable and that construction on the project may proceed (Mosbergen 2018: n.p.).

Throughout the course of this debacle, protesting persists on the Mauna, and across the islands. One of the largest protests was held on 5 December 2018, when more than 200 students, faculty and staff from various campuses of the University of Hawai'i System (UH) met at the flagship campus, the University of Hawai'i at Mānoa. Their goal was to peacefully urge University of Hawai'i President David Lassner to terminate all agreements for the construction of TMT (HNN 2018). Chairpersons of numerous university departments were

present that day to voice their concerns. Prolific Indigenous studies scholar and Chair of the Political Science Department, Noelani Goodyear-Kaʻōpua, stated:

> As the university community, we should oppose research that severely compromises the work already done to build an ethical relationship between the academy and our community in Hawaiʻi, and that undermines the UH goal to become a model Indigenous-serving institution. (UH News 2018: n.p.)

Hawaiian Studies Chair, Konia Freitas, exclaimed: 'The policy and practice of UH must begin to prioritize the protection of the Mauna's natural and cultural resources, respect the protectors and Native Hawaiian cultural practitioners, and begin to heal the degradation that has already occurred' (UH News 2018: n.p.). As a Native Hawaiian scholar, who was hired in Fall 2019, as a faculty member in the Department of Communication at the University of Hawaiʻi, Hilo, my sentiments align with both Goodyear-Kaʻōpua and Freitas. Reflexively and ethically, my research is not my own but acts as another voice that advocates for the preservation and revitalization of the Hawaiian culture.

Construction was set to begin again on 15 July 2019, and again the resurgence of a core of Hawaiian activists gathered at the access road to Mauna Kea. Over 400 protestors peacefully engaged in chanting, and blocking of the access road, but due to the sheer number of participants, police officers arrested thirty-eight kupuna (mentors) and elders. Protestors camped out on the mountain and continued to block access to the summit of the mountain until December 2019, when then Big Island mayor, Harry Kim, offered a truce for both sides, stating that construction would not commence until after February 2020. On 21 July 2022, Governor David Ige, along with the Hawaiʻi State Senate and House, announced the creation of House Bill 2024, Act 255, better known as the formation of the Mauna Kea Management Stewardship and Oversight Authority. This newly formed group would strip the University of Hawaiʻi System of full stewardship authority of Mauna Kea, and instead bestow this responsibility to an eleven-member voting group (Governor's Office 2022). On 13 September 2022, along with the chairperson of the Board of Land and Natural Resources, the mayor of the County of Hawaiʻi, and the chairperson of the University of Hawaiʻi Board of Regents as ex-officio voting members, and the University of Hawaiʻi, Hilo Chancellor as an ex-officio non-voting

member, eight members were announced. These eight members range from Native Hawaiian practitioners and scholars to business and engineering experts (UH News 2022: n.p.). In the process of writing this chapter in April 2024, construction has not yet restarted. Activists and scholars alike, urge the University of Hawai'i Board of Regents to uphold the Hawaiian phrase and state motto, Ua mau ke ea o ka 'āina i ka pono, translated as 'The life of the land is perpetuated in righteousness.'[10] Indeed, this cause, and others connected to the Hawaiian Sovereignty Movement, constantly fight for the struggle over their ancestry, culture and land, all of which are related – they are one and the same. In an empathetic effort to show compassion, in 1893 a non-Hawaiian missionary wrote: 'It is to be hoped that the time will soon come when Hawaiians shall be permitted to speak of themselves in their own way' (Malo 1893: 121). Nearly 180 years later, Hawaiians are still hoping that this time will arrive.

10 Although this phrase was adopted as the state motto in 1959 when it was first established as the fiftieth State, it was conceived by King Kamehameha III as something he said when sovereignty was restored to the Kingdom of Hawai'i from the British Navy. It is this original use of the phrase that I am emphasizing, rather than the State motto, see Miyose and Grimshaw (2019: 5).

Cécile Heim

'It's Not Me': Displacing Alienness in Stephen Graham Jones's
All the Beautiful Sinners and *Not for Nothing*

I think it's just charting your own, like,
threshold for success and being happy,
really. It's just – you know, really, it's just
existing. We're not supposed to be around
anymore. We were supposed to be erased
at the 19th century, but here we are going strong.
So I think if you're just around,
then you might be a good Indian.

– Stephen Graham Jones[1]

I had started out to write a detective story ...
but I couldn't name the white man who was guilty
because all white men are guilty.

– Chester Himes[2]

Engaging with horror, gothic, speculative and crime fiction, Stephen Graham
Jones has, to date, published more than twenty-five novels, twenty-ish pieces
and collections of short fiction, co-authored six comic books and all in all
written hundreds of stories. His increasingly recognized work earned him
multiple fellowships and awards, before a first critical volume, *The Fictions*

1 Stephen Graham Jones, interview by Ari Shapiro, *Fresh Air*, NPR, 29 July 2020. Trying
 to better understand the title of Jones's novel, *The Only Good Indians*, Shapiro asked
 Jones what he thinks it means to be a good Native American. The epigraph was Jones's
 answer.
2 Chester Himes, qtd. in Reddy (2010: 140).

of Stephen Graham Jones: A Critical Companion (2016) edited by Billy
J. Stratton, appeared. Stratton is also a co-founder of the academic Stephen
Graham Jones Society which aims to draw critical attention to the quality of
Jones's work. Jones's first published novel, *The Fast Red Road* (2000) is fol-
lowed by the speculative novel taking place in Montana, *The Bird Is Gone: A
Monograph Manifesto (2003)*. Further publications include the horror story
collection *Bleed into Me: A Book of Stories (2005)*, the intelligent horror novel
Demon Theory (2006), the speculative novel *Ledfeather* (2008), the crime
novel *Seven Spanish Angels* (2011), the autobiographical novel *Growing Up
Dead in Texas (2012)*, the coming-of-age werewolf novel *Mongrels* (2016),
the coming-of-age ghost novella *Mapping the Interior (2018)* and the deeply
moving horror novel, *The Only Good Indians* (2020), to mention only a few
of his publications. In a review of the latter novel for NPR, Gabino Iglesias
writes that 'Jones is a superb storyteller who understands great writing has
to retain the same intimate quality narratives possess when they're told in
person' (Iglesias 2020: n.p.), thus underlining the intimate quality of Jones's
narrative voices. His latest novel at the time of this writing is *Don't Fear the
Reaper* (2023), which is a sequel to *My Heart is a Chainsaw* (2021). As it is
impossible to do justice to all of Jones's work in one chapter, this one focuses
on his horror detective fiction by analysing *All the Beautiful Sinners* (2011)
and *Not for Nothing* (2014) which illustrate Jones's innovative and subversive
contribution to crime fiction.

 While Jones is Blackfeet and while his ancestry and culture are vital to
his work, he underlines the importance of not being categorized exclusively
as Native American writer for two main reasons. Firstly, it seems important
to him that his work be valued for its intrinsic artistic quality rather than as
a cultural experience (Jones 2016b: xii). Secondly, Jones resists any critical
and market prescription on Native American writers in an attempt to dic-
tate and/or commodify Native American culture and identity. In *Letter to a
Just-Starting Out Indian Writer*, he explains that it is crucial to 'understand
that the market, the publishing industry, they're going to want to package
you as "exotic", as somehow foreign and alien on a continent you didn't need
anybody's help finding. Always resist this. Always displace that alienness back
onto them' (Jones 2016b: xii). Yet Jones's refusal to be categorized exclusively as
Native American author to avoid critical dismissal and stereotypical dictation
does nothing to diminish the interest of Jones's work in questions of Blackfeet

identity and culture, settler-colonial violence and racism. This is evident in *Ledfeather* (2008), *The Bird Is Gone: A ~~Monograph~~ Manifesto* (2005) or his more recent novel *The Only Good Indians* (2020). By discussing the ways in which Jones appropriates crime fiction through the subversion of motifs, the narrative perspective and jokes, this chapter aims to show how Jones 'displaces alienness' and, thus, resists and deconstructs settler-colonial prescriptions of *indian* identity and the damaging power relations at play in such prescriptions.

Jones's work is crucial in deconstructing settler-colonial stereotypes of Native Americans, which most famously include the Vanishing American narrative.[3] The violence and damage of such stereotypes cannot be overstated since they shape socio-political realities. Hence, they are a form of symbolic power the force of which Pierre Bourdieu underlines by stating that 'symbolic power is a form of reality constructing power which tends to establish an epistemological order' (Bourdieu 1991: 204).[4] Symbolic power, including stereotypes, therefore functions to establish and maintain power relations. In the case of *indian* stereotypes, they serve the genocidal attempts of the disappearing of Indigenous peoples and the legitimacy of the settler-colonial nations. Gerald Vizenor (White Earth Anishinaabe) defines the concept of *indian* as 'a misnomer, a simulation with no referent and with the absence of natives; *indians* are the other, the names of sacrifice and victimry' (Vizenor 1998: 27). He adds that the category of *indians* is 'both oppressive and a prison of false identities' (Vizenor 1998: 22). This is reinforced by Joanne Barker (Lenape) as she asserts their damaging potential:

> They [Berkhofer, Green and Vizenor] argue that the point of the 'Indian' was and is not her or his *accuracy* but her or his *utility* in constituting and perpetuating the national narrations

3 This myth describes the idea that Indigenous peoples are doomed to vanish because of their supposedly insufficient technology. It is reflected in a series of nineteenth-century American literary works such as James Fenimore Cooper's *The Last of the Mohicans* (1826). For further analyses of the many stereotypes being perpetuated in American culture in general, see Adrienne Keene's blog *Native Appropriations*. For further studies on *indian* stereotypes or white discourses on 'Indians' see Barbour (2016), Barnett (1975), Berkhofer (1979), Bird (1996), Deloria (2004), Huhndorf (2001) and Vizenor (1998).

4 My translation of: 'Le pouvoir symbolique est un pouvoir de construction de la réalité qui tend à établir un ordre *gnoséologique*', emphasis in original.

that uphold Native subjugation. It was meant to fit within the preexisting archetypes of national narrations – having been defined there to *simulate* both the legitimacy of those narratives and the supremacy of U.S. society [emphasis in original]. (Barker 2011: 29)

This simulation which Barker describes corresponds to what Jones terms 'alienness', since settler-colonial stereotypes attempt to make strangers of Indigenous peoples on their land. Jones resists this alienization by deconstructing stereotypes in his engagements with the genre of crime fiction.

Even though genre, as it is used in this chapter, is a concept from settler literary scholarship, it is a productive angle from which to read Jones's work since his writing shows a high awareness of specific genres as well as of genre as a concept. Through its potential to include and exclude simultaneously, genre creates an economy of belonging. Even at its most inclusive, genre is based on exclusionary strategies. This is why Chickasaw scholar Jodi A. Byrd connects genre's intrinsic production of exclusion to settler-colonial ideology because genre 'demands affiliation at the same time that it marks differentiation' which reveals that 'it enacts colonialist discourse at the site of imagination' (Byrd 2014: 346). The constant negotiation for affiliation while stressing exclusion is not only an artistic practice but also a lived experience for Indigenous peoples. For, this generic bargaining reflects their continued existence in a settler state which continues to try to alienate them from their lands as the settler state's foundation relies on the presumption of Indigenous disappearance. Yet, through his use of genres such as crime fiction, Jones transforms genre's economy of belonging. Without undoing it, Jones unsettles genre by powerfully subverting defining characteristics of this literary practice thus re-appropriating it and the (literary) territory it generates.

As a genre, crime fiction offers insight into the political potential of genre since it controls its own territory while interrogating the policing of legality and morality in a given community. Conventionally, literary scholarship assumes that some of the earliest texts of American crime fiction are Edgar Allan Poe's Auguste Dupin stories, 'The Murders of the Rue Morgue' (1840), 'The Mystery of Marie Rogêt' (1842–1843) and 'The Purloined Letter' (1845).[5] Together, these three stories pose essential features of early crime fiction such

5 For mainstream scholarship on crime fiction, see Bertens and D'haen (2001), Knight (1980, 2010), Malmgrem (2001), Priestman (2003), Ross-Nickerson (2010), Rzepka and Horsley (2010), Scaggs (2005), Worthington (2011) and Ascari (2007).

as the sidekick-narrator, the trope of the double, the relationship between the media, the police and the detective, or the locked-room murder. The genre is, then, further expanded with the appearance of the hard-boiled detective in the United States, most famously with Dashiell Hammett's Sam Spade or Raymond Chandler's Philip Marlowe.[6] This new generation of detectives are characterized by their wise-ass comebacks, violence, social realism and moral ambiguity. This cursory history of the genre already shows how closely its development is connected to the evolution of American society, including an increased urbanization or the establishment of the police force at the time of Poe or the Great Depression and the evolution in mobility and film at the time of Hammett and Chandler. Considering the close ties of this genre with societal processes, it follows that crime fiction bears characteristics and ideology that reflects these processes. Generally speaking, then, the genre reproduces and reinforces such settler ideals as white supremacy, rigid gender roles and the glorification of tough masculinity. Simultaneously, this genre also becomes an ideal platform to resist and undermine settler values as shown by its African American or feminist innovators such as Chester Himes or Sara Paretsky.[7] Indigenous authors, including Louis Owens (Choctaw/Cherokee), Thomas King (Cherokee), Mardi Oakley Medawar (Cherokee), Louise Erdrich (Anishinaabe) and Stephen Graham Jones (Blackfeet) have also successfully taken advantage of the subversive potential of this genre, often to resist and defy settler colonialism.[8] Jones overturns the settler values by deconstructing

6 To learn more about hard-boiled crime fiction, see McCann (2000), Breu (2005) and Lewis Moore (2006).

7 For more on 'ethnic' or feminist crime fiction, see Reddy (1988, 2002), Pepper (2000), Matzke and Mühleisen (2006), Soitos (1996), Fisher-Hornung and Mueller (2003) and Christian (2001).

8 A note on terminology: I use the term *indian* as coined by Gerald Vizenor (Anishinaabe). He describes *indian* as having 'no native ancestors; the original crease of that simulation is Columbian. [...] The *indian* is a simulation, the absence of natives, the *indian* transposes the real, and the simulation of the real has no referent, memories, or native stories' (Vizenor 1998: 15). In other words, *indian* denotes the settler colonial, stereotypical construct of all Native Americans often used to justify their genocide. Wherever possible I will use the names of Indigenous nations and the term 'Native Americans' to describe Indigenous people in the United States collectively, and the term 'Indigenous' to denote Indigenous nations on all continents.

stereotypes through the anti-racist subversion of the double, by illustrating settler-colonial violence through storms, and by deconstructing the legitimacy of settler-colonial narratives through jokes in *All the Beautiful Sinners* as well as through the second-person narrative perspective of *Not for Nothing*.

Subverting Literary Devices in *All the Beautiful Sinners*

In *All the Beautiful Sinners* the displacement of alienness from the protagonist onto the readers happens through the subversion of the device of the double, the motif of storms and jokes. This novel, which was first published by Rugged Land in 2003 and republished in a revised version by Dzanc in 2011, is a dense, apocalyptic, psychological crime thriller.[9] It tells the story of Jim Doe, whose sister, Sarina, and friend, Gerry Cajas, disappeared following a tornado during his childhood. Years later, Jim is a Sheriff's Deputy who starts a manhunt across the American Southwest after his Sheriff, Tom Gentry, is shot by a man called Amos. Jim's investigation is punctuated by interferences of two FBI agents, Walter Maines and Bill McKirkle, until Jim Doe realizes, at the end of the investigation, that Amos is actually Gerry Cajas who was kidnapped with Sarina by the famous serial killer Tin Man.

On his website, *demontheory.net*, Jones writes that since this novel is his first crime thriller, he decided to 'take the genre for a ride' (Jones 20 October 2011). In her analysis of *All the Beautiful Sinners*, Cathy Covell Waegner argues that 'Jones largely inverts [the] paradigm of Natives capturing (mainly) Caucasians on the frontier, basing his plot on the systematic kidnapping of Midwestern Native children during the last two decades of the twentieth century' (Waegner 2016: 199). While he explores the possibilities of the thriller genre in this novel, he also bases it on the true fact of Joan Gay Croft's disappearance, which is a likely abduction during the Glazier-Higgins-Woodward

9 According to Jones's website, there are two different versions of *All the Beautiful Sinners*. The narrative of the first one is different from the second version, the latter being the one studied in this chapter, because Jones himself considers this second version to be the better one between the two (Jones 20 October 2011).

tornadoes of 1947.[10] This storm is classified as F5 and is considered to be one of the deadliest storms to ever have hit the United States. It is this stormy climate of disappearances that shapes the obscure and apocalyptic climate of the novel. This atmosphere, along with the device of the double and jokes, efficiently illustrate settler-colonial attitudes towards Indigenous people, which constantly exert violence against them, disenfranchise and criminalize them while attempting to dictate their identity.

Jones's innovative use of the double in *All the Beautiful Sinners* reinforces his dismantling of power relations deriving from and feeding into stereotypes. The double is a potent and widespread device in Gothic and crime fiction, as examples such as Poe's *The Purloined Letter*, Hammett's *The Maltese Falcon*, Chester Himes' Coffin Ed and Grave Digger Jones or Patricia Highsmith's *The Talented Mr Ripley* show. Its uses vary from underlining the similarity between the detective and the criminal to deconstructing the concept of identity, undermining the notion of rationality and criminality or emphasizing the effects of racist oppression in crime fiction. Ilana Shiloh explains in her book *The Double, the Labyrinth and the Locked Room: Metaphors of Paradox in Crime Fiction and Film* (2011), that the double can either result from the replication of the self (e.g. the Doppelgänger, mirror images, twins, shadows or humanoid machines) or from the splitting of the self (such as clones or split personalities) (Shiloh 2011: 5). Basing her study on psychoanalysis, Paul Ricoeur's concept of identity and deconstruction, she asserts that the double is a useful device with which to consider the concept of identity: 'Identity is an ambiguous concept, which may denote either a state of being the same as someone or something, or a state of being oneself or one thing, and not another. Identity thus conflates the notions of sameness and of difference' (Shiloh 2011: 27). To employ the device of the double in an innovative way is

10 On 9 April 1947, when the mega-storm hit Woodward, Oklahoma, Joan Gay Croft was 4 years old. Her disappearance is so uncanny because she disappeared not during the storm, but in the chaos following it: she and her sister, Geri, had taken shelter in the basement of Woodward hospital with their aunt and many other Woodward inhabitants. Even though their aunt checked on them before going to sleep herself, Geri woke up her aunt the next morning suggesting that Joan had been kidnapped by several men. She was never seen again after that. For more information on the Glazier-Higgins-Woodward storm, see Coppock (2007).

therefore to approach the concept of identity in a new way, which, in Jones's case, aims to criticize and resist settler-colonial dictation of an *indian* identity.

To lay the ground for an efficient deployment of the double, the protagonist's name – Jim Doe – indicates, at least initially, a lack of identity, since 'John Doe' is the name commonly given to an unidentified corpse. Jones explains on his website that his protagonist's name lacks the power of identification to illustrate the ways in which *indian* stereotypes dictate an imagined identity. This suggests that Jim Doe's last name, and therefore his genealogy, is, at least at first, unidentifiable which seems to hint at the very absence that *indian* stereotypes refer to. His first name is from a stereotypical description of a Native American character:

> I remembered that Tony Hillerman's young deputy, he was 'Jim Chee', right? And my attitude toward Hillerman's mysteries set in Navajo land, I don't know. I liked the stories themselves … but I also wondered if I was being tricked into some whitewashed approximation of 'Indian' too. (Jones 20 October 2011)

The name of Jim Doe is therefore important not only for the non-identity it contains, but for its referencing of *indian* stereotypes. As a consequence, Jim Doe's name is designed to be identity-less, an empty signifier, void of a personal identity and, thus, free for society to construct his identity according to their *indian* stereotypes. Put another way, Jim Doe's name serves to emphasize the dictating and damaging potential of racist stereotypes at the same time as it resists symbolic force because of its lack of signifying power.

The seemingly empty signifier of the protagonist's name reinforces Jones's use of the double. The first and most obvious deployment of the double in Jones's *All the Beautiful Sinners* is the simultaneous conflation and criminalization of Native Americans based on racist stereotypes. The double is omnipresent in this novel: Jim Doe is systematically considered to be the same person as Amos; by association Tom Gentry and Tin Man have the same structural function of the father figure to Jim Doe and Amos, respectively; and Jim Doe's sister Sarina and the high school girl Terra are said to look alike. These are only a few examples of the Doppelgänger in the novel while the narrative also contains various doubles, such as Tin Man who kidnaps children in pairs or Tom Gentry whose murder scene is doubled. However,

the most prominent Doppelgänger pair of the novel, Jim Doe and Amos, is a socially created one. For, during the first stop of Jim Doe's manhunt, he shows a picture of Amos to the counter girl asking her if she has seen him. She responds, '"This is a joke?" "It's not me", Jim Doe said. He'd had to say it in Montezuma and in Jetmore and in Bazine already' (Jones 2011: loc. 542). By repeatedly having to answer 'It's not me', Jim Doe – faithful to his name – negates an identity attributed to him through racial profiling, leaving him to define himself in negative and excluding terms only. Scenes similar to the one above are repeated several times later in the novel. Having stopped at another gas station, 'Jim Doe showed [the clerk] the flyer of the longhair. The clerk looked from it up to Jim Doe, then back again, like this was a joke and Jim Doe looked away' (Jones 2011: loc. 914). These moments of racial profiling are reinforced by Maines and McKirkle's incessant interferences and racist criminalization of Jim Doe. These instances when Jim Doe must actively deny an imposed identity illustrate how settler-colonial society perceives all Native Americans to look the same, which strips them of personal identity and conflates them into sameness.

The social prescription of Jim Doe's identity becomes ubiquitous and strong to the point where he internalizes it. In *Why Indigenous Literatures Matter*, Cherokee writer and scholar Daniel Heath Justice describes the violence of settler colonialism: 'Settler colonial hatred is powerful, too, and the horror of this kind of hate is not just in the immediate violence, which is bad enough, but in the way it seeps into your bones, how it robs you of your own sense of worth, and dignity, and even your own sense of presence' (Justice 2018: 105). This settler-colonial violence is powerfully illustrated in the scene where Jim Doe is approaching the limit of his strength and investigative capacities as he gets hit by Amos's car: 'All Jim Doe could think, his upper body flapping from the seat to the door to the steering wheel, was that he was dancing. That the tape [which belongs to Amos] stuck in the deck had finally infected him all the way, was turning him into the longhair once and for all' (Jones 2011: loc. 1349). At the very height of his despair and identitarian denial which is emphasized by his body's 'flapping' as if deprived of human agency, Jim Doe is finally ready to become Amos just as settlers keep telling him. But his transformation into Amos is depicted as a sickness catalysed by the trauma of the car accident as the Amos' tape 'infected' Jim. The violence

of stereotypes is therefore materialized in the car accident and their insidiousness in the metaphor of infection.[11]

This violence is amplified at the same time as its logic is deconstructed when Jim Doe identifies Tin Man. For, Tin Man meant to kidnap two Indigenous children. But because he was incapable of differentiating a Mexican boy (Gerry) from an Indigenous boy (Jim) and because Gerry was playing with Sarina while Jim was covered by the ruins of the house, Tin Man assumed that Gerry was Sarina's little brother and was convinced to have kidnapped two Native American children. Accordingly, Tin Man educated Gerry (who became Amos) according to his *indian* stereotypes and trained him to be a serial killer. This becomes evident when Jim identifies Tin Man in a bar and forces him to admit to it: 'Tell me you didn't make Gerry think he was Indian. Tell me you didn't – ', to which Tin Man reacts: 'He was more Indian than any of you' (Jones 2011: loc. 3069). Jones hence constructs a parallel between the violent imposition of a settler colonially defined *indian* identity and the training of a serial killer. The violence and damaging potential of stereotypes and the prescription of identity is therefore equated to the lawlessness and psychopathic violence of serial killers.

The anti-racist reading of the Jim Doe/Amos double is reinforced by *Sinners*' intertextual connections to L. Frank Baum's *The Wizard of Oz*. The references to *Oz* are obvious when Jim Doe calls his sister Dorothy, referencing *Oz*'s protagonist, after her disappearance. A further obvious connection is the serial killer's naming after the heartless Tin Man (Tin Woodman in *Oz*). While Jim uses this narrative to make sense of his sister's disappearance and to keep hoping that she will return, it also anchors *All the Beautiful Sinners* into a destructively racist context. As Unangax scholar and activist Eve Tuck and K. Wayne Yang underline, the creator of *Oz* supported the genocide of all Native Americans at the turn of the century: 'L. Frank Baum [...] famously asserted in 1890 that the safety of white settlers was only guaranteed by the "total annihilation of the few remaining Indians"' (Tuck and Yang 2012: 8). Hence, a dramatic irony is created when Jim Doe renames his sister, who does

11 African American authors and scholars have intensely explored the effects of this dictation of identity based on stereotypes. Most famously, though not exclusively, W. E. B. DuBois developed the concept of 'double-consciousness' in his *The Souls of Black Folks*, which Stephen Soitos (1996) applies to African American crime fiction.

not come home, after a protagonist who is lost and returns home and whose creator was a major advocate of the Native American genocide. Still, this dramatic irony turns into resistance when Jim manages to identify Tin Man and reverts to calling his sister Sarina.

Expanding his critique of and resistance to settler-colonial stereotypes, Jones uses apocalyptic storms to illustrate settler-colonial violence in *All the Beautiful Sinners*. Through their violence and destructiveness these deadly storms epitomize the genocidal history of Indigenous peoples. The devastating effects of these storms are portrayed in the very first chapter of the book, when Tin Man walks through a destroyed Nazareth the day of Gerry and Sarina's abduction and observes a survivor: 'Her head wobbled to the side, like maybe a neck ligament had had some trauma [...]. Her pupils were blown wide. There was blood trailing down from her right ear. He traced it with a gloved finger and she shivered, hugged herself' (Jones 2011: loc. 59). The apocalyptic feeling emerging from this passage sets the atmosphere for the rest of the novel: the survivor Tin Man has an interaction with uncannily resembles a zombie with her blown pupil, bleeding ear and hanging head. Such an introduction sets the novel into a traumatic after. In other words, it sets the novel into a time frame after something utterly destructive and extremely violent, such as an F5 storm or a genocide, has occurred. Moreover, the repeated occurrence of these storms throughout the narrative incarnates the continuous violence and/or threat of it, which equally characterizes settler colonialism. Jones's storms thus work as efficient metaphors for settler colonialism thanks to the atmosphere they create, their continuous indiscriminate destruction and violent imposition of chaos.

Beyond creating an atmosphere, however, these storms also act as narrative markers. They appear in every scene crucial to the investigation: the above-mentioned opening scene when Sarina and Gerry are abducted, the first meeting between Jim and Amos, and the following scene, which is the final shoot-out with the two FBI agents, Jim and Tin Man. In this confrontation, the scene is described in apocalyptic terms: 'It was gone, Earth. That simple [...]. And were there any Indians in Earth? [...] It was an F5. The single most destructive force on earth, spinning itself back together for one more go-round. A temporary black hole, scraping across the land' (Jones 2011: loc. 2884). The obvious play on the name of the town, Earth and the figurative language describing the tornado as a black hole across the land cements the

Indigenous Detective Fiction

reading of the novel's deadly storms as metaphors for settler colonialism which parallel settlers' genocidal policies and progressive land grabbing. This is reinforced by Justice's argument when he writes that

> Yes, Indigenous and Black folks understand apocalypse – our peoples have lived it. [...] When apocalypse appears as an overt theme in Indigenous writing, it's more than speculation – it's experiential, even in its most fantastical, because in a very real way it hasn't ended. Our nations are still subjected to the terrible traumas of colonialism. (Justice 2018: 167–168)

Thus, by acting as metaphors and narrative markers, Jones's storms reflect the brutality and actuality of settler colonialism in obvious ways. Moreover, they highlight its self-destructiveness – which is evident considering its unsustainability, exploitative character and hyper-normativity, to mention only a few of its defaults – by giving the evocative name of 'Earth' to the location destroyed by the storm.

The self-destructiveness of settler colonialism is further emphasized by Jones's use of racist jokes which exemplifies the perversity of white supremacy and completes settler colonialism's dismantling. As Vine Deloria states in *Custer Died for Your Sins*,

> One of the best ways to understand a people is to know what makes them laugh. Laughter encompasses the limits of the soul. In humor life is redefined and accepted. Irony and satire provide much keener insights into a group's collective psyche and values than do years of research. (Deloria 1969: 148)

While Jones, and Indigenous authors in general, demonstrates a great sense of humour throughout his work, the joke discussed here is pronounced by the serial killer and illustrates his racism. Jokes therefore often express a subconscious thought or purpose, which is particularly accurate in the case of racist jokes. In *All the Beautiful Sinners*, there are several jokes which reinforce the subliminal racism in the novel, often pronounced by Maines and McKirkle. But the joke that is most revealing is the one which leads to Tin Man's identification. Jim Doe mentions that people always tell him *indian* jokes at which he forces himself to laugh but which he can never remember. However, a week after Sarina's disappearance an insurance man comes to see Horace Doe, Jim's father, to offer him an insurance check of $2,200 for

the loss of their property and their daughter. After this, the insurance man tells Horace

> [a]n Indian joke, one Jim Doe would never be able to remember, just that it made his father laugh, sitting there on the couch. Made him laugh for the first time in days. The sound of his laughter spilled through the house and out into the grass, and for a moment his wife stopped sweeping, and his son stood up, and the three of them looked at each other, and started getting better. Started becoming three instead of four. (Jones 2011: loc. 965–972)

This joke, despite its underlying racism which readers discover towards the end of the novel, seems at first to be a promise of hope which allows the Native American family to start healing. Yet, the laughter works as an outlet for the sadness and despair, since it is depicted as an uncontrollable force which 'spills' beyond the physical limits of the house. This one joke therefore acts, in its first appearance, as defence mechanism against or form of emotional compensation for the family's tragedy. The perversity of this racist joke hence lies in the fact that it helps relieve – at the cost of the very people it dismisses – part of the pain which its subliminal motivation (racism) creates in the first place.

Similarly, this perverse joke also serves the ultimate undoing of settler colonialism in the novel. It does so by significantly contributing to a dismantling of settler-colonial attitudes because it leads to the identification of Tin Man: 'And through it, Jim Doe heard a voice at the counter finishing a joke, and realized he knew the punchline. It was about Indians, and horses, and how you get your name' (Jones 2011: loc. 3047). Thus, this joke, which seems to be yet another way of determining *indian* identity, simultaneously serves to uncover the most acute source of violence in the novel embodied in the serial killer called Tin Man. Moreover, Jim forces Tin Man to reveal himself by making him admit that he was mistaken about Gerry's identity. Consequently, instead of serving its social purpose of spreading settler-colonial ideology in seemingly harmless ways, this joke turns back on itself as a tool to prevent its racism from spreading further and contributes to uncovering the source of evil. While the joke itself is racist and pronounced by a white supremacist, the joke functions ironically since it undoes the very racist violence it is supposed to profess. Jones's ironic use of this joke thus echoes John Gamber's observation on Indigenous humour that

Humor, then, is not only a method of entertainment, or as Deloria asserts, a method
by which to forge political coalition or increasing political allegiance. Instead, Indian
humor is an assertion of active, vibrant Native presence and a force by which tactical
justice can be meted out in the face of anti-Indian sentiment, doctrine, and practice.
(Gamber 2011: 140–141)

This ironic use of racist jokes, along with the device of the double and the
motif of storms, undermines and deconstructs settler colonialism and emp-
ties stereotypes of their signifying power, thus displacing alienness back onto
Tin Man and, by extension, settler colonialism.

Questionable Complicity in *Not for Nothing*

Not for Nothing tells the story of Nick Bruiseman who returns to Stanton,
the small town in Texas where he grew up, after having been demoted from
homicide detective to a security guard at a storage facility. At this seemingly
low point of his life, his high school crush, Gwen Tracy, asks Nick for help
to protect her from a stalker. He reluctantly accepts and a spiral of violence
and betrayal ensues, which leads Nick into the darkest corners of small-town
life. It is a hard-boiled detective novel which is illustrated through the stock
characters of the detective and the femme fatale; the sarcastic, wise-ass tone;
the relationship between the police and the detective; and the plot struc-
ture, including red herrings and a resolution of the crime which fails to
instil a sense of security and balance but leaves a bitter and bleak aftertaste
instead. Most importantly, the narrative voice is crucial in hard-boiled de-
tective novels and invites complicity with the detective as (anti-)hero. Jones's
novel is even self-referential about its similarity to the hard-boiled novel as
exemplified by meta-literary comments of the narrator such as 'though you
don't consider yourself hardboiled, you spend the next twenty-four hours in
a bottle' (Jones 2014: 22). This level of detail emphasizes the author's aware-
ness of these genre conventions. Jones's play with this genre by questioning
the nature of the complicity between protagonist, narrator and reader while
resisting stereotypes through a second-person narrative perspective which,
ironically, fails to fully frame the identity of the protagonist.

At first glance, the narrator's tone in *Not for Nothing* appears to be one of intimacy between the narrator, Nick and the reader. The closeness is constructed, firstly, through the novel's engagement with a well-established genre. Because the reader knows before starting to read that this is a hard-boiled detective novel, they have specific expectations towards the novel and, especially, towards the detective. The novel thus prompts a familiarity which it reinforces every time it conforms to the genre. Secondly, the tone's proximity to spoken language further strengthens the sense of closeness. While written, Jones's tone retains a strong spoken character, as Iglesias also notes in the review to *All the Good Indians*. Finally, the intimacy of the narrative tone is established by the second-person narrative perspective. The ambiguous address of the 'you' that this narrative perspective creates invites a direct implication of the reader into the story. For instance, the narrator states while considering Nick's memories that 'But, still, you could drown in them, you know' (Jones 2014: 269). While the focalization is on Nick, the 'you know' has a double meaning where it can state the fact that Nick knows this statement to be true at the same time as it can refer to the linguistic tick in spoken English. The deictic reference of the 'you' is thus, occasionally, ambiguous. The novel therefore initially establishes an intimacy and complicity between the narrator, reader and protagonist.

Yet, the novel's very characteristics of conforming to genre and second-person narrative perspective which increase the novel's capacity to create complicity simultaneously also creates a distance and, even, a slight form of enmity. The genre's stereotypical expectations imposed onto the detective are also what creates an alienation by giving the impression that one knows how the detective should be instead of how they actually are. This process is therefore similar to Vizenor's concept of *indian*. That the creation of an identity based on stereotypes is an oppressive process becomes clear in *Not for Nothing*. By choosing a second-person narrator for his adaptation of the hard-boiled novel, the tone of the narrator sounds mostly prescriptive: 'You stare at it, stare at it, then say just what does she need here?' (Jones 2014: 167). Such statements often sound like orders rather than a narration producing the overall impression that the narrator denies free agency to Nick in order to make him a product of circumstance and narration rather than a potent agent.

Indigenous Detective Fiction

The reversal of the knight motif in *Not for Nothing* further emphasizes the protagonist's limited agency. In Raymond Chandler's *The Big Sleep*, one of the hard-boiled crime genre's foundational texts, the novel opens on the detective's contemplation of a stained-glass panel depicting a medieval scene. Philip Marlowe, the narrator and protagonist, observes that the panel showed

> a knight in dark armor rescuing a lady who was tied to a tree and didn't have any clothes on but some very long and convenient hair. The knight had pushed the vizor of his helmet back to be sociable, and he was fiddling with the knots on the ropes that tied the lady to the tree and not getting anywhere. I stood there and thought that if I lived in the house, I would sooner or later have to climb up there and help him. He didn't seem to be really trying. (Chandler 1988: 1)

This scene creates a continuum between the heroic figure of the knight and the contemporary hard-boiled detective. This connection is crucial as it assigns to the detective the same potential for agency, honour, heroism and power as to the medieval knight. This potential is even reinforced in *The Big Sleep* when Marlowe thinks he can perform better than the knight. This continuum is interrupted and the illusion of agency undone in *Not for Nothing*. When Nick is arrested and interrogated about Rory's, Gwen's husband, murder, he asks a police officer to call his lawyer, Arnot King, whose card reads 'Your Knight in Legal Armor' (Jones 2014: 71). In response to the card, David Garrett, the police officer, asks Nick 'This make you a – a what, then? Damsel?' (Jones 2014: 71). Not only is this remark reversing the stereotypical masculine all-powerfulness of the protagonist, but the reversal of the sexist knight motif where the detective is the passive, fragile object who needs rescuing also limits the protagonist's agency and his potential as hero. Instead of a free and powerful agent, then, this reversal of the knight motif, in addition to the narrative perspective, in *Not for Nothing* insinuates that the detective is a product of narration.

While maintaining the narrator's prescriptive tone, Jones simultaneously questions the concept of narrative authority and, thereby, defies the monolithic adherence to its promoted values. Although this second-person narrative perspective might, at first, induce the illusion of an easier empathizing with the protagonist, it simultaneously creates and maintains a constant distance between the reader, the narrator and the protagonist. In a personal interview,

Jones confirms this reading as he explains that 'to keep this distance, always the same distance, was actually the hardest part when writing' (Jones 31 January 2018). In other words, this narrative perspective serves to alienate the reader from the narration and the protagonist. This irreducible gap between reader and protagonist is especially plainly illustrated in scenes relating to Nick's personal life, such as his relationship to Gwen:

> What she gave you once, what for a long time you said had ruined you, was the picture in your mind of the delicate print her hair left against the passenger side window of her father's single-cab Ford. Because there hadn't been enough room on the driver's, with the steering wheel. It had been January. The windows had been fogged with urgency. (Jones 2014: 6)

In this scene, which is emblematic for the novel's narrative style, the sense of alienation is provoked by embedding a direct address (the narrator to Nick) into an unknown referential system (Nick's memories). Furthermore, not only is a distance maintained, but an increasing sense of intrusion is provoked by the intimacy of the scene leaving the reader in a voyeuristic position.

The impression of trespassing provoked by the second-person narrative perspective evolves into a questionable complicity as the narrative continues. When Nick faces an altercation with the murder victim's son, Dan Gates, the narrator relates:

> You close your eyes against it like that'll hide you, and, your hands balled at your sides, have to accept the real reason you let Dan Gates go at you: it wasn't because you're a good person or anything special, but because that righteous way he was feeling, you've always wanted that. (Jones 2014: 108)

If the comments on Nick's attitude and character are not read as sarcasm and proof of humility, but as contemptuous mocking and derogatory criticism of Nick, the tone becomes abusive. This is supported by the fact that the narrator is telling a hard-boiled novel, the narrator presumes – and possibly wrongly so – to know everything about Nick, since he is supposed to reincarnate the hard-boiled detective. In other words, the narrator's portrayal of Nick is based on the stereotypes of the hard-boiled genre and, consequently, dictates Nick's identity to fit the pre-existing narrative and hegemonic expectations.

Indigenous Detective Fiction

Reading contempt in the second-person narrator of *Not for Nothing* exemplifies the damaging and imprisoning power relations created by stereotypes. As Dakota historian Philip Deloria explains, 'A stereotype, we might say, is a simplified and generalized expectation [...] that comes to rest in an image, text, or utterance. It is [...] a crudely descriptive connection between power, expectation, and representation' (Deloria 2004: 9). Accordingly, the construction of and indulging in stereotypes also always includes a power relation as *Not for Nothing* demonstrates through its narrative perspective. Thus, the mindless use of stereotypes not only questions the reliability of the narrator but also denounces and criticizes the power of stereotypes to prescribe people's identity. The abuse, then, emerges not from the tone itself, but rather from the fact that the narrator abuses their narrative authority to dictate a stereotypical identity to Nick and the reader's participation in this process. In sum, the second-person narrative perspective questions and criticizes the abuse of narrative authority and the assumption of identity based on stereotypes, thus displacing the stereotypical expectations from the text back onto the readers through a questioning of the narrator's reliability and of the reader's complicity with the genre and narrator.

Through the process of alienating the reader as well as the narrator from the protagonist, Jones uses the narrative perspective ironically where the narrator's imperative tone and use of the second-person pronoun deconstructs narrative authority and reliability. The narrator's unreliability is reinforced by the discrepancy between the 'you' constructed by the narrator and the protagonist's actions. That Nick escapes the narrator's grasp is shown towards the end of the novel:

> And now your keen detective senses are telling you it's *past* time for you to steal away in a stolen truck. Try to change your name to something even less probable. Disappear until even you forget who you are, who you were, who you could have been, had things played out differently. (Jones 2014: 256)

The narrator's nihilistic take on Nick's identity is countered by Nick's actions. For, he decides to stay, see the investigation successfully through and to, finally, confirm his belonging to Stanton as he 'nod[s], keep[s] nodding, guilty as charged' (Jones 2014: 269) when someone asks him whether he is from this place. Nick and the 'you' of the narrator are therefore never quite the same. Jones's slippery use of the pronoun *you* is reminiscent of Vizenor's

comment on this pronoun: 'The native *you* is a trickster pronoun with no obvious antecedence. The *you* is the transmotion of the other, the transcendence of the *indian* as the other, the narrator, and the reader' (Vizenor 1998: 36). In this sense, the architecture of the text allows Nick to escape prescription and remain constantly elusive while the 'you' is a constant placeholder for Nick without being identical.

Instead of through narration, then, Nick's character is especially forged in dialogues. Throughout the novel, there are long sequences of dialogues, especially between Nick and David Garrett, the local police officer. It is in these moments that Nick's identity is constructed relatively independently from the narrator's influence. It is in these moments of dialogic freedom that Nick is not told how he feels and what he needs to do by the narrator and has the freedom to be whoever he is. This relation between the narration and dialogues echoes Vizenor's comment that 'Natives create their identities in "dialogical relations" with many others, with nature, and with those who must bear the *indian* simulations of dominance' (Vizenor 1998: 22). Thanks to the independence that the dialogues grant to Nick, he can escape the grasp of the dominant narrative. In other words, Nick's elusiveness allows him to evolve in constant transmotion, which Vizenor defines as 'that sense of native motion and an active presence' that is '*sui generis* sovereignty' (Vizenor 1998: 15). That Nick is not explicitly defined as Native American does not diminish his capacity for transmotion because of his capacity to escape prescription in the dialogic spaces of the novel's narration.

Writing Indigenous Presence

In his takes on crime fiction, then, Stephen Graham Jones (re-)appropriates the hard-boiled novel in *Not for Nothing* and the crime thriller in *All the Beautiful Sinners* and demonstrates the potential of Indigenous popular culture for resisting, and undermining settler colonialism. Jones does so by undoing the symbolic power of settler stereotypes through the subversion of devices, motifs and jokes in *All the Beautiful Sinners* and through the narrative perspective and the use of dialogues in *Not for Nothing*. Together, these two novels efficiently demonstrate and undermine the creation of

stereotypical identity through their detective's elusive yet present identity. Jones thus takes advantage of the popularity of this genre and uses it ironically to undo stereotypical identities and settler colonial values that this genre, at least in its earliest iterations, tends to perpetuate. What Vizenor writes of authors such as Leslie Marmon Silko (Laguna) and Louise Erdrich (Ojibwe) also applies to Jones's texts:

> These are the stories of native endurance and survivance; the stories that create a sense of presence, a native self, a teasable self in names, relations, and native contingencies, not victimry. That sense of self is a creation, an aesthetic presence; the self is not an essence, or immanence, but the mien of stories. (Vizenor 1998: 20)

In other words, in the *indian* absence created by settler colonial values and the promotion of stereotypes, Jones (re-)inscribes presence by mastering his literary craft.

Even more than writing presence, though, Jones's and Indigenous authors and artists' use of popular culture in general are also epistemological interventions which (re-)inform their audiences' knowledges and values. They question what we know, how we know it and the ways in which we express knowledges. Literature, in particular, considers our knowledge and the origins of our knowledge and values by challenging the ways in which we create meaning. We create and practice our identity by telling stories, be it the stories of how the universe came to be (physics and other natural sciences, to use settler disciplines in comparison), the stories of how our bodies function (medicine, biology, chemistry), the stories of what forces rule the world and what happens to us after life (religions and spirituality), the stories of our ideas and morality (philosophy, sociology, history, laws), the stories of our nations (history, political sciences), the stories of where we were born, what era we live in and of who we are (culture). We might physically exist without stories, but we do not live, that is, we do not have any consciousness and a sense of who we are without stories: 'The truth is that stories is all we are' (King 2001: 2), as Cherokee author Thomas King famously states. Hence, by creating and engaging with popular culture Indigenous authors and artists undermine hegemonic narratives by, in Jones's case, undermining narrative authority and reliability as well as questioning complicity. Indigenous popular culture thus creates (stories about) Indigenous pasts, presents and futures.

Kati Dlaske

Mediating Indigenous Voices: Sámi Lifestyle Blogs and the Politics of Popular Culture

Introduction

Popular media culture is infamous for circulating stereotypes of Indigenous peoples, and the media landscape in Finland is no exception. While the entertainment industry has exploited the Indigenous Sámi people as a source for tacky humour, featuring these as dirty, alcoholic men, the tourism industry upholds the image of a pristine but primitive savage. These cultural representations go hand in hand with a general ignorance on the part of the majority population about the Sámi and Sáminess and a continuous neglect of the Sámi in national policymaking. In this cultural and political climate, young Sámi people are increasingly tapping into spaces and genres of popular culture – TV comedy, rap, pop art and social media – to make their own voices heard and to take a public stand on the situation of the Sámi in Finland.

This chapter focuses on one such genre, that of personal lifestyle blogs. Combining aspects of multimodal critical discourse studies with insights from cultural and media studies (Fairclough 1992; Kress and van Leeuwen 2001; Rettberg 2014; Noppari and Hautakangas 2012) within a nexus analytical framework (Scollon and Scollon 2004; Pietikäinen 2015), the study examines how young Sámi women use personal lifestyle blogs as a resource for challenging prevailing stereotypes and ignorance about the Sámi, and for forging new dimensions of belonging. In contrast to previous research that has characterized the genre of lifestyle blogs as non-political in nature

(Rettberg 2014: 28), the study argues that in the context of Indigenous struggles for recognition and revival, lifestyle blogs can provide a resource for (identity) political participation and activism, offering possibilities that barely any other medium is capable of. At the same time, the study concludes, the availability of this niche is indicative of the prevailing social and political order that determines where the voices of young Indigenous women can be heard.

Before proceeding to the analysis and the subsequent conclusions, I will sketch a context for the investigation by discussing aspects of the contemporary situation of the Sami in Finland and introduce the data and the analytical framework of the study.

The Indigenous People of Sámi in Finland

The Sámi people are the only Indigenous people in the European Union. The domicile area of the Sámi, *Sápmi*, extends over the northern parts of Norway, Sweden and Finland and north-west Russia. Estimates of the number of Sámi people vary between 50,000 and 100,000, depending on the criteria used. Approximately 10,000 of the Sámi live within the borders of the Finnish nation state. Nowadays, over a half of the Sámi in Finland live outside the Sámi domicile area, many in the urban centres of central and southern Finland. Nevertheless, most Finns know very little about the Sámi. This general ignorance sustains stereotypes and lays the basis for a subtle but persistent structural exploitation, for instance, in the field of tourism in Lapland. In the imagery circulated by the tourism industry, the Sámi figure as pristine and primitive people living in huts and herding reindeer. In school textbooks, the presentation often follows along the same simplistic lines, with reindeer herding highlighted as the core of the Sámi way of life. In the popular media, the dominant image of the Sámi is that of a dirty, overly sexual, alcoholic man. Either way, echoing global tendencies of colonial representation, all these notions construct the Sámi as a distant 'Other' (Sano se saameksi, n.d.; Lehtola 1999, 2015; Dlaske and Jäntti 2016; Kuokkanen 2007; Pietikäinen and Leppänen 2007).

Contributing to the invisibility of the actual Sámi in society is the fact that topics relating to the Sámi have rarely been part of mainstream news media coverage. More recently, however, Sámi-related issues have surfaced in the news media landscape rather frequently. A number of these relate to government decisions that weaken the cultural-political position of the Sámi. One such was the decision to delay, once again, ratification of the ILO 169 Convention that grants Indigenous peoples the same rights and opportunities as the majority population. Another series of incidents debated in the media recently relates to the use by various Finnish public figures and institutions (the Miss World candidate, a world-famous athlete, a Finnish bag company, a tourism promotion agency) of a cheap copy of the traditional Sámi dress to represent Finland. In all of these cases, representatives of the Sámi voiced their concern over what was happening, but rather than bringing about any actual change, the critique prompted a new type of media coverage: articles reporting on 'the sore Sámi', always complaining 'for nothing' (see Näkkäläjärvi 2016). In this cultural and political climate, young Sámi people have started to tap into the spaces and genres of popular media culture to take a stand on the course of events. Among these are the lifestyle blogs of Sallamaria and Milla,[1] which will be introduced next.

Data: Two Types of Lifestyle Blogs

1. Blogs are a social media genre that has seen an exponential expansion over the past twenty years. Despite the introduction of more recent social media platforms, such as Instagram or TikTok, blogs have lost none of their popularity. Recent estimations (for the year 2023) suggest there to be over six million blogs worldwide and seven million blog posts published daily (Djuraskovic 2023). With expansion comes variation, and now there is a blog on nearly any conceivable topic. Blogs differ too in terms of their institutional context, commercial connections and degree of professionalism (Rettberg 2014; Engholm and Hansen-Hansen 2014).

1 Both names are pseudonyms.

Despite this diversity, there are features that make blogs recognizable as a genre. The posts are typically written in a personal, conversational style in the first person and are organized in reverse chronological order, which has led researchers to compare blogs to diaries. Unlike diaries, however, blogs are not private but at least to some degree public, written for others to read and comment on. Interaction, with readers commenting on the posts and the blog itself, and the author engaging in conversation with the readers, has been highlighted as a further key characteristic of blogs that also contributes to the significance of the genre in online community-building (Rettberg 2014; Chittenden 2010).

Lifestyle blogs – blogs dealing with different aspects of the blogger's personal (style of) life, and more particularly personal fashion blogs – count at the present among the most popular blog subgenres. Dealing with the personal sphere of life and with topics culturally associated with femininity (fashion, cooking, home decoration, consumption) and the readers and writers being predominantly women, lifestyle blogs form, similarly to women's magazines, (an often trivialized) feminine genre, and a gendered cultural space (Ballaster et al. 1991).

While lifestyle blogs have proliferated in the past fifteen to twenty years in Finland as elsewhere, lifestyle blogs dealing with, or even touching upon, Sáminess remain a rarity. The present study focuses on two such blogs, the richest in this respect. The two blogs have different foci: Sallamaria blogs about style and fashion, but also about her everyday life as a schoolgirl and as a Sámi person. Milla blogs about food and cooking, but discusses also her family life and current social issues, ranging from the present government to body politics. Besides the different thematic foci, the two blogs exemplify two different aspects of the lifestyle blog phenomenon (see Rocamora 2011; Noppari and Hautakangas 2012). For Sallamaria the blog embodied an identity project, which she took on in the autumn of 2013 as a 16-year-old schoolgirl living in the northernmost Finland and grew out of a few years later; she removed the blog from the blogosphere in the spring of 2016. Milla, a young woman in her 30s, lives in central Finland, in one of the largest cities in the country. Having started to blog in 2008, she became a professional blogger. For ten years, the blog served as her main outlet of expression, eventually giving way to more versatile professional activities as a writer, speaker and

event producer. Milla has been nominated for and awarded national blogger prizes, and she had a number of commercial partners. Like the lifespan of the blogs, also the topography of the postings shows a different profile: in 2013 Sallamaria published twenty-two posts, in 2014 eighteen, in 2015 six and in 2016 one post. The blog attracted 135 followers. In her blog, Milla published a posting every few days. After ten years, her blog archive included hundreds of posts and she had, according to the promotional description in the blog, 6,000 unique readers a week. Despite the differences, the blogs cohere in the discourses the bloggers deploy and the ways they relate to Sáminess. To unpack and analyse these, this study draws on the nexus analytical approach, introduced in the following section.

Analytical Framework: Inspiration from Nexus Analysis

Nexus analysis is an approach in discourse studies designed for multidimensional examination of language use as social action. First put forward by Scollon and Scollon (e.g. 2004), nexus analysis has been applied by scholars to investigate issues relating to multilingualism and multiculturalism, among other things (Hult 2010; Pietikäinen 2015; Kauppinen 2014; Dlaske 2015). The value of the nexus analytical approach for the present investigation lies precisely in its focus on *social action*, which is viewed as 'tak[ing] place at the intersection, or nexus, of three main elements': *discourses in place*, the *interaction order* and the *historical bodies* of the social actors in the action. The methodological key in nexus analysis is to select for actual analysis the aspects of these three elements that are most significant for the action in question (Scollon and Scollon 2004). While the dimension *discourses in place* refers in the Scollonian use to virtually any discursive aspect of a particular moment (see Dlaske 2015: 248), the present study focuses on actual discourses, understood here as signification practices that signify a particular part of the world from a particular perspective (Fairclough 1992; Kauppinen 2013). The dimension *interaction order* relates to 'the interactional normativities at any moment of language use' and can thus also be understood in terms of a genre (Pietikäinen 2015: 209; 2012). The notion *historical body*, in turn, emphasizes

on the one hand 'the life experiences of the individual social actors' (Scollon and Scollon 2004: 19), and on the other, their embodied existence in the world (Dlaske 2015; Scollon and Scollon 2004). Of these three elements, the present study focuses on three particular discourses in place and on the interaction order/genre of lifestyle blogs, investigating how these function as resources for challenging the prevailing stereotypes and ignorance about the Sámi, and forging new dimensions of belonging. As the blogposts examined here in many cases deal with the lives and experiences of the bloggers, the dimensions of historical body and discourses in place overlap (see Scollon and Scollon 2004). Rather than viewing the posts as windows into the lives of the bloggers (Noppari and Hautakangas 2012), they are examined here as sites of discursive signification of one's life and self. The dimension of historical body remains significant, however, in terms of the discursive and material positioning of the actors.

I have named the three discourses in the focus of the analysis as 'high' lifestyle discourse, 'low' lifestyle discourse, and 'education' discourse. The first of these signals fashion, style and other consumption-related aspects as the signifying elements of life; a discourse that also lies behind particularly the glossy women's magazines (Machin and van Leeuwen 2005; Engholm and Hansen-Hansen 2014). The low lifestyle discourse, on the other hand, deals with the more mundane, less fashionable and glamorous aspects of life, representing these nevertheless as a 'style of life' (see Giddens 1991: 81). The education discourse takes an educational approach to a particular aspect of the world. Since discourses operate as the signifying elements in interaction, in the following analysis I will examine each of the discourses in turn, discussing the interaction order and the historical bodies of the bloggers along the way.

Lifestyle Discourses: 'High' and 'Low'

Especially the early postings of Sallamaria's blog draw on the high lifestyle discourse. In her first blog post, she introduces the blog as follows: 'This blog will be mostly a lifestyle blog including among other things outfits of the day,

all kinds of chatter, daydreaming and lots of pictures.'[2] The second blog entry two days later features the mentioned 'outfit of the day', a type of photograph characteristic of fashion blogs (Noppari and Hautakangas 2012: 24), and shows Sallamaria in blue skinny jeans and a black cardigan combined with turquoise Converse shoes, a white lace top and a black leather bag. Below the image, typically of fashion and lifestyle blogs (Rettberg 2014), the caption details the brands she is wearing. She comments in the posting: 'I am just so in love with peplums, dr. denims, pearl necklaces and different shades of pastel. Together they make a nice girly outfit.'

More often than images of Sallamaria's outfits, however, the subsequent postings feature her 'favourite things' (see Chittenden 2010: 506), presenting, for example, the contents of her vanity case, her favourite beauty products of the month, her new camera and new jogging shoes, each posting mentioning the brand of the product and where this has been purchased or is available. The postings imitate similar presentations in women's magazines and, more recently, in lifestyle blogs (see Chittenden 2010; Engholm and Hansen-Hansen 2014). In Sallamaria's case, however, the seemingly obvious commercial connections are symbolic, or indexical, in that she does not get any financial reward for mentioning the brands; rather, the mentioning of the brands functions as an index of belonging, or as a means of connecting, to a particular discursive universe, that of the globalized lifestyle consumer culture.

While the high lifestyle discourse in women's magazines serves to suggest a lifestyle one could have, in blogs the same discourse becomes a resource for self-signification (Machin and van Leeuwen 2005; Noppari and Hautakangas 2012). Whereas Sallamaria's postings tapping into the high lifestyle discourse represent her life in terms of fashion, style and consumption, posts drawing on the low lifestyle discourse depict other aspects of her life. In a posting from 23 September 2013, she writes about her life as follows:

> Hello! Hrr ... It's *cold* up here! Yesterday I went with my family to the Norwegian side, to Karasjok, to watch a Sámi performance and after that around 7 pm it was only 0 degrees. The performance was really good, the actors were good and on top of that they were particularly good at joiking (joik = Sámi national anthem [sic]). Yesterday, I woke up as usual at weekends, slowly, I lay in bed and read some magazines, watched an extra

2 The quotes from the blogs are originally in Finnish.

episode of Life for a Child [a charity pop concert] and after a long time I went for a run of almost 9 kilometers. [...] Tomorrow I'm heading for a dance class to a completely new place, I'll start going to a class about 100 km away from here, we'll see what it's going to be like there. It's so cool to get to dance with an instructor again after such a long time!

On Saturday, I came back from our school trip to Pulmankijärvi, happy, but at the same time very tired. We spent from Thursday to Saturday there, and it was really so much fun! [...] They had planned an awfully big programme for the trip, we didn't manage to do even half of it, but it didn't matter. We popped into a grocery store in Nuorgam before going to Pulmankijärvi and into a small store that sells clothes and shoes, among other things. It's pretty funny, but they sell Converse shoes even this far north!

I managed to drop my iphone from a height of about one metre right onto stony asphalt, huh. Luckily, it only got one scratch, and that was on the protective cover and not on the phone itself. Amazingly enough, nothing worse happened! Pulmankijärvi was in such lovely natural surroundings and where we stayed was really good, beautiful all round about.

While the high lifestyle discourse connects to globalized consumer culture, the low lifestyle discourse draws more strongly on the local. The 'style of life' Sallamaria describes in this and other similar posts has quite a lot in common with the lifestyle of other young women in different parts of Finland (and other parts of the westernized world), such as going on school trips, lazing in bed at weekends and watching TV, going to the theatre, jogging and taking dancing lessons. However, there are also a number of features that point to Sallamaria's northern living environment and her connections to Sámi culture. In relation to the former she refers to the northern location of the theatre and to the distance she has to travel to get to the dancing class, mentions how cold it is 'here' and thinks how 'funny' it is that 'they sell Converse shoes also this far north.' In relation to the latter, she mentions that the performance was a Sámi performance and she evaluates the actors' skills in joiking, a traditional Sámi form of singing, indexing thus the close relationship of her historical body to Sámi culture. Drawing on the conventions of lifestyle blogs (e.g. Rettberg 2014), the posting is illustrated with thirteen photographs taken from the different events she describes in the post. Six of these present the 'lovely natural surroundings' at Pulmankijärvi mentioned in the blog text: the photographs feature fells, autumn colours and reindeer footprints in the sand. Photographs like this of the nearby, often recognizably northern landscape are a recurring feature in Sallamaria's blog. As such,

they echo a particular type of image typical of lifestyle blogs, namely 'images from the surroundings', which Noppari and Hautakangas (2012: 35) interpret as a further means of representing one's self and one's lifestyle. In Finnish lifestyle blogs, the surroundings, indexed through both textual description and images, are predominantly the urban milieu of Helsinki, in the south of Finland (Noppari and Hautakangas 2012: 35). In her blog, Sallamaria turns this setting upside down by depicting the open northern countryside as the site of her daily life and inserting this as part of her self into the low lifestyle discourse.

On the one hand, the posting examined above includes indexes pointing to the local, to the northern environment in which Sallamaria lives and her connections to Sámi culture. On the other hand, it bears references to the global high lifestyle discourse, related to fashion and consumption. These references include the mention of the visit to the shop selling clothes and shoes (and in particular Converse shoes) and the reference to Sallamaria's iPhone. Both the shoes and the iPhone are also featured in the images in the blog entry. This embedding of the high into the low lifestyle discourse echoes the conventions of the genre of fashion and lifestyle blogs (Noppari and Hautakangas 2012: 35–36) and it is typical of Sallamaria's postings more generally. In a posting dated 18 March 2014, for example, entitled 'Fav things in my room', Sallamaria presents readers with large images of the things she likes best in her room. One of the photographs shows a white bookshelf with pigeonholes, in which one can see arranged not books, but make-up equipment, leather bags, high heels and jewellery. Another photograph shows a rack with clothes in pastel colours and a third photo is a white wooden box filled with fashion magazines. In a short commentary below the images, she explains that 'as a shopaholic' she especially loves these items in her room. Along with this self-ascription, the images contribute to linking Sallamaria's everyday life and through this her historical body even more firmly to the high lifestyle discourse.

In Milla's blog, the high lifestyle discourse relates above all to fine dining and restaurants. In these posts, she evaluates restaurants and food-related events that she visits, not always, but sometimes, at the invitation of the owners or organizers. Thus these posts function also as a medium of content marketing. A posting from 8 October 2016 entitled 'Restaurant [name] serves the best brunch in [the name of the city]' is a typical example of these

kinds of posts and the manifestation of the high lifestyle discourse in Milla's blog. The post begins with a large, bright picture of a bottle of sparkling wine standing next to a silver cooler on a restaurant table. After this, the textual part begins as follows:

> For the last couple of years I've been suffering from serious brunch deprivation. Partly because with kids weekend mornings usually begin far earlier than any brunch, but also because there hasn't been any brunch worth bothering about in [name of the city]. [...]

In this opening passage, Milla represents herself as a person with a certain lifestyle; a person who has been used to going to brunches, but who lately has not been able to do so and is now suffering on this account. After this opening, she describes herself as a 'snob' 'when it comes to brunch', and goes on to detail what, in her opinion, brunch should be like. Through this description, she positions herself not only as a participant but also as an expert with insights into and expectations of certain standards in this aspect of lifestyle culture. While in the context of this particular post, this discursive self-positioning provides Milla with the authority to write the subsequent review of the brunch at the restaurant, in the context of her whole blog it contributes to the discursive signification of her historical body. Alternating with large, bright pictures of the staff and the food served at the restaurant, the text of the post describes and evaluates in detail each course included in the brunch, along with the atmosphere and the price level of the restaurant.

The low lifestyle discourse in Milla's blog, on the other hand, relates above all to her family life and her role as the mother of two small children. Whereas the restaurant reviews are entertaining but businesslike, the descriptions of her family life are often written with a twinkle in the eye and characterized by a norm critical twist. A post from 21 March 2015 entitled 'We're having a party!' provides an example.

> Today we celebrated the kids' birthday and now I'm going to make a shocking revelation: we didn't have any programme, theme, circus, angling, goodie bags or even artisan chocolate. Instead, we had frozen pastry, paper plates collected from all over the place, close friends and a lot of laughter and whoops of delight. I've already shared the secret of our party on the Instagram site: beautiful flowers and a colourful tablecloth – a bit like earrings, the table cloth is always the poor woman's facelift for the home.

She goes on to describe her last-minute preparations and what they ended up having on the coffee table. The visual part of the posting includes sixteen photos showing children playing and opening presents and the food served at the party. In the posts drawing on the low lifestyle discourse, Milla does not position herself as superior to others. On the contrary, she often depicts herself, like here, as less than the 'perfect' mother, who nevertheless (or, perhaps, precisely because of that) manages to be a good mother and succeeds in navigating through the ups and downs of family life.

In the postings that draw on the lifestyle discourses, Milla does not touch upon the topic of Sáminess. In one short post published on the Sámi national day in 2014, she reflects on what Sáminess means to her, summarizing this as follows: 'Family name, home, culture. A heritage that is becoming more and more important with every year. A sense of togetherness – that I come from somewhere. That I have a place and a meaning in this world.' This brief but deep reflection suggests that Sáminess forms a rather essential part of Milla's historical body. While Sallamaria represents aspects of Sámi culture as part of her everyday style of life, dismantling, in so doing, notions of Sáminess as something mystical and archaic (see below), Milla pursues similar aims by emphasizing how the Sámi are, in terms of their everyday lifestyle, 'very ordinary' people, 'most of whom already live outside the Sámi domicile area.' She herself is a case in point.

Education Discourse

While lifestyle discourses are an elementary part of the genre of lifestyle blogs, flexibility in genre convention (Rettberg 2014) gives bloggers the freedom to integrate also other kinds of discourses into the whole. The following examination focuses on what I call an education discourse, a discourse that is not an integral part of lifestyle blogs but is one that the two bloggers have chosen as an approach to the topic of Sáminess in their blogs. Sallamaria's first posting that draws on the education discourse is from 17 September 2013. Entitled 'Me and Sáminess' it begins as follows:

Hi there! I've been thinking for some time about a topic to post about, but haven't had any ideas. Now, however, with so many things to do, I've decided to come and make this posting a little bit more special, namely, to write about my Sáminess. Not all Finns even know who the Sámi are and what the Sámi language is like. In this posting, I'll talk about myself and my Sáminess.

I am Sámi on my father's side, Finnish on my mother's side. I'm very proud of my roots, although I haven't always been. At some point I was ashamed of being Sámi because my then friend and I wanted to forget the whole language. Nowadays I openly and quite soon say to new acquaintances too that I come from Lapland, I am Sámi and go to a Sámi-medium school. Usually, people can't tell that someone is a Sámi person. Sámi people don't look very different from Finns, except that Sámi are often shorter. At least in my case people have accepted the Sáminess very well, many have seen it as cool and have wanted to hear about the language straightaway. Some of my friends, on the other hand, hide their Sáminess as far as possible and many of them have also come across people who have something against the Sámi. I think it's funny that some people say the Sámi have come onto the Finns' lands when in fact it's quite the other way round.

I love the Sámi national dresses! They are just so incredibly nice and nowadays you can make them look just however you want. For women, a gákti (the so-called 'dress' of the Sámi national dress) made of dark blue baize with a red hem is the so called 'traditional choice', but nowadays one also finds gáktis made even of lace or velvet. Usually the confirmation gákti and the wedding gákti are so important that they are very well and carefully planned. I would have liked my confirmation gákti to be turquoise with a white hem, but nice turquoise baize is hard to find so I ended up with a slightly lighter shade than the traditional blue one. Personally, I'm very satisfied with my confirmation outfit! My confirmation gákti can be seen in the upper pictures.

Sáminess shows to some extent in my everyday life and also in my hobbies. I sing and play mostly in Sámi, I dance to Sámi language music, I act in Sámi and draw pictures related to Sáminess. I've been asked many times whether I feel more Sámi or Finnish. I am not more or less one or the other, but both equally. Sáminess is nevertheless a very big part of me, now and always.

As indicated in the opening paragraph of the blog post, the purpose of the text is to provide the non-Sámi readers of the blog with information about Sáminess. However, rather than offering some encyclopaedic facts about the Sámi, following the interactional conventions of lifestyle blogs, the text draws on the perspective of Sallamaria's historical body and her individual voice (Rettberg 2014) to convey experience-based insights into how it is, or feels, to

be a Sámi in contemporary Finland, a perspective to which the readers of her blog arguably can relate. Besides mediating the education discourse through these genre-specific features, Sallamaria mixes it in the posting with the two lifestyle discourses discussed above. In a similar affective tone to the one in which Sallamaria declared in an earlier post that she 'loves' Dr denims and peplum tops, expressing there her relation to the latest fashion trends, here she expresses her 'love' of Sámi dresses. While elaborating on the cultural practices related to the dress, she renders the dress a fashion item as in *haute couture*; not only carefully planned and individually made, but also adaptable to the personal taste and style of the wearer. Thus, the description not only inserts the Sámi dress into global fashion discourse but uses this discourse to convey something of its cultural meaning to the non-Sámi followers of the blog who understand fashion. The subsequent description of how Sáminess shows in Sallamaria's everyday life, on the other hand, draws on the low lifestyle discourse and provides another example of how Sallamaria depicts aspects of Sámi culture as part of her everyday lifestyle.

The comments Sallamaria receives from her readers to her posts are generally positive, as for instance, 'Very nice blog! :)', 'You're beautiful! Your blog seems very nice :)' and 'Wow, what a cute outfit! And those sneakers are lovely, I dream of those in peach :)'. Many comments of this kind are followed by the address of the commentator's own lifestyle blog and an invitation to check it out. While often downright flattering, these comments may at least partly be an effect of the interaction conventions of fashion/lifestyle blogs, which are geared towards affirmation and reciprocity (Noppari and Hautakangas 2012: 52). The comments on the postings that focus on Sáminess, on the other hand, seem to indicate genuine interest, and an emerging open relation to 'the Other.' Some of the comments on the 'Me and Sáminess' post examined above, read: 'Awesome posting! I'd be interested to hear more:--)', 'Really interesting posting, I got a whole new idea of Sáminess!' and 'Wow, incredibly interesting posting!:> You could tell more. Really I know hardly anything about the Sámi, and this really roused my interest. Cool!! :)'.

Inspired and encouraged by these comments, Sallamaria begins to post more on Sáminess; the education discourse becomes a characteristic feature of her blog, partly alternating with, partly interwoven with the lifestyle discourses. Over the following year, which is the heyday of her blog, she elaborates

in one posting on the question of how Sáminess shows in her everyday life. In another, she introduces her favourite Sámi artists and bands, talking about their background and recommending particular songs for her readers to listen to. In yet another post, she prompts her readers to send her expressions they would like to know in Sámi, creates a video in which she teaches these expressions, and uploads it on YouTube. In a posting entitled 'Jeara! Kysy! Ask! Fråga!' she writes: 'Hi there! People have been asking me a lot about living in Lapland, Sáminess and many other things, so today I decided to launch a question posting. In other words, you can ask anything related to me/my blog/ anything else!' In reply she receives twenty-seven comments full of questions ranging from her favourite food, film and book to Sámi traditions, mythology and languages. In the reply post, she divides her answers into four categories, entitled 'About me', 'School', 'Sáminess' and 'Random stuff.' Under the heading *Sáminess*, among the questions she publishes are: 'How have you learned to speak such fluent Finnish if your mother tongue is Sámi?', 'Do you also wear your national dress at other times than on festivities? When?', 'Does the north sometimes feel like too small a place to live? Would you like to move to a bigger city?' In reply, she explains that she has learned both languages at the same time and that her Finnish does not deviate in any way from the language of other Finnish young people, and that one can wear the dress basically whenever one feels like it; she admits that sometimes where she lives indeed feels too small and that she would like to live in a bigger city at some point.

Here, too, Sallamaria draws on a typical feature of lifestyle blogs, namely a 'question-and-answer-posting' aimed at giving followers of the blog the chance to get to know the blogger better (Noppari and Hautakangas 2012: 61). While the questions and answers that appear often relate to the everyday lifestyle and the blogger her/himself, as they also do here, significant here is the way Sallamaria intertwines Sáminess with other aspects of her identity and life – just as she does elsewhere in her blog. From the point of view of the interaction order, the 'question-and-answer-posting' offers her a resource she can use to make her readers engage interactively not only with the low lifestyle discourse and through this with aspects of her everyday life, but also with the education discourse and through this with aspects of Sámi culture.

While posts informing or 'educating' her readers on Sáminess become a characteristic feature of Sallamaria's blog, they do not play such a significant

part in Milla's blog in quantitative terms. Besides the short pieces mentioned above, in which she reflects on what Sáminess means to her and discusses the 'ordinariness' of the Sámi in terms of everyday life, there are two longer posts, one of which discusses the notion of cultural appropriation, the other explains 'What we are talking about when we talk about Sámi rights.' The latter post, written in December 2015, presents a numbered list of issues related to the Sámi and Sáminess that had 'caused a stir' in Finland that year and explains, point by point, 'what they mean and how they relate to each other.' Referring to the two recent cases, in which a Finnish athlete and a Miss World candidate represented Finland wearing a cheap copy of the Sámi dress and connecting these to the broader phenomenon of cultural appropriation on the one hand, and elaborating on the other on the meaning of the Sámi dress in Sámi culture by linking the post to personal testimonials of Sámi people published in a local Lapp newspaper, she tries to explain what the 'fake dress cases' are ultimately all about: not a piece of clothing, but structural exploitation of an Indigenous culture. She continues with a discussion of recent debates around land right laws and controversies about the definition of who is a Sámi person. The posting is long and detailed, a mixture of personal insight and a range of other sources, often linked to the text. Unlike many other posts in Milla's blog, the text clearly makes no attempt to be entertaining. On the ratification of the ILO 169 Convention, for instance, she writes as follows:

> The ILO (International Labour Organization) 169 Convention deals with Sámi rights and the purpose of its ratification is to guarantee Indigenous peoples the same rights and opportunities as those belonging to the majority population, and to counteract the negative effects of the policy of assimilation. Finland signed the Convention already in the 1980s, but has not yet ratified it. ILO 169 and The Convention of the Rights of Persons with Disabilities are the *only Human Rights Agreements of the United Nations* that Finland has not ratified. (Emphasis in original)

For more than six months this posting ranked as the most read post in Milla's entire blog and received sixty-nine comments (in other posts, the number of comments ranges between zero and fifty-two). While a couple of (male) commentators seek to challenge the very notion of Indigenous/Sámi rights, many more thank Milla for the informative text. Most of the comments, however, are requests to say more on certain aspects of the post, and answers to these requests. For example, one commentator wonders about the definition

of the Sámi and about the acceptance of persons on the electoral register of the Sámi Parliament as follows:

> I started to wonder about the bit on how the Supreme Administrative Court approves people for the electoral register. Is it that these [Finnish] people feel so Sámi that they want to be part of the decision-making and apparently also fulfil some other criteria since the claims went through at the Supreme Administrative Court? Can you say what could have prevented the Sámi Parliament from accepting them? I'm just trying to understand the background because these issues are not familiar to me at all and I hope I don't sound offensive.

Particularly noteworthy here are the genuine attempts of the commentator to understand the issues at hand and her discretion, indicated by the particularity of the questions and the explicit hedging '*I'm just trying to understand the background [...] I hope I don't sound offensive*.' The inquirer receives a detailed reply from Milla. Other questioners do too, but not necessarily from her; there are a number of other Sámi persons who join in the discussion, sharing their own insights and experiences. This interaction order, characterized by sharing, support and respect, is typical of lifestyle blogs (Rettberg 2014; Noppari and Hautakangas 2012). It does not, however, preclude the discussion of political topics as suggested by researchers elsewhere (Rettberg 2014: 28). Instead, it creates a space in which the political becomes personal and the personal political, and enables a new, attentive relation to 'the Other'.

Conclusions: Lifestyle Blogs and the Politics of Popular Culture

Popular culture, and lifestyle blogs as one of its recent manifestations, are often seen as a site of enjoyment, associated with 'rituals of relaxation and abandonment' (McRobbie 2004: 62; see also Rettberg 2014). The notion of the 'politics of popular culture' (Nieguth 2015; McRobbie 2004) connects the popular and cultural with the social and political and recasts popular culture as a site in which 'relations of power are made and remade' (McRobbie 2004: 262). While most of the critical inquiry into popular culture in discourse and media studies has focused on the shaping of power relations

from the top down (e.g. Machin and van Leeuwen 2005; McRobbie 2009; Kauppinen 2013; Nieguth 2015), the development of the social media has opened up genres and spaces that enable new forms of engagement from the bottom up, thus adding a new dimension to the politics of popular culture and related research (Häkkinen and Leppänen 2014; Ross and Rivers 2017). Connecting to these more recent developments and drawing inspiration from a nexus analytical approach, this study has examined how two young Indigenous Sámi women appropriate the genre of lifestyle blogs to challenge the prevailing stereotypes and ignorance about the Sámi and to forge new dimensions of belonging.

If women's magazines provide a site for consuming the high lifestyle discourse, lifestyle blogs provide a 'writing technology' (see Bröckling 2005) for embodying the discourse. Both Sallamaria and Milla signify their historical bodies by drawing on the high lifestyle discourse: Sallamaria by representing herself as 'a shopaholic' 'loving' fashion and style, Milla by writing reviews of her experiences of eating out. Positioning the authors in this way as 'ideal neoliberal consumer subjects' (Harris 2008: 492), lifestyle blogs may not seem to have much to offer to the Sámi political project of cultural decolonization (see Kuokkanen 2007). What the signification of the self through the high lifestyle discourse does, however, is to link the Sámi and Sáminess to the notions of 'trendy', 'hip' and 'cool' as opposed to the prevailing stereotypes associated with primitiveness and backwardness (Moriarty 2014). Both the high and low lifestyle discourse provide, moreover, a resource for forging links of belonging to a broader discursive community and to its individual members. While the lifestyles of both Sallamaria and Milla share a lot with those of other members of the discursive community of lifestyle bloggers and their followers, thereby emphasizing that the Sámi really are, as Milla puts it, 'very ordinary people', the way Sallamaria inserts her northern location and aspects of Sámi culture into the lifestyle discourses makes them intelligible as part of 'a style of life' as well. If the lifestyle blogs provide a medium to give the Sámi 'a new face', which is not that of a middle-aged, alcoholic man (Dlaske and Jäntti 2016) but of a young, attractive woman, they also give young Sámi women a voice. While blogs in general have been associated with hope for the increasing democratization of political participation, lifestyle blogs have not been among the most obvious candidates to realize this hope (Noppari and

Hautakangas 2012: 95; Rettberg 2014: 26–28). However, both the flexibility of the genre and its numerous subgenres enable the incorporation and mediation of a broad selection of elements; in this case, the education discourse, which both bloggers draw on to 'educate' their readers in questions relating both to Sámi life and culture and to contemporary political debates. While the putatively apolitical character of lifestyle blogs has been attributed, among other things, to their ego-centredness and the striving towards harmony among the participants (Rettberg 2014: 26–28; Noppari and Hautakangas 2012), here part of the (identity) political potential of the genre goes back to precisely these two features. As often mentioned with regard to lifestyle blogs, the continued focus on the blogger's life along with the possibility of interacting with her lead followers to feel as if they knew the blogger (e.g. Noppari and Hautakangas 2012). As Noppari and Hautakangas (2012: 60) note, the sense of being equal and of closeness in lifestyle blogs is one that the traditional print media can only dream of. Drawing on these interactional affordances on the one hand and the education discourse on the other, the two blogs examined here open up a space in which the personal and the political blend and the relationship to 'the Other' goes beyond the mere politics of representation, to reciprocal engagement.

Many of the discursive practices examined here, one might argue, fall into the realm of identity politics. Identity politics, however, are connected to broader structural issues and to 'actual' policy making (Nieguth 2015). As young Sámi activist Niillas Holmberg recently put it, 'if people know nothing about us, it is comparable to a situation in which we do not exist at all. And if we do not exist at all, it is pretty difficult for us to claim any rights either' (Mikkonen 2016). As shown above, the genre of personal lifestyle blogs offers a means of contributing to altering how the majority population understands the Sámi and Sáminess in a way that is arguably not available to any other media. In so doing, this genre provides an intriguing example of how popular social media open up spaces for political participation and activism. At the same time, however, the politics of this genre showcases the prevailing social and political order, which defines spaces where young Indigenous women's voices can be heard, thus adding yet another dimension to the politics of popular culture.

Creatorship, Fandom and Critical Practice in IndigePop

Monica Flegel and Judith Leggatt

From Speculative Fiction to Indigenous Futurism: The Decolonizing Fan Criticism of *Métis in Space*

Métis in Space/Otipêyimisiw-Iskwêwak Kihci-Kîsikohk (2014–present) by Molly Swain and Chelsea Vowel began as one of the flagship podcasts of the *Indian and Cowboy* media network and has grown to include a Land Back project. In each podcast episode, 'Molly and Chelsea, drink a bottle of (red) wine and, from a tipsy, decolonial perspective, review a sci-fi movie or television episode featuring Indigenous peoples, tropes and themes' (Swain and Vowel, 'About'). Intersectionality is at the heart of the podcast, as it is 'unapologetically Indigenous, unabashedly female & unblinkingly nerdy' (Swain and Vowel, 'About'), and Swain and Vowel critique the ways in which mainstream speculative narratives misrepresent and exclude them as Indigenous women, both in terms of cultural identity and in terms of gender.[1] They also include their own speculative fiction stories as segments in the podcast; these change from season to season. The conceit of the show, that the two hosts have come from an Indigenous-controlled future to show the way forward to 'decolonization – the non-metaphorical return of our lands and the repatriation of Indigenous laws and worldviews as guiding relationships among all living beings', demonstrates its forward-thinking nature (Swain and Vowel 2014: 14). In this paper, we will look at

1 While this paper focuses primarily on the ways in which the podcast deals with Indigeneity, Swain and Vowel also make regular and pointed critiques of the gender constructions of the texts they review, lambasting the emphasis on patriarchy (absent fathers are a recurring trope in the texts they review), the promotion of 'mediocre white men', and the marginalization of female characters.

how the podcast engages in 'Indigenous Futurisms', practices that combine speculative imaginings of the future with decolonial thought and thus, according to Vowel, allow Indigenous creators 'to foreground our worldviews and realities' (Vowel 2022: 14; see also Dillon 2012, 2014). In so doing, Swain and Vowel produce a truly transformative version of criticism, one that reveals the limitations of both academic and fannish review cultures, particularly in terms of their reliance on structural whiteness.

The Uses and Limitations of Academic Criticism

In the introduction to the first episode of *Métis in Space*, Molly Swain warns the listener:

> If you are into this because you think you are going to be getting some really intelligent and academic reviews on media, I would recommend clicking away. Basically, it's a couple of really big nerds drinking a bottle of wine and talking about how much they love and/or hate sci-fi. Mostly hate, probably. (Swain and Vowel 2016: Ep. 1.1, 1:40–2:00)

Despite this disclaimer, however, the show does provide 'really intelligent' commentary, and Swain and Vowel both have academic credentials. Vowel has degrees in Law, Education and Native Studies and teaches nêhiyawêwin (Cree language) at the University of Alberta; likewise, Swain is also an educator, and currently a University of Alberta instructor and doctoral student. Nevertheless, their disclaimer makes clear that the two hosts wish to distance themselves from academic media studies and textual analysis, even while they reference Indigenous academics. These references include Māori thinker Linda Tuhiwai Smith,[2] who the hosts squee was in the audience for a live taping (Swain and Vowel 2016: Ep. 5.1, 3:32–3–53) and Eve Tuck, whose 'Decolonization is not a Metaphor' they suggest could have been written as a response to a *Quantum Leap* episode in which the lead character, a white man temporarily occupying an Indigenous body, transcends his own race

2 Smith is the author of the seminal text of Indigenous academic theory, *Decolonizing Methodology*.

and embodies the settler fantasy of becoming 'Native, but, like, better than Native' (Swain and Vowel 2016: Ep. 1.2, 56:48–57:42).

This rejection of academia is, in part, a means of critiquing the role that the scholarly community has played in constructing Indigenous peoples as objects of study, rather than as bearers of knowledge, and the widespread ignorance and erasure that has resulted from this. The first episode, which critiques the 'Pangs' episode (1999) of *Buffy the Vampire Slayer* (1996–2003), offers a perfect example of how the hosts reject, critique and transform academic discourse. The rejection comes first from the setting – two nerds drinking wine and discussing nerd texts – which provides an informality that sets the scene far apart from a stuffy lecture hall and the power dynamics found within. Their tone is also not that of typical academic discourse. They laugh constantly, they are emotional and they make many of their points through sarcasm. Furthermore, much of this sarcasm is aimed directly at the academy, reversing the power structure between scholar and object of study by mockingly challenging the ideology underlying academic disciplines. For example, the hosts pretend to be as clueless as the Scoobies (the team who fights with Buffy to defeat the monsters-of-the-week) when trying to figure out why the Chumash spirit attacks anthropologists: 'The irony was lost upon me, because I didn't understand. Why would anyone care about an Anthropology department opening up a cultural centre? Culture is good, is it not? I'm not sure where he was going with that. I mean, I love anthropologists. I just adore them' (Swain and Vowel 2016: Ep. 1.1, 7:02–7:27). This passage is not just a rejection of academic tone, but also an explicit critique of anthropology and its guiding assumptions ('Culture is good, is it not?'). The hosts directly link the notion of capital-C 'Culture' with the colonizing objectification of Indigenous cultures by many anthropologists. Linda Tuhiwai Smith, for example, demonstrates how academic study is implicated in colonial practices when she explains that 'the West' claims 'ownership of our ways of knowing, our imagery, the things we create and produce', while 'simultaneously reject[ing] the people who created and developed those ideas' and 'deny[ing] them further opportunities to be creators of their own culture and own nations' (Smith 1999, 1). Swain echoes these thoughts when she explains, 'Indigenous peoples are probably the most studied peoples on the planet. We have had anthropologists in and out of our communities for generations, coming in, being very intrusive' (Swain and Vowel 2016: Ep. 1.1, 29:44–29:54). Labelling these anthropologists as

'intrusive' reminds us that the right of academics to study 'the Other' is self-appointed, and often violates the standards and norms of the communities they claim to represent.

The hosts further destabilize academic 'authority' through direct parody, and in so doing, emphasize that their rejection of academic discourse is not due to a lack of facility with, or understanding of, those modes of critique. For example, Molly displays her fluency in academic discourse by ironically using the language of anthropology to describe Buffy's position:

> MOLLY: This is really an important episode, because this is the first time that
> Buffy is hosting a Thanksgiving dinner, which, as we all know, is basic-
> ally a rite of passage for settlers, whereupon hosting the Thanksgiving
> dinner signifies that you have become an adult. Now, if this were to be
> interrupted, it's possible that Buffy might never actually enter into that
> realm of adulthood. So being torn between these two opposing narra-
> tives and these two opposing objectives [Willow's liberal sympathy and
> Giles' British imperialism] she's really risking a lot [...].
>
> CHELSEA: The crux of the episode is: Is Buffy going to be able to enact this white
> ritual and to move into the next stage of her adult life? (Swain and Vowel
> 2016: Ep. 1.1, 10:39–11:07, 11:34–11:04)

Here Molly engages in what Vowel later calls 'switching observer-subject roles' so that the person expected to be 'under the gaze of the white anthropologist' instead views 'the outsider through our own cultural lenses' (Vowel 2022: 15). This parodic reversal of the anthropological gaze operates on multiple levels. Molly and Chelsea puncture the seriousness of academic discourse by demonstrating how it can distort the object through generalization – we, the audience, know that Buffy will be able to claim adulthood even if she never manages to successfully prepare a turkey. In so doing, the hosts make us recognize how flawed anthropology can be, and has been, in its analysis of the cultures that are subject to its gaze. But even further, by subjecting Buffy and her friends to this gaze, the hosts succeed in decolonizing the listener – that is, they use 'the master's tools to dismantle the master's house.'[3] They encourage the listener not to see whiteness as a given,

3 Audre Lorde famously titled her 1979 talk critiquing the limitations of tokenism in
 academia 'The Master's Tools Will Never Dismantle the Master's House.'

but instead as a racial and cultural identity, one that can be defamiliarized as the norm against which Indigeneity is 'othered.' Perhaps the hosts are correct in asserting that Buffy truly would not be perceived as achieving adulthood if she failed at Thanksgiving. The rites and passages of whiteness, that is, come under scrutiny and become visible as ethnographic practices through Métis women's eyes.

Furthermore, by briefly taking on the role of faux anthropologists, the hosts emphasize how it is actually whiteness that is central to the episode's focus, making clear that academic analysis has often told us more about those who are gazing than it does about those who are gazed at: while 'Pangs' is an episode that is, on its surface, about addressing Indigeneity and the legacies of colonialism, Indigenous cultures are in fact marginalized within the narrative:

MOLLY: It really is about Buffy's own narrative, and the Indigenous peoples provide a really excellent foil upon which that is enacted.

CHELSEA: See, the regular settler gets to kill the Indigenous person by eating a turkey, so the act of genocide tends to be more symbolic than actual in modern-day society. Unfortunately, Buffy is actually faced with having to kill [...] in this story, the last remaining spirit of the Chumash people. (Swain and Vowel 2016: Ep. 1.1, 11:43–12:14)

It is fitting that Indigenous people merely 'haunt' this episode, operating as they do as signifiers of a 'dead' past that is exerting force on the present, a common trope in postcolonial texts: 'The haunting of the colonial frequently turns on what is undoubtedly a well-intended desire to relate to the Other, the silenced, and the hidden, but it also reveals a more problematic inability to situate resistance' in a complex present (O'Riley 2007: 1). Joss Whedon is nothing if not an exemplar of a certain well-intended 'wokeness' of 1990s media, but this episode clearly, as Swain and Vowel point out, participates in a false construction of Indigenous extinction and of colonialism as 'post.' The women explain the ongoing colonial implications of the 'last of his people' narrative by emphasizing just how many times the episode tells the viewer that the Chumash people, and Indigenous Americans, have been 'wiped out by settlers' (Swain and Vowel 2016: Ep. 1.1, 5:37–5:50). While this position was likely intended by the *Buffy* episode's writers to emphasize the wrongs of colonization, the hosts' ironic emphasis, and undercutting of the

position with asides such as 'the Chumash people who still exist and are not exterminated, but who are exterminated for purposes of this episode' (Swain and Vowel 2016: Ep. 1.1, 13:57–14:02) show how such laments support an ongoing and complicit erasure of the continued Indigenous presence on their own land.

Similarly, their critique of Willow, who is the mouthpiece of 'heartbroken progressive white liberal settler guilt' in the show, and who, as Vowel puts it, 'Feels for us. Identifies with us. Advocates for us' (Swain and Vowel 2016: Ep. 1.1, 9:58–10:04), illustrates the problematics of academic allyship, especially when the 'Indigenous position' is voiced only by a white character. Vowel argues that Giles' point, which the episode eventually endorses, that the idealism and sympathy for Indigenous people must give way to the 'urgent' need to defeat this vengeance spirit, is 'an economic argument': 'It's all great to talk about bringing things to light and giving back the land, but in moments of urgency you need to push that aside and just focus on the demands of the moment' (Swain and Vowel 2016: Ep. 1.1, 25:35–25:44). This is an attitude that has undercut progressive rhetoric about Indigenous rights from governments around the globe. Vowel explicitly connects the 'urgency' of 'being under attack by a vengeance demon' with 'the urgency of a pipeline' (Swain and Vowel 2016: Ep. 1.1, 26:26–26:50), an argument that has been, and continues to be, prevalent in current North American politics and an impediment to establishing nation-to-nation relationships. In the end, both hosts agree that they are most annoyed by Willow, whose professed sympathy does not lead to any change in behaviour.

The hosts also skewer academic discourse by demonstrating just how much it has failed to educate, arguably its sole purpose. When Giles suggests that atrocities against Indigenous people are in history books, so 'obviously everyone knows about them' (Swain and Vowel 2016: Ep. 1.1, 24:48–24:00), the women laugh at this 'very 100% true and useful fact' and transfer the concept to the Canadian context, with Swain laughingly suggesting that 'everyone has read the Royal Commission of Aboriginal Peoples, right?' and claiming that it 'is taught in elementary school up to university ... Oh, no wait, no. I'm confused' and Vowel chiming in: 'I think you're thinking about the bible' (Swain and Vowel 2016: Ep. 1.1, 24:55–25:15). This critique of the failure of academic institutions to educate the public, together with repeated references to their own problems with the institutions – such as when Swain responds to the

grandfather in *Quantum Leap* asking his grandson 'Didn't you learn anything in that college you went to?'(Swain and Vowel 2016, Ep. 1.2, 33:40–33:44) by saying 'that kinda pierced me in the heart, because I'm a student and it's true I'm not learning anything in that college I'm going to'(Swain and Vowel 2016, Ep. 1.2, 33:45–33:50) – point to a major role for their own podcast. By shaping their own critical discourse, the women powerfully challenge the authority of the academy as a source of information or knowledge about Indigenous peoples and culture.

Finally, not to leave our own discipline, literary analysis, free from critique, we argue that Swain and Vowel also distance themselves from textual criticism as a form of evaluation. They warn that they will not proceed like other review podcasts, saying in several of the early episodes that 'This review podcast may or may not actually contain reviews.'[4] Review culture is certainly not reducible to academic discourse, but many professional critics have backgrounds in, and authorize their interpretations with reference to, English and/or Film Studies (see Roberts 2010). Swain and Vowel make clear that the point of *Métis in Space* is not to assess how 'good' or 'bad' the shows are aesthetically, but to think through and explain the implications of their representations of Indigenous characters, tropes and themes. Rather than assign stars, therefore, the podcasters create a unique rating system for each episode, based on something specific from the show, but often deliberately playful and resistant to reading as an objective system of value. For example, they place 'Pangs' 'six out of five' on a scale of 'ominous flutes', which they note is 'breaking math' (Swain and Vowel 2016: Ep. 1.1, 41:29–41:35), 'Wendigo' (2005) an episode of *Supernatural* (2005–2020) on 'Bags of M&Ms' (Swain and Vowel 2016: Ep. 1.2, 56:05–56:22) and the 'aesthetics' of Indigenous representation in 'The Paradise Syndrome' (1968), a notorious episode of *Star Trek: The Original Series (TOS)* (1966–1969), as 'zero out of five shitty headbands'(Swain and Vowel 2016: Ep. 1.6, 35:40–35:46).[5] While these rating systems provide

4 First stated in Swain and Vowel (2016: Ep. 1.1, 2:01–2:06). *Métis in Space* is no longer alone as an Indigenous review podcast; for example, in the *Storykeepers* podcast (2021–2023) hosts Waubgeshig Rice, Jennifer David and their guest hosts use laughter, conversation and storytelling in their discussions of Indigenous literature.
5 Note that the rating system changed after the first episode so that the higher numbers indicated a better show and the lower numbers a worse one.

comedy, and usually draw attention to some of the ridiculous aspects of the text under consideration, they also provide a critique of rating systems themselves; the hosts' shifting signifiers of evaluation question the notion that a text can be evaluated 'objectively' since notions of quality have long been caught up in Western/Eurocentric systems of value. For example, media texts that they might consider aesthetically 'good' often fall down when it comes to Indigenous representation. Swain is a fan of *Star Trek*, but rates 'The Paradise Syndrome' (1968) one and a half 'phallic alien obelisks (P.A.O.s)' (Swain and Vowel 2016: Ep. 1.6, 1:11:06–1:13:45). Rating, review and evaluation of texts are revealed to be fraught enterprises for Vowel and Swain because both their own enjoyment of the text and, arguably, its value as a text, are damaged by the stereotypical and often offensive representations of Indigenous people found therein.

The Uses and Limitations of Fandom and Fannish Criticism

We argue that the position of both loving and hating a text, and of being both served by it and disappointed by it, is a position with which most fans are very familiar; it is not surprising, then, that the hosts of *Métis in Space* often occupy a fannish role and adopt many of the markers of a form of critique that theorists have identified as central to fandom. They regularly self-identify as 'huge nerds' and establish their nerd-cred by noting which series they have watched in their entirety, and which they are coming to fresh, and by making connections between the text they are reviewing and others in the genre. Such moves work to establish the 'canon' of the text they are addressing, a central feature of fan criticism (Jenkins 1992: 88–91), as well as their own particular fan positioning as either newcomers or established fans in relation to each text (see Johnson 2007: 289–291). Furthermore, in one telling moment when reviewing *Star Trek: The Next Generation*'s 'Journey's End', Swain appreciates Wesley's father's 'great vintage uniform', which she identifies as 'circa *Star Trek 7* (like, the movie, *Generations*)' (Swain and Vowel 2016: Ep. 1.11, 1:09:20–1:09:36). Such attention to detail is very much a signifier of fan criticism and fan association with a beloved text, in which 'an

individual's socialization into fandom often requires learning the "right way" to read as a fan' (Jenkins 1992: 89). Swain's identification of the uniform's era is an example of textual trivia that operates 'as a source of popular expertise for the fans' (Jenkins 1992: 87), establishing her right to speak to fan texts such as *Star Trek* within its fan community. The hosts might disavow academic credentials, but they fully embrace and perform nerdish/fannish forms of authority.

Like other fans, Vowel and Swain also employ 'writing back to the fan text' in order to negotiate their own sense of frustration with it. In his early analysis of fan fiction, Jenkins observed that 'fan culture reflects both the audience's fascination with programs and fans' frustration over the refusal/inability of producers the tell the kind of stories viewers want to see' (Jenkins 1992: 162). Swain and Vowel retell the narratives of the shows they watch in their own words, adding their criticism as they go. These retellings are akin to fanfiction, in that Molly and Chelsea regularly give voice to character's inner thoughts, provide alternate readings of scenes and deliberately read against the text and its aims. For example, in the first episode they appreciate the casting of the Chumash vengeance spirt, and admit to 'totally rooting for him' against the Buffy gang (Swain and Vowel 2016: Ep 1.1, 18:23–18:30). When reviewing 'The Paradise Syndrome', Vowel reads Mirimanee as wanting to stay with Salish and only being devoted to Kirk/Kir-ack because tradition demands it (Swain and Vowel 2016: Ep. 1.6, 40:50–41:35). The women also focus on minor Indigenous characters; for example, they give a backstory to the sister in *Quantum Leap*'s 'Freedom', imaging her turning into a hawk and valorizing her everyday heroism of being a school teacher and taking care of their grandfather over the years (Swain and Vowel 2016: Ep. 1.2, 48:21–50:47). In so doing, Vowel and Swain provide examples of transformative writing: refocalization, by which they 'shift attention away from the programs' central figures and onto secondary characters, often women and minorities, who receive limited screen time'; and 'moral realignment', by which they 'invert or question the moral universe of the primary text, taking the villains and transforming them into the protagonists of their own narratives' (Jenkins 1992: 165, 168). Fannish criticism, operating as it does on the margins, and sharing with Indigenous cultures a position of objectification and judgement by academics and broader society, thus offers a meaningful and powerful alternative to traditional textual criticism for Vowel and Swain.

However, while early critics such as Jenkins celebrated the subversive potential of fan criticism as a 'collective strategy' against 'dominant ideologies', more recent criticism has challenged this viewpoint, noting the extent to which fan communities participate in 'the continuation of social inequalities' (Grey et al. 2007: 2, 6). Mel Stanfill points out that while 'both fan studies and fandoms themselves like to think of fandom as progressive', the very 'notion that fandom is a vector of inequality often ignores the ways fans may (or may not) experience marginalization on the basis of race, class, language, and other structures' (Stanfill 2018: 305). Rebecca Wanzo likewise points out how both fandom and fan studies have failed to reckon with the regressive politics of fandom, particularly in terms of race, and that, in fact,

> high-profile racist and misogynist speech and bullying demonstrate that some fans of speculative works *depend* on the centrality of whiteness or masculinity to take pleasure in the text. Sexism, racism, and xenophobia are routinely visible in fan communities, including the cases of Gamergate (the harassment of women who are involved in the video game industry or who criticize it) and the fans of Suzanne Collins's popular young adult novel *The Hunger Games* (2008) who voiced anger that a tragic young character described as dark skinned in the book is played by an African American actress in the 2012 film. (Wanzo 2015: 1.4, emphasis added)

Further examples (and the fact that there are so many simply underline the urgency of Stanfill's and Wanzo's work) such as the backlashes against diversity in the Marvel and *Star Wars* franchises, and in the 2016 *Ghostbusters* reboot, all of which featured high-profile harassment of actors of colour, clearly demonstrate that fan criticism is in no way inherently progressive.

Swain and Vowel's podcast, and their experience as fans, speak loudly to the continued exclusion and marginalization at work in fan communities. For example, the hosts' outsider status was emphasized during their visit to the 2014 Montreal ComicCon. Swain introduces the audio from ComicCon by raising the question 'what does it mean to be an Indigenous person at an event like this?' (Swain and Vowel 2016: Ep. 1.5, 4:25–4:50). This question has, at its heart, the desire to find a place for themselves as Indigenerds. Specifically, the hosts 'were looking for some kind of Indigenous content, Indigenous people, maybe dressed up, maybe not dressed up, or people working on projects that had to do with Indigeneity and we thought that we would find a lot', but 'what [they] found instead was clueless white guys' (Swain and Vowel 2016: Ep. 1.5,

16:45–17:08, 22:15–22:18). The ease with which they found material for their podcast shows that 'there is a surprising amount of Indigenous content in a lot of sci fi' or at least 'the inclusion of certain Indigenous tropes'; but their experience in a mainstream fan space even more clearly demonstrates that 'in the wider sphere' among 'regular non-Native people' these ubiquitous tropes are invisible, which they see as 'analogous to the way that Indigenous presence is ubiquitous and invisible everywhere' (Swain and Vowel 2016: Ep. 1.5, 29:22–31:02). They read their experience at a Con metaphorically; their assertion that it 'would be easy to lose ourselves in the crowd and disappear forever' (Swain and Vowel 2016: Ep. 1.5, 17:36–17:38) echoes back to the trope of disappearing Indigenous people that they have critiqued in speculative texts. Their feelings of exclusion echo, though are less overt than, the experience of self-identified Cherokee speculative fiction writer Craig Strete who, in a letter to the editor in the August 1974 issue of *Amazing*, describes being turned away from a science fiction convention that 'Two other Indians and myself attended or rather tried to attend' (Strete 1974: 73). The 'slightly drunk' official who greeted them began by saying 'How big chiefs! Where the hell do you think you are going?' then refused them tickets, saying 'Like hell, no f----- Indians are coming in here' (Strete 1974: 73). Swain and Vowel are not so explicitly excluded, but their encounters with racist representation – a vendor selling a shirt with a headdress but unable to name a single Indigenous character in science fiction or comic books, and a woman dressed as a 'stereotypical sexy Indian Princess' – make them feel 'isolated', 'alienated', 'exhausted', 'frustrated' and in 'a very hostile space' (Swain and Vowel 2016: Ep. 1.5, 23:07–24:16, 41:30–45:22, 28:24–28:26, 43:36, 45:52, 32:04–32:05).

Perhaps in response to this exclusion, the women make concerted efforts to create and foster an Indigenous fandom. Vowel notes that they have some ideas about how they 'can maybe reclaim or make space at ComicCon' (Swain and Vowel 2016: Ep. 1.5, 5:10–5:13). Both their disappointment and their resistance can be seen as a 'microcosm of the outside world' in that 'we're suffering, we're cast adrift, we're looking for other Indigenous people, we're trying to signify to other Indigenous people that we're here' (Swain and Vowel 2016: Ep. 1.5, 18:36–18:47). The two cosplay as their future selves, using a combination of regalia to identify themselves 'as Indigenous people' and 'campy space' items to show their humour, but noted that 'most people' at the con

failed to 'recognize any of the symbols of the regalia or anything' and instead focused on the mid twentieth-century sci-fi 'elements of the costume' (Swain and Vowel 2016: Ep. 1.5, 6:30–10:45). While most Con attendees cannot read the Indigenous signifiers of their costumes, more explicit acts of identification do work. Introducing themselves as hosts of the world's 'most famous (and only) Indigenous sci-fi podcast' gives them 'legitimacy' and creates a 'small niche' space for Indigenous sci-fi fans to use as 'their wedge in' (Swain and Vowel 2016: Ep. 1.5, 33:12–33:48). Meeting Hope Nicholson, who was promoting her edition of *Nelvana of the Northern Lights*, also provides a place where they can find themselves represented, as they find someone with whom they can really engage with Indigenous nerd culture, and who immediately recognizes the signifiers of their costumes (Swain and Vowel 2016: Ep. 1.5, 45:35–51:08).[6] They look to grow this community and make it more visible, encouraging Indigenous fans to attend conventions and imagine forming a 'Nici block' and round dance to 'decolonize ComicCon' and bring all the major guests to them (Swain and Vowel 2016: Ep. 1.5, 1:06:18–1:09:07). The image of the round dance evokes the Idle No More movement, in which participants protested continued colonial structures and policies, and emphasized their continued presence in North America. The Kino-nda-niimi Collective explains: '[W]e collectively embodied our diverse and ancient traditions in the round dance by taking the movement to the streets, malls, and highways across Turtle Island' (The Kino-nda-niimi Collective 2014: 24). A round dance at a Con would be a continuation of this practice, not claiming new ground, but reminding other attendees that the ground was always Indigenous.

In another acknowledgement of the limitations of mainstream fandoms for their purposes, Swain and Vowel parody the whiteness and masculinity of mainstream criticism and fan community through their 'Ask a môniyâw' (white man) segment that recurs throughout the first season. In the first episode, they claim that the segment comes from both 'the knowledge that not

6 Looking into *Nelvana of the Northern Lights* in more detail reveals that it contains many of the same problematic stereotypical representations that Swain and Vowel find in the television shows they critique. Hope Nicholson has amplified Indigenous voices by editing Indigenous speculative work, such as *Love Beyond Body, Space and Time: An Indigenous LBGT Sci Fi Anthology* and the first two volumes of *Moonshot: The Indigenous Comics Collection*.

just sci-fi, but all media is really made by and for the white man' and a desire not to 'neglect our white male listeners' (Swain and Vowel 2016: Ep. 1.1, 45:41– 45:50, 4:42–4:46). In the segment, they parody this 'voice of the most important demographic when it comes to looking at things like science fiction from a decolonial or Indigenous-centric standpoint' by asking ridiculous questions – such as 'As a white man, do you think casinos are the new buffalo?' – and by having the clueless and stereotypical white man give answers that show a lack of understanding of the question itself, but at the same time are excellent examples of mansplaining: 'It's okay. I can explain it again if you want. Buffalo is a town. Four legged ruminants are called cows' (Swain and Vowel 2016: Ep. 1.1, 45:57–46:27). Even when the question is rephrased as 'Do you think that casinos can replace the economic foundation of Indigenous peoples who had their economies destroyed by colonization?' the môniyâw remains clueless: 'I'm sorry. Did this happen in Buffalo?' (Swain and Vowel 2016: Ep. 1.1, 47:03–48:11). The môniyâw is further disempowered by naming. The segment is not called 'ask a white man', showing that he is being shaped by their language, rather than vice versa. The use of a Nêhiyawêwin label is not, however, an invitation into their territory, as is shown by the ironic bestowal of an 'Indian name' on each môniyâw. While the women ironically claim that these names have ceremonial importance, the use of the term 'Indian name' (the hosts usually use 'Indigenous' when not using Nation-specific signifiers) suggests that the name is more connected to what Daniel Francis terms 'The Imaginary Indian' than to actual Indigenous naming ceremonies. Names such as 'Mystical Syphilis' actually disempower the bearer. Besides the obvious critique in naming a man after an STI, the name also reminds the viewer of the women's earlier analysis, that Xander's syphilis, contracted spiritually when he entered the Chumash tomb, signified an attack on his masculinity (Swain and Vowel 2016: Ep. 1.1, 23:19–23:58).

The hosts discontinue the 'Ask a Môniyâw' segment after the first season, in part because it wasn't fair to Vowel's partner who found it difficult playing the role, even ironically (Swain and Vowel 2016: Ep. 1.11, 1:24:57–1:26:08), but more significantly because a segment that aimed to show the ridiculousness of focusing on white male perspectives was actually providing a focal point for the very perspectives it was critiquing: 'According to the hosts, *Métis in Space* listeners cite the "Ask a môniyâw (white man)" segment as their favourite

part of the podcast [...] After uploading episodes to SoundCloud, *Métis in Space* started receiving earnest requests from several men who wanted to be the guest môniyâw' (Domingo 2015: n.p.). At best, such requests suggest that non-Indigenous listeners were laughing at themselves by focusing on their own white guilt, a position that still puts the white audience at centre-stage. At worst, the desire to act the môniyâw demonstrates a desire to speak from a licenced position of privilege. The hosts explain their decision to cut the spot, saying: 'We recognise that this was a favourite spot for many of you, but I think it had its day. It's a fine line between satire and just replicating some of the racist b.s. that we hear all the time' (Swain and Vowel 2016: Ep. 2.1, 8:03–8:16). In the same episode, they critique the 'disgusting' and 'horrible' ways that *Cowboys & Aliens* (2011) addresses, and fails to address Indigenous peoples, but point out that the overt racism of the characters and situations is performed in 'that kinda "wink, wink, nudge, nudge" way' that suggests ' "well, really, we're all past that", so we can just re-access this as kind of a joke' (Swain and Vowel 2016: Ep. 2.1, 20:26–20:41). In case readers don't catch the similarity, at the end of the episode, they explicitly connect their critique of *Cowboys & Aliens* to their discontinuation of the môniyâw segment, reinforcing the difficulty of mocking something without reinscribing its values (Swain and Vowel 2016: Ep. 2.1, 1:08:34–1:08:15).

Indigenous Futurisms and the Way Forward

Both academic and fannish criticism, embedded as they are in 'structural whiteness' (Stanfill 2018: 305), prove limiting to the hosts in their approach to texts, but when they combine what is useful from each with the concept of Indigenous futurisms, they can enunciate their feelings towards, and relationship with, sci-fi texts in ways that acknowledge their intersectional experience as Indigenous, female fans. Swain and Vowel follow thinkers such as Grace Dillon, who built on the concept of Afrofuturisms in her construction of Indigenous futurisms, especially the importance of 'not relegating Afrofuturisms to a purely sf field, but rather recognizing that sf theory and Afrofuturisms have much to gain by the exchange' (Dillon 2012: 2).

Likewise, Dillon explains how 'Indigenous Futurisms press further with the time-space of a common pot, shared at all levels by all peoples (animal, plant, minerals, spirits, human and so on) and, so, could be said, to extend far beyond the perimeters of known sf' (Dillon 2014: 6). At its heart, Dillon's concept of Indigenous Futurisms combines the tropes of science fiction with the Anishinaabe concept of biskaabiiyang, a term she translates as 'returning to ourselves', which involves discovering how personally one is affected by colonialism, discarding the emotional and psychological baggage carried from its impact, and recovering ancestral traditions in order to adapt in our post-Native Apocalypse world' (Dillon 2012: 10). The fan criticism in *Métis in Space* follows a similar trajectory: naming, deconstructing and rejecting the colonial tropes of mainstream sci-fi, amplifying Indigenous voices in the genre, and engaging in their own futuristic world-building first in their story-telling, and then through a physical land back project in which they hope to build a 'feminist Indigenous compound' ('Back 2 the Land': n.p.). These projects give the hosts figurative and literal spaces through which to cast themselves 'far into the future' in potentially emancipatory ways (Vowel 2022: 19).

The decolonial critique of most genre texts in the early seasons of *Métis in Space* is, thus, an act of Indigenous futurism. Unlike mainstream fan disappointment, which is sometimes fuelled by battles over interpretations of what constitutes 'canon' and its relation to fans' personal identification with the texts (see Goodman 2015), the hosts' disappointment with fan texts springs from the effect such texts have not only on their identities as fans, but on their lived experiences in the material world. Speculative fiction has long posed difficulties for Indigenous fans. The genre contains, at its heart, narratives of colonization with Indigenous peoples either literally or metaphorically being cast as other, and dehumanized (see Adare 2005; Rieder 2008). At the same time, even the stereotypical representations in the genre provide an alternative to most representations of Indigenous people. Where popular narratives – in any medium – tend to represent Indigenous people as mystical and from the past, science fiction, with its focus on technology and the future, can suggest the possibility of Indigenous scientific literacies and Indigenous futurisms. Sierra S. Adare begins her introduction to *Indian Stereotypes in TV Science Fiction: First Nations Voices Speak Out* with a recollection of her excitement over the now-infamous 'Paradise Syndrome' episode of *Star Trek: The Original*

Series, an episode that the hosts of *Métis in Space* completely lambaste. Adare, on the other hand, recalls that the lack of characterization and authenticity in the Indigenous representation didn't matter to her child self because '[i]t was the only time I could remember seeing TV "Indians" who were not being chased by the cavalry or shot by cowboys and whose intent was not to massacre innocent settlers' (Adare 2005: 1).[7] She goes on to argue that 'science fiction is the only genre that suggests that First Nations peoples and their cultures have a future that has not been assimilated into the dominant society' (Adare 2005: 6). This statement points to the way Indigenous futurisms counter the recurrent trope that Indigenous peoples 'always have to be disappearing' or 'going extinct' or 'are already extinct, so they don't have to think about us' (Swain and Vowel 2016: Ep. 1.5, 32:33–32:43). By framing their fan criticism in the context of Indigenous futurisms, Swain and Vowel not only critique the problematic elements of mainstream science fiction, but also turn fan criticism and fan storytelling into a decolonial act.

Indigenous futurisms differ from science fiction in that, rather than looking only to the future, they involve a 'simultaneous return to our pasts and active presence in the current moment, the continuous motion of our stories and teachings, all that we are constantly transforming' (LaPensée 2014: 3). Like Adare, Swain and Vowel can see hints of Indigenous futurisms in even problematic shows, such as Tom Jackson's 'awesome' line in the otherwise colonial 'Journey's End' episode of *Star Trek: The Next Generation*: 'Our culture is rooted in the past, but not *limited* to the past' (Swain and Vowel 2016: Ep. 1.11, 1:04:04–1:04:08, emphasis in original). Swain introduces this moment in a segue from a critique of the 'crappy' representation of the Indigenous people's spirit lodge: 'But let's be happy with his quote about culture', and they see the line as 'Indigenous futurism, right there'; however, while they encourage their listeners to 'pay attention to that' and explicitly state that 'that should be the point of the show', they acknowledge that 'it is not' (Swain and Vowel 2016: Ep. 1.11, 1:03:28–1:04:28). As Indigenous fans, they are usually forced to ignore large portions of the fan text to make it fit their needs, but Swain and

7 Later in the study, Adare spends a chapter criticizing the episode. It has also been the
 subject of much of the early scholarly writing on representations of Indigenous people
 in science fiction (see, e.g. Morris 1979). Molly Swain notes that she wrote a university
 paper on the episode (Swain and Vowel 2016: Ep. 1.6, 18:22–18:30).

Vowel instead operate very much as resistant readers of mainstream speculative fiction. By combatting discourses that suggest that Indigenous people belong in the past, and by reframing narratives to emphasize the ongoing presence of Indigenous peoples, their scientific literacies, and their present and coming resurgence, Swain and Vowel reshape the narrative and ask their listeners to act to bring such futures into being.

One of the main ways in which the women move towards Indigenous futurisms happens in the fourth season, when they begin to review more Indigenous-created works, including independent shorts such as Jeff Barnaby's *File under Miscellaneous* and Nanobah Becker's *The 6ᵗʰ World* (Swain and Vowel 2017: Ep. 4.3), shows aimed at a general audience, such as APTN's *Indians and Aliens* (Swain and Vowel 2018: Ep. 4.9) and blockbusters such as *Thor: Ragnarok*, directed by Taika Waititi (Swain and Vowel 2018: Ep. 4.8). They identify the necessity of amplifying Indigenous voices back in the first season, when they visit Montreal ComicCon, and recognize that, although there are many Indigenous artists creating nerd texts, they are not represented in the mainstream fan spaces. They explain the importance of focusing on Indigenous creators: '[Y]ou know, we're everywhere and it's been so rare that we are the ones that have been able to control [the representations]' (Swain and Vowel 2016: Ep. 1.5, 57:24–57:39). By focusing on Indigenous-created stories – including ones that they think fall short in some ways, as well as the ones they love – the women provide an alternative to mainstream science fiction, and emphasize the ongoing existence of Indigenous peoples as creators of their own stories, rather than subjects in other peoples' texts.

While Indigenous futurism is usually produced by Indigenous people, it is always grounded in an Indigenous worldview. As Vowel explains in the Q&A at a live show, when they began their own world-building within the show, it was important that they 'envision a way that we could start over using Indigenous principles' (Swain and Vowel 2016: Ep 2.6, 1:56:48–1:56:51). One of the ways the podcast does this, of course, is by *enacting* Indigenous futurism through story, rather than only critiquing current colonial texts. Lee Maracle argues that Indigenous theorists believe that '*story* is the most persuasive and sensible way to present the thoughts and values of a people' and that this separates them from academics who 'waste a great deal of effort deleting character, plot, and story from theoretical arguments' (Maracle 1992: 62). Swain and Vowel

engage in science fiction storytelling both within and around their podcast. Their storytelling acts as fanfiction, not for individual science fiction texts, but for the genre as a whole, because 'Despite the problems in science fiction, Swain and Vowel are still huge fans of the genre' (Domingo 2015). Swain's assertion that 'science fiction is almost inherently Indigenous because it is so much about world building and future building and telling stories in a way that points to where we want to go' (Domingo 2015) shows her reshaping the genre, emphasizing its potential in the face of all the disappointing texts in front of her. The hosts 'reclaim [them]selves from science fiction in order to create science fiction' (Domingo 2015), but their science fiction is grounded in Indigenous futurism and Métis worldviews.

The hosts' own world-building begins in the first season, with their created backstory. They come from a future marked by Indigenous resurgence that, paradoxically, they themselves started. An interview in the *kimiwan* magazine special issue on Indigenous Futurisms (2014), taped as one of two non-review episodes of the first season (Swain and Vowel 2016: 1.10), is framed as happening on 'October 2314, the tricentennial of the debut of *Métis in Space*' and the speculative interviewer from the *Nü Moccasin Telegraph* explains that the duo

> made waves when they refused the Nobel Peace Prize earlier this year for their podcasting contributions to humanity. Notoriously reticent and crotchety, they rarely leave the comforts of their Métis in Spaceship, as it orbits kitaskinaw ôma, so it was a pleasure and a privilege for this reporter to receive their insights and wisdom, as well as to hear a little bit about their temporal travels – already the stuff of legend – that launched the great interplanetary decolonization of 2135. (Swain and Vowel 2014: 14)

In the interview, the otipêyimisiw-iskwêwak defamiliarize the reader's present, which the fictional interviewer describes as 'a time so marked by its violence and whiteness', and explain the history leading from the neo-liberal Canada of 2014 to 'the Indigenous miyo-wîcêhtowin[8] society which we all now enjoy' (Swain and Vowel 2014: 14). The premise that the podcast itself comes from the future also allows Swain and Vowel to speak from a position of hindsight, identifying the ways in which mainstream science fiction supports continued colonization and marginalization of Indigenous peoples.

8 The Cree principle of 'living together well' (Swain and Vowel 2016: Ep. 2.6, 1:57–56–1:57:58).

Vowel argues that the 'stereotypes and tropes of Indigeneity in the settler media of the time were significantly contributing to ongoing colonial policies and violence'; however, she offers hope by explaining 'that naming and discussing these stereotypes was the first step to overcoming them' (Swain and Vowel 2014: 14). The use of the past tense here casts fan criticism as a specifically political and futurist act. While early fan theorists certainly did recognize fan criticism as a form of sub-cultural, outsider politics, theorists such as Rebecca Wanzo have demonstrated how activist fandom for people of colour has often connected black fans to their political mainstream, because 'in the case of African Americans, love and hate of cultural productions are often treated as political acts' (Wanzo 2015: 3.3). By balancing critique with an imagined path to decolonization, Vowel and Swain provide a strong counternarrative to the limiting and repressing representations in mainstream science fiction.

Their emphasis on Indigenous futurisms intensifies in the second season when the hosts replace the 'Ask a Môniyâw' segment with segments that feature 'a bit more world building, a bit more Indigenous futurisms in the sense of what are the possibilities in the future instead of just being held back by the realities of today' (Swain and Vowel 2016: Ep. 2.1, 8:20–8:31). This world-building occurs in two interlocking segments that recur throughout the season. The first is fictional commercial spots from new sponsors, the Georgians, a future religion: '[B]eginning in the 2100s, Chief Dan George actually becomes a revered figure for a small but influential and relatively well-off religious sect' (Swain and Vowel 2016: Ep. 2.1, 15:32–15:44). The Georgians send the hosts dispatches from the future in exchange for them reading passages from the book of George, 'their holy text', on the podcast in a 'reciprocal and community building way' (Swain and Vowel 2016: Ep. 2.1, 15:57–16:16). The women go on to note that this reciprocity brings about the future that they are referencing: 'Ironically, the fact that we start reading these passages in our second season, it doesn't really become noted until a grad student quite some time from now does a thesis on this and actually is the one who founds the Church of George, so it sort of has to be like this' (Swain and Vowel 2016: Ep. 2.1, 16:23–16:45). This 'timey-wimey' ontological paradox, in turn, points to the importance of Indigenous futurisms. In order for strong futures to happen, they first have to be imagined.

Indigenous futurisms are not unrealistically idealist, and the utopia of
the twenty-fourth century imagined in *Métis in Space* is not without diffi-
culty. The other recurring segment in the second season comes in the form
of the dispatches sent back from the future by the Georgians; in these seg-
ments, the future versions of Chelsea and Molly are dealing with a group of
môniyâwak who have returned from a self-imposed exile on Mars and are
refusing to live by the principles of miyo-wîcêhtowin; they are overhunting
the de-domesticated cows, and drive around tankers full of corn syrup (Swain
and Vowel 2016: Ep. 2.5, 37.19–41:10). When future Molly and Chelsea come
down from their Métis in Spaceship, and attempt to diffuse the situation with
humour, the môniyâwak read their actions as aggressive, and fight back with
lethal weapons (Swain and Vowel 2016: Ep. 2.1, 1:12:45–1:15:47). This story not
only depicts a larger future world as it could (or should) be but also addresses
the fears of those who would have to give up their own, flawed, worldviews,
their ways of interacting with the environment and their positions of privilege,
in order to fit into the new utopia. The storytellers, like their future selves in
the story, use humour as a weapon and encourage all audiences to identify
with the otipêyimisiw-iskwêwak rather than the môniyâwak. At the same
time, this story – along with the story of 'Girl Champlain', an alien child who
has adopted a colonial persona, in the third season – emphasize that decol-
onization is a process, and that colonial forces can reassert themselves at any
time, and from any direction.

The podcast not only depicts but also enacts Indigenous futurism, in part
by actively nurturing an Indigenous nerd community. They bring in special
guests to contribute to the reviews, and the number of guests increases as the
series progresses, with two episodes having guest reviewers in season one, one
in season two, and four in each of seasons three and four. Similarly, they tape
live episodes of the podcasts at university venues such as The University of
British Columbia (Swain and Vowel 2016: Ep. 2.6) and McGill (Swain and
Vowel 2018: Ep. 4.7), festivals such as the Atotam Literary Festival (Swain
and Vowel 2017: Ep. 4.3), and special events such as the Generation Energy
Conference (Swain and Vowel 2017: Ep. 4.5) and the 'Exploring The New
R&R: Resistance and Resilience of Indigenous Women' symposium (Swain
and Vowel 2018: Ep. 5.1). In the *kimiwan* interview, a future Molly explains
how their podcasting work was part of larger network of Indigenous voices:

> The intersection of grassroots, academic, professional, traditional, educational, and future-space groups and projects inverted colonial discourses, which up to that point were led by non-Indigenous people, and resulted in us taking that space and dialogue back from the môniyâwak to create and imagine our own futures. We were talking not just to the regime, which we knew would never undermine its own power and listen to us, but to one another, building relationships of resistance and our capacities for sustained, supported, and reciprocal decolonizing. miyo-wîcêhtowin was on the horizon. (Swain and Vowel 2014: 15)

By creating fan spaces, and building community, the women turn a review podcast into an active tool of decolonization and Indigenous futurism. One can see how a review podcast might, in the future they imagine, earn Swain and Vowel the Nobel Peace Prize (Swain and Vowel 2014: 14).

Conclusion: The Uses and Limits of Antifandom

Much of Swain and Vowel's podcast could be characterized as engaging in 'antifandom'. Antifans are characterized as 'disliking genres, texts, or personalities', but they 'do not dislike popular texts for nothing'; often, for example, there are 'moral and ethical objections' at work (Theodoropoulou 2007: 317). Rebecca Wanzo points out that 'antifandom is omnipresent in black cultural criticism' as a means of pointing out 'intense pleasure, disgust, or investments in popular representations of black people' (Wanzo 2015: 1.5). Swain and Vowel's critique of stereotypical, damaging and just plain lazy tropes of Indigenous people in sci-fi – such as flute music 'whether or not that was a part of your culture' (Swain and Vowel 2016: Ep. 1.1, 9:28–9:30), animal transformation, the presence of bears, a white man temporarily assuming an Indigenous identity for personal growth – also critiques the mores of the societies in which we live, especially in terms of dominant ideologies of Indigenous people and their place in mainstream America and Canada. But as seen in their 'Ask a Môniyâw' segment, there are limitations to mocking and critiquing stereotypes of Indigenous people, not least because such work demands continually engaging with these stereotypes. We have shown that Swain and Vowel's analysis is an act of Indigenous futurism that

combines the affect and community-building typical of fan criticism with the decolonial outlook, storytelling and community-building of Indigenous discourse. By taking control of and supplanting science fiction narratives that undercut Indigenous worldviews, and by building a land trust on which those worldviews can thrive, Swain and Vowel are working towards making an Indigenous-centred future a reality.

Voices of the Indigenous Comic Con 2: Indigenous Popular Artists in Conversation with Kati Dlaske and Svetlana Seibel

Note from the Interviewers

This concluding chapter presents a selection of interviews conducted at the Indigenous Comic Con 2 in Albuquerque, NM, in 2017. The convention's second year represents a pivotal moment in the long-term development of the event, as well as Indigenous popular culture in general. Whilst the inaugural IndigiCon in 2016, designed as a considerably smaller event, tested the ground and confirmed interest, the convention fully came into its own in its second instalment, affirming continuity and a clear vision for its future. Speaking to us, actor Jonathan Joss noted: 'I said it during a panel: Indigenous Comic Con Nr. 1, that ... that was an idea; Nr. 2 means, you know what, the idea worked; Nr. 3 means we're here to stay, it means there's gonna be a 4, there's gonna be a 5, there's gonna be a 6.'[1] For that, the second Indigenous Comic Con is of unique significance in the development of contemporary Indigenous popular culture in North America, and beyond (in 2019, Indigenous Comic Con Australia took place in Melbourne under the management of Cienan Muir (Yorta Yorta and Ngarrindjeri), who was a guest at the Indigenous Comic Con 3 in Albuquerque in 2018).[2] In its reinvented guise as IndigiPopX, today Indigenous Comic Con continues to be

[1] The quote is taken from an unpublished interview with Jonathan Joss conducted by the editors at the Indigenous Comic Con 2, Albuquerque, NM, in 2017.

[2] See Lovegrove (2018). For more information on IndigiCon Australia, see <https://ind iginerd.com.au/indigenous-comic-con-2019-australia/>.

the central hub of contemporary Indigenous popular culture, the veritable 'Indiginerd HQ.'[3]

With interview selections offered here, we wish to highlight and fore-ground the perspectives and viewpoints of the artists and practitioners of Indigenous popular culture in their own words. During our conversations with them, we were interested in their views and opinions on the role of Indigenous popular culture and the Indigenous Comic Con in contemporary Indigenous life – personal, cultural and political. The artists' reflections on these subjects, which we are sharing here, offer invaluable insights into the core values and dynamics of IndigePop.

For reasons of scope, we could include neither full interviews nor excerpts from all of them in this chapter. What we offer here, therefore, are excerpts from a few of the interviews we conducted in the course of the convention's three days, slightly edited for clarity and with some sections rearranged, but with no changes to the content. We deliberately kept the editing very light to preserve the oral quality of these conversations, which took place sometimes in the coffee shop, sometimes in the diverse sitting areas of the venue, but mostly with the two of us sitting on the floor in the artists' booths, pressing the pause button on the interview recordings from time to time so that the artists could attend to their customers and fans. The names of the interviewees are presented here in accordance with their own stated preferences. In our selection for this publication, we were guided by considerations of thematic cohesion; the ex-cerpts we chose, therefore, mostly address questions pertaining to the cultural and political significance of Indigenous popular culture as seen by its creators and practitioners. But these exchanges contain so much more than that. Each one offers personal reflections, stories, passions, nerdy moments and pop cul-tural experiences that enrich the conversation far beyond any purely concep-tual thinking, and so we made sure to include some of these stories as well.

Svetlana Seibel and Kati Dlaske, 2024

3 See the event's webpage under <https://indigenouscomiccon.com/>.

The Interviews

<div style="text-align:center">***</div>

JOHNNIE JAE (Choctaw/Otoe-Missouria), artist, founder of A Tribe Called Geek, a media platform for Indigenous geek culture and STEM, and Grim Native, a platform concerned with Indigenous representation in horror. Organizer of the panel *Surviving the Zombie Apocalypse: Rez Style* at the Indigenous Comic Con 2.

KATI: *You had the zombie apocalypse panel last year as well. Can you tell a little bit about the background [of the idea]?*

JOHNNIE: Yes, yeah, well, we do the zombie survival rez style panel and the reason that we do this is a way for us to talk about our experiences as Native people and colonization. As Native people we've already survived the apocalypse, we've already gone through the shock of losing our way of life, we've gone through having to rebuild, you know, and now we're in that rebuilding, we're still in the rebuilding phase. Because, you know, everything that we were was wiped out and while we still carry our traditions, while we still have our language, while we still have a lot of things that, you know, that we've been able to hold on to, we still have to figure out who we are as Native people *now*. Because we're not gonna be our ancestors, you know, we're never gonna be who they were, and we're never gonna be who our grandparents were. We're a new people as Indigenous people and we're still trying to figure out what that means in this post-apocalyptic reality, you know, because what served our ancestors isn't necessarily gonna serve us now. And so it's a lot of disseminating that information, what do we need to hold on to, what can we evolve. And, you know, like our language, it's constantly evolving, our traditions, you know, now that we're in that rebuilding phase, so much was lost that we're also in this process of revitalization, where we're taking the responsibility to go back, reclaim, restore and revive these practices that were lost, languages that were lost, traditions that were lost, even relationships in

terms of, like, our identities, our sexuality, you know. These are all things that we're having to rebuild upon now. And so for us to talk about it in terms of a zombie apocalypse is a way to do it, and a way that is not preachy and people understand what we are talking about, because they're all ... they're familiar with the zombie apocalypse, you know, they see it in movie after movie, we've got TV shows that are built on this. So it's easy for them to know what we are talking about because they see it on TV, they see these struggles that, you know, survivors are going through in the TV show and when we relate it back to our experiences as Native people, it clicks. And then it's also just a fun way for us to, even as Native people, to start talking about revitalization, to talk about the importance, you know, of going back and reclaiming, restoring and reviving. And, it's getting our kids interested in, you know, traditional practices that were lost, weaponry that they don't know about, because now, you know, all our kids are into video games, they're more into technology. So when we try to teach them language, or, you know, get them to practice culture, sometimes they're not interested or it doesn't get their attention, but if you can relate it back to something they are interested in, then they're excited about it. So, you know, talking zombies, showing weapons, [...] it's an easy ... it's just an easy way for us to talk about our experiences as Native people in a way that everybody can understand it, and also in a way for us to kind of gear into talking about Indigenous futurisms, so it's, to me, it's just fun.

SVETLANA: *Did you also play a part in even conceiving this event [Indigenous Comic Con] ... or the idea?*

JOHNNIE: Yeah, we did, actually, and, you know, the thing with the Indigenous Comic Con is that this has been a dream for Indigenerds, like, forever [...] this is something you've always dreamed about, you know. You go somewhere like the Wizarding World, or the Wizard World Comic Con, you know, an of these mainstream Comic Cons and you're thinking, 'Why isn't there an Indigenous Comic Con?' And when we started A Tribe Called Geek, me and Jackie started sitting down and looking at what did we wanna accomplish with A Tribe Called Geek and the first thing I listed was an Indigenous Comic Con. But we were thinking, ok, if we're gonna do this, it's

gonna have to be, like, maybe two, three, maybe four years down the road, because we're self-funded and we didn't have the funding for it. But it was something that we were gonna work on. And then, probably about a year ago, Lee [Francis] called us and he was, like, 'What would you guys think about an Indigenous Comic Con?' and we were, like, 'Yes'!, [...] and he's, like, 'Well, I've got funding' and he's, like, 'Let's do this' and we're, like, 'We're on board!'. And so it came together really quickly and we really weren't expecting it to be as successful as it was. We were at the National Hispanic Cultural Centre and we figured that would be a good space 'cos we were expecting about 300–400 throughout the entire weekend, like, entirely. And when the Indigenous Comic Con started, people just started showing up and we were just, like, 'Oh, wow, this is awesome', because it was so crowded, it was just like people were showing up and everybody was just talking. It was the first time that a lot of us have been able to meet each other in person, 'cos we have this whole network of graphic novelists, of artists and, you know, just people that we admire and we talk with and this was the first time that we were all in the same place at the same time, so it was all really exciting. But to see the support that we got, like, every single panel that we had was completely filled because people wanted to hear what are Native people doing in geek culture, so it was exciting to see that, and even this year, we're in a bigger venue, but it's packed in there. And to see that support growing, you know, that kind of shows to us that, yes, what we do matters, you know, as creators, it matters and there's value to that and to see other people supporting that and being just as excited as we are as Native people. It's to me, it's like 'Yes, it's about time!'

SVETLANA: *And do you think the Indigenous Comic Con is a part of, you know, bringing this revitalization in contemporary context ... the revitalization of language and Indigenous way of life and tradition and so forth in the modern world you were talking about, there is a political dimension to it, right?*

JOHNNIE: Absolutely, and, you know, and that's one of the things with being Native that people don't understand. Almost every aspect of who we are down to, you know, the decisions that are made in our communities is a political reality for us, but, as far as Indigenous Comic Con, you know, it's absolutely

vital, because this is a great way for our Native youth to see themselves and their culture represented in so many healthy and positive manners. They're getting to see Native superheroes, and when you look at some of the super-heroes that we have as Native people, those powers are steeped in our tradition, they're steeped in our cultural heritage. There's one comic book that we have and the creator isn't here this year, and I really had wished he would be, but his name is Teddy Tso and he created Captain Paiute. Captain Paiute is one of my favourite Native superheroes, because in order to use his powers – 'cos he can control the elements – but in order to gain control over those powers, he has to learn about what water is in relation to his tribe. And because he's in the Southwest, he has to be mindful to use that in a responsible manner, because water is scarce so he cannot just waste that power or waste water because water is sacred to his people. But he also has to learn about the land, what's the con-nection to the land in order to control the land. And while he's looking at air, what is that, what is the relationship that his tribe has to the air, how did they use it, why is it important to them. The same with fire. So in order to gain con-trol over his powers, he has to learn who he is as an Indigenous person first, which is what I really love. And, you know, there's a huge discussion going on now, why don't we have a superhero who gains power by learning his language, because language is such a huge part of who we are as Native people. But there's all these discussions going on that you don't see anywhere else but here at the Indigenous Comic Con. And it's great for our youth to see those discussions happening, but to also see those representations within comic books, and to see these artists who are creating such wonderful things and being able to show them here and get support, and that lets them know that they are capable of doing the same thing, that they can be successful, that they can be an artist, that they can be a musician or they can create comic books and be successful and happy.

[...] What we're starting to see, are these new generations that are coming up and bringing to the table their gifts and their talents. And for them to come up at this time when people are looking at us, when they're seeing what they are doing, that to me is even more exciting because, you know, most of us had to do this at the time when there was no support. But for our new generation to come out at a time when there is that support for them, when they can

find funding, when there's that interest in Native created products, it's almost like validation and it's almost like encouragement, like, 'Ok, just keep being Native, just keep being Native', whereas we had to do it despite not having that support. But for our youth to have it, I love that, because I wanna see us Native youth being celebrated, you know, I wanna see our Native people being celebrated and being honoured for their contributions. But not just because they're Native, but because it's amazing, you know, that work is quality work, it's unique, it has a unique story to tell, and that's what I'm loving about Indigenous pop culture right now. Because we're in this time when there's all this support flooding in and, you know, it's just continuing to grow, it's encouraging new voices to rise up and it's encouraging new artists to show, you know, to just step out of that box and be like, 'Here's what I love, here's what I'm doing', and sharing it, because, before, you know, we rarely stepped out of our comfort zone. And then now, that's all you're seeing is people stepping out, and to me that's just the most amazing part of geek culture right now.

<div align="center">***</div>

KRISTIN GENTRY (Choctaw Nation of Oklahoma), artist, photographer, curator and writer, vendor at the Indigenous Comic Con 2, IndigiPopX director.

KATI: *Would you like to tell a little bit about your crafts?*

KRISTIN: Sure, okay. So, I went to art school to become a painter and a traditional woodwork print maker, and then I became an art teacher. So, when I became a mom, I stopped teaching. [...] I do a lot of painting, I almost always do water-based painting, so I do acrylic or watercolour. I always work on wood, I don't typically work on canvas. So the jewellery I make is also hand-painted on wood, and all the patterning and the design work is reflective of my tribal culture, which is the Choctaw Nation of Oklahoma, and then some of the tribal culture within Oklahoma, like with some Muskogee Creek influence, sometimes Cherokee influence. [...] A lot of the vibrant colours definitely are reflective of Oklahoma tribal culture as well. [...] My grandparents were woodcarvers, so I grew up doing festivals very similar to this. My mom did craft shows growing up, so I kind of grew up like my

daughter, just going to them, always being around art. It's just, I don't know, it felt natural to me to be an artist. And the wood, I think, I don't know if it's in my blood because my grandparents were woodcarvers, but I just prefer working with the natural element.

Oh, I am also a portrait photographer. [...] So I do a lot of families and, like, fashion shows, and they are always Native fashion shows. So it's contemporary artists that are taking their cultural designs and making it into contemporary fashion, working with, again, Native models, which don't typically conform to traditional society's norms for modelling. Like, some of the models are under five feet tall, which is definitely not normal for modelling. [...] Their sizing is, like, a lot of times normal women instead of the standard model sizing. So it's really nice to see our culture embracing that women aren't just one size, so they have the variety of sizes. I enjoy photographing that, and so then I get to use my jewellery for that sometimes, with the models. Yeah, so we kinda have like a big mix within, like, everyone's trading and joining together, kinda a collaboration of all our different arts to create different things.

SVETLANA: *Would you like to comment [also] on these pieces, the Batman signs? [Points at wood crafted pieces in the shape of the symbol of Batman on the vendor table.]*

KRISTIN: The Batman wall pieces, they were, like, cut out in the shape of the Bat symbol, and then I wanted to add my own tribal patterning, like I do on all my other pieces, like, my jewellery, my paintings, trying to blend the two together. My daughter loves Batman [...]. So I tend to do Batman work because she likes it. So, like, it ended up being really interesting to try to mix my Choctaw work into Batman, like, 'how do I blend those two together?' It created, like, a problem I had to solve, 'cause I never made artwork like this, so it was neat.

KATI: *Do you have a feeling of what this event means to you?*

KRISTIN: I think it's a good way to show the mainstream culture, like, getting out of just the Native community and into regular culture, that our artwork is so contemporary, yet it is still part of our traditional values. That we

can do both. That we're still here, we're still part of culture, and that we can take, I guess, pop culture and mix the two well and still keep it our own.

<p style="text-align:center">***</p>

QUEEN BREAD SAMA (Comanche Nation of Oklahoma), cosplay artist, vendor and co-organizer of the panel Cosplay 102 at the Indigenous Comic Con 2, more recently working with fashion and film industries.

KATI: *Would you like to tell a little bit about yourself?*

QUEEN BREAD SAMA: So my name is Queen Bread Sama, this is my cosplay name, and I am a cosplayer who happens to be Indigenous. I come from the Comanche tribe of Oklahoma. [...] This is my first year Indigenous Comic Con and I am absolutely in love with Comic Con.

KATI: *What do you love most about it? What's the best?*

QUEEN BREAD SAMA: I have to say, I love most seeing Native people into nerd and pop culture, I think that's my favourite thing seeing so far. I felt like, when I go to conventions, I hardly ever see any Indian or Native people, or Indigenous people. Within that kind of realm, I always feel isolated. [...] I go to comic cons with my partner, and we both go together, but we go out of state, sometimes it feels like there's not really a big community there, it's just a lot of people meeting up in one space. But I feel like here there is a community outside of Indigenous Comic Con. It feels like it's just a giant family gathering. That's what I love the most about it.

SVETLANA: *So would you say that the conception of the Indigenous Comic Con sort of changed things for Indigenous pop culture, for Indigenous nerd culture?*

QUEEN BREAD SAMA: I would say it changed ... it changed it in a way to where more Indigenous people can actually come out and show their art and have other people understand it, because they are, first off, Indigenous, and secondly, nerds. So, I feel like I see a lot of Native *Star Wars* paintings here, and I feel like people within this area, I feel like they can connect to it, and also bring their culture to it.

SVETLANA: *And which types of characters do you like to cosplay?*

QUEEN BREAD SAMA: My favourite characters are male characters, I cosplay a lot of male characters. I like to do the characters that no one likes, so, for example, I was Professor Snape on Friday, and not a lot of people like Professor Snape, a lot of people have, like, mixed feelings ...

SVETLANA: *I like Professor Snape. [all laughing]*

QUEEN BREAD SAMA: I *love* Professor Snape, he is my favourite character. When I was sewing him, I was, crying about him, 'cause I almost, like, went off on a tangent – I was really tired that night as well. I just like to cosplay male characters, characters that are fun, and also have a lot of personality, characters I can relate to, yeah, that I find some qualities that I'm matched with. And also I like to cosplay characters that match my partner's, so usually we cosplay characters that are couples, whether they are male-female, male-male, love is love, and I just love cosplaying with her, it's a lot of fun.

KATI: *Would you like to tell us about this character [you are cosplaying right now]?*

QUEEN BREAD SAMA: Yes. So, my costume is Prince Ashitaka from *Princess Mononoke*, and it is a Studio Ghibli film by Hayao Miyazaki, and it's one of my favourite cosplays because I ... watching it as a child, I've seen it once, and then re-watching it as an adult, I realized it has a much deeper, profound meaning. The movie is pretty much about a warrior, [...] and he is trying to find a way to get rid of the curse on his arm, and as he goes through the forest he realizes out there are forest spirits, and there is much more of a spiritual connection to the earth, and he realizes that his curse is actually formed by an iron company, in the middle of the forest, killing the forest spirits. So, once he finds that out, he is encountered by a wild woman, I would say, I would say she is more Indigenous, honestly, she is an Indigenous woman who tries to ... she is a member of the wolf family, but she's obviously human. So, she was abandoned by her mother as a child, and then these wolf spirits took care of her. But she tries to kill him, because he is a human, and she hates humans because they're killing the earth and they're killing spirits of the forest and I feel like

that relates to a lot of issues now, and I felt like this costume was appropriate to wear for this Con. [...] So I feel like this cosplay is a really nice one, it just, like, relates, and throughout the whole movie there's, like, a fight for earth and a fight for protection, and I felt like it's really relevant to this Con. Like, a lot of people are still on Standing Rock, and things like that. But I reeeeally loved it. It's my favorite one so far, it's the most comfortable. [And] I get to wear my moccasins, so I'm fine with that. [...] They are my family's, they're passed down in my family, so I wore them, they are Cherokee moccasins, male. My dad's side of the family is Cherokee, and I'm Comanche tribe. So it felt like it's really interesting to incorporate this for Indigenous Comic Con.

KATI: *And the cosplay contest? What kind of feelings do you have about it?*

QUEEN BREAD SAMA: Oh my god, I'm just blown away for the costume contest! Being in multiple costume contests, I feel like it's always exhilarating and full of anxious feelings, like, you can feel everyone being afraid, but then once they get on the stage it disappears, everyone is their character, they're not themselves, they are their character, and they're just into the feeling that I had, this feeling of love and compassion while watching other cosplayers come up and talk about their costumes, really show them off, so happy and proud of that. It made me happy.

<p style="text-align:center">***</p>

SABA (Diné/Jemez Pueblo), graffiti and mural artist, live screen printer, vendor at the Indigenous Comic Con 2 and live screen printer of the official Indigenous Comic Con t-shirts.

KATI: *Would you like to start off by telling a little bit about yourself?*

SABA: Yes, absolutely, my name is Saba, I'm Jemez and Navajo from the Southwest of America. I am a human, for one, that likes to push colours around on many different surfaces. I prefer to put pigments on walls. [...] My passion is graffiti, but it doesn't always pen out and pay the rent, so I had to think of a new way and screen printing is what I've chosen, my second weapon of choice, and what I print is ... it's a combination of Native and

Hip-Hop cultures. I believe that Native culture's Hip-Hop, and Hip-Hop has always been around forever. And Hip-Hop was the reason I came back to myself, you know, growing up non-traditionally was ... was rough, so I took it out on the streets, the walls [...]. I laid out, I sprayed my aggressions, and I got good, I guess, and now I do it on t-shirts! And t-shirts, I look at t-shirts like tags, like I look at tags – the more shirts I have printed the better for me. And, yeah, the content of my work is, I don't know what is it – social? [...] It has a lot of historical narrative, or it challenges a lot of historical narratives, or just tells a story of, like, during these times of colonization and all the stuff that happened to us Indigenous people here. I think ... and looking at this whole event [the Indigenous Comic Con], it's ... we chose art to express, you know, deal with it and cope with it, all the tragedies that have happened, you know. So I'm super honoured to do this interview, to be a part of this event, and to also ... continue doing my work, my passion, you know, and supporting my family.

SVETLANA: *Could you talk a little bit about some of your designs, like the one on your shirt now, the Apache Jedi?*

SABA: Yeah, this is the Apache Jedi, a master t-shirt, and more so known as the Homeland Security shirt, with Jeronimo and his soldiers lined up. The original designer Matthew Tafoya, whom I worked with earlier in my career, designed that t-shirt, the Homeland Security shirt, which is now worldwide sold. Of course, the question always came up, well, like, are you gonna pursue these people that are duplicating your shirts? And he's, like, 'No, not at all', because the more it gets duplicated the more the message moves, you know? And that stuck with me from the beginning. [...] So I did a new rendering of the same picture he used, but I left out the Homeland Security, and just put lightsabers in their hands instead of guns.

SVETLANA: *Why lightsabers?*

SABA: Well, to connect with the *Star Wars*, you know. I'm a *Star Wars* fan, and you know, I would love to be a Jedi. *[all laugh]*

SVETLANA: *What is it about Star Wars that you love so much?*

SABA: Everything. The funk. It's so funky, the characters, everything. [...] And then, of course, the whole storyline. [...] I mean, I can relate, you know? I'm a rebel all in, you know, just being alive I'm a rebel, you know what I'm saying, being an Indigenous person of this land and making ... my ancestors making it through all the crazy times and still today, you know, it's just as crazy as it was back then. But, except, we are doing it to ourselves now, so that's ... that's horrible, but, you know, the more we do stuff like this, the Indigenous Comic Con, all these young people will see that we can do this, like, we're allowed to do this. Somebody was wearing *black moccasins* earlier, and I'm like 'What? We're allowed to do that?' you know, like, that's awesome, you know ... so it's like, we have to do this stuff, we are doing it, and we will continue to do it better, honestly. And that's not, like ... you know, it's not disrespectful but, we're just doing these things a little more, you know what I mean? Like, 'Oh, you screen print?' – 'Yeah. I'm screen printing – live. In front of you. On your shirt. With your naked body standing in front of me.' Like, that's a lot cooler than just printing shirts in a garage, you know, somewhere. So. That's the way we do things. I'm super, super excited for the future of people, of humans in general because we are acknowledging our Indigenous people from the lands and really learning and trying to take it and, you know, respect the people of the land. Because we're visitors, all people are visitors. I mean, we go across seas and we're the visitors, so we gotta respect them, because they know the land there. [...] I guess it's ... that's kind of what this shirt speaks about. That's all, all my work, I try to ... of course the primary purpose, too, is having, having presence, you know, having Native presence in this time, too. I've met some kids, some children that believed that we are extinct just like the dinosaurs. Which I don't blame them, when you take the kids on a field trip to the Natural History Museum, and you got the T-Rex, and then you have the Navajo people, and you have this and that, you know, it's like, hey, these guys must be gone, too. [...] How does this exist where kids do not know that we still exist, or just think of us as a stereotypical, you know, TV Native or whatever. So, again, having presence and being able to put our imagery in these pop culture icons, it's like, it's cool for me because I'm a graffiti artist, and that's just what we do, you know, we hack things, we write on things, so, when somebody embraces that so for me it's like, 'Awesome. What, and you're gonna pay me too?' So, it works for me, but also, I get to practice what I love.

KATI: *Yeah, would you like to tell a little bit more about the graffiti projects?*

SABA: The graffiti projects, I do a lot of community murals where I go into a community and talk to the Elders, talk to the people that know the story, that have lived there, and I take those stories and translate them on a giant wall, you know, and I am trying to encourage the public to come and paint the walls too, because, again, that's not ... it's looked down upon, I guess, spray painting, you know, and nobody ever touches a can in their life unless it's to, like, paint their bedpost or something. So when you give them the permissions, 'Here's a can, spray the wall, like, it's ok, you're not gonna get arrested', then it's just addicting after that, because ... I also have a theory that I'm working on ... because of the historical trauma, we all have this 'grahh', you know, and not only Natives, but everybody that lives now ... [...].

KATI: *And you were in the first Indigenous Comic Con last year too?*

SABA: I was, yes. I've never been to a Comic Con, which is wild to me, 'cause this is, like, where I belong, you know? But, yeah, Lee [Francis] invited me out to do the live screen printing, or I asked him, [...] but it was a hit, and I've been busy this whole weekend, and it was the same as last year. And I'm very thankful for that, because I get to show people how the process of screen printing works and also inspire the young kids to do it, 'cause it's the only way I think the world would change is through the kids, you know, and the more we expose them to cool stuff to do, they'll do it rather than, like, stuff I was exposed to [...]. That's really what I try to do, just lead by example, you know, rather than talking, 'cause we can all talk. I do talk a lot, but it's better just to show – for me, personally. And, yeah, I can't be more thankful that I get to do that every single day of my life. Well, not every day ... but I get to do it. This is my job. I think they call it a career.

<p style="text-align:center">***</p>

WESHOYOT ALVITRE (Tongva/Scottish/Spanish), comic book artist, writer and illustrator, vendor at the Indigenous Comic Con 2.

KATI: *Would you like to tell about your work a little bit?*

WESHOYOT: Yeah. The work that I have at the convention this year, it's all Native based. My tribe is Tongva, from California, and I am working a lot through Lee Francis of Native Realities, through publishing Native stories, and I am working a lot with his Native titles, so. [...] I have comic book work for Lee Francis, and I also have a lot of No DAPL oil pipeline protest work that I did from the start of the pipeline protest in Dakota. So I have two pieces for sale here today, one of the Rosie the Riveter figure, and the other is Lakota Skywalker, which is a play-off of *Incident at the Oglala* and *Star Wars*, the film, kinda juxtaposing those two pop culture things.

SVETLANA: *And could you maybe talk a little bit about this event, about the Comic Con, and your impressions so far, experiences?*

WESHOYOT: Oh yeah. It's my first year going, I was invited last year but I couldn't attend. And I've been to a lot of comic book conventions, I've been to San Diego Comic Con, Los Angeles, Wizard World, Long Beach, and ... the energy and creativity here is something that I haven't seen in any of these conventions, and I've been to a lot of them multiple times. There is so much comradery here and this level playing field, that all these people seem to understand about environmental issues or common ground in, you know, being fans of *Star Wars* or things like that that have borrowed from Native cultures. And it's kind of unspoken, like, if you ever go to other conventions you kinda have to bring it up in conversation, explain yourself a little bit. And I feel like there is this common ground and understanding here that I've *never* seen before in my life. I didn't grow up on a reservation and I didn't grow up around a lot of other Native people in California, our tribe is very small, we're not federally recognized, and there's very few people from our tribe that we've had access to ... even just hang out, or go to a powwow together. So it's been mainly family that I've grown up around being Native. And so all the acceptance here and the common ground is just ... such a warm inviting feeling, and it's so positive too, like, so many people are so happy to see other Natives doing what they're doing. And I have experienced absolutely no negativity or anything, it's just warm happy conversation, really intelligent conversations too, people that've come around to talk, which's been really, really wonderful to, you know, join in, so.

SVETLANA: *And do you think events like this, like the Comic Con, and just geek culture in general, Indigenous geek culture, if they have political significance?*

WESHOYOT: I think they do. I mean, underlying, so many Natives, they have experienced something in regards to, like, quote-unquote oppression in this country, whether it be reservation Natives who have had to deal with reservation laws and constructs or, I think, any Native going through the American education system has had to deal with that political aspect, because you're raised a certain way and if your family has any sort of history on what's going on with Native people, and then you're plugged down into the American education system which is in complete denial of any of this stuff that's actually gone on, you, from a young age experience that, and you also are, I think, educated at a young age about a lot of political things. I don't know very many Natives that aren't aware of what has gone on with land theft, and genocide, and massacres and ... you know, even going through the legal system and having the US government not even stand up to their own legal responsibilities as far as treaties, like, not holding their treaty rights. So, it's rare that you meet a Native person that's not politically motivated, or at least has that behind them. And I think it inspires everything here, and I think it makes that a little bit more powerful too, so.

SVETLANA: *Since you're working in comic books, just in general about this form of a comic book, what do you think is its significance for Indigenous popular culture, and how do you feel, what are your thoughts about the form?*

WESHOYOT: What are my thoughts? Comics, I think, are very special because they are a combination of writing, they are a combination of art, and ... the two of those things combined, you're not only using visual styles that might be significant to your particular tribe, (because there're so many art styles within Native cultures), so it allows you to use those particular arts from your own culture into the art that you do with comics. But you're also using writing, which could be historically based, and I think words are very powerful too. So the combination of that, it's like ... it almost creates, like, a double weapon to make change for Indigenous culture. And it also allows us to have control over ... I think, showing ourselves as people that are here, we are involved in modern pop culture, you know, we like *Star Wars*, we like ...

regular comics, we're alive daily, and we're not something that has died, you know, it's like cowboy and Indian type of thing, where it's in the past and we fit into whatever genre and stereotype they've placed us in. Like, you could pop a Native person into any current world and we would still exist, and you could put them into any sort of future world, in sci-fi here, and we still exist. And I think that is empowering to a lot of the people here, and I think it's a positive way to build strength with the youth here too, so.

Bibliography

Adams, David Wallace, *Education for Extinction: American Indians and the Boarding School Experience, 1875–1928* (Lawrence: University Press of Kansas, 1995).

Adare, Sierra S., *'Indian' Stereotypes in TV Science Fiction: First Nations Voices Speak Out* (Austin: University of Texas Press, 2005).

Akindes, Fay Yokomizo, 'Sudden Rush: Na mele paleoleo (Hawaiian rap) as Liberatory Discourse', in *Discourse* 23/1 (2001), 82–98.

Aldama, Frederick Luis, 'Foreword: Assembling an Intersectional Pop Cultura Analytical Lens', in Domino Renee Perez and Rachel González-Martin, eds, *Race and Cultural Practice in Popular Culture* (New Brunswick: Rutgers University Press, 2019), ix–xii.

——, ed., *Multicultural Comics: From Zap to Blue Beetle* (Austin: University of Texas Press, 2010).

——, ed., *Graphic Indigeneity: Comics in the Americas and Australasia* (Jackson: University Press of Mississippi, 2020a).

——, 'Graphic Indigeneity: Terra America and Terra Australia', in Frederick Luis Aldama, ed., *Graphic Indigeneity: Comics in the Americas and Austrlasia* (Jackson: University Press of Mississippi, 2020b), xi–xxiii.

——, ed., *The Oxford Handbook of Comic Book Studies* (Oxford: Oxford University Press, 2020c).

Antinora, Sarah, 'The Rhetoric of the Hawaiian Sovereignty Movement: Resistance against Commodification, Consumption', in *The Quint* 9/3 (2017), 30–60.

Archibald, Jo-ann Q'um Q'um Xiiem, 'Indigenous Storywork in Canada', in Jo-ann Archibald Q'um Q'um Xiiem, Jenny Bol Jun Lee-Morgan and Jason De Santolo, eds, *Decolonizing Research: Indigenous Storywork as Methodology* (London: Zed Books, 2021), 17–21.

Archibald, Jo-ann Q'um Q'um Xiiem, Jenny Bol Jun Lee-Morgan and Jason De Santolo, 'Introduction. Decolonizing Research: Indigenous Storywork as Methodology', in Jo-ann Archibald Q'um Q'um Xiiem, Jenny Bol Jun Lee-Morgan and Jason De Santolo, eds, *Decolonizing Research: Indigenous Storywork as Methodology* (London: Zed Books, 2021), 1–15.

Ascari, Maurizio, *A Counter-History of Crime Fiction: Supernatural, Gothic, Sensational* (New York: Palgrave, 2007).

Associated Press, 'After State Approval, Thirty Meter Telescope Still Faces Fight from Hawaiian Opponents', *NBC News*, 30 September 2017. <https://www.nbcnews.com/news/asian-america/after-state-approval-thirty-meter-telescope-still-faces-fight-hawaiian-n806236> accessed 20 March 2024.

Austin, John Langshaw, *How to Do Things with Words* (Oxford: Oxford University Press, 1962).

'Back 2 The Land: 2Land 2Furious', *GoFundMe*, 29 July 2019. <https://www.gofundme.com/f/vmha2p-back-2-the-land-2land-2furious>

Baglo, Cathrine, *På ville veger? Levende utstillinger av samer i Europa og Amerika* (Stamsund: Orkana akademisk, 2017).

Baker, Emerence, 'Loving Indianness: Native Women's Storytelling as Survivance', in *Atlantis* 29/2 (2005), 111–121.

Baldwin, James, *The Evidence of Things Not Seen* (London: Michael Joseph, 1986).

Ballaster, Ros, Margaret Beetham, Elizabeth Frazer and Sandra Hebron, *Women's Worlds: Ideology, Femininity and the Women's Magazine* (Basingstoke: Macmillan, 1991).

Balto, Runar, *Sámi máilbmi* (Karasjok: Davvi girji, 2010).

——, *Sápmi – Guovdajoga máilbmi* (Kárášjohka: E-skuvla, 2017).

——, 'Hilmar studerer kunst', *NRK Sápmi av Ronardo*, 1 March 2017. <https://www.nrk.no/sapmi/hilmar-studerer-kunst-1.13404476> accessed 7 March 2024.

——, 'Skrik – Sápmi Tegneserie', *Atelier Runar Balto*, 2 June 2017. <https://www.facebook.com/photo/?fbid=1300851556699600&set=ecnf.100054618841622> accessed 7 March 2024.

Barbour, Chad A., *From Daniel Boone to Captain America: Playing Indian in American Popular Culture* (Jackson: Mississippi University Press, 2016).

Barker, Joanne, *Native Acts: Law, Recognition, and Cultural Authenticity* (Durham: Duke University Press, 2011).

Barnett, Louise K., *The Ignoble Savage: American Literary Racism, 1790–1890* (Santa Barbara: Praeger, 1975).

Baum, L. Frank, *The Wonderful World of Oz: The Wizard of Oz, The Emerald City of Oz, Glinda of Oz* (London: Penguin, 1998).

Beamer, Kamanamaikalani, 'Tutu's Aloha 'āina Grace', in Aiko Yamashiro and Noelani Goodyear-Ka'opua, eds, *Values of Hawaii 2: Ancestral Roots, Oceanic Visions* (Honolulu: University of Hawai'i Press, 2014), 9–15.

Begay, Cynthia, Email message to author, 6 August 2020.

Bergstø, Kirsti and Torgeir Knag Fylkesnes, 'Representantforslag 30 S 2016–2017, Representantforslag om en sannhetskommisjon for fornorskningspolitikk og urett begått mot det samiske og kvenske folk i Norge', in *Stortinget*, 20 December

2016, 2016–2017. <https://www.stortinget.no/no/Saker-og-publikasjoner/Publik
asjoner/Representantforslag/2016-2017/dok8-201617-030s/?all=true> accessed
7 March 2024.

Berkhofer, Robert F., *The White Man's Indian: Images of the American Indian from Col-
umbus to the Present* (London: Penguin Random House, 1979).

Bertens, Hans and Theo D'haen, *Contemporary American Crime Fiction* (New York: Pal-
grave, 2001).

Bird, Elizabeth S., *Dressing in Feathers: The Construction of the Indian in American
Popular Culture* (Boulder, CO: Westview Press, 1996).

Bourdieu, Pierre, *Langage et pouvoir symbolique* (Paris: Points, 1991).

Breu, Christopher, *Hard-Boiled Masculinities* (Minneapolis: University of Minnesota
Press, 2005).

Brock, Bernard L., 'Rhetorical Criticism: A Burkeian Approach Revisited', in Malcolm
Sillars and Bruce Gronbeck, eds, *Methods of Rhetorical Criticism: A Twentieth-
Century Perspective* (Detroit: Wayne State University Press, 1998), 183–195.

Bröckling, Ulrich, 'Gendering the Enterprising Self: Subjectification Programs and
Gender Differences in Guides to Success', in *Distinktion* 11 (2005), 7–23.

Brooker, Will, *Using the Force: Creativity, Community and Star Wars Fans*
(New York: Continuum, 2002).

Brown, Marie Alohalani, 'Mauna Kea: Ho'omana Hawai'i and Protecting the Sacred',
in *Journal for the Study of Religion, Nature & Culture* 10/2 (2016), 150–168.

Buck, Elizabeth, *Paradise Remade: The Politics of Culture and History in Hawaii* (Phila-
delphia: Temple University Press, 1993).

Burke, Kenneth, *A Rhetoric of Motives* (Berkeley: University of California Press, 1969).

Butler, Judith, 'What Is Critique? An Essay on Foucault's Virtue', *Transversal*, 30
September 2015. <http://eipcp.net/transversal/0806/butler/en> accessed 20
March 2024.

Byrd, Jodi A., 'Red Dead Conventions: American Indian Transgeneric Fictions', in
James H. Cox and Daniel Heath Justice, eds, *The Oxford Handbook of Indigenous
American Literature* (Oxford: Oxford University Press, 2014), 344–358.

Chandler, Raymond, *The Big Sleep* (New York: Vintage Crime/Black Lizard, 1988).

Chittenden, Tara, 'Digital Dressing Up: Modelling Female Teen Identity in the Discur-
sive Spaces of the Fashion Blogosphere', in *Journal of Youth Studies* 13/4 (2010),
505–520.

Christian, Ed., *The Postcolonial Detective* (New York: Palgrave, 2001).

Christoffersson, Rolf, *Med tre röster och tusende bilder. Om den samiska trumman* (Upp-
sala: Uppsala universitet, 2010).

Chute, Hillary, *Disaster Drawn: Visual Witness, Comics, and Documentary Form* (Cam-
bridge: Harvard University Press, 2016).

——, *Why Comics? From Underground to Everywhere* (New York: HarperCollins, 2017).

Coburn, Elaine, 'Introduction: Indigenous Resistance and Resurgence', in Elaine Coburn, ed., *More Will Sing Their Way to Freedom: Indigenous Resistance and Resurgence* (Halifax: Fernwood Publishing, 2015), 24–49.

Cocq, Coppélie and Thomas A. DuBois, *Sámi Media and Indigenous Agency in the Arctic North* (Seattle: University of Washington Press, 2020).

Cooper, James Fenimore, *The Last of the Mohicans* (London: Penguin, 1986).

Coppock, Mike, 'Oklahoma's Deadliest Tornado', *HistoryNet. World History Group Network*, 2007. <http://www.historynet.com/oklahomas-deadliest-tornado.html>.

Cordova, V. F., 'Matrix: A Context for Thought', in Kathleen Dean Moore et al., eds, *How It Is: The Native American Philosophy of V. F. Cordova* (Tucson: The University of Arizona Press, 2007), 61–66.

Covell Waegner, Cathy, 'Rampaging Red Demons and Lumpy Indian Burial Grounds: (Native) Gothic-Postmodernism in Stephen Graham Jones's *All the Beautiful Sinners* and *Growing Up Dead in Texas*', in Billy J. Stratton, ed., *The Fictions of Stephen Graham Jones: A Critical Companion* (Albuquerque: University of New Mexico Press, 2016), 194–217.

Daynes, Sarah, *Time and Memory in Reggae Music: The Politics of Hope. Music and Society* (Manchester: Manchester University Press, 2010).

Deloria, Philip J., *Indians in Unexpected Places* (Lawrence: University Press of Kansas, 2004).

Deloria, Vine, *Custer Died for Your Sins: An Indian Manifesto* (New York: Avon Books, 1969).

Dillon, Grace L., 'Introduction: Imagining Indigenous Futurisms', in Grace L. Dillon, ed., *Walking the Clouds: An Anthology of Indigenous Science Fiction* (Tucson: The University of Arizona Press, 2012), 1–12.

——, 'Indigenous Futurisms as Stardust Imaginings:Passwawag [Echomakers] of Indingnous Futurisms', in *kimiwan, Special Issue on Indigenous Futurisms* 8 (2014), 6–7.

Djuraskovic, Ogi, 'Blogging Statistics 2023. Ultimate list with 47 Facts and Stats', *First Site Guide*, 15 June 2023. <https://firstsiteguide.com/blogging-stats/> accessed 15 September 2023.

Dlaske, Kati, 'Discourse Matters: Localness as a Source of Authenticity in Craft Businesses in Peripheral Minority Language Sites', in *CADAAD Journal* 7/2 (2015), 243–262.

Dlaske, Kati and Saara Jäntti, 'Girls Strike Back: Politics of Parody in an Indigenous TV Comedy', in *Gender & Language* 10/2 (2016), 191–215.

Domingo, Nadya, 'The Trope Slayers', in *This Magazine*, 20 March 2015. <https://this.org/2015/03/20/the-trope-slayers/> accessed 29 May 2024.

Dreesbach, Anne, *Gezähmte Wilde. Die Zurschaustellung 'exotischer' Menschen in Deutschland 1870–1940* (Frankfurt am Main: Campus, 2005).

DuBois, W. E. B., *The Souls of Black Folk* (New York: Barnes & Noble Classics, 2003).

Dudley, Michael Kioni and Keoni Kealoha Agard, *A Call for Hawaiian Sovereignty*, Vol. 2. (Kapolei: Na Kane O Ka Malo Press, 1993).

Duffett, Mark, *Understanding Fandom: An Introduction to the Study of Media Fan Culture* (New York: Bloomsbury, 2013).

Eaglespeaker, Jason, et al., *UNeducation Volume 1: A Residential School Graphic Novel*, 2nd edn (Calgary: CreateSpace Independent Publishing Platform, 2014).

Egerer, Juliane, 'Teasing People into Health? Sami Cartoons, Indigenous Humour, and Provocative Therapy', in *Tijdschrift voor Skandinavistiek* 27/1 (2020a), 19–37. <https://doi.org/10.21827/tvs.37.1.36930> accessed 7 March 2024.

——, 'Exploring Transcultural Community: Realistic Visions in Sami (Norwegian-Danish) and Ojibwe (Canadian) Novels', in *Scandinavian-Canadian Studies/ Études Scandinaves au Canada* 27 (2020b), 2–34. <https://doi.org/10.29173/sca ncan181> accessed 7 March 2024.

Engholm, Ida and Erik Hansen-Hansen, 'The Fashion Blog as Genre – Between User Driven Bricolage Design and the Reproduction of Established Fashion System', in *Digital Creativity* 25/2 (2014), 140–154.

Erdrich, Louise, *The Round House* (London: Corsair, 2012).

'Eurocentrism', *Psychology*, IResearchNet. <www. psychology.iresearchnet.com/ counseling-psychology/multicultural-counseling/eurocentrism/> accessed 21 May 2024.

Evans, R. and William Thorpe, 'Indigenocide and the Massacre of Aboriginal History', in *Overland* 163 (2001), 21–39.

Fairclough, Norman, *Discourse and Social Change* (Cambridge: Polity, 1992).

Finlay, Barbara, 'Nonverbal Aspects of Nationalism in Musical Protest', unpublished manuscript, November 1980, typescript.

Fischer-Horning, Dorothea and Monika Mueller, eds, *Sleuthing Ethnicity: The Detective in Multiethnic Crime Fiction* (Madison, NJ: Fairleigh Dickinson University Press, 2003).

Fiske, John, *Reading the Popular* (London: Routledge, 2000).

Francis, Daniel, *The Imaginary Indian: The Image of the Indian in Canadian Culture* (Vancouver: Arsenal Pulp Press, 1992).

Frith, Simon, 'Popular Culture', in Michael Payne and Jessica Rae Barbera, eds, *A Dictionary of Cultural and Critical Theory* (Chichester: Wiley-Blackwell, 2010), 553–555.

Gamber, John, 'So, a Priest Walks into a Reservation Tragicomedy: Humor in *The Plague of Doves*', in Deborah Madsen, ed., *Louise Erdrich: Tracks, the Last Report on*

the Miracles at Little No Horse, The Plague of Doves (London: Continuum, 2011), 136–151.

Giddens, Anthony, *Modernity and Self-Identity: Self and Society in the Late Modern Age* (Stanford: Stanford University Press, 1991).

Glenn, Charles L., *American Indian/First Nations Schooling: From the Colonial Period to the Present* (New York: Palgrave MacMillan, 2011).

Goodman, Lesley, 'Disappointing Fans: Fandom, Fictional Theory, and the Death of the Author', in *Journal of Popular Culture* 48/4 (2015), 662–676.

Goodyear-Ka'opua, Noelani, Ikaika Hussey and Erin Kahunawaika'ala Wright, *A Nation Rising: Hawaiian Movements for Life, Land, and Sovereignty* (Durham: Duke University Press, 2014).

Governor's Office, 'Governor's Office Joint News Release: State Seeks Applicants for Mauna Kea Management Stewardship and Oversight Authority', *Governor of the State of Hawai'i Website*, 21 July 2022. <https://governor.hawaii.gov/newsroom/governors-office-joint-news-release-state-seeks-applicants-for-mauna-kea-management-stewardship-and-oversight-authority/> accessed 20 March 2024.

Gray, Jonathan, Cornel Sandvoss and C. Lee Harrington, 'Introduction: Why Study Fans?', in Jonathan Gray, Cornel Sandvoss and C. Lee Harrington, eds, *Fandom: Identities and Communities in a Mediated World* (New York: New York University Press, 2007), 1–16.

Gruber, Eva, 'Humorous Restorifications: Rewriting History with Healing Laughter', in Kerstin Knopf, ed., *Aboriginal Canada Revisited: Politics and Cultural Expression in the 21st Century* (Ottawa: University of Ottawa Press, 2008), 220–245.

Hagbrink, Bodil, *Barnen i Kautokeino* (Stockholm: Bonniers, 1986).

Hagen, Rune Blix, *Ved porten til helvete. Trolldomsforfølgelse i Finnmark* (Trondheim: Cappelen Damm, 2015).

——, 'Trolldomsforfølgelse Av Samer', *Norgeshistorie*, 24 August 2016. <http://www.norgeshistorie.no/kirkestat/artikler/1132-trolldomsforfolgelse-av-samer.html> accessed 7 March 2024.

Haircrow, Red, 'When I Think about America', *Medium*, 7 February 2020. <https://medium.com/@redhaircrow_74042/when-i-think-about-america-b1foeebf1a6b> accessed 21 May 2024.

Häkkinen, Ari and Sirpa Leppänen, 'YouTube Meme Warriors: Mashup Videos as Satire and Interventional Political Critique', in *eVarieng* 15 (2014). <http://www.helsinki.fi/varieng/series/volumes/15/> accessed 23 June 2020.

Hammerback, John C. and Richard J. Jensen, 'Ethnic Heritage as Rhetorical Legacy: The Plan of Delano', in *Quarterly Journal of Speech* 80/1 (1994), 53–70.

Hammett, Dashiell, *The Maltese Falcon* (New York: Vintage Crime/Black Lizard, 1989).

Hansen, Ketil Lenert, 'The History and Current Situation of Discrimination against the Sámi', in Sanna Valkonen, Áile Aikio, Saara Alakorva and Sigga-Marja Magga, eds, *The Sámi World* (London: Routledge, 2022), 328–347.

Harris, Anita, 'Young Women, Late Modern Politics, and the Participatory Possibilities of Online Cultures', in *Journal of Youth Studies* 11/5 (2008), 481–495.

Hatfield, Charles, *Alternative Comics: An Emerging Literature* (Jackson: University Press of Mississippi, 2005).

Hebdige, Dick, *Subculture: The Meaning of Style* (London: Routledge, 1979).

Heilmann, Ann and Mark Llewellyn, 'Introduction', in Ann Heilmann and Mark Llewellyn, eds, *Metafiction and Metahistory in Contemporary Women's Writing* (Basingstoke: Palgrave Macmillan, 2007), 1–14.

Helander, Elina and Kaarina Kailo, 'The Nomadic Circle of Life: A Conversation on the Sami Knowledge System and Culture', in Elina Helander and Kaarina Kailo, eds, *No Beginning, No End: The Sami Speak Up*. The Circumpolar Research Series No. 5 (Edmonton and Kautokeino: Canadian Circumpolar Institute and Nordic Sámi Institute, 1998), 163–184.

Henry, Gordon D. Jr, 'Allegories of Engagement: Stories/Theories – A Few Remarks', in Gordon D. Henry Jr, Nieves Pascual Soler and Silvia Martínez-Falquina, eds, *Stories Through Theories/Theories Through Stories: North American Indian Writing, Storytelling, and Critique* (East Lansing: Michigan State University Press, 2009), 1–24.

Herlinghaus, Hermann, 'Introduction: Towards a Cultural Pharmacology', in Hermann Herlinghaus, ed., *The Pharmakon: Concept Figure, Image of Transgression, Poetic Practice* (Heidelberg: Winter, 2018), 1–18.

Herrick, James A., *The History and Theory of Rhetoric: An Introduction* (New York: Routledge, 2017).

Highsmith, Patricia, *The Talented Mr Ripley* (London: W. W. Norton and Company, 2008).

Hilder, Thomas R., 'Sámi Festivals and Indigenous Sovereignty', in Fabian Holt and Antti-Ville Kärjä, eds, *The Oxford Handbook of Popular Music in the Nordic Countries* (New York: Oxford University Press, 2017), 363–378.

Hill, Gord, *The 500 Years of Resistance Comic Book* (Vancouver: Arsenal Pulp Press, 2010).

Himes, Chester, *Cotton Comes to Harlem* (New York: Vintage Crime/Black Lizard, 1988).

Hiraoka, Ryan and Keala Kawaauhau, *Rise Up*, digital album (Honolulu: Rubbah Slippah Productions LLC, 2015).

HNN, 'Protest against TMT Project to Take Place at UH-Manoa Campus', *Hawaii News Now*, 5 December 2018. <http://www.hawaiinewsnow.com/2018/12/05/prot est-against-tmt-project-take-place-uh-manoa-campus/> accessed 20 March 2024.

Huhndorf, Shari, *Going Native: Indians in the American Cultural Imagination* (Ithaca: Cornell University Press, 2001).

Hult, Francis, 'Analysis of Language Policy Discourses across the Scales of Space and Time', in *International Journal of the Sociology of Language*, Issue 202 (2010), 7–24.

Hætta, Kenneth, 'Å være same er ikke gøy', *NRK Sápmi*, 7 October 2010. <http://www.nrk.no/sapmi/samesatire-om-prestesex-1.7322873> accessed 7 March 2024.

Iglesias, Gabino, 'Grief and Guilt Spawn Horrors in *The Only Good Indians*', NPR, 16 July 2020. <https://www.npr.org/2020/07/16/891433693/grief-and-guilt-spawn-horrors-in-the-only-good-indians?t=1597327050247> accessed 27 May 2024.

Imada, Adria, 'Head Rush: Hip Hop and a Hawaiian Nation "On the Rise"', in Dipannita Basu and Sidney Lemelle, eds, *The Vinyl Ain't Final* (Ann Arbor: Pluto Press, 2006), 85–99.

Jenkins, Henry, *Textual Poachers: Television Fans and Participatory Culture* (New York: Routledge, 1992).

——, *Convergence Culture: Where Old and New Media Collide* (New York: NYU Press, 2006).

Jenkins, Henry and Dan Hassler-Forest, 'Foreword: "I Have a Bad Feeling About This": A Conversation about Star Wars and the History of Transmedia', in Sean Guynes, ed., *Star Wars and the History of Transmedia Storytelling* (Amsterdam: Amsterdam University Press, 2017), 15–32.

Jenkins, Henry, Mizuko Ito and danah boyd, *Participatory Culture in a Networked Era: A Conversation on Youth, Learning, Commerce, and Politics* (Cambridge, UK: Polity Press, 2016).

Johansen, Siri Broch, *Elsa Laula Renberg. Historien om samefolkets store Minerva* (Kárášjohka – Karasjok: Čálliid Lágádus, 2015).

Johnson, Derek, 'Fan-tagonisms: Factions, Institutions, and Constitutive Hegemonies of Fandom', in Jonathan Gray, Cornel Sandvoss and C. Lee Harrington, eds, *Fandom: Identities and Communities in a Mediated World* (New York: New York University Press, 2007), 285–300.

Jones, Stephen Graham, *The Fast Red Road: A Plainsong* (Tuscaloosa: Fiction Collective 2/The University of Alabama Press, 2000).

——, *All the Beautiful Sinners* (New York: Rugged Land, 2003).

——, *The Bird Is Gone: A Monograph Manifesto* (Tuscaloosa: Fiction Collective 2/The University of Alabama Press, 2003).

——, *Bleed into Me: A Book of Stories* (Lincoln: University of Nebraska Press, 2005).

——, *Demon Theory* (San Francisco: MacAdam/Cage, 2006).

——, *Ledfeather* (Tuscaloosa: Fiction Collective 2/The University of Alabama Press, 2008).

——, *All the Beautiful Sinners* (Westland, MI: Dzanc Books, 2011), ebook.

——, *Seven Spanish Angels* (Westland, MI: Dzanc Books, 2011).

——, 'All the Beautiful Sinners, Eight Years Later', *Demon Theory*, 20 October 2011. <https://www.demontheory.net/all-the-beautiful-sinners-eight-years-later> accessed 27 May 2024.

——, *Growing Up Dead in Texas* (Douglas, UK: MP Publishing, 2012).

——, *Not for Nothing* (Westland, MI: Dzanc Books, 2014).

——, 'Letter to a Just-Starting-Out Indian Writer', in Billy J. Stratton, ed., *The Fictions of Stephen Graham Jones: A Critical Companion* (Albuquerque: University of New Mexico Press, 2016a), xi–xvii.

——, *Mongrels* (New York: Harper Collins, 2016b).

——, *Mapping the Interior* (New York: A Tom Doherty Associates Book, 2017).

——, interview by Cécile Heim, Boulder, CO, 31 January 2018, unpublished.

——, 'In His New Book Stephen Graham Jones Explores the Idea of "Good Indians"', interview by Ari Shapiro, *Fresh Air*, NPR, 29 July 2020. <https://www.npr.org/2020/07/29/896840079/in-his-new-book-stephen-graham-jones-explores-the-idea-of-good-indians> accessed 27 May 2024.

——, 'Demon Theory', last modified 16 August 2020. <https://www.demontheory.net> accessed 27 May 2024.

Justice, Daniel Heath, *Why Indigenous Literatures Matter* (Waterloo: Wilfrid Laurier University Press, 2018).

Kanahele, George Hu'eu and George S. Kanahele, *Ku Kanaka Stand Tall: A Search for Hawaiian Values* (Honolulu: University of Hawaii Press, 1992).

Kauppinen, Kati, ' "Full Power Despite Stress": A Discourse Analytical Examination of the Interconnectedness of Postfeminism and Neoliberalism in the Domain of Work in an International Women's Magazine', in *Discourse & Communication* 7/2 (2013), 133–151.

——, 'Welcome to the End of the World! Resignifying Periphery under the New Economy: A Nexus Analytical View of a Tourist Website', in *Journal of Multicultural Discourses* 9/1 (2014), 1–19.

Keene, Adrienne, *Native Appropriations*, last modified 15 June 2020. <www.nativeappropriations.com>.

Keskinen, Suvi, Salla Tuori, Sari Irni and Diana Mulinari, eds, *Complying with Colonialism: Gender, Race and Ethnicity in the Nordic Region* (Surrey: Ashgate, 2009).

King, Thomas, *The Truth about Stories: A Native Narrative* (Toronto: Anansi, 2001).

——, *The Red Power Murders: A Dreadful Water Mystery* (New York: Harper Perennial, 2017).

The Kino-nda-niimi Collective, *The Winter We Danced: Voices from the Past, the Future and the Idle No More Movement* (Winnipeg: ARP Books, 2014).

Knight, Stephen, *Form and Ideology in Crime Fiction* (New York: Palgrave Macmillan, 1980).

———, *Crime Fiction since 1800: Detection, Death, Diversity* (New York: Palgrave Macmillan, 2010).

Knipe, Rita, *The Water of Life: A Jungian Journey Through Hawaiian Myth* (Honolulu: University of Hawaii Press, 1989).

Körber, Lill-Ann and Ebbe Volquardsen, eds, *The Postcolonial North Atlantic: Iceland, Greenland and the Faroe Islands* (Berlin: HU, 2012).

Kovach, Margaret, *Indigenous Methodologies: Characteristics, Conversations, and Contexts* (Toronto: University of Toronto Press, 2012).

Kress, Gunther and Theo van Leeuwen, *Multimodal Discourse: The Modes and Media of Contemporary Communication* (London: Arnold, 2001).

Kristofferson, Rob, 'Resistance Comics', in *Labour/Le Travail* 86 (2020), 177–190.

Kristofferson, Rob and Simon Orpana, 'Shaping Graphic History: Primary Sources and Closure in *Showdown! Making Modern Unions*', in *Labor/La Travail* 82 (2018), 189–226.

Kuokkanen, Rauna, 'Saamelaiset ja kolonialismin vaikutukset nykypäivänä [The Sámi and the Impact of Colonialism Today]', in Joel Kuortti, Mikko Lehtinen and Olli Löytty, eds, *Kolonialismin jäljet: keskustat, periferiat ja Suomi* [The Traces of Colonialism: Centres, Peripheries and Finland] (Helsinki: Gaudeamus, 2007), 142–155.

Lake, Randall A., 'Enacting Red Power: The Consummatory Function in Native American Protest Rhetoric', in *Quarterly Journal of Speech* 69/2 (1983), 127–142.

LaPensée, Elizabeth, 'Letter from the Guest Editor', in *kimiwan, Special Issue on Indigenous Futurisms* 8 (2014), 3.

LaRocque, Emma, '"Resist No Longer": Reflections on Resistance in Writing and Teaching', in Elaine Coburn, ed., *More Will Sing Their Way to Freedom: Indigenous Resistance and Resurgence* (Halifax: Fernwood Publishing, 2015), 5–23.

Larsen, Dan Robert, 'Utgir tegneseriealbum på samisk', *NRK Sápmi*, 11 March 2011. <https://www.nrk.no/sapmi/utgir-tegneseriealbum-pa-samisk-1.7545543> accessed 7 March 2024.

———, 'Samisk tegneserie topprangert', *NRK Sápmi*, 26 April 2012. <https://www.nrk.no/sapmi/samisk-tegneserie-topprangert-1.8102797> accessed 7 March 2024.

———, 'Sápmi tegneserie ut til et større publikum', *NRK Sápmi*, 15 January 2015. <https://www.nrk.no/sapmi/sapmi-tegneserie-ut-til-et-storre-publikum-1.12150158> accessed 7 March 2024.

Lee, Lloyd L., 'Introduction', in Lloyd L. Lee, ed., *Diné Perspectives: Revitalizing and Reclaiming Navajo Thought* (Tucson: University of Arizona Press, 2014), 3–13.

Lehtola, Veli-Pekka, 'Aito Lappalainen ei syö haarukalla ja veitsellä [A real Lapp Does Not Eat with Fork and Knife]', in Marja Tuominen, Seija Tuulentie, Veli-Pekka Lehtola and Mervi Autti, eds, *Pohjoiset identiteetit ja mentaliteetit 1* [Northern Identities and Mentalities 1] (Inari: Kustannus-Puntsi, 1999), 15–32.

——, *Saamelaiskiista: Sortaako Suomi alkuperäiskansaansa?* [The Sami Contention: Does Finland Oppress Its Indigenous People?] (Helsinki: Into, 2015).

Lewis, George H., 'Style in Revolt: Music, Social Protest, and the Hawaiian Cultural Renaissance', in *International Social Science Review* 62/4 (1987), 168–177.

Lilienskiold, Hans H., Rune Hagen and Per Einar Sparboe, eds, *Trolldom og ugudelighet i 1600-tallets Finnmark* (Tromsø: Universitetsbibliotekets i Tromsøs skriftserie ravnetrykk Nr. 18, 1998).

Loft, Steven, 'Decolonizing the "Web"', in Steven Loft and Kerry Swanson, eds, *Coded Territories: Tracing Indigenous Pathways in New Media Art* (Calgary: University of Calgary Press, 2014), xv–xvii.

Lorde, Audre, 'The Master's Tools Will Never Dismantle the Master's House', in *Sister Outsider: Essays and Speeches* (Berkeley, CA: Crossing Press, 2007), 110–114.

Lovegrove, Kimberley, 'Indigenous Comic Con Coming to Australia in 2019', *IndigenousX*, 3 December 2018. < https://indigenousx.com.au/indigenous-comic-con-coming-to-australia-in-2019/> accessed 30 May 2024.

Machin, David and Theo van Leeuwen, 'Language Style and Lifestyle: The Case of a Global Magazine', in *Media, Culture & Society* 27/4 (2005), 577–600.

Malmgrem, Carl D., *Anatomy of Murder: Mystery, Detective, and Crime Fiction* (Bowling Green, OH: Bowling Green State University Popular Press, 2001).

Malo, David, 'On the Decrease of Population on the Hawaiian Islands', in *Hawaiian Spectator* 2 (1839), 127–131.

Manderstedt, Lena, Annbritt Palo and Lydia Kokkola, 'Rethinking Cultural Appropriation in YA Literature through Sámi and Arctic Pedagogies', in *Children's Literature in Education* 52 (2021), 88–105. <https://doi.org/10.1007/s10583-020-09404-x> accessed 7 March 2024.

Manker, Ernst, *Die Lappische Zaubertrommel. Eine ethnologische Monographie. I. Die Trommel als Denkmal materieller Kultur* (Nordiska Museet: Acta Lapponica I. Stockholm: Bokförlags Aktiebolaget Thule, 1938).

——, *Die Lappische Zaubertrommel. Eine ethnologische Monographie. II. Die Trommel als Urkunde geistigen Lebens* (Nordiska Museet: Acta Lapponica VI. Stockholm: Hugo Gebers Förlag, 1950).

——, *Boken om Skum* (Stockholm: LT Förlag, 1965).

Maracle, Lee, 'Oratory: Coming to Theory', in Heather Macfarlane and Armond Garnet Ruffo, eds, *Introduction to Indigenous Literary Criticism in Canada* (Peterborough: Broadview, 2016 [1992]), 61–65.

Martínez-Rivera, Mintzi Auanda, '(Re)imagining Indigenous Popular Culture', in Domino Renee Perez and Rachel González-Martin, eds, *Race and Cultural Practice in Popular Culture* (New Brunswick: Rutgers University Press, 2019), 91–109.

Matzke, Christine and Susanne Mühleisen, eds, *Postcolonial Postmortems: Crime Fiction from a Transcultural Perspective* (Amsterdam: Rodopi, 2006).

McCann, Sean, *Gumshoe America: Hard-boiled Crime Fiction and the Rise and Fall of New Deal Liberalism* (Durham: Duke University Press, 2000).

McCarthy, Cormac, *Blood Meridian or the Evening Redness in the West* (New York: Vintage International, 1992).

McGlennen, Molly, 'Ignatia Broker's Lived Feminism: Toward a Native Women's Theory', in Gordon J. Henry, Nieves Pascual Soler and Silvia Martínez-Falquina, eds, *Stories through Theories, Theories through Stories: North American Indian Writing, Storytelling, and Critique* (East Lansing: Michigan State University Press, 2009), 105–120.

McLeod, Neal, 'Coming Home through Stories', in Heather Macfarlane and Armand Garnet Ruffo, eds, *Introduction to Indigenous Literary Criticism in Canada* (Peterborough: Broadview Press, 2016), 170–186.

McRae, Chris, 'Hearing Performance as Music', in *Liminalities: A Journal of Performance Studies* 11/5 (2015), 1–19.

McRobbie, Angela, 'Post-feminism and Popular Culture', in *Feminist Media Studies* 4/3 (2004), 255–264.

——, *The Aftermath of Feminism: Gender, Culture and Social Change* (London: Sage, 2009).

Medawar, Marid Oakley, *Death at Rainy Mountain* (Berkeley: Berkley Trade, 1998).

Mikkonen, Nadja, 'Kyse on oikeudesta maahan, kieleen ja kulttuuriin [It's About Right to Land, Language and Culture]', in *YLE uutiset* [YLE News], 9 September 2016. <http://yle.fi/uutiset/3-9135075> accessed 23 September 2023.

Million, Dian, 'Felt Theory', in *American Quarterly* 60/2 (2008), 267–272.

Minde, Henry, 'The Destination and the Journey: Indigenous Peoples and the United Nations from the 1960s through 1985', in Henry Minde, Svein Jentoft, Harald Gaski and Georges Midré, eds, *Indigenous Peoples: Self-determination, Knowledge, Indigeneity* (Delft: Eburon, 2008), 49–86.

Minde, Henry, Svein Jentoft, Harald Gaski and Georges Midré, eds, *Indigenous Peoples: Self-determination, Knowledge, Indigeneity* (Delft: Eburon, 2008).

Miyose, Colby and Eean Grimshaw, 'Ua mau ke ea o ka 'āina i ka pono: Cultural Appropriation of the Hawaiian Language in Hawaii Five-o', in *Prism* 15/1 (2019), 1–17.

Montes, Brian, 'Maya *Historietas* as Art for Remembering War', in Frederick Luis Aldama, ed., *Graphic Indigeneity: Comics in the Americas and Australasia* (Jackson: University Press of Mississippi, 2020), 197–209.

Moore, Lewis D., *Cracking the Hard-Boiled Detective: A Critical History from the 1920s to the Present* (Jefferson, NC: McFarland, 2006).

Moriarty, Máiréad, 'Súil Eile: Media, Sociolinguistic Change and the Irish Language', in Jannis Androutsopoulos, ed., *Mediatization and Sociolinguistic Change* (Berlin: DeGryuter, 2014), 463–486.

Morishita, Ashley, 'Lost in the Shuffle: "Rise Up" for Mauna a Wākea', *Ka Leo o Nā Koa: The Voice of the Warriors*, 18 April 2015. <https://kaleoonakoa.org/opini ons/2015/04/18/lost-in-the-shuffle-rise-up-for-mauna-a-wakea/> accessed 20 March 2024.

Morris, Charles E. and Stephen H. Browne, *Readings on the Rhetoric of Social Protest* (Philadelphia: Strata Publishing Inc., 2013).

Morris, Christine, 'Indians and Other Aliens: A Native American View of ScienceFiction', in *Extrapolation* 20/4 (1979), 301–307.

Mosbergen, Dominique, 'Hawaii's Supreme Court Approves Giant Telescope on Sacred Mountain', *Huffington Post*, 31 October 2018. <https://www.huffing tonpost.com/entry/hawaii-thirty-meter-telescope-permit-supreme court_us_ 5bd93964e4b0da7bfc150bb3> accessed 20 March 2024.

Munch Edvard, 'Munchmuseet, MM T 2367', *eMunch – Edvard Munchs tekster digitalt arkiv*, 1892. <https://emunch.no/HYBRIDNo-MM_T2367.xhtml> accessed 7 March 2024.

——, 'Skrik', *Nasjonalmuseet*, 1893. <https://www.nasjonalmuseet.no/samlingen/obj ekt/NG.M.00939> accessed 7 March 2024.

Näkkäläjärvi, Pirita, 'Näkökulma: Närkästyneet saamelaiset otsikoissa [Perspective: The Sore Sámi in the Headlines]', in *YLE Saame*, 16 May 2016. <http://yle.fi/uutiset/ osasto/sapmi/nakokulma_narkastyneet_saamelaiset_otsikoissa/8877876> ac- cessed 17 Juni 2023.

Nelson, Robin, *Practice as Research in the Arts: Principles, Protocols, Pedagogies, Resist- ances* (Basingstoke: Palgrave Macmillan, 2013).

Nieguth, Tim, *The Politics of Popular Culture: Negotiating Power, Identity and Place* (Montreal: McGill-Queen's University Press, 2015).

Noori, Margaret, 'Native American Narratives from Early Art to Graphic Novels: *How We See Stories/Ezhi-g'waabamaanaanig Aadizookaanag*', in Frederick Luis Aldama, ed., *Multicultural Comics: From Zap to Blue Beetle* (Austin: University of Texas Press, 2010), 55–72.

Noppari, Elina and Mikko Hautakangas, *Kovaa työtä olla minä. Muotibloggaajat mediamarkkinoilla* [Hard Work to Be Me. Fashion Bloggers on the Media Market] (Tampere: Tampere University Press, 2012).

O'Riley, Michael F., 'Postcolonial Haunting: Anxiety, Affect, and the Situated En- counter', in *Postcolonial Text* 3/4 (2007), 1–15.

Osumare, Halifu, 'Beat Streets in the Global Hood: Connective Marginalities of the Hip Hop Globe', in *Journal of American & Comparative Cultures* 24/1–2 (2001), 171–181.

Owens, Louis, *Bone Game: A Novel* (Norman: University of Oklahoma Press, 1996).

Paretsky, Sara, *Indemnity Only* (New York: Dell, 2010).

Pepper, Andrew, *The Contemporary American Crime Novel: Race, Ethnicity, Gender, Class* (Chicago: Fitzroy Dearborn Publishers, 2000).

Perry, Imani, *Prophets of the Hood: Politics and Poetics in Hip Hop* (Durham: Duke University Press, 2004).

Pietikäinen, Sari, 'Kieli-ideologiat arjessa. Neksusanalyysi monikielisen inarinsaamenpuhujan kielielämäkerrasta [Language Ideologies in Everyday Life. A Nexus Analysis of the Language Biography of a Multilingual Inari Sámi Speakers Language Biography]', in *Virittäjä* 3 (2012), 410–440.

——, 'Multilingual Dynamics in Sámiland: Rhizomatic Approach to Changing Language', in *International Journal of Bilingualism* 19/2 (2015), 206–225.

Pietikäinen, Sari and Sirpa Leppänen, 'Saamelaiset toisin sanoin [The Sámi in Other Words]', in Joel Kuortti, Mikko Lehtinen and Olli Löytty, eds, *Kolonialismin jäljet: keskustat, periferiat ja Suomi* [The Traces of Colonialism: Centres, Peripheries and Finland] (Helsinki: Gaudeamus, 2007), 175–189.

Pihlainen, Kalle, 'Of Closure and Convention: Surpassing Representation through Performance and the Referential', in *Rethinking History* 6/2 (2002), 179–200.

——, 'Performance and the Reformulation of Historical Representation', in *Storia della Storiagrafia* 51 (2007), 3–16.

——, 'Futures for the Past ("This is a stub")', in *Rethinking History* 20/3 (2016), 315–318.

Platou, Jeanette, Barbro Ross Viallatte and Vivien Cunningham, *NRK Bokprogrammet*, 25 March 2014. <http://tv.nrk.no/serie/bokprogrammet/MKTF01000814/25-03-2014> accessed 7 March 2024.

Poe, Edgar Allan, 'The Murders in the Rue Morgue', in Jonty Claypole, ed., *Tales of Mystery and Imagination* (London: Penguin Collector's Library, 2003), 107–152.

——, 'The Mystery of Marie Rogêt', in Jonty Claypole, ed., *Tales of Mystery and Imagination* (London: Penguin Collector's Library, 2003), 153–219.

——, 'The Purloined Letter', in Jonty Claypole, ed., *Tales of Mystery and Imagination* (London: Penguin Collector's Library, 2003), 220–244.

Polak, Kate, *Ethics in the Gutter: Empathy and Historical Fiction in Comics* (Columbus: The Ohio State University Press, 2017).

Powell, Malea, 'Rhetorics of Survivance: How American Indians Use Writing', in *College Composition and Communication* 53/3 (2002), 396–434.

Priestman, Martin, ed., *The Cambridge Companion to Crime Fiction* (Cambridge: Cambridge University Press, 2003).

Prior, Lindsay, 'Following in Foucault's Footsteps: Text and Context in Qualitative Research', in David Silverman, ed., *Qualitative Research: Theory, Method and Practice* (Newbury Park, CA: Sage, 1997), 63–79.

Quirk, Trevor, 'Sovereignty under the Stars: On the Island of Hawaii, a Proposed Telescope Has Ignited a Fight between the Champions of Modern Astronomy and

Hawaiians Seeking to Protect a Sacred Site', in *Virginia Quarterly Review* 93/1 (2017), 70–87.

Ramnarine, Tina K., 'Aspirations, Global Futures, and Lessons from Sámi Popular Music for the Twenty-First Century', in Fabian Holt and Antti-Ville Kärjä, eds, *The Oxford Handbook of Popular Music in the Nordic Countries* (New York: Oxford University Press, 2017), 277–292.

Rasmussen, Torkel, Inker-Anni Sara and Roy Krøvel, 'The History of the Hybrid Sámi Media System', in Sanna Valkonen, Áile Aikio, Saara Alakorva and Sigga-Marja Magga, eds, *The Sámi World* (London: Routledge, 2022), 415–429.

Reddy, Maureen T., *Sisters in Crime: Feminism and the Crime Novel* (London: Continuum, 1988).

——, *Traces, Codes, and Clues: Reading Race in Crime Fiction* (Chicago: Rutgers University Press, 2002).

——, 'Race and American Crime Fiction', in Catherine Ross Nickerson, ed., *The Cambridge Companion to American Crime Fiction* (Cambridge: Cambridge University Press, 2010), 135–147.

Reder, Deanna, *Autobiography as Indigenous Intellectual Tradition: Cree and Métis âcimisowina* (Waterloo: Wilfrid Laurier University Press, 2022).

Reder, Deanna and Linda M. Morra, eds, *Troubling Tricksters: Revisioning Critical Conversations* (Waterloo: Wilfrid Laurier University Press, 2010).

'Redraw', 3.a, *Oxford English Dictionary*, September 2023. <https://doi.org/10.1093/OED/1201088562> accessed 7 March 2024.

Rettberg, Jill Walker, *Blogging*, 2nd edn (Cambridge: Polity Press, 2014).

'Rewrite', *Cambridge Advanced Learner's Dictionary*, 4th edn, CD-ROM (Cambridge University Press, 2013).

Rieder, John, *Colonialism and the Emergence of Science Fiction* (Middletown, CT: Wesleyan University Press, 2008).

Rifkind, Candida and Jessica Fontaine, 'Indigeneity, Intermediality, and the Haunted Present of *Will I See?*', in Frederick Luis Aldama, ed., *Graphic Indigeneity: Comics in the Americas and Australasia* (Jackson: University Press of Mississippi, 2020), 340–360.

Roberts, Jerry, *The Complete History of Film Criticism* (Santa Monica: Santa Monica Press, 2010).

Robertson, David Alexander, *Sugar Falls: A Residential School Story* (Vancouver: HighWater Press, 2011).

——, Illustrated by Scott B. Henderson, *7 Generations: A Plains Cree Saga* (Winnipeg: HighWater Press, 2012).

Rocamora, Agnes, 'Personal Fashion Blogs: Screens and Mirrors in Digital Self Portraits', in *Fashion Theory* 15/4 (2011), 407–424.

Rogue One: A Star Wars Story, dir. Gareth Edwards (San Francisco: Lucasfilm, 2016).

Ross, Andrew S. and Damien J. Rivers, 'Digital Cultures of Political Participation: Internet Memes and the Discursive Delegitimization of the 2016 US Presidential Candidates', in *Discourse, Context and Media* 16 (2017), 1–11.

Ross-Nickerson, Catherine, ed., *The Cambridge Companion to American Crime Fiction* (Cambridge: Cambridge University Press, 2010).

Rzepka, Charles and Lee Horsley, eds, *A Companion to Crime Fiction* (Hoboken, NJ: Wiley-Blackwell, 2010).

Sandström, Moa, *Dekolonieseringskonst. Artivism i 2010-talets Sápmi* (Umeå: Sámi dutkan/Institutionen för språkstudier, 2020).

Sannhets- og forsoningskommisjonen, *Sannhet og forsoning – grunnlag for et oppgjør med fornorskingspolitikk og urett mot samer, kvener/norskfinner og skogfinner. Rapport til Stortinget fra Sannhets- og forsoningskommisjonen. Avgitt til Stortingets presidentskap 01.06.2023* (Oslo: Sannhets- og forsoningskommisjonen, 2023). <https://www.sto rtinget.no/globalassets/pdf/sannhets--og-forsoningskommisjonen/rapport-til-stortinget-fra-sannhets--og-forsoningskommisjonen.pdf> accessed 7 March 2024.

Sano se saameksi. Pikaopas saamelaiskulttuuriin [Say It in Sámi. A Quick Guide to the Sámi Culture], n.d. <http://sanosesaameksi.yle.fi/pikaopas-saamelaiskulttuuriin/ > accessed 20 August 2023.

Scaggs, John, *Crime Fiction* (London: Routledge, 2005).

Schell, John Logan, 'This Is Who I Am: Hybridity and Materiality in Comics Memoir', in Frederick Luis Aldama, ed., *The Oxford Handbook of Comic Book Studies* (Oxford: Oxford University Press, 2020), 256–276.

Schroeder, Jonathan E., and Janet L. Borgerson, 'Packaging Paradise: Consuming Hawaiian Music', in Anshuman Prasad, ed., *Against the Grain: Advances in Postcolonial Organization Studies* (Copenhagen: Copenhagen Business School Press, 2012), 32–53.

Scollon, Ron and Suzie Wong Scollon, *Nexus Analysis: Discourse and the Emerging Internet* (London: Routledge, 2004).

Shiloh, Ilana, *The Double, the Labyrinth and the Locked Room: Metaphors of Paradox in Crime Fiction and Film* (Bern: Peter Lang, 2011).

Siméant, Johanna and Christophe Traïni, *Bodies in Protest: Hunger Strikes and Angry Music* (Amsterdam: Amsterdam University Press, 2016).

Simpson, Leanne, *Dancing on Our Turtle's Back: Stories of Nishnaabeg Re-creation, Resurgence and a New Emergence* (Winnipeg: Arbeiter Ring Publishing, 2011).

Snorri Sturluson and Bjarni Aðalbjarnarson, *Heimskringla* (Reykjavík, Ísland: Hið Íslenzka Fornritafélag, 1941).

Smith, Linda Tuhawai, *Decolonizing Methodologies: Research and Indigenous Peoples* (London: Zed Books, 1999).

Soitos, Stephen, *The Blues Detectives: A Study of African American Detective Fiction* (Boston: University of Massachusetts Press, 1996).

Sons of Yeshua, *#WeAreMaunaKea* (Honolulu: Rubbah Slippah Productions LLC, April 2015).

Spillane, Mickey, *I, the Jury* (London: Penguin, 1975).

Stanfill, Mel, 'The Unbearable Whiteness of Fandom and Fan Studies', in Paul Booth, ed., *A Companion to Media Fandom and Fan Studies* (Hoboken: Wiley, 2018), 305–318.

Star Wars: Episode IV – A New Hope, dir. George Lucas (San Francisco: Lucasfilm, 1977).

Star Wars: Episode V – The Empire Strikes Back, dir. Irvin Kushner (San Francisco: Lucasfilm, 1980).

Star Wars: Episode VI – Return of the Jedi, dir. Richard Marquand (San Francisco: Lucasfilm, 1983).

Star Wars: Episode VIII – The Last Jedi, dir. Rian Johnson (San Francisco: Lucasfilm, 2017).

The Star Wars Holiday Special, dir. Steve Binder (Hollywood: Smith-Dwight Hemion Productions, 1978).

Stillman, Amy K., 'Hula Hits, Local Music and Local Charts: Some Dynamics of Popular Hawaiian Music', in Philip Hayward, ed., *Sound Alliances: Indigenous Peoples, Cultural Politics and Popular Music in the Pacific* (New York: Bloomsbury Academic Collections, 1998), 89–103.

Storey, John, *Cultural Theory and Popular Culture: An Introduction* (Harlow: Pearson Education, 2006).

Stortinget, 'Innstilling 493 S, Innstilling fra kontroll- og konstitusjonskomiteen om representantforslag om en sannhetskommisjon for fornorskningspolitikk og urett begått mot det samiske og kvenske folk i Norge', *Stortinget*, 2016–2017. <https://www.stortinget.no/no/Saker-og-publikasjoner/Publikasjoner/Innstillinger/Stortinget/2016–2017/inns-201617–493s/> accessed 7 March 2024.

——, 'Instilling 408 S, Innstilling fra Stortingets presidentskap om mandat for og sammensetning av kommisjonen som skal granske fornorskingspolitikk og urett overfor samer, kvener og norskfinner – BERIKTIGET', *Stortinget*, 2017–2018. <https://www.stortinget.no/no/Saker-og-publikasjoner/Publikasjoner/Innstillinger/Stortinget/2017–2018/inns-201718–408s/> accessed 7 March 2024.

——, 'Sannhets- og forsoningskommisjonen', *Stortinget*, 24 June 2021. <https://www.stortinget.no/no/Hva-skjer-pa-Stortinget/Nyhetsarkiv/Hva-skjer-nyheter/2017–2018/sannhets--og-forsoningskommisjonen/> accessed 7 March 2024.

Stratton, Billy J., ed., *The Fictions of Stephen Graham Jones: A Critical Companion* (Albuquerque: University of New Mexico Press, 2016).

Street, John, *Music and Politics* (Hoboken: Wiley, 2013).

Strete, Craig, 'Letter to the Editor', in *Amazing: Science Fiction* 48/2 (1974), 73–74.

Swain, Molly and Chelsea Vowel, '1.1: *Buffy* "Pangs"', *Métis in Space*, Podcast, 51:02, 2 April 2016. <http://www.metisinspace.com/episodes/2016/4/2/mtis-in-space-ep1-buffy-pangs>.

——, '1.2: *Quantum Leap* "Freedom"', *Métis in Space*, Podcast, 1:09:36, 2 April 2016. <http://www.metisinspace.com/episodes/2016/4/2/mtis-in-space-ep2-quantum-leap-freedom>.

——, '1.4: *Supernatural* "Wendigo"', *Métis in Space*, Podcast, 59.41, 2 April 2016. <http://www.metisinspace.com/episodes/2016/4/2/mtis-in-space-ep4-super natural-wendigo>.

——, '1.5: Montreal ComicCon Special', *Métis in Space*, Podcast, 1:15:41 2 April 2016. <http://www.metisinspace.com/episodes/2016/4/2/mtis-in-space-ep5-montreal-comiccon-special>.

——, '1.6: *Star Trek: The Original Series* "The Paradise Syndrome"', *Métis in Space*, Podcast, 1:17:47, 2 April 2016. <http://www.metisinspace.com/episodes/2016/4/2/mtis-in-space-ep6-star-trek-the-original-series-the-paradise-syndrome>.

——, '1.10: The Nü Moccasin Telegraph Interview', *Métis in Space*, Podcast, 13:12, 2 April 2016. <http://www.metisinspace.com/episodes/2016/4/2/mtis-in-space-ep10-the-n-moccasin-telegraph-interview>.

——, '1.11: Star Trek TNG "Journey's End"', *Métis in Space*, Podcast, 1:34:20, 2 April 2016. <http://www.metisinspace.com/episodes/2016/4/2/mtis-in-space-ep11-star-trek-tng-journeys-end>.

——, '2.1: *Cowboys & Aliens*', *Métis in Space*, Podcast, 1:22:50, 2 April 2016. <http://www.metisinspace.com/episodes/2016/4/2/mtis-in-space-s2-ep1-cowboys-aliens>.

——, '2.5: *Are You Afraid of the Dark* "The Tale of The Manaha"', Podcast, 50:04, 2 April 2016. <http://www.metisinspace.com/episodes/2016/4/2/mtis-in-space-s2-ep5-are-you-afraid-of-the-dark-the-tale-of-the-manaha>.

——, '2.6: LIVE at UBC Sty-Wet-Tan Great Hall', *Métis in Space*, Podcast, 2:03:25, 2 April 2016. <http://www.metisinspace.com/episodes/2016/4/2/mtis-in-space-s2-ep6-live-at-ubc-sty-wet-tan-great-hall>.

——, '4.3: Atotam Literary Festival Live Shorts', *Métis in Space*, Podcast, 43:48, 8 November 2017. <http://www.metisinspace.com/episodes/2017/11/8/mtis-in-space-s4-ep3-atotam-literary-festival-live-shorts>.

——, '4.5: Generation Energy Science Interview', *Métis in Space*, Podcast, 53:40, 11 November 2017. <http://www.metisinspace.com/episodes/2017/11/11/mtis-in-space-s4-ep5-generation-energy-science-interview>.

——, '4.7: Si Vis Pacem, Para Bellum, Live at McGill', *Métis in Space*, Podcast, 58:59, 20 April 2018. <http://www.metisinspace.com/episodes/2018/4/20/mtis-in-space-s4-ep7-si-vis-pacem-para-bellum-live-at-mcgill>.

——, '4.8: *Thor: Ragnarok*', *Métis in Space*, Podcast, 1:36:53, 10 June 2018. <http://www.metisinspace.com/episodes/2018/6/10/mtis-in-space-s4-ep8-thor-ragnarok>.

——, '4.9: *Indians and Aliens*, "Episode 1"', *Métis in Space*, Podcast, 44.14, 21 June 2018. <http://www.metisinspace.com/episodes/2018/6/21/mtis-in-space-s4-ep9-indians-and-aliens-episode-1>.

——, '5.1: Resistance and Resilience Symposium: 3 Shorts', *Métis in Space*, Podcast, 57:33, 13 September 2018. <http://www.metisinspace.com/episodes/2018/9/13/mtis-in-space-s5-ep1-resistance-and-resilience-symposium-3-shorts>.

——, 'About', *Métis in Space*. <http://www.metisinspace.com/about> accessed 28 September 2018.

——, 'Métis in Space', in *kimiwan, Special Issue on Indigenous Futurisms* 8 (2014), 14–16.

Takacs, Stacy, *Interrogating Popular Culture: Key Questions* (New York: Routledge, 2015).

Taylor, Drew Hayden, 'Interview with Drew Hayden Taylor' by Birgit Däwes and Robert Nunn, in Robert Nunn, ed., *Drew Hayden Taylor: Essays on His Work* (Toronto: Guernica, 2008), 190–240.

——, *Night Wanderer: A Native Gothic Novel* (Toronto: Annick Press, 2012).

Teves, Stephanie, '"Bloodline Is All I Need": Defiant Indigeneity and Hawaiian Hip-Hop', in *American Indian Culture and Research Journal* 35/4 (2011), 73–101.

——, *Defiant Indigeneity: The Politics of Hawaiian Performance* (Chapel Hill: University of North Carolina Press, 2018).

Theodoropoulou, Vivi, 'The Anti-fan Within the Fan: Awe and Envy in Sport Fandom', in Jonathan Gray, Cornel Sandvoss and C. Lee Harrington, eds, *Fandom: Identities and Communities in a Mediated World* (New York: New York University Press, 2007), 316–327.

Thibodeau, Anthony, ed., 'The Force Is with Our People', in *Plateau* 11/1 (2020).

Trask, Haunani-Kay, *From a Native Daughter: Colonialism and Sovereignty in Hawai'i* (Honolulu: University of Hawai'i Press, 1993).

Tso, Theo, *Captain Paiute*, issue #0 (Albuquerque: Native Realities, 2015).

Tuck, Eve and K. Wayne Yang, 'Decolonization Is Not a Metaphor', in *Decolonization: Indigeneity, Education and Society* 1/1 (2012), 1–40.

UH News, 'Group of UH Students and Faculty Affirmed Opposition to Thirty Meter Telescope', *University of Hawai'i News*, 6 December 2018. <https://www.hawaii.edu/news/2018/12/06/group-affirmed-opposition-tmt/> accessed 20 March 2024.

——, '8 Nominees Proposed for New Mauna Kea Authority Board', *University of Hawai'i News*, 13 September 2022. <https://www.hawaii.edu/news/2022/09/13/8-nominees-mauna-kea-authority-board/> accessed 20 March 2024.

Uthaug, Maren, *Marens Blog*, 2009–ongoing. <https://marenuthaug.wordpress.com/maren-uthaug/> and <https://www.facebook.com/MarensBlog> accessed 7 March 2024.

——, *Det er gøy å være same* (Karasjok: ČálliidLágádus, 2010a).

——, *Ságer somá leat sápmelažžan* (Karasjok: ČálliidLágádus, 2010b).

——, *Same shit* (Karasjok: ČálliidLágádus, 2011a).

——, *Ságeris Ságat* (Karasjok: ČálliidLágádus, 2011b).

——, *Mens vi venter på solen* (Karasjok: ČálliidLágádus, 2012a).

——, *Berkelen Saernieh* (Karasjok: ČálliidLágádus, 2012b).

——, *Tjalluhis Sága* (Karasjok: ČálliidLágádus, 2012c).

——, *Dan botta go vuordit beaivváža* (Karasjok: ČálliidLágádus, 2012d).

——, 'Ting jeg gjorde', *Politiken*, 2013–ongoing. <http://politiken.dk/striber/tingje ggjorde/> accessed 7 March 2024.

——, *Og sådan blev det* (København: Lindhardt og Ringhof, 2013a).

——, *Madi bæjvátjav vuordatjip* (Karasjok: ČálliidLágádus, 2013b).

——, *Dan bodten goh biejjiem vuertebe* (Karasjok: ČálliidLágádus, 2013c).

——, *Og sånn ble det*, translated into Norwegian by Eivind Lilleskjæret (Bastion Forlag: Oslo, 2014).

——, *Det var en gang en same. En nesten sann fortelling om sameness historie* (Karasjok: ČálliidLágádus, 2015a).

——, *Lei oktii muhtin sápmelaš: measta áibbas duohta muitalus sámiid historjjás* (Karasjok: ČálliidLágádus, 2015b).

——, *Nu dat lei*, translated into North Sámi by Hans Petter Boyne (Karasjok: ČálliidLágádus, 2016a).

——, *Aktii lij muhtem sábme. Vargga duohta subtsas sámehiståvrås* (Karasjok: ČálliidLágádus, 2016b).

——, *Hvor der er fugle* (København: Lindhardt og Ringhof, 2017a).

——, *Ikth lij saametje: mahte eevre saetnies saemien soptsese* (Karasjok: ČálliidLágádus, 2017b).

——, *En lykkelig slutning* (København: Lindhardt og Ringhof, 2019).

——, *11%* (København: Lindhardt og Ringhof, 2022).

Vizenor, Gerald, *Fugitive Poses: Native American Indian Scenes of Absence and Presence* (Lincoln: University of Nebraska Press, 1998).

Vowel, Chelsea, *Buffalo Is the New Buffalo* (Vancouver: Arsenal Pulp Press, 2022).

Walker, Taté, 'Making Space for Indigenerds', in *Native Peoples* 29/6 (2016), 18–19.

Waltah, Bruddah and Island Afternoon, *Hawaiian Reggae* (Honolulu: Platinum Pacific Records, 1990).

Wanzo, Rebecca, 'African American Acafandom and Other Strangers: New Genealogies of Fan Studies', in *Transformative Works and Cultures* 20 (2015). <https://journal.transformativeworks.org/index.php/twc/article/view/699/538>.

Weaver, Jace, *That the People Might Live: Native American Literatures and Native American Community* (New York: Oxford University Press, 1997a).

——, 'Native American Authors and Their Communities', in *Wicazo Sa Review* 12/1 (1997b), 47–87.

Weintraub, Andrew N., 'Jawaiian Music and Local Cultural Identity in Hawai`I', in Philip Hayward, ed., *Sound Alliances: Indigenous Peoples, Cultural Politics and Popular Music in the Pacific* (New York: Bloomsbury Academic Collections, 1998), 78–87.

Werner, Ann, 'Digitally Mediated Identity in the Cases of Two Sámi Artists', in Fabian Holt and Antti-Ville Kärjä, eds, *The Oxford Handbook of Popular Music in the Nordic Countries* (New York: Oxford University Press, 2017), 379–393.

'What Is the Transformative Learning Theory', *Western Governors University Blog*, 17 July 2020. <https://www.wgu.edu/blog/what-transformative-learning-theory2007.html> accessed 20 May 2024.

White, Hayden, 'The Historical Text as Literary Artifact', in Robert H. Canary and Henry Kozicki, eds, *The Writing of History: Literary Form and Historical Understanding* (Madison: University of Wisconsin Press, 1978), 41–62.

White, Michael and David Epston, *Narrative Means to Therapeutic Ends* (New York: W. W. Norton, 1990).

Wilson, Shawn, *Research Is Ceremony. Indigenous Research Methods* (Halifax: Fernwood Publishing, 2008).

Wirth, Uwe, ed., *Performanz. Zwischen Sprachphilosophie und Kulturwissenschaften* (Frankfurt a. M.: Suhrkamp, 2002).

Womack, Craig, *Red on Red: Native American Literary Separatism* (Minneapolis: University of Minnesota Press, 1999).

Woolford, Andrew, *This Benevolent Experiment: Indigenous Boarding Schools, Genocide, and Redress in Canada and the United States* (Lincoln: University of Nebraska Press, 2015).

Worthington, Heather, *Key Concepts in Crime Fiction* (New York: Palgrave Macmillan, 2011).

Zoonen, Liesbet van, *Entertaining the Citizen: When Politics and Popular Culture Converge* (Lanham: Rowman & Littlefield Publishers, 2005).

Notes on Contributors

WESHOYOT ALVITRE is a Tongva, Spanish and Scottish comic book artist, writer and illustrator. She was born in the Santa Monica Mountains on the property of Satwiwa, a cultural centre started by her father Art Alvitre. Her work focuses on art and writing that visualizes historical material through an Indigenous lens.

SONNY ASSU (Ligwiłdaʼxw of the Kwakwakaʼwakw Nations) was raised in North Delta, BC, over 250 km away from his ancestral home on Vancouver Island. Having been raised as your everyday average suburbanite, it wasn't until he was 8 years old that he uncovered his Kwakwakaʼwakw heritage. Often autobiographical, humorous and political, Assu's work explores multiple mediums and materials to negotiate Western and Kwakwakaʼwakw principles of art-making. 'Personal Totems' was his first professional essay, which looked at how his early life influenced his contemporary art practice. It sardonically looked at how the early aughts shaped our consumeristic ideologies and habits, shaping and defining who we are in our materialistic western society. He currently resides in ƛamʼataxʷ (Campbell River, BC), within unceded Ligwiłdaʼxw territory.

RICHARD VAN CAMP is a proud Tlicho Dene from Fort Smith, NWT. A recipient of the Order of the Northwest Territories, he is the author of twenty-eight books, these past twenty-eight years in just about every genre. You can visit him on Facebook, Instagram, Twitter and at <www.richardvanc amp.com>. Mahsi cho!

KATI DLASKE is Senior Lecturer in the Department of Languages at the University of Helsinki, Finland. Before that she worked as a postdoctoral researcher in two successive research projects, both based at the Department of Language and Communication Studies at the University of Jyväskylä, Finland, and funded by the Academy of Finland: *Peripheral Multilingualism*

and *ReCLaS*, Research Collegium for Language in Changing Society. Her work has dealt with the indigenous Sámi and other ethno-linguistic minorities, questions of gender, and the politics of popular culture, as well as the rise of the new economy and neoliberalization of societies. She has explored these topics by drawing on discourse analytical and ethnographic approaches, among others. Her research has appeared in a range of international journals, including *Discourse and Communication, Language in Society, Gender and Language, Multilingua, Social Semiotics* and *Journal of Multicultural Discourses.*

JAMES J. DONAHUE is Professor and Assistant Chair of English & Communication at The State University of New York, College at Potsdam. He regularly teaches courses on Native American Literature, Young Adult Literature and The Graphic Novel. He is the author of *Contemporary Native Fiction: Toward a Narrative Poetics of Survivance* (Routledge 2019) and *Indigenous Comics and Graphic Novels: Studies in Genre* (UP of Mississippi 2024), as well as the author or co-editor of four other volumes.

JULIANE EGERER is a tenured Academic Lecturer and scholar in Scandinavian/Nordic and Comparative Literary and Cultural Studies at the University of Augsburg, Germany. She holds a binational PhD in Scandinavian Studies from the University of Basel, Switzerland, and the University of Freiburg i. Br., Germany. In order to establish a transatlantic Indigenous Studies perspective, a significant part of her research focuses on Indigenous literatures from Northern Europe and North America, concentrating on the interdependencies of decolonization, identity constructions, gender issues, transculturality, environmental humanities and ecocriticism. From 2023 to 2025, Dr Egerer has been accepted as a fellow in the Female High Potentials Program of the University of Augsburg, which aims to promote the representation of women and their research in top academic positions.

MONICA FLEGEL and JUDITH LEGGATT are members of the English department at Lakehead University, Canada. Dr Flegel teaches cultural studies. She has published articles and books on fanfiction, animals in Victorian

culture and child studies. Dr Leggatt teaches Indigenous literature and science fiction. She has published articles on Indigenous science fiction, tricksters in Indigenous literature and Indigenous comics. Together they have published a book chapter on racism in fan reactions to Marvel's All-New, All-Different campaign, and co-authored *Superhero Culture Wars: Politics, Marketing and Social Justice in Marvel Comics* (Bloomsbury 2021).

DR LEE FRANCIS 4 (aka Dr IndigiNerd) is the CEO of A Tribe Called Geek (ATCG) Media and the Executive Director of Native Realities, both of which are dedicated to creating pop culture media that celebrates Indigenous identity. He is also the founder of the Indigenous Comic Con, the world's only event by, for and about Native and Indigenous popular culture. He is an award-winning editor of over a dozen comic books and graphic novels and has won accolades for his work on *Ghost River*, *Sixkiller* and *Native New York*. You can find more about his work on social media @dr_indiginerd. He lives in North Carolina with his family.

D. S. RED HAIRCROW is a writer, psychologist, educator and documentary filmmaker of Native (Chiricahua Apache/Cherokee) and African American heritage. They received the 2023 Ma'iingan Scholarship award for their support of gender expansive diversity, and their research and work continues on intergenerational historic trauma, suicide prevention and intercultural understanding. Current projects include the documentary, 'Almost', on Indigeneity, gender diversity and stigma, and the adventure RPG 'Exanimate Sea', on origins, our Earth, the ancient present and an alternative future.

CÈCILE HEIM is Swiss and French and finished her PhD in North American literatures and cultures as well as in gender studies at the University of Lausanne in Switzerland. Her dissertation examined the representation of violence against Indigenous women and girls in Louise Erdrich's (Anishinaabe) *The Round House*, Franci Washburn's (Lakota) *Elsie's Business*, Eden Robinson's (Haisla/ Heiltsuk) *Monkey Beach* and Katherena Vermette's (Métis) *The Break*. Cécile now works as a political advisor in environmental politics for the Socialist party in Switzerland.

COLBY Y. MIYOSE is Assistant Professor at the University of Hawaiʻi, Hilo. He is an Asian American and Pasifika scholar whose research interests pertain to various forms of representation in media of gender, sexuality, race, and class (film, social media, television, music). His methods and theoretical approach stem from critical-cultural studies from postcolonial theories to queer theories. Some of his works include, 'Eh ... You Hawaiian?: Kanaka Maoli and ʻAina in Hawaii Five-o', 'Ua mau ke ea o ka ʻāina i ka pono: Cultural Appropriation of the Hawaiian Language in *Hawaii Five-o*' and 'Unrealistic Weeds of Love and Romance: Galician's Loves Myths in "Flower Boy" K-Dramas'.

SVETLANA SEIBEL is a postdoctoral research associate in North American Literary and Cultural Studies at Saarland University, Germany. She completed her dissertation on Indigenous popular culture as a member of the International Research Training Group 'Diversity: Mediating Difference in Transcultural Spaces'. She is a co-editor of the special issue of *Studies in Canadian Literature* on 'Indigenous Literary Arts of Truth and Redress' (2021), and her work has been published in journals such as *European Journal of American Studies, Transmotion, Studies in Canadian Literature* and *Recherches Germaniques*, as well as in various edited collections.

ANTHONY J. THIBODEAU is an anthropologist with a Master of Arts degree in Popular Culture from Bowling Green State University in Ohio. Tony joined the staff at the Museum of Northern Arizona in Flagstaff in 2016 and in 2019 curated the exhibition 'The Force Is With Our People', which explored the cultural connections between the *Star Wars* universe and contemporary Indigenous art. This exhibition won the 2020 Viola Awards Excellence in Visual Arts. Tony currently serves as the Director of Research and Collections at the Museum of Northern Arizona.

Index

Genre Fiction and Film Companions

Series Editor: Simon Bacon

The *Genre Fiction and Film Companions* provide accessible introductions to key texts within the most popular genres of our time. Written by leading scholars in the field, brief essays on individual texts offer innovative ways of understanding, interpreting and reading the topics in question. Invaluable for students, teachers and fans alike, these surveys offer new insights into the most important literary works, films, music, events and more within genre fiction and film.

We welcome proposals for edited collections on new genres and topics. Please contact baconetti@googlemail.com or oxford@peterlang.com.

Published Volumes

The Gothic
Edited by Simon Bacon

Cli-Fi
Edited by Axel Goodbody and Adeline Johns-Putra

Horror
Edited by Simon Bacon

Sci-Fi
Edited by Jack Fennell

Monsters
Edited by Simon Bacon

Transmedia Cultures
Edited by Simon Bacon

Shirley Jackson
Edited by Kristopher Woofter

Toxic Cultures
Edited by Simon Bacon

Magic
Edited by Katharina Rein

The Undead in the 21st Century
Edited by Simon Bacon

The Deep
Edited by Marko Teodorski and Simon Bacon

Death in the 21st Century
Edited by Katarzyna Bronk-Bacon and Simon Bacon

Alice Through the Looking-Glass
Edited by Franziska E. Kohlt and Justine Houyaux

The Weird
Edited by Carl H. Sederholm and Kristopher Woofter

Aliens
Edited by Elana Gomel and Simon Bacon

IndigePop
Edited by Svetlana Seibel and Kati Dlaske